Creating Visual Effects in Maya

Creating Visual Effects in Maya

Fire, Water, Debris, and Destruction

Lee Lanier

Focal Press
Taylor & Francis Group

NEW YORK AND LONDON

First published 2014
by Focal Press
70 Blanchard Road, Suite 402, Burlington, MA 01803

and by Focal Press
2 Park Square, Milton Park, Abingdon, Oxon OX14 4RN

Focal Press is an imprint of the Taylor & Francis Group, an informa business

Library of Congress Cataloging-in-Publication Data
Lanier, Lee, 1966-
Creating visual effects in Maya : fire, water, debris, and destruction / by Lee Lanier.
pages cm
1. Maya (Computer file) 2. Computer animation. 3. Computer graphics. I. Title.
TR897.7.L368 2014
777'.7--dc23 2013032102

ISBN: 978-0-415-83418-6 (pbk)
ISBN: 978-0-203-50184-9 (ebk)

Typeset in Myriad Pro Family
By TNQ Books and Journals Pvt. Ltd.

Printed in China by CTPS

Bound to Create

You are a creator.

Whatever your form of expression — photography, filmmaking, animation, games, audio, media communication, web design, or theatre — you simply want to create without limitation. Bound by nothing except your own creativity and determination.

Focal Press can help.

For over 75 years Focal has published books that support your creative goals. Our founder, Andor Kraszna-Krausz, established Focal in 1938 so you could have access to leading-edge expert knowledge, techniques, and tools that allow you to create without constraint. We strive to create exceptional, engaging, and practical content that helps you master your passion.

Focal Press and you.

Bound to create.

> We'd love to hear how we've helped
> you create. Share your experience:
> **www.focalpress.com/boundtocreate**

Focal Press
Taylor & Francis Group

Contents

Contents

Contents

Contents

Introduction

Although Autodesk Maya is often used for such tasks as modeling, texturing, lighting, rigging, and animation, it has a wide range of visual effects systems and tools. You can create the visual effects for a fully-built Maya scene or prepare the visual effects for exportation and integration with live-action film or video footage. In a broad sense, *visual effects* refers to digitally-created special effects that recreate natural phenomena that are too complex for standard 3D techniques.

You, the Reader

Creating Visual Effects in Maya: Fire, Water, Debris, and Destruction is aimed at digital artists who have a working knowledge of Autodesk Maya but would like to learn more about the program's visual effects systems and tools. As such, it's assumed that the reader is familiar with the Maya interface and general work flow. Introductory knowledge of Autodesk MatchMover, Autodesk Composite, Adobe After Effects, The Foundry Nuke, Google SketchUp, and Adobe Photoshop is also useful as motion tracking and render pass compositing are covered in the last few chapters.

Topics Covered

Creating Visual Effects in Maya: Fire, Water, Debris, and Destruction covers critical visual effects systems and tools, including Paint Effects, Fur, nHair, nDynamics (including nParticles, nCloth, colliders, and fields), scripting (including expressions, MEL, Python, and PyMEL), Fluid Effects, and Dynamics rigid bodies. In addition, the book covers the use of mental ray render passes and the combination of render passes in compositing programs.

This book is organized around multi-chapter tutorials that recreate various phenomena found in the real-world. The phenomena include the following:

- Foliage
- Fire
- Smoke
- Short hair
- Long hair
- Grass
- Electric arcs
- Flowing water
- Pooled water
- Thick smoke
- Sparks

- Insect swarms
- Bubbles
- Semi-rigid debris
- Dust puffs
- Environment fog
- Trailing thin smoke
- Explosive fireballs
- Small flames
- Large bodies of water
- Small bodies of water, such as puddles
- Isolated surface damage
- Complex, large-scale destruction

Although this book is tutorial-based, it includes critical information on visual effects theory, Maya tool functionality, and scripting construction. For example, node networks created by various tools are discussed in detail. Important syntax of expressions, MEL, Python, and PyMEL scripting is also covered. In addition, this book places an emphasis on matching the aesthetic qualities of real-world phenomena.

Required Software

This book was written with Autodesk Maya 2013 and tested with Autodesk Maya 2014. Any significant differences between 2013 and 2014 are noted in the text. Tutorial files are saved in the Maya 2013 `.ma` format, except where nHair examples are included, in which case the files are saved in the Maya 2014 `.ma` format. Motion tracking examples are saved as MatchMover `.mmf` files. Compositing examples are saved as Autodesk Composite 2013 `.txcomposition` files, Adobe After Effects CS6 `.aep` files, and The Foundry Nuke 7 `.nk` files.

System Requirements

Maya, After Effects, and Nuke will run poorly unless your computer's hardware and operating system software meet minimum criteria. The criteria are carefully spelled out at the following web pages:

- **Maya:** `www.autodesk.com/products/autodesk-maya/system-requirements`
- **After Effects:** `helpx.adobe.com/x-productkb/policy-pricing/system-requirements-effects.html`
- **Nuke:** `www.thefoundry.co.uk/products/nuke/system-requirements/`

Downloading the Tutorial Files

Example tutorial files are provided for this book and may be downloaded from `www.focalpress.com/cw/lanier`. These include five gigabytes of Maya

scene files, MatchMover project files, Composite project files, After Effects project files, Nuke project files, texture bitmaps, MEL scripts, Python scripts, PyMEL scripts, rendered image sequences, image sequences converted from video footage, and various Maya-created data, such as Fur files. The files are organized in the following directory structure:

ProjectFiles/Project*n*/maFiles/	Maya scene files (`.ma`)
ProjectFiles/Project*n*/Textures/	Texture bitmaps (PNG, Maya IFF `.iff`, and TIFF `.tif` files)
ProjectFiles/Project*n*/renderData/	Various Maya IFF fur maps, arranged in subfolders
ProjectFiles/Project*n*/data/	Cache XML and `.mc` files
ProjectFiles/Project*n*/MELscripts/	MEL scripts saved as text `.mel` files
ProjectFiles/Project*n*/Pythonscripts/	Python and PyMEL scripts saved as text `.py` files
ProjectFiles/Project*n*/mmfFiles/	MatchMover 2013 `.mmf` project files
ProjectFiles/Project*n*/txFiles/	Composite 2013 `.txcomposition` project files
ProjectFiles/Project*n*/aeFiles/	After Effects CS6 `.aep` project files
ProjectFiles/Project*n*/nkFiles/	Nuke 7 `.nk` project files
ProjectFiles/Project*n*/Footage/	PNG image sequences arranged in subfolders; these are derived from video footage
ProjectFiles/Project*n*/images/	Layered PSD `.psd`, Maya IFF, and RLA `.rla` image sequence subfolders; these are generated with Maya renders passes
ProjectFiles/Project*n*/Models/	OBJ model files and SketchUp `.skp` project files

Using the Tutorial Files with Windows, Mac, and Linux Systems

If you are running Maya and Nuke on a Windows system, I recommend copying the tutorial project files onto your C: drive before opening any files. If you are running Maya and Nuke on a Mac or Linux system, I recommend copying the project files onto your root drive.

Before opening a Maya scene file, set the project to the current project folder. For example, before opening `Project1.1.ma`, choose File > Set Project and select the `/ProjectFiles/Project1/` directory folder. With this step, Maya will open the various texture bitmaps in a correct manner.

If you open a Maya file and the texture bitmaps are missing (as indicated by black texture node thumbnails), you can manually reload them. To do so, use the Image Name browse button to locate the bitmap through the texture's Attribute Editor tab.

If you open an After Effects file and the image sequences are missing, RMB-click over the sequence name in the Project panel and choose Replace Footage.

If you open a Nuke file and the image sequences are missing, you can reload them by double-clicking the appropriate Read node and locating the sequence with the File browse button.

Note that this book's screen captures are taken from Maya 2013 running on 64-bit Windows 7 and 8 systems.

Naming Conventions

Creating Visual Effects in Maya: Fire, Water, Debris, and Destruction uses common conventions when describing mouse operation. A few examples follow:

Click	Left mouse button click
double-click	Rapidly click left mouse button twice
MMB-drag	Drag while pressing middle mouse button
RMB-click	Right mouse button click
Shift+click	Left mouse click while holding Shift key

When discussing various functions and interface features of Maya, After Effects, and Nuke, I've used terminology established by the programs' help files. When discussing compositing theory, I've used terminology commonly employed in the visual effects industry.

The Ctrl key on a Windows or Linux system and the Cmd key on a Mac PC serve the same function. Hence, a call to press either key is written as Cmd/Ctrl. The Windows/Linux Alt key serves the same function as the Mac Option key. Hence, a call to press either is written as Opt/Alt.

Updates

For updates associated with this book, please visit www.focalpress.com/cw/lanier.

Special Thanks

Special thanks go out to Stanley "Grey" Hash for serving as technical editor on this book.

Contacting the Author

Feedback is always welcome. You can contact me at books@beezlebugbit.com or find me on popular social media networks.

Adding Foliage, Fire, and Smoke with Paint Effects

Paint Effects is a unique visual effects system within Maya that produces myriad geometry with the stroke of a brush. Although the geometry is based on primitive tubes, simple meshes, or sprites, its complex growth can emulate a wide range of natural objects, including a variety of plant life, animal fur and feathers, fire, electrical arcs and sparks, base elements such as metal and water, and artistic materials that include pencil, pastel, and oil.

You can apply Paint Effects to an empty Maya scene, onto a 2D canvas, or onto a specific surface. With preparation, you can render Paint Effects with Maya Software or mental ray. However, the true power of Paint Effects lies in your ability to adjust hundreds of attributes to create an almost inexhaustible number of permutations. Surface quality, shadow-casting, built-in dynamic animation, and growth patterns are all adjustable.

This chapter includes the following critical information:

- Application of Paint Effects to surfaces
- Adjustment of Paint Effects attributes
- Rendering of Paint Effects with Maya Software and mental ray

In addition, this chapter covers Part 1 to Part 3 of Project 1. The project features a modeled, textured, and lit 3D scene featuring a Neolithic huntress in a desert landscape (**Figure 1.1**). We'll add interest to the scene by applying Paint Effects.

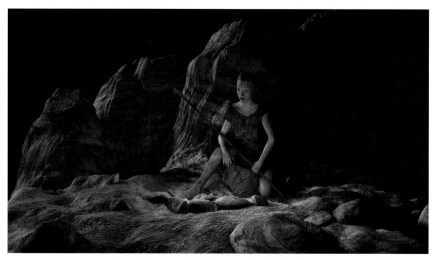

FIG 1.1 Project 1 Maya scene. In this chapter, we'll add foliage, fire, and smoke.

An Overview of Visual Effects

Visual effects is imagery created or adjusted for a film or video that cannot be obtained during a live-action, real-world shoot. The current visual effects industry creates such imagery, with the majority of the work produced digitally through 3D animation programs, such as Autodesk Maya, and 2D compositing programs, such as Autodesk Composite. The industry produces visual effects for theatrical motion pictures, television programs, television commercials, and various on-demand online content.

In a broader sense, *visual effects* refers to digitally-created special effects that recreate natural phenomena that are too complex for standard 3D modeling, rigging, animation, and rendering techniques. Such phenomena might include the flash flood of a valley, the explosive collapse of a building, the eruption of a super-volcano, the plying of an ancient ship on stormy seas, or an angry swarm of giant insects. These effects might appear in a live-action

feature film, a 2D or 3D animated feature film, an independent short film, a scientific visualization, or a cross platform video-game.

Hence, this book will tackle visual effects in two forms: visual effects designed to stay within Maya and visual effects intended to be integrated with live-action footage. The first seven chapters include three tutorials that introduce you to the majority of Maya's visual effects tools. The effects are applied to pre-built 3D scenes and are not exported. In contrast, the last three chapters cover a single tutorial that creates visual effects within Maya for the purpose of exportation and compositing with video footage.

VFX Notes: Optimizing Your Work Flow

Many of the visual effects created in this book are time-intensive—they either slow down the interactive playback of the timeline or they take a significantly long time to render. Here are some steps you can take to make sure your work flow is efficient:

- Alter the render resolution. Start with a small resolution, such as 640×360, and work your way up to larger resolutions, such 1280×720 or 1920×1080.
- Render small regions when testing. Use the Render Region function in the Render View. (Click drag a red marquee box in the Render View render area and click the Render Region button.)
- Temporarily lower the render quality. With Maya Software, change the Edge Anti-Aliasing menu to different quality presets. With mental ray, alter the attribute settings within the Sampling section of the Quality tab (Maya 2014) or change the Quality Presets menu at the top of the Quality tab (Maya 2013 and earlier). Raise the render quality once the visual effects have been adjusted.
- Temporarily hide unwanted objects. Alternatively, create display or render layers to divide the objects among layers that you can turn on or off. Render layers are discussed in Chapters 1, 2, and 10.
- Create Playblast movies (Window > Playblast) when the timeline playback is slow.
- Employ Dynamics or nDynamics caches. Caches save the motion of objects, such as nParticles, in memory. When a simulation is cached, you can play the timeline in reverse or start the playback on a late frame. Caches are discussed in Chapter 10.
- When working with Dynamics and nDynamics systems, reduce the number of dynamic items. For example, try to work with fewer nCloth objects, particles, or Fluid Effects container voxels. Many Dynamics and nDynamics components have their own quality settings. Start with low-quality settings and work your way up to high-quality. These settings are discussed throughout this book.

Although these techniques are mentioned when they are the most critical to efficiency, feel free to apply them at any time.

Planting Foliage with Paint Effects

Part 1 of Project 1 starts with the addition of plants to the landscape. This will allow us to discuss Paint Effects basics, including painting strokes, reviewing nodes, adjusting attributes, rendering with Maya Software and mental ray, and casting shadows.

Painting Paint Effects Strokes

There are three ways you can apply Paint Effects: 1) Create a stroke in the view plane; 2) Create a stroke directly on a polygon or NURBS surface; 3) Create a stroke on a Paint Effects 2D canvas. Painting directly on a surface allows the Paint Effects stroke (which is a specialized curve) to follow the undulations of the surface; if the surface deforms, the stroke automatically adjusts to maintain alignment.

We'll start by painting flowering shrubs along the foreground. You can follow these steps:

1. Open the `Project1.1.ma` scene file. This is located in the `/ProjectFiles/Project1/maFiles/` tutorial directory; to avoid missing texture bitmaps, choose File > Set Project and select the `/ProjectFiles/Project1/` folder before opening the file. The scene includes a large desert surface, several loose rocks and logs, and a posed character with a spear and loose fur garment. Note that there are two perspective cameras in the scene: the default Persp camera and an additional camera named WorkCamera. The Persp camera is positioned for the final render and should be left in place. However, feel free to move the WorkCamera around the scene to focus in on various details as you set up the effects.
2. Select the Ground surface. Switch to the Rendering menu set. Choose Paint Effects > Make Paintable. This directs the Paint Effects brush to "stick" to the surface when the brush passes over the surface.
3. Choose Paint Effects > Get Brush. The Visor window opens and automatically switches to the Paint Effects tab. The left column displays a long list of Paint Effects category folders. Click on the *grasses* folder. Icons for the various brushes appear in the right column (**Figure 1.2**). Click on the cactusGrass icon so that a yellow line appears around its edge.
4. In one of the view panels, LMB-drag the mouse over the Ground surface. Place the stroke so that the plants appear in the front left of the Persp camera frame. When you select the brush through the Visor, the mouse icon changes to a pencil with a small red sphere. When you release the mouse button, one or more cactus grass plants appear with a single stroke.
5. The brush provides a default scale for the plants. You can interactively change the scale by pressing the B key and LMB-dragging in a 3D view to change the brush size (as indicated by the red sphere). For example, press Ctrl+Z or Cmd+Z to undo the previous stroke, press B and LMB-drag right to increase the brush size, and paint a new stroke. Note that you can

FIG 1.2 The Visor window with the Paint Effects tab and grasses folder selected.

change the scale at any time, even after the stroke is painted; we'll discuss this in the "Adjusting Paint Effects Attributes" section later in this chapter.

Each time you LMB-drag the Paint Effects brush, a separate stroke is created that carries its own set of attributes. Although you can create strokes of any length, it's generally more efficient to keep them fairly short. A short stroke produces fewer Paint Effects components, such as tubes. In addition, you can add greater variety with several short strokes instead of a single long stroke. For example, in **Figure 1.3**, two strokes are painted to create patches of cactus grass along the foreground left. If you switch to a different tool, such as the Select Tool, you can retrieve the Paint Effects brush by choosing Paint Effects > Paint Effects Tool or pressing the Y key to repeat the last tool used.

FIG 1.3 Two Paint Effects strokes are painted on the Ground surface, producing two patches of cactus grass. At this point, the scale of the strokes has not been adjusted. An example Maya file is included as Project1.2.ma in the /ProjectFiles/Project1/maFiles/ tutorial directory. Although the stroke curves are not visible in this screen snapshot, they run along the surface.

At this point, the Paint Effects strokes are sticking to the Ground surface. However, if you LMB-drag the Paint Effects brush in an empty area of the scene or over a surface that has not been made paintable, no stroke is created. Nevertheless, if you choose Paint Effects > Paint On View Plane, you can paint on the XZ plane through a perspective view panel. To return to painting on surfaces, choose Paint Effects > Paint On Paintable Objects.

Reviewing Paint Effects Nodes

Before adjusting Paint Effects strokes, it helps to understand the basic components that make the system work. Each stroke is composed of five nodes: a stroke transform node, a stroke shape node, a curve shape node, a hidden curve transform node, and a brush shape node (**Figure 1.4**).

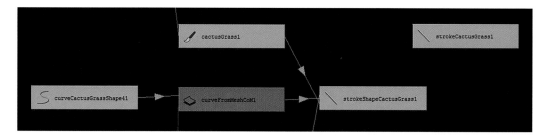

FIG 1.4 The stroke transform, stroke shape, curve shape, and brush node of a single Paint Effects stroke, as seen in the Hypergraph: Connections window. The brush node is indicated by the paintbrush icon. In addition, a curveFromMeshCoM node allows the stroke to follow the painted surface.

The stroke transform node carries basic transforms, such as translation. You can move, rotate, or scale a stroke through this node (although the X, Y, and Z scales remain equal for the item growing from the stroke). The stroke shape node carries global quality settings. For example, the Display Quality attribute determines how much detail is displayed for the stroke within the view panels. Lower values present a simplified representation without affecting the actual render quality. High Quality settings, however, show a more accurate representation of the strokes but may make the view panel updates sluggish.

The brush shape node carries a long list of attributes that affect how the painted item grows and is rendered; we'll examine these attributes in more detail in the next section. You can unhide the otherwise hidden curve transform node, named curve*brush*, by selecting it in the Hypergraph or Outliner and choosing Display > Show > Show Selection. You can display, manipulate, and keyframe the curve vertices as you would with any other NURBS curve. Any change to the curve affects the stroke automatically. If a stroke is painted on a surface, the curve follows the surface as it deforms; this is possible through the automatic connection of a curveFromMeshCoM node. Thus, Paint Effects is ideally suited for adding growth to a rigged character; for example, you can use Paint Effects to create patches of facial hair. (Long, flowing hair is better suited for Maya's nHair system and wider

swathes of dense hair is better suited for Maya's Fur system, both of which are demonstrated in Chapter 2.)

Adjusting Paint Effects Attributes

Once a Paint Effects stroke is painted, you're free to adjust its numerous attributes. For Project 1, we'll adjust the scale of the cactus grass, vary the growth between the clumps of grass, and fine-tune the basic material qualities of the plants. Follow these steps:

1. Select the first stroke. Using the Select Tool, you can click on the plant tubes. Optionally, you can select the stroke transform node in the Hypergraph or Outliner. Open the Attribute Editor. Switch to the cactusGrass*n* brush tab. (Each stroke is numbered.) Adjust the Global Scale. A value between 1.25 and 1.5 works well for Project 1.
2. Create a test render of the Persp camera through the Render View. Note that Paint Effects is a post-process; that is, the strokes are added to the render at the end of the rendering process (**Figure 1.5**). To save time, you can use the default quality settings for the Maya Software render. You can also use the Render Region function of the Render View to render a small area.

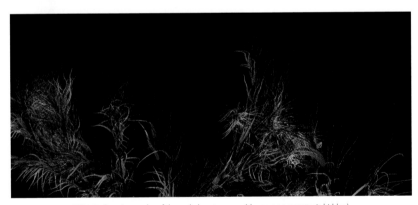

FIG 1.5 A region render of the scaled cactus grass (the scene geometry is hidden).

3. Reselect the stroke and return to the cactusGrass*n* tab of the Attribute Editor. Scroll down to the Tubes section and expand it. Expand the Growth subsection (see **Figure 1.6**). The brush has Branches, Twigs, Leaves, and Flowers attributes selected (and Buds is deselected). Deselect the selected attributes, one at a time. The matching components disappear in the view panels. Paint Effects brushes that use tubes have the option of using these components in any combination. Select Branches, Twigs, Leaves, and Flowers to return the cactus grass to its prior state.
4. Scroll higher in the Attribute Editor and expand the Shading section and Tube Shading subsection (**Figure 1.7**). The Color 1 and Transparency 1

attributes set their namesake for the base of each branch and twig. The Color 2 and Transparency 2 attributes set their namesake for the tip of each branch and twig. The center of each branch and twig is a mixture of 1 and 2 attributes. Note that the colors are randomly shifted if Hue Rand, Sat Rand, and Val Rand (in the Tube Shading subsection) possess values above 0. Color *n* and Transparency *n* attributes are additionally altered if Map Color and Map Opacity are selected in the Texturing subsection (found below Tube Shading). In this situation, Color 1 and Color 2 are multiplied by the colors produced by a built-in texture generated by the Texture Type attribute. As an experiment, deselect Map Color, reduce Hue Rand to 0, and change Color 1 and Color 2 to bright colors. In addition, set Incandescence 1 and Incandescence 2 to non-black colors. Test render. The colors of the plants change significantly (**Figure 1.8**). While Color 1 and Color 2 affect branches and twigs, Incandescence 1 and Incandescence 2 affect all the tubes. Although such colors are not particularly realistic, you are free to fine-tune the attributes in these sections for a customized result.

FIG 1.6 The Growth subsection.

FIG 1.7 The Shading section and Tube Shading subsection as seen with default setting for the cactusGrass brush.

FIG 1.8 The result of altering Color 1, Color 2, Incandescence 1, and Incandescence 2.

5. Set Color 1 and Color 2 to 1.0-white. Set Incandescence 1 and Incandescence 2 to 0-black. In the Texturing subsection, select Map Color and Map Opacity. Setting Color 1 and Color 2 to white prevents the color alteration of the Texture Type texture. Color 1 is multiplied by Tex Color 1 and Color 2 is multiplied by Tex Color 2. (Tex Color 1 and Tex Color 2 are located below the Texture Type attribute.) Texture Type is set to V Ramp by default, which signifies that Tex Color 1 transitions to Tex Color 2 along the V direction. When texturing Paint Effects strokes, U is the direction along the stroke curve and V is the direction across the curve. Aside from the V Ramp option, you can also change the Texture Type to one of the following:

Checker places a checker pattern on the tubes. This may be useful for testing.
U Ramp repeats a ramp along the U direction (along the stroke curve).
Fractal mixes Tex Color 1 and Tex Color 2 in the noise pattern.
This offers the means to make the texture appear dirty or more random.
File allows you to apply a bitmap, as is defined by the Image Name attribute at the bottom of the subsection. The V direction of the bitmap is mapped along the height of each tube.

By default, the texture is mapped to each tube through a 2D UV space, as is set by the Tube 2D option of the Map Method attribute. With this option, any potential texture seam is hidden on the back side of the tube. Other mapping options include:

Full View projects the texture from the view of the rendering camera.
Brush Start works in a similar fashion to Full View but the texture scale is based on the distance each tube is from the camera.
Tube 3D works in a similar fashion to Tube 2D, but no effort is made to hide the texture seams.

6. Set Tex Color 1 to dark red and Tex Color 2 to medium green. Change Texture Type to Fractal (**Figure 1.9**). Test render. At this point, it's difficult to see

color changes to the branches and twigs because they are very thin and are covered by the leaves and flowers. In addition, the brightness or darkness of any given tube is affected by the lights in the scene. Expand the Illumination subsection (below the Texturing subsection) and temporarily deselect Illuminated. This forces the Paint Effects tubes to ignore the scene lighting. Return to the Growth subsection. Deselect Leaves and Flowers. Expand the Branches and Twigs subsections. In these subsections, you'll find numerous attributes that control width, length, and angle of growth. Change Twig Base Width to 0.85 and Twig Tip Width to 0.035. Test render. (If necessary, increase the render resolution and anti-aliasing quality so you can see the plant detail.) The wider twigs are easily seen. However, the fractal pattern provided by the Texture Type attribute may appear unclear. In the Texturing subsection, alter the Repeat U and Repeat V values and continue test rendering. For example, with the provided project files, a Repeat U of 5 and a Repeat V of 0.1 works well (**Figure 1.10**). Altering the U and V tiling attributes allows you to adjust the texture size.

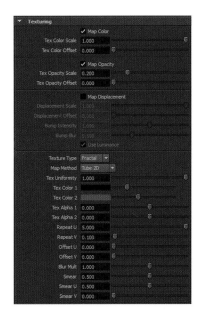

FIG 1.9 The Texturing subsection with Tex Color 1 and Tex Color 2 altered and Texture Type set to Fractal. Repeat U and Repeat V are adjusted so that the fractal pattern becomes recognizable.

FIG 1.10 The altered branches and twigs (the scene's geometry is hidden).

7. Select the Illuminated attribute in the Illumination subsection. In the Growth subsection, select Leaves and Flowers. Test render. At this point, the leaves appear light brown and are much wider than other parts of the plant. The flowers are very thin and appear at the tops of the twigs. The colors, widths, lengths, numbers, distribution, and orientations of the leaves and flowers are found in the Leaves and Flowers subsections (directly below the Twigs subsection). You can alter any of the attributes. In fact, an efficient way to learn what affect attributes have is to adjust their sliders. Any alterations to the leaf and flower tube growth, such as a change in width or length, appear immediately in the view panels. For example, you can make the plants appear heavier, thornier, and more succulent (that is, greener with better access to water) by setting the following attributes to the listed values in Table 1.1:

TABLE 1.1

Attribute	Value	Notes
Leaves In Cluster	5	Number of leaf clusters per branch/twig.
Leaf Dropout	0.4	Rate at which leaves are "killed off."
Leaf Length	0.4	
Leaf Base Width	0.1	
Leaf Tip Width	0.001	
Leaf Start	1.0	Where the leaves start on the branch/twig tubes. 0 is the tube base and 1.0 is the tube tip.
Leaf Angle 2	0	Angle of leaf at the branch/twig tip.
Leaf Twist	0	
Leaf Bend	1.0	
Leaf Segments	12	
Leaf Flatness	0.1	The higher the value, the thinner and flatter and more 2D the leaves become.
Leaf Size Decay	1.0	The lower the value, the more the leaves shrink as they approach the tip. With a value of 1.0, the leaves are all the same size.
Leaf Stiffness	1.0	The lower the value, the more petals react to built-in dynamics, such as Gravity.
Leaf Translucence	0	
Leaf Specular	0.3	
Leaf Color 1	Dark green	Color at leaf base.
Leaf Color 2	Medium red	Color at leaf tip.

Continued

TABLE 1.1—cont'd

Attribute	Value	Notes
Leaf Val Rand	0	
Petals In Flower	10	
Petal Length	0.5	
Petal Base Width	0.015	
Flower Angle 1	10	Angle of flower at the branch/twig base.
Flower Angle 2	30	Angle of flower at the branch/twig tip.
Flower Twist	1.0	
Petal Bend	0	
Petal Twirl	0	
Petal Flatness	0.6	The higher the value, the thinner and flatter and more 2D the petals become.
Flower Size Decay	0.35	The lower the value, the more the flowers shrink as they approach the branch/twig tip.
Flower Specular	0.2	
Petal Color 1	Dark green	Color at petal base.
Petal Color 2	Pale green	Color at petal tip.

FIG 1.11 The adjusted Leaf Width Scale graph ramp. You can insert new curve points by clicking on the curve line. You can delete points by clicking the small × boxes at the graph ramp base. The left of the graph ramp is the leaf base and the right of the graph ramp is the leaf tip.

Due to the increase in leaf size, it's necessary to increase the Tube Width 1 value in the Creation subsection to 0.075. Tube Width 1 controls the base width of the branches (while Tube Width 2 sets the width of the branch tips). You can exert additional control over the leaf width by utilizing the Leaf Width Scale graph ramp, located in the Leaves subsection. The graph ramp curve serves as a multiplier, altering the values provided by Leaf Base Width and Leaf Tip Width. The pyramid-shaped curve seen in **Figure 1.11** causes each leaf to have a narrow base, a wide center, and a narrow tip. See **Figure 1.12** for a before and after comparison of the cactusGrass strokes.

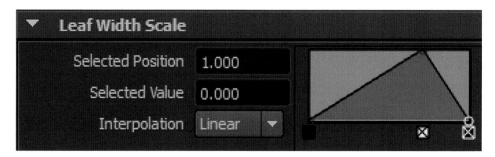

FIG 1.12 Foreground: cactusGrass stroke adjusted to create a heavier, thornier, and more succulent look. Background: cactusGrass stroke with default settings (the scene's geometry is hidden). An example Maya file is included as Project1.3.ma in the /ProjectFiles/Project1/maFiles/ tutorial directory.

Copying Attributes between Paint Effects Brushes

If you've painted more than one stroke using the same Paint Effects brush, it's difficult to manually match the attribute settings between the strokes. However, you can copy attribute setting between strokes. To do so, follow these steps:

1. Select a Paint Effects stroke that carries adjusted attributes. Choose Paint Effects > Get Settings From Selected Stroke.
2. Deselect the first stroke. Select one or more new strokes whose attributes you wish to match. Choose Paint Effects > Apply Settings To Selected Strokes. The new strokes take on all the settings of the first stroke.

Although copying attributes is a significant time-saver, it can lead to plants that appear identical. To prevent this, you can adjust the following attributes for each stroke:

Global Scale (at the top of the brush node tab). You can alter the size of each stroke.
Brush Width (in the Brush Profile section, below Global Scale). This attribute determines how closely the tube growth follows the stroke curve. The larger the value, the more spread out the growth is.
Start Branches (in the Branches subsection). This attribute sets the number of branches that occur at the base of a single growth (such as a single plant). Changing this value has a significant impact on the shape of the growth.
Gravity (in the Forces subsection of the Behavior section). Each stroke has its own built-in dynamic forces. The higher the Gravity value, the more the tubes droop downwards.
Random (above Gravity). The higher the value, the greater the randomness found within the branching of the tubes. The lower the value, the more vertical the resulting growth.

13

Seed (found at the top of the stroke shape node tab). This value is set automatically each time you paint a stroke. However, you are free to change the value and therefore generate a new random growth pattern.

As an example, these attributes were adjusted for the two cactusGrass strokes used in Project 1 (**Figure 1.13**).

FIG 1.13 Two strokes are given slightly different Global Scale values. In addition, the stroke on the right (selected) is given lower Gravity and Random values plus a higher Start Branches value. An example Maya file is included as Project1.4.ma in the /ProjectFiles/Project1/maFiles/ tutorial directory.

Casting Paint Effects Shadows

By default, Paint Effects brushes do not cast shadows. You can change this behavior, however, through the Shadow Effects section of the brush node (**Figure 1.14**). If you select the Cast Shadows attribute, the Paint Effects tubes and meshes will appear as part of any cast depth map shadows when rendering with Maya Software.

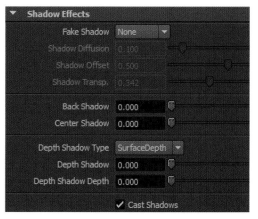

FIG 1.14 The Shadows Effects section of a brush node. Cast Shadows is selected.

You can also simulate cast shadows by switching the Fake Shadow attribute to 3D Cast. In this case, a shadow is cast below the stroke on a virtual plane. Note that 3D Cast takes into account the lighting present in the scene to determine the shadow direction. In fact, a unique shadow is created for each light in the scene (even if Use Depth Map Shadows remains deselected for the lights). The Cast Shadows attribute is overridden unless Fake Shadow is set to None.

To add shadows to Project 1, follow these steps:

1. Paint an additional cactusGrass stroke along the left edge of the rock wall. Copy the attributes from the original stroke to the new stroke. Alter the Global Scale, Brush Width, Start Branches, Gravity, and Random attributes so that the strokes aren't identical. Use the prior section as a guide for this process.
2. You may find that your scene updates slowly when multiple Paint Effects strokes are present. You can simplify the view panel render of each stroke by opening the stroke shape node and lowering the Display Quality below 100. This does not affect the render.
3. In the Shadow Effects section for the new stroke, select the Cast Shadows check box. Test render. Shadows are cast on the ground and rock wall. In addition, self-shadows are cast on the tubes themselves (**Figure 1.15**). In this case, a directional light serving as the moon and three point lights placed over the fire pit are casting soft depth-map shadows. Despite the post-process addition of the Paint Effects strokes, the resulting cactus grass fits appropriately behind the character.

FIG 1.15 Left: A new cactusGrass stroke does not cast a shadow on the ground or rock wall. Right: The cactusGrass stroke cast shadows on the ground and walls as well as self-shadows itself with the Cast Shadows attribute selected. (The foreground plants remain dark in both renders because little light is arriving from the direction of the camera.) An example Maya file is included as Project1.5.ma in the /ProjectFiles/Project1/maFiles/ tutorial directory.

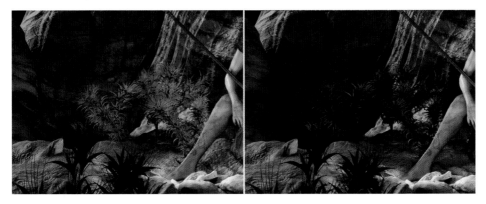

If the ground shadows are difficult to see, render a different view through the WorkCamera. Alternatively, you can temporarily adjust the shadows created by the Moon directional light and Firelight point lights. To sharpen a shadow, increase the light's Resolution attribute and lower the Filter Size attribute. To render Paint Effects with raytraced shadows or to use the mental ray renderer, you must convert the strokes. This is discussed in the next section.

Converting Paint Effects

When using Paint Effects, you are not limited to the native format. You can convert strokes to polygon or NURBS surfaces. For example, to convert the cactusGrass strokes to polygons, follow these steps:

1. Select a Paint Effects stroke. Choose Modify > Convert > Paint Effects To Polygons. The stroke is replaced with a polygonal copy. The original stroke is hidden. Each tube subset becomes a unique node with a group node tying everything into a hierarchy. With a cactusGrass stroke, the branches and twigs become one node, while the leaves and flowers receive separate nodes (**Figure 1.16**).

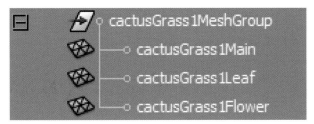

FIG 1.16 The hierarchy created for a converted Paint Effects cactusGrass stroke, as seen in the Outliner window.

2. If Paint Effects To Polygons is applied with default settings, it's possible that part of the Paint Effects growth disappears. If this is the case, press Crtl+Z or Cmd+Z to undo the conversion. Choose Modify > Convert > Paint Effects To Polygons > □. In the Convert Paint Effects To Polygons Options window, select Quad Output, enter a higher number into the Poly Limit cell (such as **500,000**), and click the Convert button.

3. Using a higher Poly Limit helps to preserve the original shape of the stroke; however, it may add an excessive number of polygon faces to the scene. Nevertheless, after the conversion, you can reduce the polygon count by applying the Reduce tool. To do so, select one of the polygon nodes, such as cactusGrass1Leaf. Switch to the Polygons menu set, choose Mesh > Reduce > □. In the Reduce Options window, enter a reduction value in the Reduce By (%) cell (Maya 2013) or Percentage cell (Maya 2014), and click the Reduce button. You may have to experiment with Reduce By/Percentage values. Values that are too high may cause the branches, leaves, or flowers to lose their general shape. For example, in **Figure 1.17**, a cactusGrass stroke was converted to polygons with Poly Limit set to 900,000. The cactusGrass1Leaf node was reduced by 50%, while the cactusGrass1Flower node was reduced by 80%. The cactusGrass1Main node, which includes the branches and twigs, was left as is because it only carried a total of 982 faces. These operations reduced the polygon count for the stroke to roughly 370,000 faces.

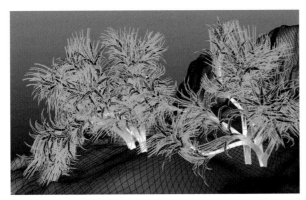

FIG 1.17 A converted Paint Effects stroke.

4. Construction history remains active after the conversion. Hence, you can update the attributes of the brush node and the new polygon copy automatically updates. To test this, open the brush node for the converted stroke. Adjust the Global Scale. The converted stroke is simultaneously scaled. To locate the brush node, select one of the converted nodes, such as cactusGrass1Flower, and choose Window > Hypergraph: Connections.

5. The conversion tool also creates new material networks that emulate the textures built into the Paint Effects brush. Open the Hypershade window (Windows > Rendering Editors > Hypershade). There are three new materials: cactusGrass*n*Shader, cactusGrass*n*LeafShader, cactusGrass*n*-FlowerShader. Unfortunately, these shading networks are not linked to the original brush. Changing the texturing attributes of the brush node has no affect on the materials. That said, you're free to delete the polygon conversion and new materials at any time and reapply the Paint Effects To Polygons tool to the original stroke. To display hidden Paint Effects, select the matching stroke shape node and choose Display > Show > Show Selection. To locate the stroke shape node, select one of the converted nodes, such as cactusGrass1Flower, and choose Window > Hypergraph: Connections; the shape node will carry the *strokeShape* prefix.

6. Note that the Reduce tool's application is stored as history in the scene; this may slow the opening of the file, camera manipulation, and scrubbing the timeline. Therefore, it's recommended that you delete the history of the converted strokes once you are satisfied with their appearance. To do so, select the polygon nodes created by the Paint Effects To Polygons tool and choose Edit > Delete By Type > History. You are also free to delete the original Paint Effects strokes at this point.

You can also use the Modify > Convert > Paint Effects To NURBS tool to convert strokes. However, this produces a separate NURBS surface for each and every tube. In Contrast, Modify > Convert > Paint Effects To Curves produces a NURBS curve for each tube. You can use the curves for additional modeling or render them directly with a render plug-in such as RenderMan.

17

You can also attach a Paint Effects brush to a NURBS curve by selecting the curve and choosing Paint Effects > Curve Utilities > Attach Brush To Curves.

Rendering Paint Effects with mental ray

Once you've converted a Paint Effects stroke to polygons or NURBS, you're free to render with the mental ray renderer. In addition, you can cast shadows as you normally would with any other polygon or NURBS surface. For example, with Project 1 you can switch from depth map to raytraced shadows. To do so, follow these steps:

1. Open the Render Settings window (Window > Rendering Editors > Render Settings). Switch the Render Using menu to mental ray. The default render quality settings are suitable at this stage. (If mental ray is not listed in the Render Using menu, load the Mayatomr.mll plug-in through Window > Setting/Preferences > Plug-In Manager.)

2. Select the Firelight point light. In the Attribute Editor, select Use Ray Trace Shadows. Test render. The shadow edges produced by Firelight are very sharp. To soften the raytrace shadow, increase the Light Radius to 1.0 (**Figure 1.18**). The larger the Light Radius, the wider the virtual light and the more overlap of light rays occurs at the shadow edges—this produces a soft shadow where the shadow edges become softer with distance. To improve the edge quality and remove any graininess, increase the Shadow Rays attribute to 32. The higher the Shadow Rays value, the better the quality but the longer the render. Switch Fire-Light1 and FireLight2 to raytrace shadows and adjust their Light Radius and Shadow Rays values. Test Render until the shadows are satisfactory. For example, in **Figure 1.19**, the Persp camera is rendered with mental ray. The point lights use raytrace shadows. Due to the high polygon count of each converted Paint Effects stroke, only two converted stroked are saved: one along the left foreground and one along the background wall.

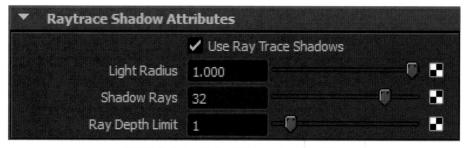

FIG 1.18 The Raytrace Shadow Attributes section of a point light.

This concludes Part 1 of Project 1.

FIG 1.19 The Project 1 scene rendered with mental ray with two converted Paint Effects strokes. An example Maya file is included as Project1.6.ma in the /ProjectFiles/Project1/maFiles/ tutorial directory.

Setting Fires with Paint Effects

Part 2 of Project 1 requires the addition of a fire to the fire pit set before the woman. This will allow us to explore the dynamic components of Paint Effects brushes, which include turbulence, tube flow, and built-in forces such as gravity. In addition, this presents an additional opportunity to adjust Paint Effects shading, texturing, and growth attributes.

Working with Paint Effects Dynamics

To explore the dynamic properties of Paint Effects, we'll apply one of the available fire brushes to our Project 1 scene. Follow these steps:

1. Select the Ground surface and choose Paint Effects > Make Paintable. Choose Paint Effects > Get Brush. In the Visor window, select the *fire* folder. Select the flameFine icon. (Note that each fire brush creates a different style and scale of flame.) Paint a short, semi-circular stroke on the Ground surface below the logs of the fire pit. One stroke is sufficient at this point. Open the flameFine1 tab in the Attribute Editor and adjust the Global Scale until the fire is a believable height; a value of between 6 and 12 works well for this project (**Figure 1.20**).

2. Play back the timeline. The flame undulates automatically. The undulation is controlled by built-in Paint Effects dynamics. You can access the dynamic attributes in the Behavior subsection. To do so, select the new stroke, switch to the flameFine1 tab in the Attribute Editor and expand the Tubes section. The Behavior subsection is further divided into Displacement, Forces, Turbulence, Spiral, and Bend subsections.

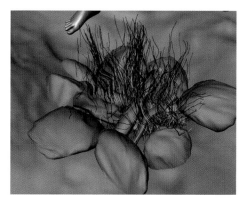

FIG 1.20 A short, semi-circular flameFine stroke is painted on the Ground surface below the fire logs and between the fire pit stones. An example Maya file is included as Project1.7.ma in the /ProjectFiles/Project1/maFiles/ tutorial directory.

3. Expand the Turbulence subsection (**Figure 1.21**). The flameFine brush uses a World Force turbulence, as is set by the Turbulence Type attribute. This deforms the tubes via a 3D fractal noise that covers the entire world space. The strength of the deformation is set by the Turbulence slider. Set this to 1.0. The size of the noise "grains" is set by Frequency; the larger the value, the smaller the bends appear in the tubes. Set this to 20. The deformation is not static and changes over time. This is achieved by sampling different "slices" of the 3D fractal noise over time. The speed of the deformation undulation is controlled by the Turbulence Speed attribute, with higher values increasing the speed. A Turbulence Speed value of 0.15 works well for this project. To accurately gauge the Paint Effects motion, create a Playblast movie by choosing Window > Playblast.

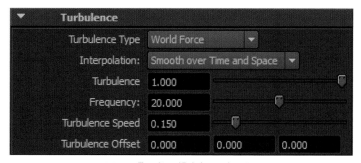

FIG 1.21 The adjusted Turbulence subsection.

4. In addition to the undulation, the tubes are not continuous–they appear broken. These "breaks" are set by the Gaps section (located below the Behavior section, see **Figure 1.22**). Increase the Gap Size to 0.8. The gaps become larger. Temporarily reduce the Gap Spacing value; the gaps become shorter. To adjust the random placement of the gaps, adjust the Gap Rand value; lower values make the gaps more likely to align with each

other. It may be necessary to reevaluate the Global Scale of the stroke after adjusting the Gap Size value.

5. The tube gaps are not static; they move upwards along the stroke. The speed of this movement is controlled by the next section: Flow Animation (**Figure 1.22**). Expand this section and change Flow Speed to 1.0. Play back the timeline. The gaps move slowly up each tube. Increase Flow Speed to 2. Play back the timeline. The flow becomes more rapid. Note that the nearby Time attribute is pre-keyed with an expression; this allows the automatic movement of the gaps.

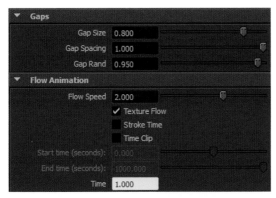

FIG 1.22 The Gaps and Flow Animation sections.

6. By default, the tubes grow from the stroke in the positive Y direction. Nevertheless, there is a slight downward pull from the brush's built-in Gravity attribute. To access the Gravity attribute, expand the Forces subsection. If you increase Gravity to a slightly larger negative value, the flames stay closer to the virtual ground. If you make Gravity positive, the tubes grow downwards. We'll discuss additional dynamic forces in the section "Adding Paint Effects Smoke" later in this chapter.

7. Switch the Render Using menu in the Render Settings window back to Maya Software. Test render. We'll discuss ways of improving the stroke in the next section. Note that the flameFine stroke does not illuminate the scene; hence, the three FireLight point lights are added to the scene to emulate the presence of fire.

Improving Paint Effects Render Quality

If the initial render quality of a brush stroke is poor, you can alter the way in which the stroke geometry is generated and rendered. In fact, any given stroke may be treated to several different rendering processes, as set by the Brush Type attribute (which you can find above Global Scale at the top of the brush's Attribute Editor tab):

Paint renders the stroke by using the brush node attribute settings; this is the default modality.

Smear renders the stroke with the Paint settings, but smears the results along each tube.

Blur renders the stroke with the Paint settings, but averages (blurs) the pixels along each tube.

Erase cuts holes into other strokes when using Paint Effects in the canvas mode. You can apply Paint Effects brushes to a virtual 2D canvas by choosing Panels > Panel > Paint Effects through a view panel menu. The canvas is useful for creating texture bitmaps. You can save a painted canvas as a bitmap by choosing Canvas > Save As through the embedded menu.

ThinLine generates thin lines along each tube, creating a fast render.

Mesh renders tubes as triangulated pieces of geometry. The Mesh mode provides more accurate tube texturing and lighting; hence, it produces better results when a Paint Effects stroke is close to the camera or takes up a large portion of the frame. The Mesh mode is also optimized to handle a large number of faces.

For example, if you change Brush Type to Mesh for the flameFine stroke, semi-transparent, hard-edged tubes appear when rendering (**Figure 1.23**).

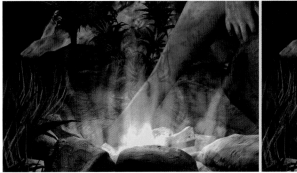
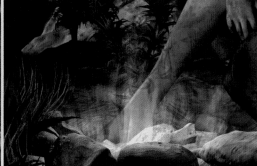

FIG 1.23 Left: The Maya Software render of the flameFine stroke. Right: Same stroke with Brush Type set to Mesh.

A better solution for the flame brush, however, is to alter the attributes in the Brush Profile section. You can follow these steps:

1. Expand the Brush Profile section in the brush's Attribute Editor tab (the second collapsible section from the top). Increase the Stamp Density and test render. Texture detail is applied to strokes in overlapping stamps; hence, Stamp Density controls how many individual stamps are applied to the tubes of a stroke. A low value, such as 2, makes the stamps easy to see. A higher value, such as 8, provides a greater overlap of the stamps and produces a smoother result. You can also increase the stamp blending by increasing the Softness attribute, which is found in the same section. Softness blurs the tube edges during the render. Note that you can animate any Paint Effects attribute over time to add additional

randomness. For example, varying the Softness value would allow the flames to take on different degrees of sharpness and softness over time.

2. While working in the Brush Profile section, adjust Brush Width. This attribute controls the distance from the stroke that the tubes are spread. For example, a value of 0 places the tubes tightly along the stroke, while a value above 0.1 begins to spread the tubes in the X and Z directions.

As you alter the Brush Profile section, it also pays to examine the Creation subsection. Although we discussed this subsection while working on Part 1 of Project 1, there are many additional attributes that affect tube growth. For example, to fine-tune the fineFlame stroke, follow these steps:

1. Expand the brush's Tubes section and Creation subsection. Change the Tubes Per Step value to 30; this controls the density of tubes along the stroke. Increase Segments to 50. This controls the number of segments per tube along their length. A low Segments value creates faceting along non-transparent brush tubes, such as those created for grass brushes. A higher Segments value also allows for a greater number of bends, twists, or turns in each tube.
2. Change Length Min and Length Max to 0.04 and 0.2 respectively. Set Tube Width 1 and Tube Width 2 to 0.04 and 0.007 respectively. While Tube Width 1 controls the width of each tube at its base, Tube Width 2 determines the width of each tube at its tip. To randomize the width values, increase the Width Rand value to 0.8. To alter the distribution of thin and fat strokes, alter the Width Bias attribute. Positive Width Bias values favor fat tubes; negative Width Bias values favor thin tubes.

You can apply finer control over tube width by using the Width Scale subsection that follows the Creation subsection. The Width Scale attribute offers a graph ramp that ultimately controls the tube width from its base to its tip. For example, to ensure the flames maintain a wider width for the majority of the tube length, follow these steps:

1. Click the top-left point in the graph ramp. This is Selected Position 0, which carries a Selected Value of 1.0. This signifies that the base of each tube carries the maximum width value as set by the Tube Width 1 attribute. (To reduce the width at this point, pull the point circle straight down or alter the number in the Selected Value cell.)
2. Click the top-right of the line running across the top of the graph ramp. This inserts a new circle that becomes a new curve point at Selected Position 1.0. Initially, the Selected Value is 1.0; this forces the tubes to use the maximum width as defined by Tube Width 2. However, if you pull this point down to the bottom of the graph ramp, the tip width is reduced.
3. The curve that runs between Selected Position 1 and Selected Position 2 represents the interpolation the program applies when averaging Tube Width 1 and Tube Width 2 as it determines the tube width along its length. At this stage, the interpolation is linear. However, you can change the

tangent type of a curve point by selecting it and changing the Interpolation menu. For example, if you select the left-most point, click-drag it to the right of the graph ramp, and change its Interpolation to Smooth, the tubes remain wide for the majority of their length, then rapidly and smoothly taper at the ends (**Figure 1.24**).

FIG 1.24 The adjusted Width Scale graph ramp for the flameFine stroke.

In addition to the custom Width Scale graph ramp shown in **Figure 1.24**, the flameFine stroke in **Figure 1.25** uses the attribute settings listed in Table 1.2.

TABLE 1.2

Attribute	Section	Value
Brush Width	Brush Profile	0.06
Softness	Brush Profile	0.6
Stamp Density	Brush Profile	6
Tube Per Step	Creation	30
Segments	Creation	50
Length Min	Creation	0.05
Length Max	Creation	0.2
Tube Width 1	Creation	0.04
Tube Width 2	Creation	0.007
Width Rand	Creation	0.8
Width Bias	Creation	0.4

Adjusting Paint Effects Textures

You can alter the shading and texturing quality of any Paint Effects brush, including the ones that generate fire. Follow these steps to alter the color and brightness of the flameFine stroke:

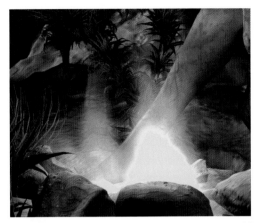

FIG 1.25 "Fatter" flames are created by adjusting the Brush Profile and Creation sections of the brush node. An example Maya file is included as Project1.8.ma in the /ProjectFiles/Project1/maFiles/ tutorial directory.

1. Expand the Shading section and Tube Shading subsection of the brush tab. Change the attributes listed in Table 1.3 to the included values (to work in HSV, click on a color swatch and change the lower-right menu of the Color pop-up from RGB to HSV).

TABLE 1.3

Attribute	Value
Color 1	Dark orange (HSV values: 39, 0.8, 0.13)
Incandescence 1	Dark yellow (HSV values: 58, 0.5, 0.07)
Transparency 1	Bright white (HSV values: 0, 0, 0.9)
Color 2	Dark red (HSV values: 360, 1.0, 0.05)
Incandescence 2	Dark red (HSV values: 360, 0.9, 0.04)
Transparency 2	Bright white (HSV values: 0, 0, 0.95)

2. Expand the Texturing subsection. Select Map Color and Map Opacity. Change Texture Type to Fractal. A built-in procedural fractal map is used as color and transparency information. Test render. Initially, the fractal pattern is grayscale as the colors are determined by Tex Color 1 and Tex Color 2 (Tex Color 1 is multiplied by Color 1 and Tex Color 2 is multiplied by Color 2).
3. Change Tex Color 1 to 60, 0.8, 3.5 in HSV. While the Value sliders stop at 1.0, you can enter a higher-than-1.0 value by typing the number into the V cell. Change Tex Color 2 to 360, 0.9, 0.05. Test render. A noise appears on the tubes. To alter the fractal pattern, change Repeat U to 0.4 and Repeat V to 0.16. This causes the fractal texture to repeat 0.4 times along the stroke curve and 0.16 times across the stroke curve. To reduce the contrast within the fractal pattern, change Fractal Amplitude, at the bottom of the

section, to 0.25. Test render. The flames take on additional complexity (**Figure1.26**).

Note that the fractal pattern does not change over time unless you animate the various UV attributes in the Texturing section. For example, if you want the fractal pattern to move along the stroke, keyframe Offset U over time. In **Figure 1.26**, Offset U is animated over the first 24 frames of the timeline. On frame 1, Offset U is set to 0. On frame 24, Offset U is set to 0.003. Determining appropriate values requires test rendering the scene (see the next VFX Notes box concerning real-world reference). When creating a batch render for a test, you can lower the resolution and rendering quality to speed up the testing process. As previously mentioned, the Persp camera is set up for the final render; hence, you should use the Persp camera for test renders. Keep in mind that the distance a camera is from a Paint Effects stroke can drastically affect its appearance; this is particularly true when incandescence or glow is involved.

FIG 1.26 From left to right: Frame 1, frame 6, and frame 12 from a test batch render. Map Color and Map Opacity add additional complexity to the flames. The Offset U is animated, causing the fractal pattern to move up the tubes. An example Maya file is included as Project1.9.ma in the /ProjectFiles/Project1/maFiles/ tutorial directory.

VFX Notes: Using Reference Material

Whenever you are required to match real-world effects, it pays to examine reference material. Photos and video give important clues to such qualities as scale, surface quality, brightness, and speed. For example, when creating fire, study photos or video of similarly-sized fires. Note the size, shape, color, and transparency of individual flames. With fire, keep in mind that the exposure of the photo or video will affect the appearance of the flames. Longer exposures will make the flames appear brighter, more opaque, and to possess longer motion blur trails. Due to available light and common exposure settings, fire generally appears more opaque during the night and more transparent during the day (**Figure 1.27**).

FIG 1.27 A shadowed, day-time photo of a camp fire used as reference. A few flames in the foreground are intensely white due to overexposure. Note the motion blur streaking of the flames and smoke caused by the same long exposure. *Photo © volff - Fotolia.com.*

Matching Real-World Fire

At this stage, the Project 1 fire is missing the bright foreground flames often seen in photographs and video of fire. To emulate this, you can create a second flameFine stroke and adjust its attributes to make the resulting flames brighter. Follow these steps:

1. Select the Ground surface and choose Paint Effects > Make Paintable. Choose Paint Effects > Get Brush and select the flameFine icon. Close the Visor and paint a short, arc-like stroke in front of the first flameFine stroke but behind the ring of firepit rocks (**Figure 1.28**).

FIG 1.28 A second flameFine stroke (indicated by the green selection) is painted in front of the old stroke, as seen from above.

2. In the Hypergraph or Outliner, select the strokeFlameFine1 node and choose Paint Effects > Get Settings From Selected Stroke. Deselect strokeFlameFine1 and select strokeFlameFine2. Choose Paint Effects > Apply Settings To Selected Strokes. The attribute values of the first stroke are copied to the new stroke.

3. Switch the flameFine2 brush tab in the Attribute Editor. Change the attributes listed in Table 1.4 to the included values.

TABLE 1.4

Attribute	Section	Value	Notes
Global Scale	(Below Brush Type menu)	5	Makes flameFine2 roughly half the height of flameFine1.
Incandescence 1	Shading	HSV: 0, 0, 0.2	A more intense, uncolored Incandescence produces whiter flames.
Incandescence 2	Tube Shading	HSV: 0, 0, 0.2	
Map Color	Texturing	OFF	Deselecting Map Color and Map Opacity removes the fractal texture and makes the flameFine2 flames more opaque.
Map Opacity	Texturing	OFF	
Tubes Per Step	Creation	6	
Segments	Creation	25	Fewer segments produce straighter flames with fewer small bends.
Turbulence Offset	Turbulence	0.5, 0.5, 0.5	Offsets the 3D fractal noise used to deform the tubes; this prevents flameFine2 from matching the shape of flameFine1.

Ultimately, the goal is to produce a smaller, brighter set of flames in front of dimmer yellow-red ones. Test render. The Project 1 fire is now closer to the reference photo shown in the previous VFX Notes box (**Figure 1.29**).

FIG 1.29 A second flameFine stroke is painted and adjusted to produce smaller, brighter flames along the front of the fire, as seen on frame 6. An example Maya file is included as Project1.10.ma in the /ProjectFiles/Project1/maFiles/ tutorial directory.

To render the Paint Effects fire with mental ray, it's necessary to convert the strokes to polygons or NURBS surfaces. You can avoid this, however, by using render layers. In such a situation, you can render the Paint Effects on one layer with Maya Software and render the remainder of the scene on a separate layer with mental ray. You can then combine the resulting renders through the Render Layer editor. We'll examine this technique in Chapter 2. This concludes Part 2 of Project 1.

Adding Paint Effects Smoke

You can use Paint Effects to add smoke to scene. In particular, there are several brushes suited for the thin smoke that is generated by a campfire (see **Figure 1.27** in the previous VFX Notes box). To add smoke as Part 3 of Project 1, follow these steps:

1. Select the Ground surface and choose Paint Effects > Make Paintable. Choose Paint Effects > Get Brush and select the smokeRisingLight from the *clouds* folder. Close the Visor and paint a short, straight stroke through the center of the fire pit.
2. Test render. Initially, an intense fractal pattern appears on a semi-opaque gray smoke. Note that the smokeRisingLight brush does not use branches, twigs, leaves, flowers, or buds; therefore, the base tubes never split. Nevertheless, you can fine-tune the stroke attributes to make a softer, more-cohesive smoke volume. To do so, set the attributes listed in Table 1.5 to the included values.

TABLE 1.5

Attribute	Section	Value	Notes
Global Scale	(Below Brush Type menu)	6	
Softness	Brush Profile	1.1	A Softness value above 1.0 aggressively softens the edges of each tube and blends together the individual stamp textures which would otherwise appear.
Transparency 1	Shading	HSV: 0, 0, 0.6	
Transparency 2	Tube Shading	HSV: 0, 0, 0.975	
Repeat U	Texturing	4	Larger Repeat U and Repeat V values decrease the size of the fractal pattern.
Repeat V	Texturing	1	
Fractal Amplitude	Texturing	0.1	A smaller value reduces the intensity of the fractal pattern, making the smoke more uniformly gray and in a more cohesive volume.

Continued

TABLE 1.5—cont'd

Attribute	Section	Value	Notes
Length Min	Creation	0.3	Larger Length values increase the tube length so that they extend past the edge of the frame.
Length Max	Creation	3	
Turbulence	Turbulence	0.2	Raising this value allows the smoke to drift.
Frequency	Turbulence	0.5	Lowering this value make the distortions larger.

3. Expand the Behavior and Forces subsections. By default, the smokeRising-Light brush uses the Uniform Force attribute. Uniform Force allows you to define the force arriving from a specific direction, much like wind. The direction must be entered as a vector, however, with X, Y, and Z cells. For example, to make the smoke slowly move to the screen left (along positive Z), enter 0, 0, 0.3 into the cells (**Figure 1.30**).

FIG 1.30 The Uniform Force attribute causes the smokeRisingLight tubes to slowly bend along the positive Z axis.

4. If you want the smoke to move more aggressively in a particular direction, enter a 1.0 into the matching Uniform Force cell. Render a test. Grayish-black smoke appears over the fire (**Figure 1.31**). If the smoke is difficult to see on your monitor, feel free to adjust the Paint Effects attributes. For example, lower the Transparency 1 and Transparency 2 values to make the smoke more opaque. As with any Paint Effects brush that uses dynamics, it's best to create a test render over multiple frames, either through the Render View or as a batch render. When using the Render View, you can store multiple renders by choosing File > Keep Image In Render View through the Render View menu; old renders are then accessible via the View's lower scroll bar.

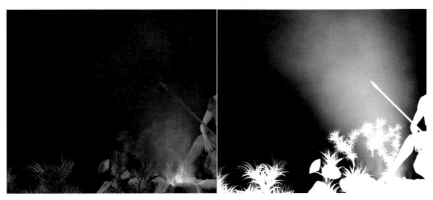

FIG 1.31 Left: Smoke is added to the render with the adjusted stroke. Right: The alpha channel of the render, revealing the smoke's semi-transparency (the Ground geometry is temporarily hidden). An example Maya file is included as Project1.11.ma in the /ProjectFiles/Project1/maFiles/ tutorial directory.

This concludes Part 3 of Project 1. **Figure 1.32** illustrates Project 1 at this stage. Note that the renderer remains set to Maya Software, so that the shadows cast by the three FireLight point lights are not active.

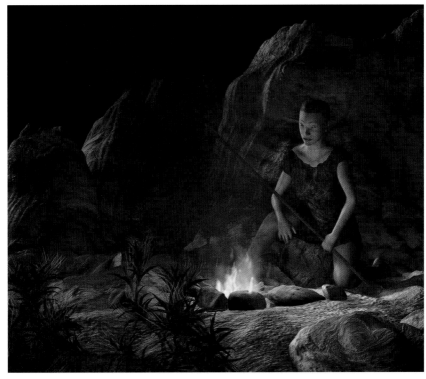

FIG 1.32 The Project 1 scene at the end of Part 3.

Growing Short Hair, Long Hair, Grass, and Electric Arcs with Fur and nHair

The Maya Fur system creates self-shadowing fur and short hair over a NURBS, polygon, or subdivision surface. You can adjust fur attributes, such as width, length, color, opacity, and general growth. This makes the Fur system ideal for emulating animal fur or growing grass over the ground. In comparison, the Maya nHair system creates dynamic curves that react to Nucleus fields. You can attach nHair curves to Paint Effects brushes, allowing you to render a wide variety of results. The nHair system is well-suited for creating long hair on a character or any dynamic situation that requires reactive hairs, strands, ropes, and so on.

This chapter includes the following critical information:

- Attachment and adjustment of fur descriptions
- Creation and stylization of nHair
- Rendering of fur and nHair with Maya Software and mental ray

In addition, this chapter steps through Part 4 to Part 6 of Project 1. The project features a modeled, textured, and lit 3D scene featuring a Neolithic huntress in a desert landscape. In Chapter 1, we added Paint Effects foliage, fire, and smoke. In this chapter, we'll add fur to the woman's garment, long hair to her head, grass to the ground, and a supernatural electrical field to the foreground.

Growing Fur

Part 4 of Project 1 starts with the addition of fur to the woman's primitive garment. This will allow us to explore the basics of the Maya Fur system, including the attachment of fur descriptions, review of fur nodes, mapping of attributes, mental ray rendering, and the custom painting of fur maps.

Working with Render Layers

You can grow Maya Fur over a polygon, NURBS, or subdivision surface so long as it has a valid UV layout. By default, the fur is grown over the entire surface. Before adding fur to Project 1, however, we can simplify our work flow by adding render layers to the scene. Render layers allow you to temporarily hide objects in your view panels and isolate objects or groups for rendering in specific passes. This prevents excess clutter in the view panels and speeds up renders in the Render View. You can follow these steps to add render layers:

1. Open the `Project1.11.ma` scene file. This is located in the `/ProjectFiles/Project1/maFiles/` tutorial directory (to avoid missing texture bitmaps, choose File > Set Project and select the `/ProjectFiles/ Project1/` folder before opening the `.ma` file). Note that there are two perspective cameras in the scene: the default Persp camera and an additional camera named WorkCamera. The Persp camera is placed for the final render and should be left in place. However, feel free to move the WorkCamera around the scene to focus in on various details as you set up the effects.
2. Open the Channel Box (you can click the Channel Box/Layer Editor tab at the far right of the program window). Click the Render Layer tab at the bottom of the Channel Box. By default, there is a single render layer, named *masterLayer*; this includes all the renderable objects in the scene.
3. Shift+select the lights in the scene (Moon, MoonFill, FireLight, FireLight1, and Firelight2). Without deselecting, Shift+select all the surfaces that form the woman and her clothing. You can make the selections through the Hypergraph or Outliner. You can select the woman by selecting the Woman group node. In the Render Layer editor, choose Layers > Create Layer From Selected. Double-click the new layer name and rename the

layer **WomanLayer.** You now have the option to display and render either the woman, by herself, or the entire scene (**Figure 2.1**). You can select or deselect the small Renderable buttons beside each layer. The buttons feature a small motion picture clapboard with a green check box (render-able) or red × (non-renderable).

Attaching a Fur Description

The Fur system is a plug-in; if the Fur menu is missing from the Rendering menu set, select Fur.mll through the Plug-in Manager (Windows > Settings/ Preferences > Plug-in Manager). To grow fur on the woman's garment as Part 4 of Project 1, follow these steps:

1. In the Render Layer editor, make the WomanLayer renderable, but leave the masterLayer non-renderable (see the end of the previous section). Select the WomanClothing surface. Switch to the Rendering menu set. Choose Fur > Attach Fur Description > New. A simplified fur appears over the entire surface.
2. The fur appears with a default length. For Project 1, it is much too long. You can quickly shorten the length by choosing Fur > Edit Fur Description > Fur Description 1. Each fur description you create is numbered and listed under Attach Fur Description and Edit Fur Description. In the FurDescrip-tion1 tab, reduce Global Scale to 0.1.
3. Test render with the Persp camera at its current location. Initially, the fur grows along the surface normals in a roughly perpendicular manner with each fur "hair" the exact same length (**Figure 2.2**). In addition, the fur appears white and is thinly dispersed. You can alter the growth and color qualities by changing various attribute values in the FurDescription1 tab. We'll discuss these in the section "Adjusting Fur Attributes" later in this chapter. If it's difficult to see the fur, feel free to increase the render resolution. To save render time, render only the region around the fur.

Reviewing Fur Nodes

Before adjusting fur attributes, it helps to understand the basic components that make the Fur system work. Each fur description is composed of three

FIG 2.1 Left: The Render Layer editor with the new layer, WomanLayer. Right: The view panel view of WomanLayer. The Render View only renders what's included on the render layer; hence, lights must be included on the layer. An example Maya file is included as Project1.12.ma in the /ProjectFiles/Project1/maFiles/ tutorial directory.

35

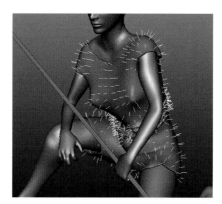

FIG 2.2 Initial fur growth. An example Maya file is included as Project1.13.ma in the /ProjectFiles/ Project1/maFiles/ tutorial directory.

nodes: a fur description node, a fur feedback transform node, and a fur feedback shape node (**Figure 2.3**).

FIG 2.3 The fur description node, a fur feedback transform node, and a fur feedback shape node of a single fur description, as seen in the Hypergraph: Connections window. The WomanLayer render layer node is also pictured, as well a hidden surface shape node.

The fur description node carries attributes that control the color, length, and various growth qualities of the fur hairs. The node provides a means to map these attributes and adjust the render quality for mental ray. The fur feedback shape node controls the accuracy with which the fur is displayed in the view panels. The fur feedback transform node carries the transform properties. There is no need to alter the transform node—fur automatically follows the surface as the surface deforms. Note that fur requires a functional surface UV layout for the fur hairs to be properly dispersed.

In addition, a defaultFurGlobals node (not pictured in **Figure 2.3**) sets the global rendering qualities of all fur descriptions in the scene. You can access the defaultFurGlobals node by choosing Fur > Fur Render Settings.

Adjusting the Growth of Fur Hairs

As previously mentioned, fur grows along the surface normals when the fur description is attached to the surface. You can alter this behavior by adjusting a long list of growth attributes in the fur description tab. To access the tab, choose Fur > Edit Fur Description > Fur Description*n*. The attributes are listed after the various Color attributes at the top of the Attribute Editor.

To force the fur hairs to have a wider root and bend downwards in a slightly erratic fashion, change the following attributes to the listed values in Table 2.1:

TABLE 2.1

Attribute	Value	Notes
Length	1.2	
Polar	0.95	Rotates the fur around the surface normal. In this case, values close to 1.0 point the fur hair towards the ground.
Base Width	0.1	
Base Curl	0.1	For Base Curl and Tip Curl, a value of 0.5 leaves the hair straight. Values between 0 and 0.5 curl in one direction, while values between 0.5 and 1.0 curl in the opposite direction.
Tip Curl	0.6	
Scraggle	0.1	Causes the hairs to become crooked. The size of the "crooks" is determined by the Scraggle Frequency.
Scraggle Frequency	2	The larger the value, the smaller the "crooks."
Clumping	0.01	Sets the degree to which the hair tips are drawn towards each other into groups. The size of each group is set by Clumping Frequency.
Clumping Frequency	5	
Segments	10	The number of sections that make up each hair. The higher the value, the smoother the hairs but the more time-intensive the render. If render times are impractical, lower this value.

The result of these adjustments is seen in **Figure 2.4**. Note that adjusted fur width is not visible in the view panels and can only be seen in a render. In fact, the fur is intentionally decimated in the view panel for the sake of efficiency. The decimation is set by U Samples and V Samples attributes carried by the fur feedback shape node. Higher values create a higher density representation of the fur. To access the feedback shape tab in the Attribute Editor, select the shape node in the Hypergraph or Outliner window. The shape node is a child of the feedback transform node.

FIG 2.4 The fur hairs are forced to bend downwards in a slightly erratic fashion by adjusting various growth attributes of the fur description node.

Adjusting Fur Shading Attributes and Baking Maps

When rendered, Maya Fur utilizes three shading components: ambient, diffuse, and specular. You can choose various component combinations through the Light Model menu at the top of the fur description node (**Figure 2.5**).

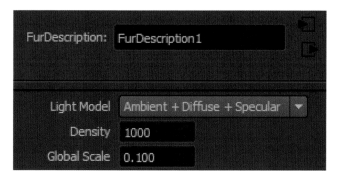

FIG 2.5 The Light Model, Density, and Global Scale attributes of a fur description node.

The Density attribute sets the total number of hairs generated by the description. If the Calc. Area Values attribute menu is set to Globally, the Density value is distributed across all surfaces to which the fur description is attached. If Calc. Area Values is set to Per Fur Description, which is the default setting, each surface attached to the fur description receives the number of hairs defined by the Density attribute. The Calc. Area Values menu is located in the Fur Render Options section of the defaultFurGlobals tab. You can access the defaultFur-Globals Attribute Editor tab by choosing Fur > Fur Render Settings.

The diffuse color of each fur hair is determined by the Base Color and Tip Color attributes, where the color transitions from the base to the tip along the hair length. The ambient color is set to Base Ambient Color and Tip Ambient Color, while Specular Color controls its namesake. Specular Sharpness sets the size

of the specular highlight; high values decrease the length of the highlight along the fur hair.

To alter the shading qualities of the fur in Project 1, follow these steps:

1. Leave Light Model set to Ambient + Diffuse + Specular. Set Density to 35,000. Note that the view panel continues to show a simplified version of the fur. Set Base Color to dark brown. Set Tip Color to medium brown. Set Specular Color to light brown. Test render the WomanClothing render layer. Any variation in the fur color is a result of the lights present in the scene and the transition from the Base Color and Tip Color along each hair.

2. To create greater color variation, you can map the Base Color and Tip Color. To do so, click the checkered Map button beside the Base Color slider. Select the File icon in the Create Render Node window. In the new file tab in the Attribute Editor, click the file browse button beside Image Name. Navigate to the `/ProjectFiles/Project1/Textures/` tutorial folder and select the `furbase.png` file. The `furbase.png` bitmap is a slighter darker and larger version of `furskin.png`, which is used as the texture color for the garment surface. Click the checkered Map button beside Tip Color and browse for `furtip.png`, which is a slightly brighter, less saturated, and larger version of `furbase.png`. Test render. At this stage, the bitmaps have no affect on the fur color. If you use Map buttons to add file textures to fur attributes, you must "bake" the textures. This is described in the following steps.

You are not limited to bitmap textures when mapping fur attributes. However, if you use a procedural texture (such as Ramp, Fractal, and so on), you must bake the texture. Baking converts the texture into a bitmap with a specific resolution that can be used by the Fur system. At the same time, if you map an attribute by using a Map button or by using the drag-and-drop method between nodes, you must bake the texture for it to be used—even if the texture is a bitmap loaded through a File node. Baking a bitmap converts the texture into the resolution you choose, plus limits the color information to valid areas of the UV texture space. The fur description node carries a Bake Attribute menu and button for this purpose.

1. To bake the bitmaps loaded in the prior set of steps, change Map Width and Map Height to 1024. This sets a smaller resolution for new Maya IFF fur maps that the Bake Attribute function writes out. The original bitmaps will remain unharmed.

2. Set the Bake Attribute menu to Base Color. Press the nearby Bake button. Change the Bake Attribute menu to Tip Color. Press the Bake button.

3. Initially, it appears that nothing has changed. However, two IFF files are generated and stored in the `/renderData/fur/furAttrMap/` directory in your project path (for example, `C:/ProjectFiles/Project1/renderData/fur/furAttrMap/`). They are named with the following formula: *sceneName_surfaceName_*furDescription*n_textureName*`.iff`. You can see the association with the fur description node by scrolling down in the Attribute Editor and expanding the Details section, the Base Color subsections

and Tip Color subsection (**Figure 2.6**). For example, in the Base Color subsection, you'll find a Maps subsection with the generated IFF file listed under the Base Color Map column. You can break the association at a later point by clicking the Remove Item button in the subsection. You can manually retrieve a bitmap by clicking the Map Item button (the new file replaces the old one). (If you load a bitmap through the Details section, it's not necessary to bake it.)

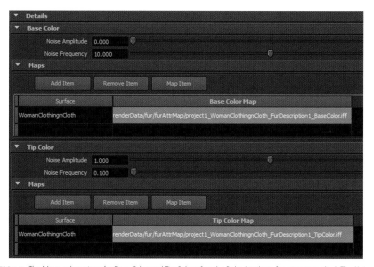

FIG 2.6 The Maps subsections for Base Color and Tip Color after the Bake Attribute function is applied. The Noise Amplitude and Noise Frequency attributes in the Tip Color subsection are altered to insert additional variation into the fur color.

4. Test render. The fur takes on the color variations found in the maps. At the same time, the fur becomes brighter due to the Tip Color map. You can insert additional color variation into the map by adjusting the Noise Amplitude and Noise Frequency attributes in each Maps subsection. For example, to vary the Tip Color, change the corresponding Noise Amplitude to 1.0 and the Noise Frequency to 0.1. A grayscale fractal pattern is multiplied by the value in the Tip Color IFF, thereby darkening some areas of the fur (**Figure 2.7**). If areas of the fur remain too bright, darken the Specular Color and increase the Specular Sharpness. For example, in **Figure 2.7** the Specular Color is set to roughly 8.9, 0.44, 0.35 in HSV and Specular Sharpness is set to 100. In addition to specular adjustment, you can employ self-shadowing, which is described in the next section.

Rendering Fur with mental ray

In Chapter 1, we switched from the mental ray renderer to Maya Software. We're now ready to switch back to mental ray. Not only is mental ray able to render fur, but it offers more control when casting shadows and generally produces high-quality results. To adjust the fur for mental ray, follow these steps:

FIG 2.7 The fur takes on greater color variation by baking maps associated with Base Color and Tip Color.

1. In the Render Settings window, change Render Using to mental ray. (This changes the render for all the layers.) If you're using Maya 2013, switch to the Quality tab and change the Quality Presets menu to Production: Rapid Fur. This deactivates raytracing, which make test rendering more efficient. If you're using Maya 2014, you have to manually deactivate Raytracing through the Features tab. In the Render View, create a test render. The fur appears brighter (the shadows from the FireLight point lights remain missing).

2. To restore raytracing in Maya 2013, change the Quality Presets menu to Production. To restore raytracing in Maya 2014, select Raytracing in the Features tab. Test render. The mental ray-rendered fur now appears significantly different (**Figure 2.8**). The fur is brighter is some areas, while shadows appear in other areas. Not only are shadows cast onto the fur, but the fur self-shadows. By default, mental ray approximates self-shadows; in other words, it takes into account the hair mass as opposed to individual fur hairs. This feature in activated by the Use Shadow Density Grid attribute in the mental ray section of the fur description node (below the Details section). The opacity of self-shadows is set by the Shadow Density Scale. For example, in **Figure 2.8**, Shadow Density Scale is set to 0.125.

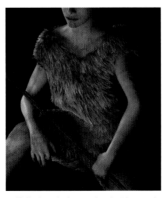

FIG 2.8 The fur is self-shadowed when rendered with mental ray and raytracing.

3. Choose Fur > Fur Render Settings. Expand the mental ray section near the bottom of the Attribute Editor. Note that the Fur Shader attribute is set to Hair Primitive by default. This causes mental ray to substitute primitive geometry for each hair. This allows the fur to be rendered with raytracing. However, you can set Fur Shader to Volume, in which case the fur is rendered with a volume shader. A volume shader is potentially more efficient; however, it requires a scanline renderer, does not support raytracing, and requires higher mental ray light samples. For more specific information on rendering fur with a volume shader, see the "Fur Render Settings" page in the Maya Help files.

Prepping UVs and Painting Fur Maps

Although we've adjusted various growth attributes of the Project 1 fur, every fur hair continues to possess the same length. At the same time, the fur grows consistently across the entire surface. To make the length less consistent and remove the fur from the legs of the garment, you can paint maps for the fur description attributes. The Paint Fur Attributes tool is available for this purpose. Note that the various growth attributes of the fur description node do not offer standard Map buttons. You must bring maps though the Maps subsections.

Before we can paint fur maps, however, we need to examine the UV layout of the garment surface. To do so, select the WomanClothing surface and choose Window > UV Texture Editor. Although the majority of the garment is arranged as a single UV shell, several other parts (inside of cuffs, belt, and edge of neck) are allowed to overlap (**Figure 2.9**).

FIG 2.9 Overlapping UV shells, as seen in the UV Texture Editor.

While such a UV layout may be acceptable with a color texture, it will not work for a fur map. For a fur map to function correctly, there should be no overlapping UV shells. You can fix this problem by following these steps:

1. With the WomanClothing surface selected, choose Fur > Fur Description (More) > Detach > Fur Description 1. This removes the fur from the surface but does not destroy the description or its custom settings.

2. In the UV Texture Editor, choose Tool > Move UV Shell Tool and click on a UV shell within the texture area. When a shell is selected all the associated UV points are highlighted. Using the standard Move tool, move the shell outside the 0-to-1.0 UV area. This area takes up the upper-right quadrant and features the texture assigned to the surface (you can hide the texture by choosing Image > Display Image so that the option becomes deselected).

3. Continue to use the Move UV Shell tool and Move tool to move all the UV shells so they no longer overlap and are sitting outside the 0-to-1.0 area (**Figure 2.10**). After the 0-to-1.0 area is empty, move, scale, and rotate the shells so they once again fit within the 0-to-1.0 area while maintaining the lack of overlap (**Figure 2.10**). When a shell is selected, you can use the standard Rotate and Scale tool found along the left toolbar of the Maya main window. When the shells are arranged, choose Edit > Delete By Type > History while the surface remains selected.

FIG 2.10 Left: UV shells moved outside the 0-to-1.0 area. A selected shell is highlighted with green UV points. The standard Move tool is used to move the shell, which was selected with the Move UV Shell tool. Right: Shells scaled and moved to once again fit within the 0-to-1.0 area.

4. Although the adjustment of the UVs will alter the way a color texture map appears on a surface, this is of minor consequence for this particular project. The color texture is noisy without any specific detail and the fur hair covers up a large portion of the surface. To reattach the fur description, select the WomanClothing surface and choose Fur > Attach Fur Description > Fur Description 1. You can update the Base Color and Tip Color maps by switching the Bake Attribute menu to the correct attribute name an clicking the Bake button. New IFF files are written over old ones and the Maps section of each attribute is updated.

With the UV texture space properly prepared, you can use the Paint Fur Attributes tool. Follow these steps:

1. Open the fur feedback shape node in the Attribute Editor. Raise the U Samples and V Samples to 64. Not only do the values control the decimation of the fur in the view panels but they also determine the size of value grids created for painted fur maps. The higher the values, the more detailed the maps and the more subtle the transitions between values (which equals longer render times).

2. Select the WomanClothing garment surface. Choose Fur > Paint Fur Attributes Tool > □. The Paint Scripts Tool opens in Tool Settings panel and the Paint Fur Attributes Tool Settings window pops up (**Figure 2.11**). Set the Fur Attribute menu to Baldness. The Baldness attribute, when set below 1.0, randomly reduces the fur density across the surface. With a painted Baldness texture, however, you can force some areas of the surface to possess no fur hairs. Set Attribute Map Width and Attribute Map Height to 512. This determines the resolution of the fur bitmap that's temporarily stored by the tool.

FIG 2.11 Top: The Paint Fur Attributes Tool Settings window. Middle: The Paint Attributes section of the Paint Scripts Tool panel. Bottom: The Display section of the Paint Scripts Tool panel.

3. Drag the mouse over the garment surface. A red brush appears. You can change the size of the brush by pressing the B key and click-dragging or by changing the Radius (U) value in the Paint Scripts Tool panel. To see the colors as you paint, select Color Feedback and Draw Brush While Painting in the Display section of the same panel. Initially, the entire Baldness map is white. To remove fur from the legs, you must paint 0-black in those areas. The value you paint is set by the Value slider in the Paint Attributes section of the Paint Scripts Tool panel. Set the Value to 0. LMB-drag the brush over the leg area (**Figure 2.12**). Use the WorkCamera to move the view closer to the woman without disturbing the rendering Persp camera. You can paint any value between 0 and 1.0 over any part of the surface. Mid-range values reduce the amount of hairs but don't eliminate the hairs completely.

4. Once you've completed the painting, expand the Export subsection (within the Attribute Maps section) of the Paint Scripts Tool panel. Set the Map Size X, the Map Size Y, and the Image Format. Press the Export button. A file browse window opens. Choose the /ProjectFiles/ Project1/Textures/directory, enter a file name, and press Save.

FIG 2.12 A Baldness map is painted to eliminate fur along the legs. A few gray areas are left at the leg openings to create a few stray hairs.

Choose Fur > Edit Fur Description > Fur Description 1. Expand the Details section and Baldness subsection. Note that the associated Maps subsection lists the garment shape node in the Surface column but the Baldness Map is listed as *UNNAMED*. Click the Baldness Map cell so that it turns blue and click the nearby Map Item button. Navigate to the baldness bitmap you wrote out. The baldness map is now functional and listed correctly.

5. Repeat steps 1 to 4 for a Length map. Paint subtle shades of gray on the surface to vary the hair lengths.

Render a test. There is more variation in fur length and the leg and belt area of the garment lacks the fur (**Figure 2.13**).

FIG 2.13 Fur growth is altered with painted Baldness and Length maps. An example Maya file is included as Project1.14.ma in the /ProjectFiles/Project1/maFiles/ tutorial directory. Painted Baldness and Length maps are included in the /ProjectFiles/Project1/Textures/ directory. The baked and updated color IFF files are also included in the /ProjectFiles/Project1/renderData/fur/furAttrMap/ directory.

This concludes Part 4 of Project 1.

Converting Fur to a Field of Grass

Part 5 of Project 1 adds grass to the ground. However, instead of using a Paint Effects brush, we'll grow fur and make it look grass-like. This is a common trick in the animation industry. While Paint Effects works well in limited areas, growing thousands of blades of grass is well-suited for the Maya Fur system. You can follow these steps:

1. Select the Ground surface and all the lights in the scene. In the Render Layer editor, choose Layers > Create Layer From Selected. Double-click the new layer name and rename it **GroundLayer.**
2. Deselect the lights so only the Ground surface is selected. Choose Fur > Attach Fur Description > New. Long fur hairs are planted over the entire landscape.
3. Open the Ground_FurFeedback node in the Attribute Editor. Raise the U Samples and V Samples to 64. Choose Fur > Paint Fur Attributes Tool > □. The Paint Scripts Tool opens in the Tool Settings panel and the Paint Fur Attributes Tool Settings window pops up. Set the Fur Attribute menu to Baldness. Set Attribute Map Width and Attribute Map Height to 512. Note that Fur Description is set to Fur Description 2. Proceed to paint a Baldness map that places the fur in a small arc along the center-foreground (**Figure 2.14**). In this case, areas that are painted black produce no fur and areas that are painted white produce the maximum amount of fur.

FIG 2.14 Fur Description 2 is limited to an arc in the center-foreground of the Ground surface through a painted Baldness map.

4. After you've completed the painting, expand the Export subsection of the Paint Scripts Tool panel. Set the Map Size X, the Map Size Y, and the Image Format. Press the Export button. A file browse window opens. Choose the /ProjectFiles/Project1/Textures/ directory, enter a file name, and press Save. Choose Fur > Edit Fur Description > Fur Description 2. Expand the Details section and Baldness subsection. Note that the associated Maps subsection lists the Ground shape node in the Surface

column but the Baldness Map is listed as *UNNAMED*. Click the Baldness Map cell so that it turns blue and click the nearby Map Item button. Navigate to the baldness bitmap you wrote out. The baldness map is now functional and listed correctly.

5. Scroll back to the top of the fur description tab in the Attribute Editor. Set the attributes listed in Table 2.2 to the included values.

TABLE 2.2

Attribute	Value	Notes
Density	50000	If this value slows down the render to a impractical degree, feel free to reduce it.
Global Scale	0.5	A value below 1.0 shrinks the scale of the hairs regardless of the various growth settings.
Base Color	HSV: 100, 1.0, 0.04	Fur has a tendency to appear excessively bright under normal lighting conditions; hence, dark color settings are used here.
Tip Color	HSV; 20, 1.0, 0.03	
Specular Color	HSV: 62, 0.45, 0.09	
Specular Sharpness	75	
Inclination	0.25	The degree to which the hairs are inclined. A value of 1.0 lies the fur flat to the surface.
Roll	0.65	Rotates the fur about the surface V direction.
Polar	0.6	Rotates the fur around the surface normal.
Base Opacity	1.0	
Tip Opacity	0.9	
Base Width	0.05	
Tip Width	0.02	
Base Curl	0.5	
Tip Curl	0.8	
Scraggle	0.4	
Scraggle Frequency	0.5	
Clumping	1.0	The degree to which hairs are pulled together in a clump.
Clumping Frequency	12	Sets the number of clumps across the surface.
Clump Shape	10	Positive values create convex clumps while negative values create concave clumps.
Segments	12	

Altering these attributes has an immediate effect on the fur as it's displayed in the view panels. To increase the apparent randomness, you can utilize the built-in fur noise functions, which are revisited in the next section.

Adding Variety and Randomness with Fur Noise

At this point, the only attribute of Fur Description 2 that carries a custom map is Baldness. As an alternative to painting additional maps, you can employ the various noise functions available to the color and growth attributes of the fur description. You can find these in the Details section. They are listed at the top of each attribute subsection. For example, the Base Color subsection lists Noise Amplitude and Noise Frequency (**Figure 2.15**).

FIG 2.15 The Noise Amplitude and Noise Frequency values assigned to Base Color.

1. Raising Noise Amplitude above 0 multiplies the current Base Color values by a grayscale fractal noise pattern laid across the surface. This causes some hairs to become brighter while others to become darker. Noise Frequency controls the size of the noise "grains," with larger values creating a smaller noise pattern. Growth attributes also carry Noise Amplitude and Noise Frequency attributes. For example, raising Noise Amplitude for Length will vary the lengths of the hairs in a random fashion. Proceed to set the Noise Amplitude and Noise Frequency attributes for Base Color, Tip Color, Length, Inclination, Roll, Base Width, Tip Width, Base Curl, and Scraggle. The values do not have to be consistent and will require test renders to determine the best value ranges (**Figure 2.16**).

FIG 2.16 Fur rendered as long, scraggly grass.

2. By default, Fur Description 2 creates cast shadows for the hairs. Once again, the shadows are approximated by utilizing the Use Shadow Density Grid attribute in the Volume Fur subsection. Initially, the shadows are difficult to see due to the softness of the shadows cast by the three FireLight point lights. To make the grass shadows more obvious, you can vary the Light Radius of these lights. To do so, select the first light (simply named FireLight). In the Attribute Editor tab for the light shape node, expand the Raytrace Shadow Attributes section and reduce Light Radius to 0. This sharpens the shadow edge. Set the Light Radius for FireLight1 to 0.25. Change the Light Radius for FireLight2 to 0.5. This will vary the sharpness of shadows arriving for the camp fire (which the point lights are emulating). Test render. The fur casts faint shadows (**Figure 2.17**). To better judge the shadows, feel free to raise the render resolution or render with the WorkCamera. In addition, you can further define the shadows by raising the fur's Base Opacity, Tip Opacity, and Segments values (this creates smoother, more opaque grass blades). We can continue to improve the shadows in the next section, "Using Depth Map Shadows with Fur."

FIG 2.17 Sharpening the point light shadows causes the fur to cast faint shadows (as seen from the WorkCamera close to the ground). An example Maya file is included as Project1.15.ma in the /ProjectFiles/Project1/maFiles/ tutorial directory. The painted Baldness map is included in the /ProjectFiles/Project1/Textures/ directory.

Using Depth Map Shadows with Fur

At this stage, the Moon directional light is casting depth map shadows. (A directional light is suitable for recreating a distant light source that creates parallel rays of light.) Unfortunately, depth map shadows do not affect fur unless special steps are taken (this applies to both mental ray and Maya Software renderers). You can follow these steps to alter the directional light so that it can cast fur shadows:

1. Directional lights support fur self-shadowing, but do not support depth map shadow casting for fur. However, you can convert the light to a spotlight, which supports both forms of shadowing. To do so, select the Moon

directional light. In the Attribute Editor, change the Type menu to Spot Light (the Type attribute is at the top of the light's shape tab). The light remains in the same position but it is converted to the new light type. Rename the light's shape node **MoonShape.** Increase the Cone Angle to 70 so that the entire ground is lit.

2. Expand the mental ray section. Expand the Shadows subsection (within the mental ray section). Select the Use Mental Ray Shadow Maps Overrides attribute. Click the Take Settings From Maya button. This activates mental ray depth map shadows and matches the Resolution and general quality to the Maya Software depth map (which is overridden with the same step). Set Resolution to 4096, Samples to 64, and Softness to 0.001. These changes create accurate shadows from the direction of the Moon light. To lighten the dark grass, adjust Fur Description 2 one more time. Incrementally raise the Base Color, Tip Color, and Specular Color values. At the same time, re-lower Base Opacity to 0.7 and Tip Opacity to 0.5. Test render (**Figure 2.18**).

FIG 2.18 Each fur hair receives a strong shadow at its base with mental ray depth map shadows cast from the Moon light, which is converted to a spot light. An example Maya file is included as Project1.16.ma in the /ProjectFiles/Project1/maFiles/ tutorial directory.

Casting mental ray depth map shadows increases render times significantly. However, depth map shadows remain more efficient than raytraced shadows if fur is involved. Nevertheless, to make the mental ray depth map render more efficient, you can reduce the Resolution and Samples values. In addition, you can reduce the number of fur hairs by lowering the Density of the fur description node. You also have the option to render with Maya Software instead of mental ray. However, if you choose the render with Maya Software, you must use the following steps to create fur shadows with a spotlight and depth maps shadows:

- With the light selected, choose Fur > Fur Shadowing Attributes > Add To Selected Light.
- In the light's shape node tab, deselect Use Auto Focus.

- Change the Focus to a value derived from the following formula: Cone Angle value + (Penumbra Angle value × 2). If you leave Use Auto Focus selected, the fur shadows render inaccurately.
- In the Fur Shading/Shadowing section of the light's shape node tab, change the Fur Shading Type to Shadow Maps.

This completes Part 5 of Project 1.

Growing Long Hair with the nHair System

Part 6 of Project 1 necessitates the addition of long hair to the woman. The Maya nHair system is ideal for this situation. Maya nHair is a dynamic hair system that allows you to create realistic hairstyles and behaviors. Because nHair is a generic dynamic curve simulation, you can also use curves to create non-hair effects, such as ropes, cables, or electrical arcs (arcs are detailed at the end of this chapter).

Creating an nHair System

There are two ways to create nHair system: 1) Creating follicles over a selected surface or selected polygon faces; 2) Defining the locations of follicles through an interactive paint tool. A follicle is a node that produces a dynamic hair curve and a clump of Paint Effects hair tubes. To create follicles over selected faces on the Project 1 woman model, follow these steps:

1. Return to the Render Layer editor. Click on the WomanLayer name so that it turns blue. The contents of the layer appear in the view panels. This may include the fur that was created for the Ground. To remove Fur Description 2 from this layer, select the FurFeedback group node in the Hypergraph or Outliner, RMB-click over the WomanLayer name in the Render Layer editor, and choose Remove Selected Objects. The FurFeedback group node serves as parent to two feedback nodes in the scene: WomanClothing_FurFeedback and Ground_FurFeedback.
2. By default, a new nHair system will not collide with surfaces around it. Therefore, the nHair hairs may intersect the woman's neck, shoulders, or garment. To avoid this problem, select the WomanBody surface, switch to the nDynamics menu set, and choose nMesh > Create Passive Collider. An nRigid node is associated with the surface. In addition, a Nucleus node, named nucleus1, is created. The Nucleus node serves as the simulation core for the nDynamics system. As a passive rigid surface, the body will automatically interact with the nHair in a believable fashion. Select the WomanClothing surface and choose nMesh > Create Passive Collider once again. A second nRigid node is created.
3. Using the WorkCamera, move close to the top of the woman's head. Select the WomanBody surface. Switch to the polygon face selection mode through the marking menu (RMB-click over the surface and choose Face). Select the faces on one-half of the head where hair would normally grow

(**Figure 2.19**). (We'll create and fine-tune hair on one side before creating hair on the second side–this will make creating a central part easier.) To save time, you can select faces with the Paint Selection Tool (found below the Select and Lasso tools in the left-hand Toolbar).

FIG 2.19 Faces on one-half of the head are selected.

4. Once the faces are selected, choose nHair > Create Hair > □. The Create Hair Options window opens (**Figure 2.20**). Note that the Output menu is set to Paint Effects. When this option is selected, the nHair system attaches Paint Effects tubes to the dynamic curves so they may be rendered. Select the At Selected Surface Points/Faces radio button. (If you select the Grid radio button, follicles will be planted across the entire surface.) Set Hairs Per Clump to 36, Points Per Hair to 10, Length to 0.8, and Place Hairs Into to New Hair System. Click the Create Hairs button. An nHair system is created. This includes small red follicles along the surface, each of which produces a clump of Paint Effects hair tubes as well as a single dynamic curve.

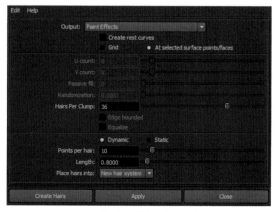

FIG 2.20 The Create Hair Options window.

5. The nHair system is dynamic. In fact, it requires dynamic simulation in order to relax into a usable start position. Using the Set The End Time Of The Playback Range and Set The End Time Of The Animation cells, change the timeline duration to 500 frames. Starting on frame 1, use the playback controls to play forward. The hair falls around the head. Stop the playback when the hair comes to an attractive resting position, such as frame 200. Although the hair avoids penetrating the head and shoulders, there is little control over how the hair falls (**Figure 2.21**). One important task of creating an nHair system is the grooming and styling of the hair. This is discussed in the next several sections.

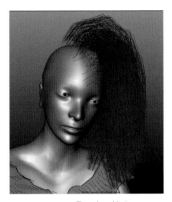

FIG 2.21 The relaxed hair.

Reviewing nHair Nodes

Before fine-tuning the hair, it will help to examine the various nodes that make up nHair system. The nodes are as follows:

hairSystem The transform node for the hair system (**Figure 2.22**). By default, nHair follicles follow the surface to which they are attached.

hairSystemShape Carries attributes that affect the length, shape, clumping, shading, and dynamic quality of the resulting hair.

pfxHairShape Creates a Paint Effects stroke node when the Create Hair or Paint Hair Follicle tool's Output is set to Paint Effects. The shape node receives its information from the hairSystemShape node.

pfxHair Displays Paint Effects hair tubes in the view panels (**Figure 2.22**).

Follicle and FollicleShape Nodes that represents a single follicle. A follicle produces a clump made of a single dynamic curve and, if the option is selected, a clump of Paint Effects hair tubes.

hairSystemFollicles A group node that serves as parent for all the follicle transform nodes of a single nHair system (**Figure 2.22**).

curve and curveShape Dynamic hair curve nodes. These curves are considered the "start" curves and control where the hair clumps begin. There is one curve per follicle.

nucleus The dynamic simulation core used for all nDynamics systems in Maya (**Figure 2.22**). This carries the dynamic solver attributes.

FIG 2.22 The nucleus1 node, nRigid nodes of the passive colliders, hairSystem node, hairSystemFollicles group node, several follicle and curve nodes, and a pfxHair node, as seen in the Hypergraph: Hierarchy window.

Altering nHair Attributes

The default look and growth of the nHair system is generally not suitable for production work. You can fine-tune the nHair attributes through the hairSystemShape node. You can follow these steps to improve the Project 1 hair:

1. Select the hairSystem1 node in the Hypergraph or Outliner. Switch to the hairSystemShape1 tab in the Attribute Editor. Expand the Clump And Hair Shape section. Increase Sub Segments to 10. This smoothes the hair by inserting additional sections to the Paint Effects tubes. Set Clump Width to 0.12. This adjusts the width of each hair clump.

2. Expand the Clump Width Scale, Hair Width Scale, Clump Curl, and Clump Flatness sections. Each of these sections contains a graph ramp that allows you to control their namesake qualities (**Figure 2.23**). The left of each ramp represents the hair at the follicle and the right of the ramp represents the hair tip. Experiment with the graph ramps. Any change you make becomes visible in the view panels. Note that you can enter values higher than 1.0 in the Selected Value cells. For example, to spread the tips of the hair clumps apart, you can set the right-hand Selected Value for Clump Width Scale to 3. To reset the dynamic simulation, return to frame 1 and play back the timeline.

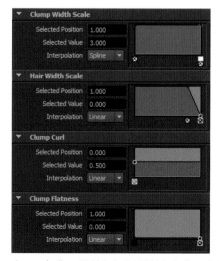

FIG 2.23 The adjusted graph ramps for Clump Width Scale, Hair Width Scale, Clump Curl, and Clump Flatness.

3. Expand the Shading section. Change the Hair Color to a brownish-red.

4. Expand the Displacements section. Set Curl to 0.02. Change Noise Method to Random and Noise to 0.4. These adjustments randomize the subtle curliness of the hair (**Figure 2.24**). Set Sub Clumping to 1.7. This pulls together the hairs along their length.

FIG 2.24 Adjustments of the hairSystemShape node attributes lead to greater variety among the hairs. An example Maya file is included as Project1.17.ma in the /ProjectFiles/Project1/maFiles/ tutorial directory.

Styling nHair

There are several ways to style an nHair system. Different types of hair (long, short, curly, straight, and so on) may require different combinations of the stylistic approaches:

- Manually alter the shapes of the dynamic curves to influence the start position of the hair.
- Constrain vertices of the dynamic curves with the addition of one or more nConstraints.
- Hand-build a network of NURBS curves and convert them to dynamic hair curves through the Make Selected Curves Dynamic tool.
- Add passive colliders, which may be animated over time or parented to an animation rig.

With any of these methods, it may be necessary to readjust the attributes within the Clump And Hair Shape section of the hairSystemShape node. For example, curly hair may require a higher Sub Segments value to appear smooth.

Unfortunately, there's insufficient space in this book to cover all of the nHair stylistic approaches (for additional information, see the "Modify and Style nHair" page in the Maya Help files). Instead, we'll use passive colliders. In particular, we can add a collider to prevent hairs from covering the woman's face. To do so, follow these steps:

1. Return to frame 1. Create a primitive polygon sphere and transform it so that it intersects the front of the woman's face. Assign it to a 100%

transparent Lambert material to see through the surface in the shaded views (**Figure 2.25**). Rename the sphere **CollisionObject.**

FIG 2.25 A primitive sphere is positioned over the face. This will become a passive collider for the nHair. The sphere is assigned to a transparent Lambert.

2. With the sphere selected, choose nMesh > Create Passive Collider. A new nRigid node is created. Play back the timeline. The hair slides off the sphere and avoids covering the face. Continue to adjust the position, scale, and rotation of the sphere and play back the timeline until the results are satisfactory. You are free to apply modeling tools to the sphere to shape it further. For example, in **Figure 2.26**, the sphere is smoothed and sculpted to give it several bumps that push the hair further aside.

FIG 2.26 A passive collider sphere is smoothed and sculpted to push the hair further aside.

Adding and Deleting nHair Follicles

You can add and delete follicles from an nHair system at any time. To delete a follicle, select it in a view panel or through the Hypergraph or Outliner and press the Delete key. To add follicles to an existing nHair system, you can use

the Create Hair tool. To create the other half of the woman's hair, follow these steps:

1. Using the WorkCamera, move close to the top of the woman's head. Select the WomanBody surface. Switch to the polygon face selection mode through the marking menu. Select the faces on the remaining one-half of the head where hair would normally grow. To save time, you can select faces with the Paint Selection Tool.
2. Once the faces are selected, choose nHair > Create Hair > □. The Create Hair Options window opens. Set Hairs Per Clump to 36, Points Per Hair to 10, and Length to 0.8. Most importantly, set the Place Hairs Into menu to hairSystemShape1. Click the Create Hairs button. New follicles are planted along the selected faces. The new hairs take on the qualities previously defined by the hairSystemShape1 node.
3. Return to frame 1 and play back the timeline. The new hair falls along with the old hair (Figure 2.27). All of the hairs react to the three passive colliders in the scene. If necessary, extend the timeline duration to give the nHair more time to come to rest.

FIG 2.27 nHair is grown on the remaining half of the head with the Create Hair tool.

Altering Lengths of nHair and Positions of Start Curves

By default, every nHair Paint Effects hair tube is the same exact length. You can interactively change the length of each clump by using the Scale Hair Tool. In this case, you must select the entire nHair system or select individual follicles. To see the follicles more clearly, you can display the dynamic curves at any time. To do so, choose nHair > Display > Start Position. The follicles with their individual dynamic curves are displayed while the Paint Effects hairs are hidden. (If the Paint Effects hairs remain visible, which may be the case with Maya 2014, select the Paint Effects mass and choose Display > Hide > Hide Selection.) By default, each curve represents the start position of the Paint Effects hair tubes. To select one or more follicles, click on the red follicle circles. To avoid selecting the surface, deactivate all the Select By Object Type icons except for Select Dynamic Objects in the Status Line.

After one or more follicles are selected, choose nHair> Scale Hair Tool. LMB-drag in a view panel to interactively scale the clumps associated with the selected follicles (**Figure 2.28**). To exit the tool, choose the Select tool from the Toolbar. To display the Paint Effects once again, choose nHair > Display > Current Position (or, with Maya 2014, choose Display > Show > Show Last Hidden). Return to frame 1 and play the timeline to see the hair at rest once again.

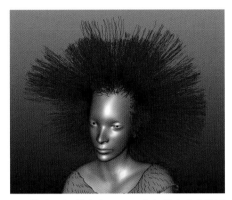

FIG 2.28 The lengths of hair clumps are varied with the Scale Hair Tool.

You can manipulate the dynamic curves to improve the result of the simulation. For example, if a clump is behaving badly and winds up lying with an odd orientation or in an odd location, you can alter the shape of the associated curve. This becomes the new start position for the clump, which causes its simulation to be different from that point forward. To alter a curve shape, choose nHair > Display > Start Position and select the curve as you would any standard NURBS curve. Display the curve vertices by RMB-clicking in the view panel and choosing Control Vertex. You can select and transform vertices as you would with any other NURBS curve (**Figure 2.29**). To see the result, choose nHair > Display > Current Position, return to frame 1, and play back the timeline.

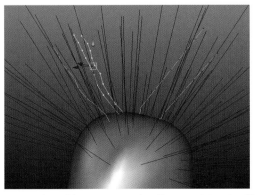

FIG 2.29 The start positions of several dynamic curves are altered by moving their vertices. This changes the simulation of the associated hair clumps.

You can force a new start position for the dynamic curves at any time. For example, you can choose a frame where the hair is at rest and make that a new start position for frame 1. To do so, select the hair mass in a view panel on a frame where it's suitably at rest. Choose nHair > Set Start Position > From Current. For Project 1, it's advisable to do this once you've fine-tuned the look of the hair. An example Maya file, with a reset start position, is included as `Project1.18.ma` in the `/ProjectFiles/Project1/maFiles/` tutorial directory.

Rendering nHair

In addition to rendering Maya Fur, the mental ray renderer has the ability to render the nHair system. However, the Render Fur/Hair attribute must be selected. You can find this in the Extra Features section in the Features tab in the Render Settings window.

Test render the Project 1 WomanLayer. Shadowing of the hair is automatically provided by mental ray (**Figure 2.30**). Note that any passive collider placed near the face will cast shadows; to defeat this, turn off Cast Shadows, Receive Shadows, and Primary Visibility in the collider surface shape node.

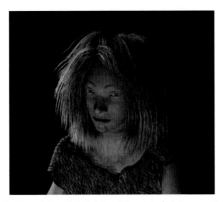

FIG 2.30 nHair rendered with mental ray. Note that the nHair and the fur hairs are casting shadows. An example Maya file is included as Project1.19.ma in the /ProjectFiles/Project1/maFiles/ tutorial directory.

At this point, you're free to continue adjusting the hair. For example, you can work in the following hairSystemShape sections:

Clump And Hair Shape: Fine-tune the Hairs Per Clump, Sub Segments, Clump Width, and Hair Width.
Shading: This section contains the Hair Color Scale subsection, where you can adjust Opacity, Translucence, Specular Color, and Specular Power. In addition, the Color Randomization subsection adds additional variety to the hair's diffuse, specular, hue, saturation, and value (brightness) shading components if the attributes are raised above 0.
Displacements: Adjust curl, built-in noise, and sub-clumping here.

You also have the option to add additional nHair systems to a surface. However, if you choose to add small areas of short hair, such as hair for eyebrows, it's generally more efficient to add Paint Effects hair. If a character requires a beard, fur is suitable for short hairs while nHair is suitable for long hairs.

This concludes Part 5 of Project 1.

Converting nHair to Electric Arcs

Although nHair is designed to grow long hair on a character, you can use the system anywhere a dynamic curve might be useful. In fact, you're not limited by the default nHair Paint Effects tubes; you can attach any Paint Effects brush to the nHair system at any time.

For Part 6 of Project 1, we'll create an electric arc field with nHair and Paint Effects. The goal is to create a mystical or supernatural light—perhaps a spirit or ghost visiting the huntress. You can follow these steps:

1. In the Render Layer editor, click on the masterLayer. Create a small, rectangular primitive plane with 5 width and height divisions and transform it so that it sits just below the Persp camera right side of the frame. With the plane selected, choose Layers > Create Layer From Selected from the Render Layer editor menu. Rename the new layer **SpiritLayer.**

2. Working on the SpiritLayer, create a new nHair system on the plane. You have the option of placing follicles on every face by selecting the Grid radio button through the Create Hair options window . Otherwise, you can place follicles on selected faces if you choose the At Selected Surface Points/ Faces radio button. In either case, set Hairs Per Clump to 4, Points Per Hair to 20, Length to 10, and the Place Hairs Into menu to New Hair System.

3. The new nHair system automatically uses the nucleus1 node. You can create a new dynamic solver, however, so that its settings do not affect the long hair simulation. To do so, select the new hairSystem2 node and choose the nSolver > Assign Solver > New Solver.

4. Open the resulting nucleus2 node's Attribute Editor tab. Note that the node has a built-in Gravity attribute in the Gravity And Wind section. Set Gravity Direction to 0, 1.0, 0 to reverse the Gravity force so that it pushes up in the positive Y direction. You have the option to create a separate wind force by raising Wind Speed above 0.

5. Play back the timeline. The hairs waver only a little. To create a more chaotic simulation, you can add one of the many fields that are available to any nDynamics simulation. For example, to add a chaotic, unpredictable motion to the hairs, apply a Turbulence field. To do this, select the hairSystem2 node and choose Fields > Turbulence. In the resulting turbulenceField1 node's Attribute Editor tab, set the Magnitude to 500. Leave the Frequency set to 1.0. A low Frequency value will create larger noise "grains." Play back the timeline. The motion is much more chaotic.

FIG 2.31 The nucleus2 node's Gravity And Wind section.

6. Stop on a frame where the position of the hairs looks interesting through the Persp camera. Select the nHair mass and choose nHair > Set Start Position > From Current.

7. Switch the Rendering menu set. Choose Paint Effects > Get Brush. In the Visor, click on the *glows* folder and the neonBlue brush icon. Close the Visor. Return to the nDynamics menu set. Select the hairSystem2 node and choose nHair > Assign Paint Effects Brush To Hair. The neonBlue brush is assigned to the dynamic curves. To see the brush, choose nHair > Display > Current Position.

8. Open the Attribute Editor tab for the hairSystemShape2 node. Expand the Displacements section. Set Noise Method to Random and set Noise to 7. This creates random kinks in each hair and causes the hairs in each clump to separate (Figure 2.32).

FIG 2.32 The neonBlue Paint Effects brush is attached to an nHair system that sprouts from a primitive plane. The Noise Method attribute of the hairSystemShape node inserts small kinks into each Paint Effects tube while the large undulations are provided by a Turbulence field.

9. Open the Attribute Editor tab for the pfxHair2 node. Scroll to the right in the Attribute Editor to reveal the neonBlue1 brush tab. Change Global Scale to 10. In the Brush Profile section, set Brush Width to 1.0, Softness to 1.78, and Stamp Density to 64. The higher the Softness value, the more

61

eroded and thinner the arcs become. The higher the Stamp Density, the smoother the Paint Effects tubes render. In the Shading section, lower the saturation and value of Incandescence 1; for example, set the color to 222, 0.7, 0.04 in HSV. Set Transparency 1 to 1.0-white. Slight changes to Incandescence 1 and Transparency 1 will significantly change the look of the render. In the Glow section, reduce Glow to 2, reduce Glow Spread to 4, and raise Shader Glow to 0.01. The Glow section adds a pink and blue glow to the arcs, thus widening them once again.

10. The neonBlue brush creates a directional light, named defaultLight, when it's applied. This light is not needed. Delete the new light by selecting it in the Hypergraph, Outliner, or Hypershade and pressing the Delete key. Click the Render Override button beside the SpiritLayer in the Render Layer editor. The button features a small clapboard with two circles. The Render Settings window opens. Note that the top of the window includes the text *Render Settings (SpiritLayer)*. These are the render settings for this particular layer. The attribute values are passed upwards from the masterLayer. However, you can override any of the attributes. For example, to avoid converting the Paint Effects brush into polygons or NURBS in anticipation of rendering with mental ray, we can override the Render Using attribute. To do so, RMB-click over the *Render Using* text and choose Create Layer Override from the menu. The *Render Using* text turns orange. Change the Render Using menu to Maya Software. Test render. The Paint Brush tubes appear to be electric or made out of some type of plasma (**Figure 2.33**). Continue to adjust the brush attributes. We'll combine this simulation with the other layers in the next section.

FIG 2.33 nHair rendered as if electric. An example Maya file is included as Project1.20.ma in the /ProjectFiles/ Project1/maFiles/ tutorial directory. Note that the printed image in this book has less saturation and less contrast than the digital image.

Final Rendering of Project 1

We've completed adding and adjusting elements for Project 1. We're ready to render all the elements at the same time. At present, we have four render layers. Make the masterLayer and SpiritLayer renderable while making the WomanLayer and GroundLayer non-renderable (**Figure 2.34**).

FIG 2.34 The Render Layer editor with four layers. The SpiritLayer has its Blending Mode menu set to Screen so that it's automatically composited over the masterLayer during the Render View render. Render All Layers has been activated.

The masterLayer uses mental ray to render while the SpiritLayer uses Maya Software. To combine the two layers together in the Render Layer editor, you can adjust the Blending Mode menu for the upper layer. Click on SpiritLayer and switch its Blending Mode menu from Normal to Screen (see **Figure 2.34**). The Screen mode composites the bright portion of the layer over the lower layers; this is ideal for the electric Paint Effects added to the SpiritLayer. In order for the layers to be composited, you must choose Options > Render All Layers from the Render Layer editor menu (so that the menu option receives a check mark). Choose Options > Render All Layers > □ to adjust the way in which the composite is carried out in the Render View window. The Composite Layers option presents a composited result in the Render View. The Composite And Keep Layers option stores the individual layers in the Render View (accessible by the bottom sliding bar) and presents a composited result afterwards. The Keep Layers option simply stores the layers in the Render View. (Any saved layer is stored as a bitmap in the */Project/*Images/tmp/directory.)

Using Material Overrides to Fit Layers Together

At this stage, the Paint Effects fire and smoke remains on the masterLayer. These will fail to render with mental ray. One solution is to add the Paint Effects to the SpiritLayer, which is done using Maya Software. The Screen Blending mode will work in this situation because the fire and smoke are generally brighter than the surrounding background. The Screen blending mode gives preference to upper layer pixels that are brighter, while ignoring pixels on the upper layer that are darker. (For more information on blending modes, see Chapter 10.) However, one problem that arises when adding objects to different layers is the ability to fit them back together in the final render. For example, the fire sits behind a ring of rocks and the rocks are partially

63

submerged into the ground. To ensure the objects fit, you can apply a material override to a render layer. A material override assigns a new material to all the surfaces on the chosen layer without affecting the masterLayer. In particular, the Use Background material is appropriate because it "cuts" holes into objects behind the surfaces it's assigned to. To set up a material override for Project 1, follow these steps:

1. Select the rocks in front of the fire and the Ground surface. RMB-click the SpiritLayer name in the Render Layer editor and choose Add Selected Objects from the menu. Select the three strokes that make up the fire and smoke. RMB-click the SpiritLayer name in the Render Layer editor and choose Add Selected Objects from the menu. Switch to the SpiritLayer.

2. RMB-click over the SpiritLayer name and choose Overrides > Create New Material Override > Use Background. A new Use Background material is created and assigned to the surfaces. This is indicated by the green surface color (Figure 2.35). The assignment only affects the current layer.

FIG 2.35 A Use Background material override is assigned to the fire pit rocks and ground, allowing the fire and smoke Paint Effects to be rendered with Maya Software while fitting together with the masterLayer.

3. Create a test render of the SpiritLayer. The fire and smoke are cut out in the shape of the rocks. In addition, no fire or smoke appears below the ground level.

Once the layers are arranged, there are a few additional items and attributes you should check:

• If you placed a collision surface near the woman's head for the nHair system, reassign its material to a transparent Lambert. If the surface was assigned to a material while working on another layer, its material reverts to the default, opaque Lambert on the masterLayer. Alternatively, deselect the Cast Shadows, Receives Shadows, and Primary Visibility attributes in the Render Stats section of the surface's shape node.

- Double-check the fur. If it's growing in an odd fashion or growing everywhere on the garment or ground surface, the painted maps might be missing. You can re-link the maps through the Details section of the fur description nodes. At the same time, check the fur shading quality. We've adjusted the lights and shadows for the scene several times in this chapter. This may lead to unexpected results. For example, adjusting the point light shadows causes the fur on the garment to become brighter; to offset this, you can lower the fur description's Specular Color value and raise the Specular Sharpness value.
- Feel free to adjust geometry to improve the composition. For example, transform the cactus grass plants or rocks. Feel free to adjust light intensities or shadow qualities.
- Open the Render Settings window while the masterLayer is selected. Each renderer receives one or more tabs. Check the resolution and quality settings for mental ray and Maya Software. These settings are passed up to other layers unless there is a layer override. Start with a small resolution and lower anti-aliasing quality when making initial test renders.

Assuming these issues are resolved, render the Persp camera while both the SpiritLayer and masterLayer are renderable The composited result should look similar to **Figure 2.36**. We'll discuss render layers and render passes in greater detail in Chapter 10.

FIG 2.36 The final Project 1 render. An example Maya file is included as Project1.21.ma in the /ProjectFiles/ Project1/maFiles/ tutorial directory. Note that the printed image in this book has less saturation and less contrast than the digital image.

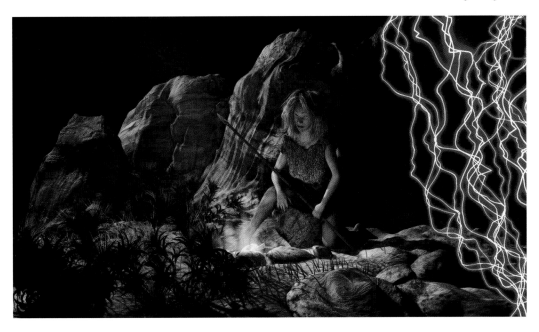

Optional Project 1 Steps

Although not specifically covered in this book, here are optional steps you can take to improve this project:

1. Animate a simple camera move to show off the 3D quality of the environment and the Paint Effects motion.
2. Animate the three FireLight point lights erratically moving to emulate flickering flames. Animate the Intensity attribute of each light so that they fluctuate.
3. Add an additional light to emulate the blue spill from the electric Paint Effects placed in the foreground. Use the light's Decay Rate to reduce its impact.

This concludes Project 1.

Creating Water, Smoke, and Sparks with nParticles

Maya nParticle simulations can create believable bodies of liquid, such as pooled oil or water. In addition, nParticles can recreate airborne particulates, such as rain, snow, ash, sparks, or smoke. You can render nParticles with a wide variety of renderers. In fact, one particle type, Blobby Surface, supports standard Maya materials. It's not necessary to animate nParticles—you need only generate particles with an emitter and influence their motion with physics-based fields and collision surfaces. Hence, nParticles presents a powerful simulation system appropriate for a wide variety of natural phenomena.

This chapter includes the following critical information:

- Emission and simulation of nParticles
- Application of fields and passive colliders
- Shading of nParticles to emulate water, smoke, and sparks

In addition, this chapter walks you through Part 1 to Part 3 of Project 2. The project features a modeled, textured, lit, and animated 3D scene featuring a surreal, mechanical animal running in place (**Figure 3.1**). In this chapter, we'll add flowing water to the short set of stairs, pooled water to the floor, billowing smoke to his smokestack ears, and sparks to his furnace belly.

FIG 3.1 The surreal mechanical animal featured in Project 2.

nDynamics versus Dynamics

Maya offers two dynamic simulation sections: nDynamics and Dynamics. Many of the tools, options, and node attributes within these two sections are similar. For example, the fields available within both sections are essentially the same and the majority of attributes between nParticles and particles are shared. Nevertheless, the nDynamics system take advantage of Nucleus nodes, which drive the physics-based simulation. The Dynamics system is based on an older simulation code and cannot directly interact with Nucleus nodes. While nDynamics provides a robust means to intermingle n-based systems, such as nParticles, nHair, nMesh, nCloth, and nConstraints, it lacks the active rigid body and Fluid Effects tools of the Dynamics system.

This book concentrates on the nDynamics system in Chapters 3, 4, 5, and 9 and Dynamics in Chapters 6 and 7.

Creating a Liquid Mass with nParticles

Part 1 of Project 2 starts with the addition of liquid flowing down the stairs to the floor. This allows us to cover the basic requirements of nParticle generation: an nParticle emitter and nParticle shape node. In addition, we'll create collisions with the Create Passive Collider tool.

Setting Up an nParticle Emitter

There are four types of nParticle emitters: 1) a standard emitter which is placed at a particular point in space; 2) a "drawn" emitter that places individual nParticles at particular start positions; 3) a surface emitter that births nParticles at each vertex position; 4) an emitter that automatically fills the volume of a surface. We'll start with a standard emitter. To add one to Project 2, follow these steps:

1. Open the `Project2.1.ma` scene file. This is located in the `/ProjectFiles/Project2/maFiles/` tutorial directory. To avoid missing texture bitmaps, choose File > Set Project and select the `/ProjectFiles/Project2/` folder before opening the `.ma` file.
2. Using WorkCamera, change the view so that you can move around the mechanical animal (we'll use the Persp camera for rendering). Switch to the nDynamics menu set. Choose nParticles > Create nParticles and change the nParticle preset from Cloud to Water (**Figure 3.2**). Choose nParticles > Create nParticles > Create Emitter. An emitter with a circular icon is placed at 0, 0, 0; a Nucleus node, with an *N* icon, is placed at the same location. To see the emitter more easily, hide the polygon and NURBS surfaces through the view panel's Show menu.

FIG 3.2 nParticle presets in the Create nParticles menu.

3. Return to frame 1. Play back the timeline. nParticles are generated in omnidirectional fashion from the emitter but soon fall downwards due to the Nucleus built-in gravity (**Figure 3.3**). To create an accurate simulation, you must start the play back at frame 1. In addition, frames should not be skipped. To ensure this, click the Animation Preferences button at the bottom-right of the Maya program window (this is directly to the right of the Auto Keyframe Toggle button and above the Script Editor button); once the Preferences window opens with the Time Slider section visible, set the Playback Speed menu to Play Every Frame.

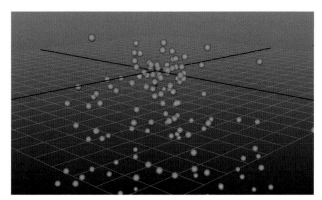

FIG 3.3 The default nParticle generation of the Water preset, as seen on frame 62.

4. Select the emitter and interactively move it so that it sits in the depression at the top-right of the stairs behind the animal. Return to frame 1 and play back. Feel free to extend the duration of the timeline to better see the simulation. You can place an emitter anywhere in the scene. You can select the emitter node through the Hypergraph or Outliner.

Reviewing nParticle Nodes

Before fine-tuning an nParticle simulation, it pays to review the various nodes of an nParticle system. A basic system is composed of the following nodes: emitter, nParticle transform, nParticle shape, Nucleus, and time. Every Maya scene carries a single time1 node that relates the timeline to any node dependent on the current frame number. As discussed earlier in this chapter, the Nucleus node handles the physics-based simulation of various nDynamics systems. If no Nucleus node exists in the scene, the n-tool creates a nucleus1 node. You have the option to create additional Nucleus nodes at any time. The emitter node combines transform and shape functionality by determining the location of the emitter and the basic emitter qualities, including nParticle directionality, nParticle birth rate, and initial nParticle speed. The nParticle shape node carries attributes that affect nParticle size, render style, lifespan, and total scene count. Note that a single nParticle shape node carries all the nParticles generated by an emitter. The nParticle transform node stores the position of the entire nParticle mass; however, when playback occurs, nParticles are always born at the emitter location.

FIG 3.4 Time, emitter, nParticle shape, Nucleus, and nParticle transform nodes, as seen in the Hypergraph: Connections window. In addition, the assigned particle material shading group node, ending with *SE*, is shown.

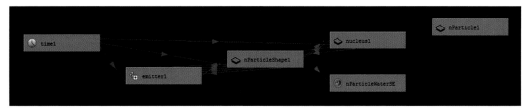

Adjusting nParticle Attributes

To save time, you can use one of the Create nParticles menu presets to create an nParticle emitter designed for a specific scenario. Aside from Water, there are also Points, Balls, Cloud, and Thick Cloud presets. The following list details important aspects of each preset:

Points creates Point nParticles that must be hardware-rendered.
Balls produces Blobby Surface nParticles that are strongly affected by Nucleus gravity.
Cloud creates Cloud nParticles that ignore Nucleus gravity.
Thick Cloud differs from Cloud in that it adds a fluid volume material to the shading network.
Water utilizes the Enable Liquid Simulation section of the nParticle shape node, is affected by Nucleus gravity, and is automatically assigned to an npWater material, which is a transparent, reflective, and refractive Blinn.

The presets remotely change the Particle Render Type menu found in the Shading section of the nParticle shape node, as well as various dynamic sections of the same node. The Particle Render Type menu carries ten particle types (Figure 3.5). Three types support software-rendering: Tube, Cloud, and Blobby Surface (this trait is indicated by the *s/w* in the menu list). The remaining seven types require hardware rendering, either through the Hardware Render Buffer, the Maya Hardware renderer, or the Maya Hardware 2.0 renderer. To combine hardware-rendered nParticles (or hardware-rendered Dynamics particles) with software-rendered layers, you must use the Render Layer editor or composite separate render passes in an external compositing program. (Render passes and compositing are discussed in Chapter 10.)

FIG 3.5 The ten particle types offered by the Particle Render Type menu in the Shading section of the nParticle shape node. The *s/w* notation indicates particles that support software rendering.

Note that nParticle presets add a shading network to the scene that includes a surface material, a volume material, and a particleSamplerInfo node. These

shading networks are discussed in more detail in the "Adjusting an nParticle Material to Emulate Smoke" section later in this chapter.

You are free to adjust any of the nParticle shape node attributes to customize the simulation. In addition, you can adjust the built-in dynamic attributes of the Nucleus node. To do so for Project 2, follow these steps:

1. In the Particle Size section of the nParticleShape1 node's Attribute Editor tab, change Radius to 0.2. The nParticles immediately change size in the view panels.
2. Open the nucleus1 node in the Attribute Editor. In the Gravity And Wind section, increase Gravity to 25. Play back from frame 1. The nParticles fall more rapidly.
3. Open the emitter1 node in the Attribute Editor, expand the Basic Emitter Attributes section (Figure 3.6), and change Rate(Particles/Sec) to 1000. Return to frame 1 and play back the timeline. The number of nParticles is significantly increased. Change the Emitter Type menu to Volume. The emitter icon changes to a cube. You can scale the icon. Play back. The nParticles are born within the space of the volume shape. Scroll down to the Volume Emitter Attributes section. The Volume Shape attribute supports five primitive shapes, which you can change at any time. Return to the Basic Emitter Attributes section and change the Emitter Type back to the default Omni. In the Basic Emission Speed Attributes section, reduce Speed to 0. Play back. The nParticles drop straight down in a line. Speed sets the nParticles' initial velocity. With Speed set to 0, Nucleus gravity is the only force imparting momentum. Return Speed to 1.0. Altering the Speed allows you to emulate a wide variety of phenomena, from slowing drifting smoke to quickly-moving fireworks.

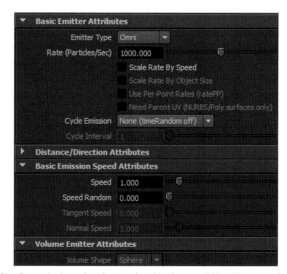

FIG 3.6 The Basic Emitter Attributes, Basic Emission Speed Attributes, and Volume Emitter Attributes sections of the emitter1 node.

4. Return to the nParticleShape1 tab. In the Liquid Simulation section, deselect Enable Liquid Simulation. Play back from frame 1. The nParticles fall in a tight column due to strong gravity. Select Enable Liquid Simulation and slowly reduce Incompressibility. Play back. High Incompressibility values prevent the nParticles from intersecting each other and thus spread them out (even when Self Collide is deselected in the Collisions section). Leave Incompressibility set to 0.01. Play back. The nParticles fall in a tight column once again, emulating the look of water falling from a spigot or bubbling up from a vertical pipe (**Figure 3.7**). We'll take advantage of other attributes within the Liquid Simulation section later in this chapter.

FIG 3.7 The simulation with Enable Liquid Simulation selected and Incompressibility set to 0.01. The nucleus1 Gravity is set to 25 and particle Rate (Particles/Sec) is set to 1000. The polygon surfaces are hidden from this view. An example Maya file is included as Project2.2.ma in the /ProjectFiles/Project2/maFiles/ tutorial directory.

Optionally, you can delete an nParticle simulation at any time by selecting the emitter and nParticle shape node and pressing the Delete key. Note that a major difference between nDynamics nParticles and Dynamics particles is the limited number of dynamic properties carried by the older particle shape nodes.

Forcing nParticle Collisions

By default, nParticles ignore other surfaces in the scene. You can force the nParticles to collide, however, by converting the surfaces into passive colliders. To do so for Project 2, follow these steps:

1. Select the Floor plane and the Stairs surface. Choose nMesh > Create Passive Collider. Two new nRigid nodes are created, one for each selected surface.
2. Play back the timeline. The nParticles automatically collide with the surface. They begin to fill the depression, but do not roll over the edge. In the Liquid Simulation section of the nParticleShape1 node, raise Incompressibility to 0.3 and play back. The nParticles., avoiding intersection, spill over the edges.

3. You can adjust the friction the surface exerts on the nParticles, and vice versa, by altering the attributes of the nRigidShape nodes and nParticleShape1 node. For example, to make the nParticles stick to the surfaces and not roll, raise the Friction or Stickiness values in the Collisions section of the nRigid shape nodes (**Figure 3.8**). Friction varies from Stickiness in that Stickiness is an adhesion force perpendicular to the surface while Friction is a force acting in a tangential direction. For full sticking (and no roll) the total Friction and Stickiness values on colliding objects should equal 1.0. nParticle shape nodes carry the same attributes in the same Collisions section. Hence, if Friction and Stickiness on an nParticle shape node are set to 0, the Friction and Stickiness values of the nRigid shape node must add up to 1.0 for full sticking. For an opposite result, you can reduce the Friction and Stickiness values and raise the Bounce value on the nRigid or nParticles shape nodes. Bounce causes the nParticles to bounce off the collision surfaces. You can use any combination of Friction, Stickiness, and Bounce values for more complex interactions. For Project 2, set Friction to 0.3, Stickiness to 0, and Bounce to 0 for each nRigidShape node and the nParticleShape1 node.

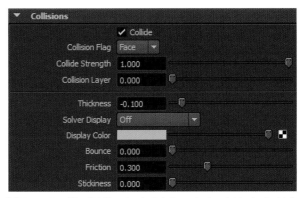

FIG 3.8 The Collisions section of the nRigidShape2 node. A similar section is carried by the nParticleShape1 node.

4. By default, the nParticle collision occurs at the outer surface of each nParticle (**Figure 3.9**). Hence, the nParticles do not penetrate the collision surface (this is a distinct advantage over Dynamics particles). You can offset the collision boundary, however, by adjusting the Thickness attribute of the nRigid shape node. For example, to let the nParticles sink slightly on Project 2, reduce the Thickness value to −0.1 for each nRigid shape node (be careful not to lower the value too far, otherwise, the nParticles will not collide with the surfaces). To display the virtual thickness of the surface, change the Solver Display menu to Collision Thickness.

By default, nParticles do not collide with themselves. You can turn on self-collisions by selecting the Self Collide attribute in the Collisions section of

FIG 3.9 A pair of nRigid passive colliders cause the particles to collide with the polygon surfaces. An Incompressibility value of 0.3 and a Friction value of 0.3 allows the particles to spill over the edge but come to a relatively quick stop. The transform handle indicates the location of the emitter. An example Maya file is included as Project2.3.ma in the /ProjectFiles/Project2/maFiles/ tutorial directory.

the nParticle shape node. Nevertheless, you can leave Self Collide deselected for a water simulation (the goal is to create a cohesive mass of water as the water falls through the virtual air).

Controlling nParticle Movement with Fields

At this stage, the Project 2 nParticles are leaving the emitter in all directions. To force the nParticles into a more defined stream, you can add a field to the scene. Field nodes simulate specific forces arriving from defined directions. In addition, you can adjust several attributes within the nParticle shape node's Liquid Simulation section to alter the liquid viscosity (resistance to deformation as a mass). You can follow these steps:

1. Select the nParticle1 node and choose Fields > Air. An airField1 node is created and is indicated by a small fan icon at 0, 0, 0. Move the airField1 icon so that it sits behind the stair geometry. Open its Attribute Editor tab. In the Air Field Attributes section, raise Magnitude to 75. Change the Direction vector to 0.33, 0, 1.0 (positive Z with a slight angle toward positive X). Play back. The nParticles are pushed along in one direction, skidding from one stair step to the next. Experiment with different Magnitude values to see different results.

2. Although the nParticles are flowing in one direction, they are spreading out and dropping over the left and right edges of the stairs. To narrow the flow, you can adjust attributes in the nParticleShape1 node's Liquid Simulation section. Set Viscosity to 0.4 and Liquid Radius Scale to 0.75. Viscosity determines the resistance to flow. Higher Viscosity values make the liquid behave like a thicker substance, such as tar. Liquid Radius Scale sets the maximum amount nParticles are allowed to overlap. The lower the Liquid Radius Scale value, the more compressed the nParticle mass. Play back. The nParticles flow in a more cohesive manner (**Figure 3.10**).

FIG 3.10 The nParticle flow is given direction with an airField node (selected). The flow is made more cohesive and narrow by changing the Viscosity and Liquid Radius Scale values. An example Maya file is included as Project2.4.ma in the /ProjectFiles/Project2/maFiles/ tutorial directory.

Test Rendering nParticles

Once you have roughed in the nParticle simulation, you can begin test rendering. Some nParticles attributes must be adjusted only after the render results are examined. To test Project 2, follow these steps:

1. Return to frame 1. Play back the timeline. Stop at a late frame, such as 70. Test render a region that contains the nParticles (the renderer is set to mental ray). To make the render tests easier to manage, hide the animal surfaces (the Machine and Interior nodes). The render produces small globs of water-like liquid. There are many gaps in the water flow.

2. In the nParticleShape1 tab, raise the Radius to 0.4. Replay the timeline. The large nParticles increase the width of the flow. To offset this, reduce the Liquid Radius Scale to 0.4. Play back and test render. Any time you make a significant change to nParticle attributes, it's best to play back from frame 1 to guarantee simulation accuracy.

3. To reduce the number of gaps between the nParticle globs, you can increase the total number of nParticles generated. Return to the emitter1 tab and raise Rate (Particles/Sec) to 4000. (The more nPartcicles that exist in the scene, the slower the playback; hence, feel free to use any number that improves the quality while keeping the work flow somewhat reasonable.)

4. The ability of nParticles to stick together and form globs at the point of render is courtesy of the Blobby Surface nParticle and is unavailable to the other nParticle types. The degree to which the nParticles stick together is controlled by the Threshold attribute, which is found in the Output Mesh section of the nParticleShape1 node (and the Shading section—linked sliders for a single attribute). The higher the Threshold value, the stickier the nParticles are and the smaller the rendered nParticle mass. (Threshold does not affect the view panel representation of the nParticles.) For example, a Threshold value of 1.0 causes the nParticles to form a fairly flat sheet when they come to rest on the Floor surface (**Figure 3.11**).

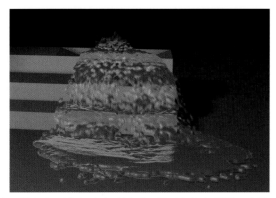

FIG 3.11 A Radius of 0.4, a Liquid Radius Scale of 0.4, a Rate (Particles/Sec) of 4000, and a Threshold of 1.0 allow the Blobby Surface nParticles to stick to together in a liquid-like sheet. An example Maya file is included as Project2.5.ma in the /ProjectFiles/Project2/maFiles/ tutorial directory.

Note that Threshold differs from Incompressibility in that Threshold changes the nParticle surface topology to create blobby, non-spherical surfaces. A low Incompressiblity value simply allows nParticles to intersect without changing their spherical shape.

Converting Blobby nParticles Into a Surface

Aside from providing the Threshold attribute, Blobby Surface nParticles also offer the advantage of surface conversion. That is, you can convert the nParticle mass into a polygon surface. Not only does this allow for the refinement of the simulation surface topology, but it makes the simulation more efficient. To convert the Project 2 nParticle simulation into a surface, follow these steps:

1. Select the nParticle1 node and Choose Modify > Convert > nParticle To Polygons. A new surface appears in place of the nParticles. The surface is linked to the nParticle nodes through history. Hence, you can update the simulation and have the surface update appropriately. In addition, you can utilize the various attributes in the Mesh Output section of the nParticle shape node to improve the overall look of the surface.

2. When you apply the nParticle To Polygons tool, the associated nParticle node is hidden. To find the nParticleShape1 node, select the new polySurface1 node in the Hypergraph window and choose Graph > Input And Output Connections from the Hypergraph menu. The hidden nParticleShape1 node is shown in the network. Open the nParticle-Shape1 node in the Attribute Editor and update the attribute values listed in Table 3.1. The attributes are located in the Output Mesh section. Descriptions of each attribute are included in the notes column.

TABLE 3.1

Attribute	Value	Notes
Threshold	0.5	Determines the smoothness of the surface created by overlapping Blobby Surface nParticles. The higher the value, the more the nParticles pull together and shrink the resulting mass.
Blobby Radius Scale	1.0	The amount the nParticle Radius is scaled to create an appropriately smooth surface. A value of 1.0 creates no additional scaling.
Motion Streak	0	Elongates individual nParticles based on the direction of their motion. 0 is essentially off. A value of 1.0 elongates the nParticles equivalent to the distance they travel over one frame.
Mesh Triangle Size	0.1	Determines the world scale of triangles used to create the mesh. Different values can significantly alter the mesh shape.
Max Triangle Resolution	100	Sets the size of a 3D grid (voxel grid) used to define the mesh topology. Lower values simplify and decimate the surface.
Mesh Method	Triangle Mesh	Creates faces with a varying number of edges through different topology mathematics.
Mesh Smoothing Iterations	4	Smoothes the surface by averaging vertex positions. The higher the value, the less bumpy the surface but the more time required for the calculation.

3. Test render the Persp view (**Figure 3.12**). To save time, render a small region. Note that the render produces the following error:

```
// Warning: (Mayatomr.Scene) : polySurfaceShape1: empty or
corrupted UV set map1 detected, ignored //
```

The nParticle To Polygons does not provide UV values to the resulting surface. However, this is a non-fatal error and can be ignored.

Note that raising the attribute values listed in Table 3.1 will slow the timeline playback significantly. To accurately gauge the result, you can create a Playblast movie (Window > Playblast) or step forward with the Step Forward One Frame button that's included with the playback controls. Once again, when playing back dynamic simulations, make sure that the Playback Speed menu, in the Preferences window, is set to Play Every Frame. Also note that mental ray motion blurs the particle mass if Motion Blur is activated through the Render Settings window and the Velocity Per Vertex attribute is selected in the Output Mesh section of the nParticle shape node. In addition, the surface is rendered without transparency, reflection, or refractivity. We'll adjust the assigned materials in the next section.

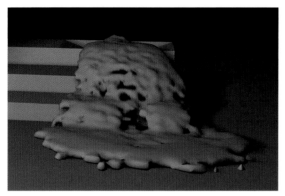

FIG 3.12 The nParticle simulation is converted to a polygon surface, as seen on frame 77. An example Maya file is included as Project2.6.ma in the /ProjectFiles/Project2/maFiles/ tutorial directory.

Creating an nParticle Surface Material to Emulate Water

When you convert a Blobby Surface nParticle simulation to a polygon surface, the surface is assigned to the default Lambert1 material. You are free to assign the surface to any other standard material. In particular, a material that supports specular shading components is suitable.

VFX Notes: Recreating Water

When adjusting a material to mimic water, or other clear liquids, there are three main shading components that are necessary to make the render realistic:

Transparency Unless the water contains silt, pollutants, or other particulates, it is 100% transparent. In this case, only the water's reflectivity and refractivity interfere with the viewer's ability to see through the mass.

Reflectivity Water is highly reflective. Keep in mind that specular highlights are reflections of bright objects, areas, or light sources, such as the sky. If the viewing angle to a body of water is low (such as looking out into the distance over a lake or the ocean), the transparency is no longer apparent and the reflectivity is at its strongest. If the viewing angle is high, the reflectivity is weak (Figure 3.13).

Refractivity The refractive index of water is 1.33, causing objects submerged in the water or sitting behind the body of water to appear bent or distorted. In contrast, the refractive index of air is close to 1.0, causing no perceptible distortion of objects. (Refractive index charts that list refractive indexes of common materials may be found online.)

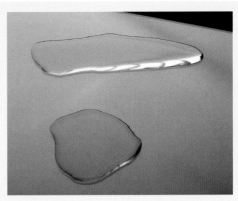

FIG 3.13 Small pools of water on a glass table top. The high angle of view (the camera is above the table) causes the center of each pool to appear transparent, while the edges remain the most reflective. The white highlights are reflections of bright light sources. *Photo by Libyphoto.*

Common Maya materials, such as Blinn and Phong, carry Transparency, Reflectivity, and Refractions attributes. If raytracing is activated for the Maya Software or mental ray renderer, Reflectivity and Refractions are put into use. (Note that the default Refractive Index value is 1.0 and must be changed for refractions to appear.) One problem that occurs when rendering reflective and refractive surfaces, however, is the appearance of "black pits." These occur for the following two reasons:

- The empty environment is reflected or refracted. By default, empty space in Maya is rendered as black. You can alter the color by adjusting the Background Color through the Environment section of the camera's Attribute Editor tab. An alternative solution requires the addition of surrounding geometry (so there's less empty space) or the mapping of an environmental texture to the Maya material's Reflected Color attribute (to create a fake reflection with a bitmap).
- Refractive rays are not carried far enough. If refractive rays are killed off before reaching solid surfaces behind the refractive surface, the resulting area is rendered black. This generally occurs around convoluted portions of the refractive surface. The number of refractive rays a camera eye ray can generate is set by the Refractions attribute in the Render Settings window (for both Maya Software and mental ray). A limit is also carried on a per-Maya-material basis; you can find the Refraction Limit attribute in the Raytrace Options section of the material's Attribute Editor tab. When using mental ray, the Max Trace Depth defines the maximum number of reflections and/or refractions and must also be raised in the Render Settings window.

To create realistic shadows with a clear liquid, you must use a shadow type that supports transparency. In this case, you have two options: raytraced shadows or mental ray Detail shadow maps. In general, depth map shadows are more efficient than raytraced shadow.

To apply these techniques to Project 2, follow these steps:

1. In the Hypershade window, create a new Blinn material. Rename the material **WaterBlinn.** Assign WaterBlinn to the water surface (polySurface1). Open WaterBlinn's Attribute Editor tab. Increase the Transparency value to 100% white. In the Specular Shading section, set Reflectivity to 1.0. Expand the Raytrace Options section and select Refractions. Set Refractive index to 1.33. Increase Refraction Limit to 10. Select the nParticle surface, named polySurface1, and assign it to the Blinn material.
2. Open the Render Settings window. Switch to the Quality tab. Expand the Raytracing section. Increase Refractions to 10. Raise Max Trace Depth to 10.
3. Temporarily disable the KeyLight depth map shadow by deselecting the Use Depth Map Shadows attribute (in the Depth Map Shadows Attributes section) and select Use Mental Ray Shadow Map Overrides attribute (in the mental ray section) of the KeyLightShape Attribute Editor tab.
4. Return to frame 1 and play back the timeline. Stop at a late frame, such as 77. Test render. Some areas of the water appear black. This is due to the reflection and refraction of the empty space and some refractive rays failing to find solid surfaces.

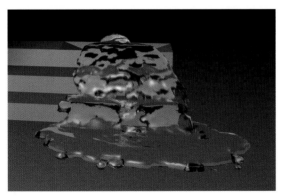

FIG 3.14 The nParticle surface is assigned to a Blinn material. Dark black areas appear when the empty space around the scene is refracted. The KeyLight shadow is temporarily disabled.

5. Through the Persp camera's view panel menu, choose View > Camera Attribute Editor. Scroll down and expand the Environment section. Change Background Color to a dark red. In the Hypershade, create a new mia_material. The mia_material icon is located in the mental ray section under Materials. Rename the material **WaterMia.** Assign WaterMia to the water surface (polySurface1). Open the WaterMia's Attribute Editor tab. In the Reflection section, reduce Reflectivity to 0.5. In the Refraction section, set Index Of Refraction to 1.33, Transparency to 1.0, and Color to bright gray (HSV: 0, 0, 0.85). Color controls the intensity of the refractive component.

6. Open the KeyLightShape Attribute Editor tab. Select Use Mental Ray Shadow Map Overrides. Unfortunately, the regular mental ray shadow type does not support transparency; hence, the shadow under the water will appear opaque. To avoid this, change the Shadow Map Format menu to Detail Shadow Map. Test render. The shadows pick up transparency (**Figure 3.15**). At this stage, the black reflections and refractions are replaced with red reflections and refractions stemming from the dark red background. By the same token, the mia_material is a more advanced and physically accurate shader. Note that the specular highlights are reflections of the lights in the scene (in contrast to the arbitrary specular highlights generated by Maya Software materials such as Blinn).

FIG 3.15 The nParticle surface is assigned to a mia_material mental ray shader. A Detail shadow map supports the transparency of the surface. An example Maya file is included as Project2.7.ma in the /ProjectFiles/Project2/maFiles/ tutorial directory.

Note that the thickness of the nParticle surface affects the apparent scale of the water. Surface tension causes small pools of water to appear thicker than large sheets of water (where the water height appears relatively short). Hence, the Project 2 simulation infers that the scene is at a small scale (similar to a miniature). To increase the apparent size of the Project 2 water simulation, use nParticles with a smaller radius and employ a greater number of nParticles in the scene.

This concludes Part 1 of Project 2.

Billowing Thick Smoke with nParticles

An nParticle simulation is well-suited for creating thick smoke. In fact, setting up the nParticle simulation for smoke is similar to setting up one that mimics water. However, it differs in the fact that the nParticles must float upwards and produce a mass that dissipates over time. In addition, the nParticles require a material that produces soft, indistinct edges. Nevertheless, when creating the nParticle emitter, you are not limited to leaving it at a fixed point in space. Instead, you can integrate it into a character hierarchy, as is described in the next section.

Parenting nParticle Emitters to a Character Rig

The mechanical animal featured in Project 2 has a pair of floppy, smokestack-like ears. You can parent nParticle emitters to the character rig and thus create the illusion that the ears are producing smoke. To create such a set-up as Part 2 of the project, follow these steps:

1. Select the emitter1 node. Temporarily change Rate (Particles/Sec) to 0. This essentially turns off the water simulation. When there are no nParticles, the following error will appear on the feedback section of the Command Line:

   ```
   // Error: (Mayatomr.Geometry) : polySurfaceShape1: mesh
   has no faces, ignored //
   ```

 You can ignore this error. The error will go away once the Rate (Particles/Sec) is raised above 0 again.

2. Select the Machine and Interior surface nodes in the Hypergraph or Outliner and choose Display > Show > Show Selection.

3. From the nDynamics menu set, choose nParticles > Create nParticles > Thick Cloud. Choose nParticles > Create nParticles > Create Emitter. While the new emitter is selected. Move it up to the top of one of the animal's ears so that it sits within the tube (Figure 3.16). Shift+select the top joint (earl3 or earr3) and choose Edit > Parent. Play back. The emitter node follows the ear as it moves through the animation.

FIG 3.16 A new emitter is moved to the tip of the ear and parented to the end joint.

4. Return to frame 1. Play back. New nParticles are generated and spread out in all directions past the end of the ear. Open the Attribute Editor tab for emitter2. Change Rate (Particles/Sec) to 200. Switch to the nParticle-Shape2 tab and change the Radius attribute to 0.6 (which is slightly smaller than the ear opening). In the Dynamic Properties section, deselect Ignore Solver Gravity; if this attribute is left selected, the nParticles will stay close to their point of birth without moving upwards.

5. In the Outliner or Hypergraph, select the nParticle2 node. Choose nSolver > Assign Solver > New Solver. Creating a new Nucleus node allows you to

adjust the Nucleus simulation for the new nParticles without affecting the water simulation created earlier in this chapter. Open the Attribute Editor tab for the nucleus2 node. Change Gravity to 15 and Gravity Direction to 0, 1.0, 0. This reverses the force so that the gravity pushes upwards. Play back the timeline. The nParticles disperse from the ear in a thick mass and gradually move upwards (**Figure 3.17**).

FIG 3.17 An emitter and its nParticles are affected by a nucleus2 node, which applies its gravity field in the positive Y direction.

6. Repeat Steps 2 through 4 to create an emitter for the second ear. To save time, you can associate the nParticle node created for the first ear with a new emitter created for a second ear. To do this, create a new emitter but delete the new nParticle node. Select the nParticle node created for the first ear and the new emitter and choose nParticles > Use Selected Emitter. This will force the emitter created for each ear to use a single nParticle node.

Adjusting an nParticle Material to Emulate Smoke

When you create an nParticle emitter using one of the nParticle presets, a shading network is automatically created. The network includes a Blinn material and particleSamplerInfo node. The particleSamplerInfo node provides particle shape attributes for the material assigned to the particle shape node and is necessary to software render. In addition, a volume material is included in the network. For example, the Thick Cloud preset adds a Fluid Shape volume material. The Points, Balls, Clouds, and Water presets use a Particle Cloud volume material. The volume material is connected to the Volume Material attribute of the shading group node while the Blinn material is connected to the Surface Material attribute (**Figure 3.18**).

When nParticles are software rendered, the surface material and volume material qualities are mixed together (that is, the values are averaged). The mixture is controlled by the Surface Shading attribute found in the Shading section of the nParticle shape node. If Surface Shading is left at the default 0,

FIG 3.18 The shading network created by the Thick Cloud preset.

the volume material is used exclusively to determine the look of the nParticles. If Surface Shading is set to 1.0, the surface material is used. A middle value, such as 0.5, mixes the two materials.

When fine-tuning the nParticle shading networks, you can follow these rough guidelines:

- To alter common shading components, such as color, transparency, and incandescence, adjust the attributes in the Shading section of the nParticle shape node.
- To alter surface-specific shading components, such as those falling into diffuse and specular categories, adjust the attributes of the surface material node.
- To alter volume-specific properties, such as built-in noise texturing or self-shadowing, adjust the attributes of the volume material node.

To create a smoke-like nParticle simulation for Project 2, follow these steps:

1. Open the nParticleShape2 node in the Attribute Editor. In the Lifespan section, change the Lifespan Mode menu to Random Range. Set Lifespan to 4 and Lifespan Random to 2. This will kill off the nParticles within a 2-second random range (thus, each nParticle will live between 3 and 5 seconds). By giving the nParticles a specific age range, it allows us to take advantage of age-driven attributes.
2. In the Radius Scale subsection (directly below Radius), insert a new point at the right side of the ramp. Set the Selected Value cell to 2.5 (**Figure 3.19**). You can exceed the default maximum of 1.0. Note that the Radius Scale Input menu is set to Age. This causes each nParticle to increase in size from a Radius-determined value to a value 2.5 times larger over the 5-second maximum lifetime. Information concerning each nParticle's age is provided by a particleSamplerInfo node. Increase the Radius Scale Randomize value to 0.5 to prevent the nParticle sizes from becoming too consistent.

FIG 3.19 The adjusted Particle Size section and Radius Scale subsection of the nParticleShape2 node. Note the 2.5 Selected Value of the right-hand graph ramp point.

3. In the Shading section, make sure that Surface Shading is set to 0. This forces the renderer to use the Fluid Shape volume material for determining the look of the nParticles. Reduce Opacity to 0.2. High Opacity values create hard-edged nParticle volumes. Select Better Illumination, which provides more accurate lighting and shadowing for the nParticles. With these settings, the Fluid Shape material creates a soft, feathery nParticle render that is better suited for smoke.

4. In the Opacity Scale subsection, insert a new point at the right side of the ramp and pull the point downwards so that its Selected Value is 0 (**Figure 3.20**). Change the Interpolation menu to Spline. Select the left point and pull it downward so its Selected Value is 0.8. Change the Interpolation menu to Spline. Note that the Opacity Scale Input menu is set to Age. This causes each nParticle to transition from semi-transparency to full transparency, with full transparency available to nParticles that live the maximum 5 seconds. Set Opacity Scale Randomness to 0; if this attribute has a non-0 value, some particles may appear hard-edged.

FIG 3.20 The adjusted Opacity Scale, Color, and Incandescence subsections.

5. In the Color subsection, change the Selected Color for the left point of the ramp to dark gray (HSV: 0, 0, 0.15). Change the Interpolation menu to Smooth. Click to the right of the first point to insert a new point at Selected Position 0.75 (**Figure 3.20**). Change the Selected Color for the new point to light gray (HSV: 0, 0, 0.85). Set the Color Input menu to Normalized Age. Normalized Age differs from Age in that the full range of the ramp is used during the lifespan of each nParticle, regardless of what duration that is. This causes each particle to change from dark gray to light gray over time.

6. In the Incandescence subsection, change the Selected Color of the ramp's left point to orange-red (**Figure 3.20**). Change Interpolation to Smooth. Insert a new point close to the first point, near the 0.1 Selected Position. Change the Selected Color of the new point to black. Set Incandescence Input to Age. This causes each particle to briefly carry red incandescence—as if glowing from fire. Play back the timeline. Note that the radius scale, color, and transparency changes are indicated in the view panels.

7. Open the npThickCloudFluid node in the Attribute Editor. In the Textures section, Set Opacity Tex Gain to 4, Threshold to 0.2, and Amplitude to 0.8. Increasing the Threshold while reducing the Amplitude reduces the contrast within the built-in noise texture. By default, the texture affects the Opacity of the particles, as set by the Texture Opacity attribute. Increasing the Opacity Tex Gain amplifies the resulting noise pattern. Change Frequency to 5 and Zoom Factor to 5. This creates smaller noise grains and "zooms" even closer into the resulting pattern. Altering the values in this section affects the quality of the nParticle edges (rough, smooth, and so on). This particular set of values imposes a slight roughness to the nParticle mass. To improve the quality of the volume edges, expand the Shading Quality section and set Quality to 1.0. The higher the Quality value, the smoother the resulting nParticle render but the longer the render time.

8. In the Lighting section, set Shadow Opacity to 1.0 and Shadow Diffusion to 0 (**Figure 3.21**). This darkens and sharpens the self-shadows. Note that Self Shadow is selected by default. Deselect Real Lights. By default, the nParticles are rendered with the light sources in the scene. However, you have the option to render with a built-in light that does not affect any geometry in the scene. The built-in light is set to a Directional by default, as is set by the Light Type menu. Enter −0.5, 0.25, 1.0 into the Directional Light cells. This is a vector direction which points towards the positive Z direction, while pointing slightly up in Y and slightly towards negative X. When lighting nParticles, it's not necessary to apply the same lighting set-up that's used for the scene's geometry; in fact, placing the lights in a unique location or at unique angles may produce more aesthetic results. In this case, the Directional light serves as a back light. Increase the Light Brightness to 2 to lighten the nParticles.

FIG 3.21 The adjusted Lighting section of the npThickCloudFluid volume material node.

9. Play back the timeline. Stop at a late frame. Test render. If the render proves excessively slow, temporarily deactivate motion blur by changing the Motion Blur menu in the Quality tab of the Render Settings window to Off. (You can also reduce the anti-aliasing quality or the render resolution.) The resulting render shows the soft smoke that transitions from incandescent red to gray with increasing transparency (**Figure 3.22**). Test additional frames and adjust the various attributes discussed in this section.

FIG 3.22 The nParticles take on a thick, smoky appearance with adjustments made to the nParticle shape node and Fluid Shape volume material node. An example Maya file is included as Project2.8.ma in the /ProjectFiles/Project2/maFiles/ tutorial directory.

Any time an nParticle attribute carries an age-driven input, the connection is automatically listed in the Per Particle (Array) section of the nParticle shape node. This relates the built-in ramps to the particle attributes provided by the particleSamplerInfo node. You can manually create such connections; this is discussed in the next chapter.

This concludes Part 2 of Project 2.

Generating nParticle Sparks

An nParticle simulation is also well-suited to generate short-lived, randomly-moving sparks. As demonstrated in the previous sections, you can force an emitter to move along with a character and thus have the nParticles "kicked out" as the character moves. However, you are not limited to simple parenting. In fact, you can convert any NURBS or polygon surface into an nParticle emitter through the nParticles > Create nParticles > Emit From Object tool. The nParticles are born at each vertex of the surface. If the surface has numerous faces, as is the case with the Project 2 machine animal, the resulting emitter generates a large number of nParticles in a short period of time—even if the Rate (Particles/Sec) attribute of the emitter node is set to a low number. Alternatively, you can use the Paint Scripts Tool to attach emitters to specific areas of a surface. This is described in the next section.

Attaching Emitters with the Paint Scripts Tool

The Paint Scripts Tool applies the result of a selected MEL script to a surface. The emitterPaint script, spherePaint script, and geometryPaint script are bundled with Maya 2013 and Maya 2014. By default, the scripts are installed in a Maya Scripts directory.

As Part 3 of Project 2, we can use the Paint Scripts Tool to generate nParticle emitters along the front of the machine animal. You can follow these steps:

1. Select emitter2 and temporarily set the Rate (Particles/Sec) to 0. Select emitter3 and temporarily set the Rate (Particles/Sec) to 0. This effectively turns off the emitters at the tips of the ears.
2. Select the Machine surface of the animal. Choose Modify > Paint Scripts Tool > □. The Paint Scripts Tool opens in the Tool Settings panel. Scroll down and expand the Setup section. Type **emitterPaint** into the Tool Setup Cmd cell and press the Enter key. This cell defines the MEL script that is to be used by the tool. If the MEL script is saved to a default Scripts directory, the script is loaded and other cells within the Setup section are automatically populated. In addition, a separate option window opens—in this case, the emitterPaintWindow.
3. In the emitterPaintWindow, set U Grid Size and V Grid Size to 25 (**Figure 3.23**). This defines the density of emitters on the selected surface. The Jitter attribute, when selected, randomizes the emitter positions so they do not form a perfect grid. Change Rate to 2 and Speed to 10; these values are passed to the resulting emitter nodes. Deselect the Per Emitter check box at the bottom of the window; this forces the created emitters to share a single nParticle node. Note that Type is set to Directional, which will generate nParticles in the direction of the surface normals.

89

FIG 3.23 The emitterPaintWindow.

4. Interactively paint along the bars at the center of the animal's belly. Emitters periodically appear (**Figure 3.24**). They are spread out due to the relatively low U Grid Size and V Grid Size values and the current UV layout of the surface. Once you've painted 5 or 6 emitters, pause to examine the Hypergraph or Outliner. The new emitters are grouped under the MachineEmitterGrp group node. You can interactively remove emitters by selecting the Remove radio button in the emitterPaintWindow. You can interactively change the brush size by pressing the B key and LMB-dragging left or right in a view panel.

FIG 3.24 Emitters are placed on the animal's surface with the Paint Scripts Tool. The polygon surface is shown in XRay mode.

5. The transforms of the MachineEmitterGrp node are automatically connected to Machine transform node. If the Machine surface translates, rotates, or scales, the emitters automatically follow. However, the connections do not communicate surface deformations. Hence, if the animal is moved solely via his joints, the emitters will not follow. As a solution, you can break the connections and parent the MachineEmitterGrp node to

a nearby joint. To do so, open the Hypergraph and select the MachineEmitterGrp node. Through the Hypergraph menu, choose Graph > Input And Output Connections. The connections between the Machine node and the MachineEmitterGrp node are revealed as a series of green and purple arrows. Draw a selection marquee across the arrows (but not the nodes). The arrows turn yellow. Press the Delete key. The connections are removed. Select the MachineEmitterGrp node and choose Graph > Scene Hierarchy through the Hypergraph menu. Shift+select the spine1 joint node. Choose Edit > Parent through the main menu. The MachineEmitterGrp node becomes a child of the joint and will follow the skeleton rig as it's animated.

6. Open the Attribute Editor tab for the shared nParticle node, named MachineEParticles. In the MachineEParticlesShape tab, expand the Lifespan Attributes section. Change the Lifespan Mode menu to Random Range. Change Lifespan and Lifespan Random to 1.0. Short-lived nParticles are more appropriate for recreating sparks or embers. In the Render Attributes section, change the Particle Render Type to Cloud. Click the Current Render Type button. Change the Radius to 0.1. Play back the timeline. A slow stream of nParticles is emitted from the front of the animal.

7. At this stage, the nParticles move in a fairly consistent direction. To make the motion more erratic, you can add several additional fields. Select the MachineEParticles node and choose Fields > Turbulence. In the new turbulenceField1 node Attribute Editor tab, change Magnitude to 1000. Play back the timeline. The turbulence forces the nParticles to move in a more random fashion. To prevent new nParticles from following the same paths as the old ones, you can offset the turbulence noise pattern by altering Phase X, Phase Y, and Phase Z. Return to frame 1 and add a keyframe for the three attributes. To set a keyframe on an attribute, RMB-click over the attribute name and choose Set Key from the menu. Go to the last frame of the timeline. Set Phase X to 50, Phase Y to −50, and Phase Z to 50. Set a keyframe for all three attributes. Select the MachineEParticles node and choose Fields > Air. In the airField2 Attribute Editor tab, set Magnitude to 25 and Direction to 0, 0, −1.0. This creates a force along the negative Z axis, which pushes the nParticles back toward the animal. You can combine multiple fields to make a more complex simulation; however, you must experiment with the Magnitude settings to avoid one field canceling out another. Play back the timeline.

Shading nParticles with the Particle Cloud Material

To emulate short-live sparks you can tap into the nParticle support of "Life" material attributes. To do so with Project 2, follow these steps:

1. Select the MachineEParticles node and assign it to the default particleCloud1 material through the Hypershade window.

2. Open particleCloud1 in the Attribute Editor. Click on the checkered Map button beside Life Color. In the Create Render Node window, select the Ramp icon. In the Hypershade, RMB-click over the particleCloud1 material

icon and choose Graph Network from the menu. The network constructed by the Life Color Map button is revealed (Figure 3.25). In this situation, a new particleSamplerInfo node feeds an outUVCoord connection to the place2d-Texture node that's connected to the ramp1 Ramp texture. This allows the age of each nParticle to be correlated to a V position within the Ramp.

FIG 3.25 The shading network constructed by the Life Color Map button.

3. Open the new ramp1 material in the Attribute Editor. Click the × box on the right side of the center green handle to delete it. Click the circle icon belonging to the bottom handle. Its color is revealed in the Selected Color swatch. Click the swatch and choose the color orange through the color selector pop-up. Click the circle icon of the top ramp handle. Its color is revealed in the Selected Color swatch. Click the swatch and choose the color black through the color selector pop-up. This forces the nParticles to shift from orange to black as they age.

4. Return to the particleCloud1 tab. Click on the checkered Map button beside Life Incandescence. In the Create Render Node window, select the Ramp icon. Adjust the new ramp2 node so that the ramp runs from red (bottom) to black (top). The top of the V ramp correlates to the oldest potential age of an nParticle (as based on the current nParticle Lifespan Attributes section settings).

5. Return to the particleCloud1 tab. Click on the checkered Map button beside Life Transparency. In the Create Render Node window, select the Ramp icon. Adjust the new ramp3 node so that the ramp runs from black (bottom) to white (top). Move the lower black handle upwards so it's near the ramp top. Change the Interpolation menu to Smooth. This will delay the transition to transparency until a late stage of the nParticles' life.

6. Play back the timeline and stop at a late frame where the new nParticles are visible. Reactivate motion blur if it was previously disabled (set Motion Blur to Full in the Quality tab of the Render Settings window). Test render. Streaked, spark-like nParticles appear. At this point, the number of individual sparks visible at any given frame is small. If you'd like to increase the total number of sparks, raise the Rate (Particles/Sec) value for each of the associated emitters. For example, in Figure 3.26, each of the five emitters is given a Rate (Particles/Sec) value of 8.

FIG 3.26 Spark-like nParticles streak past the animal. The "Life" attributes of the assigned Particle Cloud material cause each nParticle to change color, transparency, and incandescence over time. An example Maya file is included as Project2.9.ma in the /ProjectFiles/Project2/maFiles/ tutorial directory.

This concludes Part 3 of Project 2. **Figure 3.27** illustrates Project 2 at this stage. The Rate (Particles/Sec) values for all the emitters have been returned to their original values.

FIG 3.27 Project 2 at the end of Part 3. An example Maya file is included as Project2.10.ma in the /ProjectFiles/Project2/maFiles/ tutorial directory.

Generating nParticle Swarms and Bubble Masses with Expressions and MEL Scripting

Maya is built on the MEL scripting language. As such, you can use MEL scripting to control a wide variety of elements within the program. In particular, it's suited for creating the initial states of nParticle simulations. Expressions, on the other hand, are mathematical relationships between nodes and *channels* (animatable attributes). Hence, expressions automatically update with every frame of the timeline. This makes expressions perfect for controlling per-particle attributes that constantly change. While expressions are edited through the Expression Editor, MEL scripts may be written through the Script Editor, converted to shelf buttons, or saved as external files.

This chapter includes the following critical information:

- Control of nParticles with per-particle attributes and expressions
- Creation of nParticles with MEL scripts
- Use of texture emission, geometry instancing, and particle goals

In addition, this chapter takes you through Part 4 and Part 5 of Project 2. The project features a modeled, textured, lit, and animated 3D scene featuring a surreal, mechanical animal running in place. In Chapter 3, we created water, smoke, and spark simulations with nParticles. In this chapter, we'll add a small swarm of mechanical insects and a mass of bubbles with nParticles; however, we'll control the new simulations with expressions and MEL scripting.

Controlling nParticles with Expressions

Part 4 of Project 2 starts with the creation of a bubble mass percolating through the water simulation surface created in Chapter 3. This requires the creation of a new expression through the Expression Editor. While we're creating this, we'll discuss the basics of Maya expression execution, including structure, syntax, and evaluation.

An Introduction to Expressions

Expressions are special text instructions that you can apply to node channels. *Nodes* are discrete units of a hierarchy that store information (such as a transformation matrix, geometry attributes, and so on), while *channels* are keyable attributes of a node, such as Translate X, Visibility, and so on. The instructions can take the form of mathematical equations, conditional statements, or a linked relationship with a different channel (provided by the same node or a completely different node within the scene).

When an expression is applied to a channel, you cannot keyframe the channel unless you remove the expression. If an expression exists for a particular channel, its numeric cell is colored light purple (**Figure 4.1**). You can remove the expression by RMB-clicking over the channel name and choosing Break Connections from the menu. Note that this deletes the entire expression. You can also edit the expression in the Expression Editor to remove the reference to a particular channel. The editor is discussed in the next section.

Working with the Expression Editor

Maya's Expression Editor offers a means to write, edit, and access expressions within a Maya scene. You can launch the editor by choosing Window > Animation Editors > Expression Editor. If one or more expressions exist within an open scene, you can list them by choosing Select Filter > By Expression Name through the editor's top menu. To see the contents of a particular expression, click on the expression name in the Expressions field (**Figure 4.2**).

FIG 4.1 The Translate X channel of a polygon sphere indicates an expression with purple coloring.

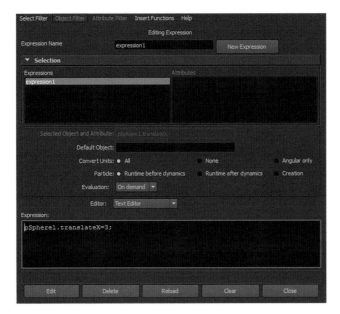

FIG 4.2 A scene carries a single expression, *expression1*. The contents of the expression are revealed in the Expression text field.

You can edit a current expression within the built-in Expression text field at the bottom of the editor. The field supports system cut and paste operations. Once you've typed the revisions, you can update the expression by clicking the Edit button at the bottom.

To create a new expression, choose Select Filter > By Expression Name through the Expression Editor menu, empty the Expression text field by clicking the New Expression button, enter a new expression name into the Expression Name field, type one or more lines in the Expression text field, and click the Create button. Maya checks the syntax of the expression at this point; if there is an error, a red line appears in the feedback section of the Command Line at the bottom of the Maya program window with the phrase `// Error: Expression invalid after edit`. If the expression is valid, the feedback section displays `//Result: [expression name]`.

When applied to geometry, expressions are stored in an expression node, which is connected to the nodes it lists within the expression text. However,

if the expression applies to a per-particle attribute, the expression is stored in the particle or nParticle shape node.

Reviewing Basic Expression Syntax

Before writing expressions, it pays to review basic syntax and construction. A few critical areas are discussed here.

End of Line You must end each line of an expression with a semicolon. The exceptions include lines that are commented with a // at the line start and conditional statements, such as if statements (discussed at the end of this section).

Channel Names To refer to a channel, you must also include the node name and a period. For example:

```
pSphere1.translateX
pCube2.rotateY
nurbsCone1.visibility
```

Maya accepts two variations of transform channel names:

```
pSphere1.translateX or pSphere1.tx
pCube2.rotateY or pCube2.ry
```

Spelling and Capitalization Maya is sensitive to spelling and capitalization. Improper spelling or capitalization of node names or channel names makes the expression invalid and no part of the expression will function. You can list the channels that are available to an expression for a particular node by selecting the node and choosing Select Filter > By Object/Attribute Name in the Expression Editor. The node is listed in the Objects field and the channel names are listed in the Attributes field. If you click on one of the channel names, the full node/channel name is listed in the Selected Object And Attribute cell, which you can select, copy, and paste into the Expression text field with operating system shortcuts (such as triple-clicking the name to select and using Ctrl+C and Ctrl+V to copy and paste in Windows).

Equations The channel that is affected by an expression line is always to the left of an equals sign. The right side of the expression line may include a value or some combination of mathematical formulas and other channel names. Here are a few examples:

```
pSphere1.translateX = 3;
pCube2.translateX = pSphere1.translateX;
pCube2.translateY = pSphere1.translateY+5;
```

Operators As for mathematical formulas, expressions use the following operators:

+	plus
−	minus
/	divide
*	multiply

For more complex mathematical operations, Maya provides a long list of MEL functions that you can access through the Insert Functions menu of the Expression Editor. These are represented with a short name and parentheses where the user inserts one or more values between the parentheses. For example, to raise 2 to the power of 12, choose Insert Functions > Math Functions > pow() and enter 2,12 between the parentheses, producing a section of the expression that reads pow(2,12). Thus, an expression line may look like this:

```
pSphere1.tx=pow(2,12);
```

Note that you can enter a mathematical formula in the Script Editor and thus use it as a command-line calculator. For descriptions of each MEL function, visit the Commands section of the Technical Documentation area of the Maya Help files.

Conditional Statements Expressions support conditional statements that test criteria before executing a specific part of the expression. The most common conditional statement is the if statement. The statement requires the flowing syntax:

```
if (node.channel < n)
     execute this line;
```

Hence, a working if statement might be:

```
if (pSphere1.ty < 10)
     pSphere2.ty=pSphere1.ty;
```

With this example, if the Translate Y value of pSphere1 is less than 10, then pSphere2's Translate Y value is taken from pSphere1. If pSphere1's Translate Y is equal to or greater than 10, then the line after the if line is skipped and pSphere2's Translate Y value is left as is. You can test this expression in a number of different ways by replacing the < (less than operator) with these other operators:

>	greater than
==	equals
!=	does not equal
<=	less than or equal
>=	greater than or equal

You can test multiple conditions by using &&. For example:

```
if (pSphere1.tx < 10 && pSphere1.ty > 5)
     pSphere2.ty=pSphere1.ty;
```

With this example, the second line is only executed if tx < 10 and ty > 5.

Employing Per-Particle Attributes with Texture Emission

By default, all the nParticles belonging to a single nParticle node work in lock-step, thus producing little if any variation between the basic nParticle appearance. You can insert some variation by adding fields such as Turbulence or activating "Life" material attributes, such as Life Color. As an alternative, you can use per-particle attributes to create a great deal of variety. To test this work flow, we'll add bubbles to the top steps as Part 4 of Project 2. You can follow these steps:

1. Open the `Project2.10.ma` scene file. This is located in the `/ProjectFiles/Project2/maFiles/` tutorial directory (to avoid missing texture bitmaps, choose File > Set Project and select the `/ProjectFiles/Project2/` folder before opening the `.ma` file).

2. Open each nParticle emitter node for the spark, smoke, and water simulation in the Attribute Editor and change Rate (Particles/Sec) to 0. In the example file, the spark emitters are named MachineEmitter*n*, the smoke emitters are named emitter2 and emitter3, and the water emitter is named emitter1.

3. Select the Stairs surface and choose nParticles > Create nParticles > Points to select the Points preset. Choose nParticles > Create nParticles > Emit From Object > □. In the Emit From Object options window, change Rate (Particles/Sec) to 5000 and change Solver to Nucleus2. A new emitter, emitter4, is placed in the center of the Stairs surface; the emitter transform node is parented below the Stairs transform node.

4. Open the new nParticle node, nParticle3, in the Attribute Editor. Switch to the nParticleShape3 tab. In the Shading section, change the Particle Render Type menu to Blobby Surface. Applying the Points nParticle preset prevents the program from linking per-particle attributes. Nevertheless, you can change the Particle Render Type at any stage of a project.

5. Play back the timeline. The new nParticles are born at each vertex. Open emitter4 in the Attribute Editor. Change the Emitter Type menu to Surface. Play back. The nParticles are born over the entire surface (**Figure 4.3**). To control where on the surface they're born, you can use texture emission. Scroll down to the Texture Emission Attributes section of the emitter4 tab. Click the checkered Map button beside Texture Rate. Pick the File icon in the Create Render Node window and browse for the `stairs.tif` bitmap in the `/Project2/Textures/` folder. This bitmap features a small white square that corresponds to the indentation at the top of the stair geometry while the rest of the image remains black. Return to the emitter4 tab and select Enable Texture Rate (directly below Texture Rate). Play back from frame 1. nParticles are born within the areas of the bitmap that are white while ignoring the areas that are black. (If this fails to happen, adjust the emitter's Rate (Particles/Sec) and play back again from frame 1.) Only a portion of the 5000 particles/second are now born (**Figure 4.3**).

FIG 4.3 Top: Emit From Object creates nParticles along a surface when Emitter Type is set to Surface. Bottom: nParticles are born in a specific location on the surface with the use of texture emission and black-and-white emission bitmap. The nParticles have been switched to Blobby Surface.

6. Select the nParticle3 node. Choose Fields > Turbulence > □. In the Turbulence Options windows, set Magnitude to 2500, Frequency to 100, and click Create. Play back. The nParticles take on a random motion. However, their speed upwards remains fairly fast. With the nParticle3 node selected, choose Fields > Gravity > □. In the Gravity Options window, set Magnitude to 10 and click Create. Play back. The new Gravity node slows down the nParticles as it counteracts the positive Y gravity of the nucleus2 node.

7. Return to the nParticleShape3 tab. Scroll down and expand the Per Particle (Array) Attributes section. Note that there are no connections. Click the General button in the next section—Add Dynamic Attributes. The Add Attribute window opens. Switch to the Particle tab, click on the word *radiusPP*, and click the OK button. The Radius PP per-particle attribute is added to the Per Particle (Array) Attributes section.

FIG 4.4 The Particle tab of the Add Attribute window.

8. RMB-click over the newly-added Radius PP cell. Note that the menu features four different ways to create a custom per-particle connection for the Radius PP attribute: Creation Expression, Runtime Expression Before Dynamics, Runtime Expression After Dynamics, and Create Ramp. The Create Ramp option connects a Ramp 2D texture node to the material network so that the age of the nParticle is related to a V position within the Ramp pattern. A creation expression executes on the frame that the nParticle is born but does not execute while the timeline plays back. In contrast, a runtime expression executes each frame during playback and is suited for a simulation that requires values that constantly change. The *Before* and *After* variations of a runtime expression determine at what point the expression is applied (before or after other dynamic calculations, such as the influence of fields, the emission of particles, and so on). Choose Creation Expression from the menu. At this point, it's not necessary to vary the value of each particle's radius after it is born.

9. The Expression Editor opens. The Creation radio button, beside the Particle attribute, is selected. The nParticleShape3.radiusPP channel is listed in the Selected Object And Attribute cell. In the Expression text field, type the following line:

```
nParticleShape3.radiusPP = 5;
```

Click the Create button. (If your nParticle shape node has a different number, swap its number for the 3.) If the line is typed correctly, a new expression is created and is stored in the nParticle shape node. Play back from frame 1. The size of the nParticles updates. Replace the 5 with .25 and click the Edit button. The expression is updated and the nParticles shrink.

10. At this stage, the nParticles are all the same size. To randomize the radius, update the expression to read as follows:

```
nParticleShape3.radiusPP = rand(.5);
```

The rand() function is one of many mathematical functions available to expressions and MEL scripting. The function selects a random number within a range from 0 to the number entered within the parentheses. Because Radius PP is made equal to the function, a different random radius value is assigned to each and every nParticle at its birth. You can choose a non-zero range by entering two values with a comma, such as (.1, .5), where the range falls between the first and second number.

11. The nParticle3 Lifespan attribute remains set to Live Forever. Although you can change the settings within the Lifespan section, you can exert greater control by adding conditional statements to an expression. In the Expression Editor, choose Select Filter > By Expression Name. Click on the nParticleShape3 name in the Expressions field. The expression is revealed in the Expression text field. Select the Runtime After Dynamics radio button. The Expression text field becomes empty. This does not destroy

the Creation expression. In fact, any given nParticle shape node can carry a Runtime Before Dynamics, a Runtime After Dynamics, and a Creation expression. Type the following:

```
if (nParticleShape3.radiusPP < .05)
    nParticleShape3.radiusPP = 0;
if (nParticleShape3.radiusPP > .05
    && nParticleShape3.radiusPP < .75)
nParticleShape3.radiusPP =
    nParticleShape3.radiusPP + rand(.02);
if (nParticleShape3.radiusPP > .75)
    nParticleShape3.radiusPP = 0;
```

Note that the limited space on the pages of this book requires line wrap. For example, the following is broken into two lines:

```
nParticleShape3.radiusPP =
    nParticleShape3.radiusPP + rand(.02);
```

You have ample room to write this as a single line in the Expression Editor Expression field. In either case, Maya understands that a single line of code ends with a semicolon, so the example line wraps are not problematic. In addition, Maya understands that a line following an if statement is only executed if the if statement is true. Also note that the example includes indentations where line wraps occur; this is not mandatory and is only included for visual clarity.

12. Click the Create button. The runtime expression is created. Play back. The nParticles slowly grow at varying rates until they "pop" and disappear when they reach a radius threshold (**Figure 4.5**). If necessary, increase the duration of the timeline to see this action.

FIG 4.5 The nParticles are born with a random radius, slowly grow over time, then "pop" and disappear as they reach a radius threshold. An example Maya file is included as Project2.11.ma in the /ProjectFiles/Project2/maFiles/ tutorial directory.

The added if statements follow this logic:

- If an nParticle radius is greater than 0.05, incrementally increase the radius with each frame. Each nParticle grows at a different rate due to the rand(.02) function. (If you'd like the nParticles to increase in size at a more rapid rate and thereby "pop" more quickly, increase the value within the rand parentheses.)
- If an nParticle radius is greater than 0.75, set the radius to 0, which "pops" it by essentially turning off the nParticle.

- If an nParticle radius is less than 0.05, change the radius to 0. This prevents the nParticle from regrowing at its current position after it "pops."

As demonstrated in this section, you can make radiusPP equal to a particular value or a mathematical formula that includes the radius value derived during the previous frame. In this situation, it's necessary to write the expression as a runtime in order for the changing radiusPP value of each nParticle to be evaluated at each frame.

Applying Bubble Materials to nParticles

VFX Notes: Emulating Soap Bubbles

Soap bubbles are uniquely formed. A thin layer of water is sandwiched between two layers of soap. Aside from naturally forming a sphere due to minimization of surface area, soap bubbles also produce shifted colors through light wave interference. The inner and outer surface of a bubble reflects light, which throws the reflected light waves out-of-sync. The colors vary based on the bubble wall thickness and bubble size, but are often seen as magenta, yellow, green, and cyan (Figure 4.6).

FIG 4.6 Light wave interference creates reflectivity with shifted colors on soap bubbles. *Photo © Vladitto-Fotolia.com.*

You can emulate the soap bubble look with a material or shader. You can apply a common Maya material, such as Blinn, with high Reflectivity and Chromatic Aberration selected. (Chromatic Aberration is located in the Raytrace Options section and shifts surface colors to emulate light wave interference.) Alternatively, you can apply a more physically accurate mental ray shader, such as mia_material. A third solution, however, uses a custom material network that controls incandescence and reflectivity with

Ramp textures and a Sampler Info node. To create such a network, follow these steps:

1. In the Hypershade, create a new Blinn material. Assign the material to the nParticle3 mass. Blobby Surface nParticles support all of the Maya Software materials. Rename the Blinn material **BubbleMaterial** and open it in the Attribute Editor. Set the attributes listed in Table 4.1 to the included values.

TABLE 4.1

Attribute	Value	Notes
Transparency	White	When Transparency is at its maximum value, the Color value will not be seen.
Eccentricity	0	Controls the size of the artificial specular highlight. Setting this to 0 turns off the highlight.
Specular Roll Off	White	The higher the Specular Roll Off value, the more intense the reflections.
Specular Color	White	
Refractions	On	In the Raytrace Options section.
Refractive Index	1.02	This produces a small amount of refractive distortion of the background as seen through the nParticle surfaces.

2. Click the checkered Map button beside Incandescence. Select the Crater texture in the Create Render Node window. Open the new Crater texture in the Attribute Editor. Set Shaker to 10. Shaker controls the degree of perturbation in the texture created by mixing Channel 1, Channel 2, and Channel 3 colors. The higher the Shaker value, the more noisy and detailed the texture. Set Channel 1 to magenta (HSV: 311, 1.0, 0.5). Set Channel 2 to green (HSV: 120, 1.0, 0.6). Set Channel 3 to blue (HSV: 240, 1.0, 0.4). The Crater texture is a 3D texture. Hence, the incandescence of the nParticles changes as they move through space. The size of the texture is also controlled by a 3D Placement utility, which is connected to the texture node automatically. The utility is drawn as a green wireframe cube in the view panels and is placed at 0, 0, 0 by default. Select the cube in a view panel or select the place3dTexture1 node in the Hypergraph or Outliner. Scale the cube to 10, 10, 10 (**Figure 4.7**).

3. Test render. The Crater color appears on the nParticles. However, the consistency of the incandescence is consistent over the entire surface (**Figure 4.8**). In addition, the reflectivity of the surrounding surfaces is equally consistent across the surfaces. In the real world, the viewing angle to the

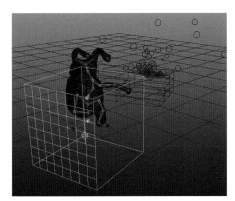

FIG 4.7 The scaled 3D Placement utility connected to the Crater texture.

FIG 4.8 The Crater texture varies the incandescence over the nParticle surfaces. However, there is no variation between the nParticle edges and centers.

surface affects the apparent transparency and reflectivity. To emulate this, you can alter the material's Reflectivity and Incandescence values based on the surface point relationship to the rendering camera. To do this, click the checkered Map button beside Reflectivity in the material Attribute Editor tab. In the Create Render Node window, choose the Ramp icon. In the new Ramp's Attribute Editor tab, delete the center ramp handle. Change the color of the top ramp handle to dark gray (HSV: 0, 0, 0.12). Change the color of the bottom handle to light gray (HSV: 0, 0, 0.7). Return to the Hypershade, RMB-click over the BubbleMaterial icon, and choose Graph Network. The material network is displayed in the work area.

4. To relate the Ramp texture colors to surface points on each nParticle based on their orientation to the rendering camera, you can add a Sampler Info node. You can find the Sampler Info node by expanding the Maya > Utilities section of the Create tab in the Hypershade. MMB-drag a new Sampler Info node and drop it on top of the new Ramp node. From the menu that appears, choose Other. The Connection Editor opens. In the left column,

click on the phrase *facingRatio* so that the line turns blue. In the right column, expand the grayed-out *uvCoord* section by clicking on the small circle with a +. Click on the word *vCoord* so that it is italicized. This creates a connection between the Facing Ratio and vCoord attributes (**Figure 4.9**). Facing Ratio produces a value between 0 and 1.0 that represents the rendering surface point's relationship to the camera. A high value indicates that the point is facing the camera while a low value indicates the point is facing away from the camera. Hence, nParticle points facing the camera receive values from the top of the Ramp, while points along the sides of the nParticles receive values from the bottom of the Ramp. Ultimately, this makes the edges of the nParticles more reflective than the centers. Test render.

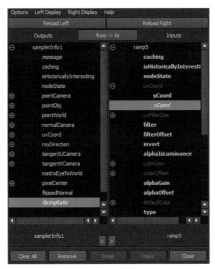

FIG 4.9 A custom connection is created between the Sampler Info node's Facing Ratio attribute and the Ramp's vCoord attribute, as seen in the Connection Editor.

5. To reduce the intensity of the incandescence at the centers of the nParticles, return to the Hypershade work area and MMB-drag the adjusted Ramp node (named ramp4 in the example files) and drop it on top of the Crater node. Choose colorGain from the menu that appears. A new connection is made (**Figure 4.10**). This connection lowers the intensity of the incandescence along the points that face the camera. In this case, the values of the Ramp are multiplied by the values of the Crater texture. Test render.

You can create a similar soapy, oily look for the water simulation by mapping a Crater texture to the assigned mia_material. To do so, follow these steps:

1. Open the emitter1 Attribute Editor tab. Return Rate (Particles/Sec) to 4000. Play back the timeline from frame 1 and stop at a late frame. Temporarily hide the Machine and Interior surfaces of the animal so that the water surface is not covered by the animal's shadow.

FIG 4.10 The final custom material network used to emulate soap bubbles.

2. Open WaterMia material in the Attribute Editor. In the Refraction section, click the checkered Map button beside Color. Choose the Crater icon in the Create Render Node window. In the new Crater texture Attribute Editor tab, change Shaker to 15. Set Channel 1 to pale magenta (HSV: 311, 0.28, 1.0). Set Channel 2 to pale green (HSV: 120, 0.25, 1.0). Set Channel 3 to pale blue (HSV: 240, 0.14, 1.0). Select the connected 3D Placement node and change its Scale to 10, 10, 10. Test render. The refractive areas of the water surface take on the colors of the Crater texture in a random pattern.

3. The bright specular highlights on the water surface are the reflections of lights in the scene. To emulate this reflectivity with the Blinn material assigned to the bubble nParticles, change the Blinn's Eccentricity back to 0.1. Test render. The bubbles now match the water surface, even though both nParticle simulations are using different materials.

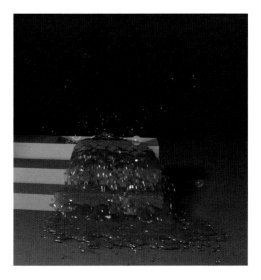

FIG 4.11 A Crater texture is mapped to the refractive color of the mia_material assigned to the water surface. Thus, the water takes on the soapy, oily look of the bubbles. An example Maya file is included as Project2.12.ma in the /ProjectFiles/Project2/maFiles/ tutorial directory.

This completes Part 4 of Project 2.

Adding nParticle Variety with MEL

Although Maya expressions allow you to control nParticles on a per-particle basis, you can add even greater variety by applying a MEL (Maya Embedded Language) script.

MEL is a cross-platform scripting language with which Maya is built. In fact, the entire user interface is constructed with MEL. Whereas expressions are stored within a Maya scene file, you can save and read MEL scripts as standalone text files. With MEL, you can construct custom interface components and create automated procedures for custom modeling, animation, dynamics, and rendering tasks.

Working in the Script Editor

The Script Editor (Window > General Editors > Script Editor) allows you to write MEL or Python scripts. (Python is discussed in the next chapter.) You can also load, source, or save scripts from the window. The top pane displays the history of executed commands and any associated results (**Figure 4.12**). The history includes all activity within Maya, whether it's created as an entered command, a loaded script, or interaction within the program. The last line within the pane is displayed in the feedback section of the Command Line at the bottom of the Maya program window.

FIG 4.12 The Script Editor. History (including error messages) appears in the top pane. Unexecuted scripts appear in the bottom pane.

You can enter MEL or Python commands in the bottom command pane within the appropriate tab–MEL or Python. To execute a command, you must press Cmd/Ctrl+Enter. For example, to create a primitive sphere, type the following line in the MEL tab and press Cmd/Ctrl+Enter:

```
polySphere;
```

A default polygon sphere is created. Note that the line must end with a semicolon. Delete the sphere, and choose Create > Polygon Primitives >

Sphere from the main Maya window. A new sphere is created. Two new lines also appear within the history pane of the Script Editor:

```
polySphere -r 1 -sx 20 -sy 20 -ax 0 1 0 -cuv 2 -ch 1;
// Result: pSphere1 polySphere1 //
```

Every tool you apply in Maya has an associated MEL command, such as `polySphere`. Options associated with the tool appear as flags. A flag has a dash followed by one or more letters. A value may follow the flag. For example, `-r 1` sets the sphere radius to 1.0. In this case, `-r` is the flag and `1` is the flag value. Flags are generally optional. Nevertheless, flags usually require one or more values to accompany them. If a particular flag is not present, a default value is supplied. For a list of MEL commands and descriptions of their flags, visit the Commands section within the Technical Documentation area of the Maya Help files.

Any line that appears with a `//` at the start is a comment. You can add `//` to comment out lines within an expression or MEL script and thus prevent the lines from executing.

You can save a script appearing in the command pane by choosing File > Save through the Script Editor menu. MEL scripts are saved as `.mel` text files and Python scripts are saved as `.py` text files. You can open a script and have it read into the command pane by choosing File > Load Script. The script is not executed until you press Cmd/Ctrl+Enter. You can load a script into memory by choosing File > Source Script. Depending on how the script is written, it will either execute immediately or wait for the entry of an additional, custom command.

Reviewing MEL Syntax

MEL shares the the same syntax as Maya expressions, with two notable exceptions: access to node channels and access to time.

With an expression, you can simply assign a channel a particular value. At the same time, you can read the value of any channel. For example:

```
pSphere1.sx = 10;
pSphere1.sy = pSphere2.sy;
```

With MEL, you must use the `setAttr` and `getAttr` commands to access channels. Thus, to set the Scale X of pSphere1 to 10, you must execute the following:

```
setAttr ("pSphere1.sx", 10);
```

As such, the node and channel names appear in quotes, while the entire operation for `setAttr` is placed within parentheses. To read a channel value, you can use `getAttr`. To pass the read channel value to another channel, you must use a variable. For example:

```
int $val = getAttr("pSphere2.sy");
setAttr ("pSphere1.sy", $val);
```

With this example, $val is the variable that stores the value of the pSphere2's Scale Y. Variables are indicated by the $ symbol. We'll discuss variables in more detail in the next section.

When working with the timeline, you can access the current frame value with an expression in this way:

```
pSphere1.tx = time;
```

With MEL, you have to create a query and store the resulting value in a variable:

```
float $test = `currentTime -q`;
```

With this example, -q is a flag that queries the time1 node for the current frame number through the currentTime command.

Using Variables in MEL

A variable is a programming construct that's able to store a value. The value may be replaced, updated, or retrieved at any point by referring to the variable name. There are three common types of variables used by MEL:

int Integer. Stores a whole number (no decimal places).
float Stores a number with decimal places.
string Stores all characters, from a single letter to a complete sentence.

To declare (that is, create) a variable and assign an initial value, follow this format:

```
int $test1 = 10;
float $test2 = 3.2837;
string $test3 = "Mary had a little lamb";
```

To retrieve a variable value, simply refer to its name, as with these two examples:

```
print $test1;
setAttr ("pSphere1.sx", $test2);
```

Integer, float, and string variables can only store one value at a time. However, there are two special variable types that can store multiple values: vector and array. A vector variable stores any three floating-point values at a time. For example:

```
vector $Vtest = <<0.5, 6.7, 2>>;
```

In this case, $Vtest stores three numeric values (x, y, z) between double pairs of greater-than/less-than symbols. To access these values, you must refer to the position within the vector by adding a .x, .y, or .z to the variable name. For example:

```
setAttr ("pSphere1.sx", $Vtest.y);
```

An array, on the other hand, is an ordered list of values that share the same variable type. You can declare an array this way:

```
float $temp[25];
```

The number in the brackets is the array size and determines how many values the array can hold. To assign values to or retrieve values from an array, include the array index—the number that determines the position within the array. For example:

```
$temp[8]=25.2;
print $temp[8];
setAttr ("pSphere1.sx", $temp[8]);
```

Controlling nParticles with MEL Scripts

You can write MEL scripts to automate almost any process within Maya. Keep in mind that MEL scripts are designed to run when called, and are not automatically launched with each frame of the timeline playback. Such a runtime behavior is better suited for expressions. As such, MEL is suitable for creating an initial state for nParticle simulations. That state may include the particle render type, birth radius, birth position, and lifespan.

For example, working in a new, empty scene, type the following text into the MEL command tab of the Script Editor and press Cmd/Ctrl+Enter to execute:

```
emitter -r 500 -type omni -pos 0 10 0 -n myEmitter;
```

An emitter, named myEmitter, is placed in the scene at 0, 10, 0. However, despite the fact that the emitter's Rate (Particles/Sec) attribute is set to 500, no particles appear when the timeline plays. Like many tools inside Maya, Create Emitter requires several lines of MEL script to function. To add an nParticle node to the scene and dynamically connect it to myEmitter, execute these additional lines:

```
nParticle -n myParticle;
connectDynamic -em myEmitter myParticle;
```

Play back the timeline. The nParticles appear. In truth, these two lines spawn many additional MEL commands. The commands create and connect a Nucleus node (if one is not present), assign a default shading network, and make changes to various interface elements. The majority of these automated commands are hidden from the history pane. To display them, choose History > Echo All Commands from the Script Editor menu. In fact, studying the history pane is a good way to determine the functionality of various tools, commands, and flags. You can clear the history pane at any time by choosing Edit > Clear History.

Note that every flag has a short form and long form name. For example, you can use either -r or -rate to set the emitter's Rate (Particles/Sec). To see a list of flags available for a MEL command, the flags' short form and long form names, and a description of each flag's functionality, visit the Commands section in the Technical Documentation section of the Maya Help files.

Planting nParticles and Creating Goals with MEL

You can create nParticles without using an emitter. You can choose nParticles > Create nParticles > nParticles Tool and interactively click in the view panel to "plant" individual nParticles. To complete the process, press Enter. The nParticles belong to a single nParticleShape node. Alternatively, you can use the nParticle command in the Script Editor. For example:

```
nParticle -p 0 0 0 - p 1 1 1 - p 2 2 2 -n myParticle;
```

This command creates a new nParticle shape node, nParticle transform node, and, if not already present, a Nucleus node. The -p flag creates one nParticle at an x, y, z location. This ability offers a means to include a limited number of nParticles per node. This is particularly useful when instancing geometry onto nParticles. For example, as Part 5 of Project 2, we can add a small swarm of mechanical bugs to the head of the animal. You can follow these steps to create the swarm:

1. Return to the mechanical animal scene. If necessary, open the Project2.12.ma scene file. Temporarily set the Rate (Particles/Sec) for emitter1 and emitter4 to 0. Unhide the Machine and Interior surfaces. Determine the approximate location of the animal's head throughout the animation. You can activate grid number by choosing Display > Grid > □ and selecting the On Axes radio button beside Orthographic Grid Numbers. The animal's head is roughly at 0, 15, 0.

2. Choose nParticles > Create nParticles > Balls to select the Balls preset. Type the following lines into the Script Editor and execute them by pressing Cmd/Ctrl+Enter:

```
int $randx = rand(-6, 6);
int $randy = rand(16, 19);
int $randz = rand(-6, 6);
vector $pv1 = << $randx, $randy, $randz >>;
$randx = rand(-6, 6);
$randy = rand(13, 16);
$randz = rand(-6, 6);
vector $pv2 = << $randx, $randy, $randz >>;
$randx = rand(-6, 6);
$randy = rand(13, 16);
$randz = rand(-6, 6);
vector $pv3 = << $randx, $randy, $randz >>;
nParticle -p ($pv1.x) ($pv1.y) ($pv1.z) -p ($pv2.x)
    ($pv2.y) ($pv2.z) -p ($pv3.x) ($pv3.y) ($pv3.z);
```

3. Feel free to alter the numbers included with the rand parentheses. Ultimately, these values determine the ranges along x, y, and z where the nParticles will be born. For example, to make the nParticles appear higher, enter larger numbers into the parentheses beside the $randy lines. You can cut and paste within the MEL pane. With Windows, use Ctrl+C and Ctrl+V to cut and paste. On a Mac, use Cmd+C and Cmd+V. You can also cut and paste from the history pane or an external text

editor. Once the text is complete, use Ctrl+Enter or Cmd+Enter to execute the script. Ultimately, three nParticles are born at random locations around the head (**Figure 4.13**).

FIG 4.13 Three nParticles are created at random positions above the head with a MEL script.

4. Play back the timeline. If the nParticles are not moving, open the new nParticleShape4 node, and scroll down to the Dynamic Properties section and deselect the Ignore Solver Gravity attribute. (This is deselected if the Balls presets is used.) By default, the new nParticles are connected to the previously-used Nucleus node. If the nParticles rise, then they are using nucleus2. If the nParticles fall, they are using nucleus1. To assign the nParticles to nucleus2, select the nParticle4 node and choose nSolver > Assign Solver > nucleus2. You can change the Particle Render Type to any particle type to see them more clearly. For example, in the Script Editor, you can enter `setAttr "nParticleShape4.particleRenderType" 4;` to switch to spheres (each type has a unique number).

5. In addition to nucleus2 positive-Y gravity, you can add fields to move the new nParticles. Return to the Script Editor and execute the following line:

```
connectDynamic -f turbulenceField1 nParticle4;
```

6. A dynamic connection is made between the pre-existing turbulence-Field1 node and the nParticle4 node, and the nParticles move chaotically. (To make the connection through the menu, choose Fields > Affect Selected Object(s).) Play back the timeline. At this point, the nParticles move away from the animal. To draw them to the animal head, you can establish the animal surface or a joint in the character rig as a goal. Before creating the goal, however, check the start position for the nParticles. If any of the nParticles are below the Machine surface, play the timeline forward until they come to a better position outside the body. You can set the new positions as their initial state (that is, where they

start on the first frame). To do so, select the nParticle4 transform node and execute this line:

```
setNClothStartState;
```

You can also choose nSolver > Initial State > Set From Current. Alternatively, you can simply move the entire nParticle transform node in x, y, or z.

7. Return to frame 1. To create a goal, execute the following MEL line:

```
goal -w 1 -utr 0 -g headtop nParticle4.pt[0:2];
```

8. Play back. The nParticles move rapidly towards the headtop joint near the top of the head. The MEL line applies the Goal command, which gives the nParticles a desire to move towards the object listed after the -g flag. The strength of the desire is established by the -w or -weight flag. 1 is a strong desire, while 0 is no desire. You can further adjust the goal weight at any time with lines similar to these:

```
particle -e -or 0 -at goalPP -fv 0.25 nParticleShape4;
particle -e -or 1 -at goalPP -fv 0.25 nParticleShape4;
particle -e -or 2 -at goalPP -fv 0.25 nParticleShape4;
```

9. With this example, -e places the command in editing mode, -at chooses the affected attribute, and -fv carries the float value assigned to the affected attribute, which is goalPP. The -or flag serves as a way to identify the nParticle, where particles are counted, in order, from 0. You can also edit goalPP weights through the Particles tab of the Competent Editor (Window > General Editors > Component Editor). However, you must select the nParticles individually. To do so, select the nParticle mass as an object in a view panel, RMB-click over an nParticle, choose Particle from the marking menu, and Shift+select one or more nParticles. To convert a surface or joint to a goal through the menus, choose nParticles > Goal.

10. The nParticles do not collide with the Machine surface. You can activate collisions by selecting the Machine surface transform node and choosing nMesh > Create Passive Collider or executing the following MEL line:

```
makeCollideNCloth;
```

11. For the collisions to work, the passive collider rigid body must use the same Nucleus solver as the nParticle node. In this case, nParticle4 is using nucleus2. You can reassign the new rigid body by selecting the nRigid3 node and choosing nSolver > Assign Solver > nucleus2. Note that the collisions, even with few nParticles, significantly slow the playback. Once a surface is converted to a passive collider, all other nDynamic objects that share the same nucleus solver will collide with the surface. Hence, the nParticle2 node, which creates the smoke simulation at each ear, will also collide. If this happens, the smoke nParticles will bounce wildly through the scene. To avoid this, open the nParticleShape2 node in the Attribute Editor and deselect the Collide attribute in the Collisions

section. An example Maya file that includes the nParticles at this stage is included as `Project2.13.ma` in the `/ProjectFiles/Project2/maFiles/` tutorial directory.

Instancing Geometry onto nParticles with MEL

You can instance geometry onto nParticles and thus give the simulation more complexity. To instance mechanical bugs onto the newest nParticles in Project 2, follow these steps:

1. Choose File > Import and select the `bug.ma` scene file in the `/ProjectFiles/Project2/maFiles/` tutorial directory. This imports a pre-animated robotic bug model. The bug sits close to 0, 0, 0 and is fairly small compared to the rest of the scene.

2. Shift+select the bug transform node, now named bug:bug due to importation, and the nParticle4 node. You can also use this MEL code:

```
select -r bug:bug;
select -tgl nParticle4;
```

3. Choose nParticles > Instancer(Replacement). You can also use this code:

```
particleInstancer -addObject -object bug:bug
    nParticleShape4;
```

4. An Instancer node is created and the bug model appears where each of the nParticles rested. Play back the timeline. The bugs fly about the head. However, they're all pointing in the same direction. To fix this, open the nParticleShape4 node in the Attribute Editor and scroll down to the Instancer (Geometry Replacement) section. The General Options and Rotation Options offer a means to offset individual instances by pegging their transforms to various per-particle attributes. Change Aim Direction to Velocity. Play back. The instances gain unique orientations as they move.

FIG 4.14 An animated robotic bug model is instanced onto three nParticles, as seen with Hardware Texturing. Their orientation is set by each nParticles' velocity. An example Maya file is included as Project2.14.ma in the /ProjectFiles/Project2/maFiles/ tutorial directory.

5. Select the imported bug:bug node and choose Display > Hide > Hide Selection. The instances are unaffected. If the current nParticles are too large and intersect the bug models, change their Radius value to 0. (If you hide the nParticles, the instanced geometry will not move.) Note that the animation of each bug is in lock step. To create offset animation, you can add multiple source models to the instancer, each with its own unique animation. The instancer shape node includes Add Selection and Remove Items buttons to add and remove source models. To instance multiple source objects on one nParticle node, set Object Index, in the General Option section of the nParticle shape node, to Particle ID. The objects are randomly distributed across the nParticles, where each nParticle accepts one instanced object.

This concludes Part 5 of Project 2.

Randomizing nParticles with More Complex MEL Scripting

When it comes to MEL scripting, you are not limited to typing text into the Script Editor.

You can convert MEL scripts into shelf icons by highlighting the text in any pane of the Script Editor and MMB-dragging it to a Maya shelf. When you release the mouse button, a dialog box opens to ask you whether you want to save the text as a MEL or a Python script. (Maya 2014 automatically recognizes MEL and Python code and creates a different shelf icon for each.) Once you choose, a new shelf icon appears (**Figure 4.15**). Initially, this is unlabeled, but you can RMB-click over the icon and choose Edit. You can select a new icon or Icon Label in the Shelves tab of the Shelf Editor window.

FIG 4.15 Three MEL scripts are converted to three shelf buttons.

As previously mentioned, you can also save, load, or source MEL scripts through the Script Editor File menu. Saving the script externally allows for greater complexity. As an example, `ParticleTweak.mel` is included in the `/ProjectFiles/Project2/MELscripts/` tutorial directory. To use this script, follow these steps:

1. Create a new Maya scene. Choose nParticles > Create nParticles > Balls to choose the Balls preset. Choose nParticles > Create nParticles > Create Emitter. Play back the timeline. Identically-sized spherical nParticles fall

rapidly downwards due to gravity. Feel free to extend the duration of the timeline or adjust the Rate (Particles/Sec) of the emitter.

2. Open the new nParticleShape1 node in the Attribute Editor. In the Dynamics Properties section, reduce Dynamics Weight to 0.1 to reduce the speed of the fall. In the Per Particle (Array) Attributes section, note that Radius PP is connected to an internal "Life" ramp as provided by the assigned material network. RMB-click over the phrase *<-nParticleShape1.internalRadiusRamp* listed in the Radius PP cell and choose nParticleShape1.internalRadiusRamp > Break Connection from the RMB menu. The cell becomes empty. This leaves it open for a new expression.

3. Open the Script Editor. Choose File > Source Script from the editor menu. Select the `ParticleTweak.mel` file in the `/ProjectFiles/Project2/MELscripts/` tutorial directory. The script is loaded into memory, but does not execute. Select the nParticle mass in a view panel. In the MEL command pane of the Script Editor, type `mypart` and press Cmd/Ctrl+Enter. A custom window opens (**Figure 4.16**).

FIG 4.16 The custom window created by the ParticleTweak.mel script.

4. The script offers two functions: 1) the decimation of nParticles based on a percentage entered by the user; 2) the random scaling of nParticles based on a percentage entered by the user. Play back to a later portion of the timeline. Increase the timeline range if necessary. Enter 50 into the script window cell and click the Decimation Percentage button. Roughly half of the nParticles disappear. The following steps occur at the button push:
 - The Lifespan Mode of the nParticle shape node is set to lifespanPP, which relies on per-particle values to determine each nParticle lifespan.
 - Roughly 50% of the nParticles are randomly assigned a lifespanPP value of 0. This kills the nParticles from the next frame to the end of the timeline. The nParticles that are killed are listed by order number in the history pane of the Script Editor.
 - The timeline is moved forward one frame to show the decimation.
 - The initial state for the nParticles is set to the current frame.
 - The Timeline is moved back to the first frame.

5. At this point, a second window opens, asking the user if s/he would like to end the nParticle emission (**Figure 4.17**). If you choose the No button, new nParticles continue to be born at the emitter. However, if you choose the Yes button, the Rate (Particles/Sec) of the nParticle shape node is remotely set to 0. Thus, when you play back the timeline, only the nParticles that survived the decimation will remain throughout the remaining playbacks. Note that you must select the emitter node before clicking Yes.

FIG 4.17 Emission window beside history with listed nParticle kills.

6. Reselect the nParticle mass in a view panel. Return to the ParticleTweak window and enter 150 into the field. Click the Scaling Percentage button. The nParticles are randomly scaled with a range of 75% to 150%. (If the scale change does not appear, deselect and reselect the nParticle mass in a view panel.) In this case, the radiusPP value of each nParticle is updated (hence, the old Radius PP internal ramp was disconnected before running the script). Play back the timeline. The scale variation disappears as the nParticles once again receive their scale information from the Radius attribute. . As soon as the Scaling Percentage button is clicked, however, a second window opens (**Figure 4.18**).

FIG 4.18 Expression window beside history with listed nParticle scaling.

7. The new window asks the user if s/he would like to install a creation expression that will impose the same random scale range on the nParticles. If you choose the No button, the window closes and nothing happens. If you choose the Yes button, a confirmation window opens with a listed expression. When you click the OK button, the Expression Editor opens with a new creation expression listed under the nParticleShape1 node. From that point forward, all nParticles receive a random radiusPP value equivalent to the last random scaling (**Figure 4.19**).

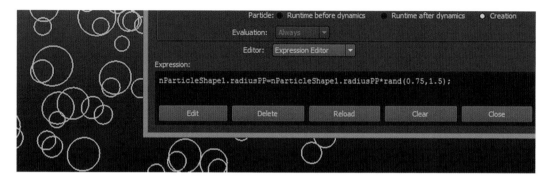

FIG 4.19 A creation expression created by the MEL script, as seen beside decimated and scaled nParticles.

You can apply the decimation and scale randomization process multiple times and in any order. If you wish to emit new nParticles, manually raise the Rate (Particles/Sec) value. When you're finished with the script, simply click the Exit button.

Examining the Particle Tweak MEL Script

The entire ParticleTweak.mel script is included here. Although it would be impossible to cover all the commands, flags, and syntax in detail in this book, comments have been included throughout to explain the logic.

```
// "Particle Tweak" MEL script by Lee Lanier, 2013.
// Creates window that gives user two choices:
//      particle decimation or radius randomization.
// Decimation causes a user-entered percentage of the current
//      particle mass to receive 0 lifespanPP; the dynamic
//      initial state is set to the decimation. User has
//      option to turn off emitter so no more particles are born.
// Randomization applies random radius values to the particles
//      within a range equal to one-half the user-entered percentage.
//      User has the option to encode the random range as a
//      creation expression.
// To run: Select particle or nParticle transform node, load script,
//      and Cmd/Ctrl+Enter mypart to launch.

// The script is broken into prodedures, as indicated by "global proc".
// This allows the procedures to be run at different times and due to
// different criteria. This procedure is named "mypart," which
```

```
// users must enter at the start to run the script.
global proc mypart() {

// Select associated shape node
pickWalk -d down;
string $select2[] = 'ls -sl';
string $psName = $select2[0];
// Set Lifespan menu to LifespanPP
string $lmenu = ($psName + ".lifespanMode");
setAttr $lmenu 3;
// Select transform node again
pickWalk -d up;

// Test for old window, kill if present
if ('window -exists myWin')
deleteUI myWin;
// Create window with user-input integer field. When Decimation
// button is clicked, jump to decim() procedure. When Scaling
// button is clicked, jump to scal() procedure. When Exit button
// is clicked, kill window.
window -t "Particle Tweak" myWin;
        rowColumnLayout;
        intField pValue;
        button -label "Decimation Percentage (1-100)" -command "decim()";
        button -label "Scaling Percentage (1-200)" -command "scal()";
        button -label "Exit" -command "deleteUI myWin";
showWindow myWin;
}

global proc decim() {

// Capture the name of the selected particle node
string $select[] = 'ls -sl';
string $pName = $select[0];

// Retrieve the user-entered value and print it
$aValue = 'intField -q -value pValue';
print ("Percentage: " + $aValue + "\n");

// Determine current number of particles in scene
int $pCount = 'nParticle -count -q $pName';
        // Examine each particle by looping from 0 to particle total.
        for ($i = 0; $i < $pCount; $i++) {
                // Create threshold value for determining
                // if particle is to be affected. Invert user
                // value by subtracting from 100.
                float $threshold=100-$aValue;
                // Draw a random number between 1 and 100.
                int $draw=rand(1, 100);
                // If random number is larger than threshold,
                // change lifespanPP to 0; otherwise, leave as is.
                if ($draw > $threshold) {
                    print ("Killing off " + $i + " with a draw of " + $draw + "\n");
                    nParticle -e -at lifespanPP -order $i -fv 0 $pName;
                }
        }
```

121

```
// Move one frame forward so that 0 lifepsan values take affect
playButtonStepForward;
// Set the dynamic initial state to the current frame
setNClothStartState;
// Return to the first frame.
playButtonStart;

// Ask user to if s/he would like to turn emission to 0.
// The current particles will remain due to the initial state.
// Kill window if No button is clicked.
// Jump to killEmit() if Yes button is clicked.
if ('window -exists myWin3')
    deleteUI myWin2;
window -t "Particle Tweak" myWin3;
        rowColumnLayout;
        text -label "Decimation complete!";
        text -label "Turn off emitter so no more particles are born?";
        text -label "If so, please select emitter node before clicking Yes.";
        button -label "Yes" -command "noEmit()";
        button -label "No" -command "deleteUI myWin3";
showWindow myWin3;

}

global proc noEmit() {
if ('window -exists myWin3')
        deleteUI myWin3;

// Capture the name of the selected emitter node
string $select[] = 'ls -sl';
string $eName = $select[0];

// Set the Rate(Particles/Sec) to 0
string $ecName = ($eName + ".rate");
setAttr $ecName 0;

}

global proc scal() {
// Capture the name of the selected particle node
string $select[] = 'ls -sl';
string $pName = $select[0];

// Retrieve the user-entered value and print it
$bValue = 'intField -q -value pValue';
print ("Percentage: " + $bValue + "\n");

// Declare variables needed for upcoming loop.
// Global variables can be seen by every procedure
// if they are declared one time in each procedure.
float $factor;
float $factorHalf;
global float $randStart;
global float $randEnd;
```

```
// Convert user input value to decimal fraction.
// For example, convert 175 to 1.75. To avoid
// "divide by 0" errors, $bValue is re-declared as a float.
$factor = float($bValue)/100;

// Create a radius range by subtracting a value
// that is one-half the size of the decimal fraction.
$factorHalf = float($factor)/2;
$randStart = $factor-$factorHalf;
$randEnd = $factor;
// Determine current number of particles in scene.
int $pCount2 = 'nParticle -count -q $pName';
print ("Particle Count: " + $pCount2 + "\n");

// Scale each particle by looping from 0 to particle total.
// Particles are scaled by a percentage derived user-entered value.
// The percentage is enlarged to a range. For example, if user value
// is 160, particles are randomy scaled between 80% and 160%.
        for ($i = 0; $i < $pCount2; $i++) {
                // Retrieve current particle radius and threshold.
                float $rad[]= 'nParticle -order $i -at radiusPP -q $pName';
                // Pull out radius value but ignore threshold.
                float $rad2 = $rad[0];
                // Multiply old radius by random value which is
                // a percentage range established earlier.
                // For example, 0.2*1.62 = 0.326.
                float $randFactor = $factor-rand($factorHalf);
                float $newRad = $rad2*$randFactor;
                // If radius equals 0, skip the print out.
                if ($rad2 != 0) {
                    print ("Scaling " + $i + " from " + $rad2 +
                        " to " + $newRad + " by " +
                        $randFactor + " factor\n");
                }
                // Assign new radius value to particle.
                nParticle -e -at radiusPP -order $i -fv $newRad $pName;
        }

// Ask user to if s/he would like to install a runtime expression.
// Kill window if No button is clicked. Jump to createScal() procedure
// if Yes button is clicked.
if ('window -exists myWin2')
        deleteUI myWin2;
window -t "Particle Tweak" myWin2;
                rowColumnLayout;
                text -label "Install creation expression with random radius range
seen here?";
                button -label "Yes" -command "createScal()";
                button -label "No" -command "deleteUI myWin2";
showWindow myWin2;
}

global proc createScal () {
global float $randStart;
global float $randEnd;
```

```
// Capture the name of the selected particle node
string $select[] = 'ls -sl';
string $pName = $select[0];

// Attach a creation expression that applies the previously-used
// random radius range to the selected particle node.

string $express = ("radiusPP=radiusPP*rand(" + $randStart + "," + $randEnd + ");");

print ("Creating expression: " + $express);

dynExpression -c -s $express $pName;
if ('window -exists myWin2')
        deleteUI myWin2;
// Inform user that expression has been added.
confirmDialog -title "Particle Tweak" -message ("Added creation expression: " + $express)

-button "OK" -cancelButton "OK" -dismissString "OK" -icon " information";

// Open Expression Editor and set filter to Expression Name with Creation.
expressionEditor EE "" "";

EEselectFilterCB expression;

EErulesCB creation;

}
```

Simulating Semi-Rigid and Rigid Debris with Python, PyMEL, and nCloth

Whereas you can automate Maya tasks with expressions and MEL scripts, you can exert even greater control with Python and PyMEL scripting. Python is a widely-used object-oriented programming language. PyMEL is a customized variation of Python developed by the animation industry. Python and PyMEL scripts may be loaded, sourced, and saved through the Script Editor. On the other hand, Maya's nCloth system offers a means to dynamically deform a surface as if it was a specific material with flexible or rigid properties.

This chapter includes the following critical information:

- Basic functionality and syntax of Python and PyMEL scripting
- Creation and adjustment of geometry through Python scripting
- nCloth creation, collision, and dynamic simulation

In addition, this chapter will step you through Part 6 to Part 8 of Project 2. Project 2 features a modeled, textured, lit, and animated 3D scene featuring a surreal, mechanical animal running in place. In Chapter 4, we created nParticle bubbles and a swarm of mechanical bugs using MEL scripting. In this chapter, we'll organize scene nodes and randomly generate debris geometry with Python and PyMEL scripts. In addition, we'll transform the debris into semi-rigid and rigid surfaces by converting them to nCloth objects.

Adjusting Nodes with Python and PyMEL Scripting

Python and PyMEL scripting offer a powerful alternative to MEL scripting. In fact, both languages are able to integrate MEL commands with their native commands, functions, and modules.

An Introduction to Python

Python is a dynamic programming language that is used in a wide variety of applications. Python is employed heavily in the animation and visual effects industries and is supported by such programs as Autodesk SoftImage, Luxology Modo, The Foundry Nuke, Side Effects Houdini, and Blender. The design philosophy emphasizes readability with syntax that requires fewer lines of code compared to other high-level programming languages. Python supports object-oriented structures, whereby the program is broken into smaller units (*objects*) that carry attributes (variables) and procedures (*methods*). You can consider each object as an independent machine that has a specific purpose; in contrast, non-object programming generally consists of a long lists of commands or sets of commands broken into subroutines (with MEL, the subroutines are procedures). Object-oriented programming makes the re-use of programming code highly-efficient.

As discussed in Chapter 4, Maya's Script Editor supports Python. In this case, Python is treated as a scripting language, whereby Python is used to control or execute tasks within the program.

Reviewing Basic Python Syntax

Before diving into Python, it pays to review basic syntax and construction. A few critical areas are discussed in this section.

Variable Declaration

Python is savvy with variable types and does not need an indication that a variable is an integer, floating-point, or string. For example, you can declare variables in the following fashion:

```
test1 = 10
test2 = 10.32763
test3 = 'I like scripting'
```

In reality, Python variables are names that point to a piece of data, whereby each piece of data is an object with a value, data type, and identity (address in memory). (As such, the $ symbol is not required as it is with MEL.) When you change the value of a Python variable, it points to a new data object. Hence, there is no danger of mixing variable types. In contrast, mixing variable types in MEL leads to errors (for example, assigning a string value to an integer).

Whitespace and End-of-Line

Python is sensitive to whitespace; that is, incorrectly placed spaces and tabs may prevent the script from working. For example, a `for` loop in Python looks like this:

```
for i in range(0, 10):
    print i
```

This code prints the value of the `i` variable as the loop executes 10 times (`i` increases with each loop). The second line must be indented for it to be a part of the loop. You can create the indentation with the Tab key or by choosing a fixed number of spaces throughout a script, such as four spaces created with the space bar. This structure also applies to conditional statements. For example:

```
i = 5
if i < 10:
    print i
```

Python indicates a loop or conditional test with a `:` colon at the end of the line, whereas MEL uses an `{` open and `}` close curly bracket to surround the statement. (For MEL examples, see Chapter 4.) Note that Python does not require the use of an end-of-line `;` semicolon.

MEL Commands

Although Python is able to utilize Maya commands, you must import the Maya command module and use the `maya.cmds.` prefix with the command. For example:

```
import maya.cmds
maya.cmds.polySphere (r=1)
```

You only need to execute `import maya.cmds` once per session. Once the module is loaded into memory, all the Maya commands are accessible to Python. You can also use shorthand to avoid typing `maya.cmds` in front of every MEL command. For example:

```
import maya.cmds as mc
mc.polySphere (r=1)
```

Note that flags may be required for the MEL command to function through Python. For example, to use the `polySphere` command, the `r` (radius) flag is included. If the flag is omitted, no sphere is created. Python flag syntax varies from MEL and is discussed further in the Flags section below.

Comments

You can create a comment, which is not evaluated when the script runs, by using the # symbol. For example:

```
# The following line does x, y, and z
```

Flags

MEL flags are indicated with dashes. Python flags are placed within parentheses and separated with commas. For example:

```
maya.cmds.polyPlane(w=1, ax=(0, 1, 0), n='myPlane')
```

Note that vector values are surrounded by their own set of parentheses. String values are surrounded by single vertical quotes. Each flag is set to a value with an = equals sign. If necessary, you can wrap the flags on multiple lines:

```
maya.cmds.polyPlane(w=1,
ax=(0, 1, 0), n='myPlane')
```

Line Wrapping and Concatenation

Although you can wrap flags onto multiple lines, you must use and a \ backslash escape symbol to indicate line wrap in other situations. For example, when concatenating a long string, the \ escape symbol is necessary to wrap the line:

```
message = 'New radius for ' + str(i) + ' is ' + \
str(rad2) + '.'
```

Concatenation allows you to combine variable values and pieces of text into a single string variable value. With Python, concatenation requires ' single vertical quotes around the text pieces and + plus signs between the pieces and variables. The variables themselves should be converted to strings with the str() function. With MEL, the concatenation requires parentheses, double quotes around the text pieces, and + plus sign between the pieces and variables. MEL does not require an escape symbol; however, it does require an end-of-line ; semicolon. For example:

```
string $message = ("New radius for " + $i + " is " +
$rad2 + ".");
```

Classes and Methods

In Python, a *class* is a user-defined prototype for an object. Each object created from the class is instanced, whereby it carries class variables that are shared amongst all the instanced objects of the class, plus instance variables that are unique to the particular object. In addition, a class carries *methods*, which are functions defined for the class and therefore shared by the instanced objects. For example, here's a script that includes a user-defined class, two instanced objects, and a class method:

```
class myClass:
  def __init__(self, attribute1):
    self.attribute1 = attribute1
  def classMethod(self):
    print 'Instanced attribute equals \
    %s.' % self.attribute1
object1 = myClass(attribute1='car')
object2 = myClass(attribute1='robot')
object1.classMethod()
object2.classMethod()
```

On the first line, myClass is created as a class with the class command. A class attribute, named attribute1, is added to the class with the def statement and an __init__ function. This statement is known as a *constructor* and allows instanced objects to share the class attribute. A class method, named classMethod is added with a second def statement, which creates the method as a new function; the new function takes the form of a print statement.

Two instanced objects are created by following the syntax *instanced object = class(class attribute = value)*. In this case, the first instance is named object1 and the second is named object2. The instanced variable, attribute1, is equal to the string car for object1 and robot for object2.

To utilize a method, you include the method name after the object name: *object.method()*. The method applies the function defined within the object class. In the above example, the classMethod method is utilized twice. Aside from custom methods, there are a large number of methods provided by the standard Python installation. For example, a set for string-manipulation methods are available via the str (string) class:

> **str.strip(*chars*)** Removes listed characters from string.

> **str.replace(*old, new*)** Replaces *old* characters with *new* characters.

> **str.split(*chars*)** Splits a string into multiple pieces wherever specific characters are encountered.

You can find detailed information on standard Python methods by visiting the Python Library Reference pages at docs.Python.org.

Using PyMEL

PyMEL is an open-source Python module for Maya that simplifies the bridge between MEL, Python, and Maya's internal API (Application Programming Interface) structure. In general, PyMEL code strives for clarity and often requires fewer lines of code to carry out complex automation. PyMEL comes with the standard Maya installation. You can find PyMEL documentation in the Technical Documentation section of the Maya Help files.

You can import the PyMEL module with the following line:

```
import pymel.core as pm
```

Many aspects of PyMEL are similar to MEL and Python. For example, to create a primitive cylinder with a radius of 2, Cmd/Ctrl+Enter execute this line in the Python tab of the Script Editor:

```
pm.polyCylinder(r=2)
```

Other aspects of PyMEL are very different. For example, you can "wrap" a Maya node in a PyNode object. Thus, the attributes of the node become accessible to object methods. Hence, you can set or get attributes without using setAttr or getAttr MEL commands. This offers an intuitive way to read and alter attribute values. For example:

```
pc = pm.polyCylinder()[0]
pc.rotateX.set(45)
temp = pc.rotateX.get()
print temp
```

The first line creates a primitive sphere. However, it's wrapped in an object named `pc`, which is an instance of the PyNode class. The second line sets the Rotate X value to 45 with the `set` method. The syntax follows *object.attribute.method*. In the third line, the variable `temp` is provided the value of Rotate X with the `get` method.

Additional examples of PyMEL are included in the next two sections.

Using Python and PyMEL to Alter Object Names

One task that is often problematic in Maya is the renaming of nodes. Complex scenes may have a large number of nodes, which makes manual renaming tedious. On the other hand, if you import one Maya file into another with default File > Import settings, Maya attaches a scene prefix to each node name. Although Maya provides the Modify > Search And Replace Name tool, it does not work in every situation. Alternatively, you can create your own "search and replace" script with Python. For example, the following script changes node name prefixes, whereby the old prefix is defined by the `oldPref` variable and the new prefix is defined by the `newPref` variable.

```
import maya.cmds
oldPref = 'bug:'
newPref = ''
nodeList = maya.cmds.ls ()
for nodeName in nodeList:
    if oldPref in nodeName:
        newName = nodeName.replace (oldPref, newPref)
    if 'Shape' in newName:
        print 'Skipping ' + nodeName + '...'
    else:
        maya.cmds.rename (nodeName, newName)
        print 'Changing ' + nodeName + ' to ' + newName
```

With this script, the two empty single quotes ' ' cause the prefix to be removed without adding back any additional characters. To apply this script as Part 6 of Project 2, open the `Project2.14.ma` file in the `/ProjectFiles/Project2/maFiles/` directory, type the script into the Python panel of the Script Editor, and press Cmd/Ctrl+Enter. Alternatively, choose File > Source Script and select

the `ChangePrefix.py` script in the `/ProjectFiles/Project2/Pythonscripts/` directory. The `Project2.14.ma` scene file contains a number of nodes with the `bug:` prefix. Note that you can prevent the attachment of a prefix when importing by choosing the Merge Into Selected Namespace And Rename Incoming Objects That Match radio button in the Import Options window. Also note that cutting and pasting from a digital copy of this book may create improper indentations for Python and PyMEL scripts (in such a case, an `# Error: unexpected indent #` warning appears).

With this script, the MEL `ls` command returns a list of every node in the Maya scene file and stores the list in the `nodeList` variable; each node name is stored as a separate element within the variable object. The `for` command loops through the list, one node name at a time; simultaneously, the `for` command stores the node name in the `nodeName` variable on each pass. The first `if` conditional statement tests to see if the `nodeName` value contains the `oldPref` value somewhere within its length. If the `if` statement is true, it proceeds to the next line. Here, a new node name is generated by using the `replace` string method, whereby the old prefix is replaced with the new prefix. The method is called by placing it after an object name with a period, as in *object.method*. (Once again, variables in Python are actually objects.)

If the first statement proves to be false, the rest of the script is skipped and the `for` statement proceeds to the next loop. The second `if` statement tests to see if the `nodeName` value includes the word `Shape`; if it does, the `if` statement skips down to the `else` portion of the statement. This is done to avoid renaming a shape node that has been previously renamed. In the `else` portion of the statement, the node is finally renamed using the MEL `rename` command and the `newName` variable. (When you use the MEL `rename` command to rename a transform node, it automatically renames the associated shape node.)

As an alternative, you can create a renaming script with PyMEL. An example follows and is saved as `ChangePrefixPyMEL.py` in the `/ProjectFiles/Project2/Pythonscripts/` directory.

```
import pymel.core as pm
oldPref = 'bug:'
newPref = ''
nodeList = pm.ls()
def changePrefix(nodeName, oldPref, newPref):
    newName = nodeName.replace(oldPref, newPref)
    nodeName.rename(newName)
for nodeName in nodeList:
    if nodeName.startswith(oldPref):
        if nodeName.startswith('Shape'):
            print 'Skipping ' + str(nodeName)
    else:
        print 'Renaming ' + str(nodeName)
        changePrefix(nodeName,oldPref,newPref)
```

This script creates a new function named `changePrefix`. This function is not attached to custom class, as is demonstrated in the earlier section "Reviewing Basic Python Syntax." As such, it's called with the following

syntax: *function_name(PyNode1, PyNode2, PyNode3...)*. PyMEL does not use traditional variables or standard Python objects; instead, it uses PyNode objects. For example, `nodeList` is a PyNode object. Nevertheless, `nodeList` carries a list of scene node names. Once you create a custom function, you can call it from multiple locations within a script or multiple times within a Maya session if you're working within the Script Editor.

The `changePrefix` function requires three PyNode objects to operate: `nodeName`, `oldPref`, and `newPref`. `oldPref` and `newPref` are created at the script start. `nodeName` is created by the `for` loop later in the script, which pulls out a single node name from the `nodeList` with each loop. The `changePrefix` function takes advantage of PyNode string methods. For example, the `replace` method swaps x for y where x and y are listed in parentheses as (x, y). The `rename` method names the PyNode object with the name listed in parentheses.

The `for` loops operate with the same functionality as the Python version at the start of this section. However, to test for the existence of a Shape suffix, the PyNode `startswith` method is used.

Note that you can access information on a particular method by executing the built-in `help` function with the following syntax: `help(object.method)`. For example, execute `help(nodeName.replace)` to print the help information for the `replace` method, which includes available flags (**Figure 5.1**). In the same way, you can use the `help` function to print information for Python methods. The `help` function is flexible enough to recognize class and object names and print information specific to them (if documentation exists). Using the `help` function with an object name reveals the class the object belongs to. For example, if an object is made equal to an integer value, the object is revealed as an instance of the `int` class. To discover what methods are available to an object, execute `dir(object)` where *object* is the object name (**Figure 5.2**).

FIG 5.1 Help information printed for the nodeName.replace method in the history pane of the Script Editor.

Python supports the use of `def` functions; hence, you can pattern the Python script after the PyMEL script so that they look virtually identical. Where PyMEL diverges from Python, however, is its ability to offer a wide variety of Maya-centric classes and methods. This is explored in the next section.

FIG 5.2 A small portion of the methods available to the nodeList object as printed by the dir(*object*) function.

This concludes Part 6 of Project 2. An example Maya file, with the nodes successfully renamed, is included as `Project2.15.ma` in the `/ProjectFiles/ Project2/maFiles/` directory.

Organizing, Identifying, and Altering Nodes with PyMEL

PyMEL includes a set of unique features that are designed specifically for the Maya environment. These include:

Attribute Class This class provides direct access to Maya node attribute values; it includes `set` and `get` methods.
Node Classes Additional classes are provided for each Maya node type. This creates methods that mimic commands.
Maya-Centric Operators Special operators are included to simplify Maya-specific tasks, such as parenting and connecting channels.
Shape Access Direct manipulation of subcomponents, such as vertex normals, is supported.
Path Manipulation The manipulation of directory paths is simplified.

Several examples of these features are included in this section.

Grouping Nodes
You can organize Project 2 using the PyMEL parent operator, which takes the form of a | pipe (you can find this above the \ backslash on your keyboard). For example, to automatically group all the field nodes under a

new group node, you can execute this code (comments are included above each line):

```
import pymel.core as pm
# Create list of transform nodes with word Field
fieldsList = pm.ls('*Field*', tr=1)
# Create a new, empty group node
gn = pm.group(em=1)
# Rename the group node FieldGroup
fn = gn.rename('FieldGroup')
# Loop through each field node in the list
for fname in fieldsList:
    # Parent each field node to the group node
    fn | fname
```

The resulting hierarchy is seen in **Figure 5.3**.

FIG 5.3 Transform nodes containing the word *Field* are automatically parented to a new group node with a short PyMEL script.

To group other related nodes, replace `Field` with other key words, such as `emitter`. This script is included as `Organize.py` in the `/ProjectFiles/Project2/Pythonscripts/` directory.

Tracking Down Connections

If you would like to identify connections between nodes, you can use PyMEL Maya-centric methods to identify associated shape nodes and node connections. For example, to identity the emitters that an nParticle node is providing particles to, select an nParticle node and execute the following script:

```
import pymel.core as pm
# Choose a node type for the script to seek
target = 'pointEmitter'
# Wrap the selected node as the selected object
selected = pm.ls(sl=1)[0]
# List all the connections of the associated shape node
conList=selected.getShape().connections()
# Create several objects needed for parsing the list.
# Set their initial value to an empty string (this causes
```

```
# them to be instances of a string class).
L = ''
last = ''
last2 = ''
# Loop through the node names in the list
for con in conList:
    # Determine node type with type method
    ct = con.type()
    # If current type = target type, then add node
    # name to list built as L object. Current names
    # are compared to two previous names to
    # prevent duplicate names in list.
    if ct == target:
        if con == last:
            # Do not add to list, but print . to show
            # script is progressing.
            print '.'
        # elif stands for else if. If the first if is false,
        # the script moves on to elif. If that is false,
        # it goes to else.
        elif con == last2:
            # Do not add to list, but print . to show
            # script is progressing.
            print '.'
        else:
            if L == '':
                # If L is empty, add node name without
                # comma.
                L = L + con
            else:
                # Add node name to list with comma
                # and space.
                L = L + ', ' + con
        last2 = last
        last = con
# Print resulting L list
print str(selected) + ' ' + str(target) + "(s): " + str(L)
```

If you choose the nParticle2 node in the Project 2 scene file, the script returns the following line:

```
nParticle2 pointEmitter(s): emitter2, emitter3
```

This script is included as `Connections.py` in the `/ProjectFiles/Project2/Pythonscripts/` directory.

Manipulating with Maya-Centric Methods

You can manipulate the camera with PyNode Maya-centric methods that are based on Maya API camera functions and camera node attributes. For example:

```
# Dolly camera 2 units forward
cam.dolly(-2)
# Track camera 2 units left
cam.track(l=2)
```

```
# Track camera 2 units right
cam.track(r=2)
# Tumbles camera 20 azimuth degrees
# and 10 elevation degrees
cam.tumble(aa=20, ea=10)
# Change camera tx value to 5
cam.translateX.set(5)
```

These lines assume that the camera transform node is wrapped in a PyMEL object. Here's one approach to wrapping a selected camera:

```
cam = pm.ls(sl=1)[0]
```

You can also create a new camera and wrap it in the same line. In fact, you can simultaneously wrap the shape node and transform node. For example:

```
camTrans, camShape = pm.camera()
```

Attributes carried by shape nodes are also candidates for methods. For example, using the camShape object, you can set the focal length:

```
camShape.setFocalLength(45)
```

If the camera shape node has not been wrapped as an object, you can jump to the shape node with the getShape method:

```
camTrans.getShape().setFocalLength(50)
```

As shown in this example, PyMEL is able to combine multiple methods on one line. As such, the method order flows left to right. Hence, getShape is applied before setFocalLength. However, each method relies on the object to its left. Hence, getShape retrieves the shape name from the camTrans object. setFocalLength sets the Focal Length value of the shape node offered by getShape. This ability gives PyMEL a distinct advantage over standard Python installations.

Seeding Random Geometry with Python

You can use scripting to manipulate geometry, either on the object or the sub-component level. As a demonstration, we can create, move, and randomly distort primitive polygons as Part 7 of Project 2. We'll use this geometry to create small bits of debris spitting out of the animal's long, tube-like arm. To do so, move the timeline to frame 1 and execute the following script in the Python tab of the Script Editor. Alternatively, move to frame 1 and source the RandSphere.py script in the /ProjectFiles/Project2/Pythonscripts/ directory.

```
import maya.cmds as mc
import random
for i in range(0, 10):
        randR = random.uniform(.2, .4)
        randX = random.uniform(3, 8)
        randY = random.uniform(3, 8)
        nameP = 'pS' + str(i)
        mc.polySphere(r=randR, sx=randX, sy=randY, n=nameP)
        mc.select('armend')
```

```
jLoc = mc.joint (q=1, p=1)
mc.select(nameP)
mc.move (jLoc[0], jLoc[1], jLoc[2], a=1)
mc.ConvertSelectionToVertices()
vertList = mc.ls(sl=1, fl=1)
for vert in vertList:
        min = -0.02
        max = 0.02
        randNumX = random.uniform(min, max)
        randNumY = random.uniform(min, max)
        randNumZ = random.uniform(min, max)
        mc.select(vert)
        mc.move (randNumX, randNumY, randNumZ, r=1)
```

When executed, the script creates 10 primitive spheres with a random radius, x divisions, and y divisions. Each sphere is automatically moved to the absolute position of the armend joint at the current frame (**Figure 5.4**). The armend joint is the last joint of the joint chain that deforms the animal's long arm. The vertices of each sphere are randomly moved to create distortion.

FIG 5.4 10 randomly-distorted polygon spheres are moved to the absolute position of the armend joint using a Python script.

The script requires the use of the random module, which provides various functions and methods for generating random values. Hence, the second line reads import random. The random.uniform() method randomly generates floating point values within a range defined with the parentheses. The random values are used to determine the radius and number of divisions, plus an offset for each vertex on each sphere.

Aside from maya.cmds and random, Maya provides a number of built-in modules. These include:

math Provides additional math operations, including power, logarithmic, and trigonometric functions. For example, you can use the math.pow(x,y) command to insert x^y into a script.

sys Provides access to some operating system variables. For example, you can use sys.getwindowsversion() to identify the operating system version.

137

os Provides a means to manipulate system directory paths. For example, you can use the following script to list the contents of a directory:

```
import os, sys
path = "c:/"
dlist = os.listdir(path)
print dlist
```

shutil Contains file copying and removal functions. For example, you can use `shutil.copytree` to copy a directory tree.

Returning to the script at the start of this section, the MEL `select` command is used to select the armend joint. To determine the joint's world position (as opposed to its local position), the MEL `joint` command is used with the `q` (`query`) and `p` (`position`) flags. Note that setting a flag equal to `1` is the same as setting it to `True`.

The current sphere is reselected with the `select` command. It's moved to the position of the armend joint with the MEL `move` command. Note that the x, y, z values stored in the `jLoc` object are retrieved through an array syntax, where `jLoc[0]` is the x value, `jLoc[1]` is the y value, and `jLoc[2]` is the z value.

To convert the selection to vertices, the MEL command `ConvertSelection ToVertices` is applied. The list of selected vertices is stored in the `vert1List` variable object. By default, the MEL `ls` command forces the vertex numbers into a range, as is demonstrated here:

```
pSphere1.vtx[0:381]
```

However, the use of `fl` (`flatten`) flag returns a long list of separate vertex names:

```
pSphere1.vtx[0] pSphere1.vtx[1] pSphere1.vtx[2]... .
```

Within the main `for` loop, a second `for` loop cycles through each vertex of the current sphere. Each vertex is reselected and moved in a random x, y, and z direction, creating the distortion.

This completes Part 7 of Project 2. An example Maya scene file is included as `Project2.16.ma` in the `/ProjectFiles/Project2/maFiles/` directory. In the next section, we will convert the randomly distorted polygons into semi-rigid nCloth objects.

Producing Semi-Rigid Surfaces with nCloth

One disadvantage of the nDynamics system is the lack of rigid bodies. Using the Dynamics system, you can convert any surface into an active rigid body and thus influence its motion with fields and allow it to collide with other active or passive bodies. To create an active body, switch to the Dynamics menu set and choose Soft/Rigid Bodies > Create Active Rigid Body. To create a passive body, choose Soft/Rigid Bodies > Create Passive Rigid Body. To apply a field, select the active body surface and choose Fields > *field name*.

If you wish to stay within the nDynamic system, you can convert a surface to an nCloth object and give the object rigid properties. In fact, you can adjust nCloth attributes to recreate a wide range of thin materials, such as flimsy silk cloth to heavy leather, or solid masses of semi-liquid material, such as putty or concrete.

Creating and Altering nCloth Objects

Earlier in this chapter, we created a series of randomly-shaped polySphere surfaces and placed them at the opening of the animal's long arm. As Part 8 of Project 2, we can convert the polySpheres to nCloth objects so that they collide with other surfaces. At the same time, we can impart various degrees of flexibility and rigidity. To do this, follow these steps:

1. Select one of the new polySpheres. These are named pS0 through pS9. Choose nMesh > Create nCloth > ☐. In the Create nCloth Options window, set Solver to Create New Solver and click Create Cloth. A new nucleus node, nucleus3, and an nCloth node, nCloth1, are created.
2. Play back the timeline. The polySphere slowly falls due to the gravity of the new nucleus3 node; however, it passes through the Floor surface. In the previous chapter, we converted the Floor surface into a passive collider. When you create a passive collider through the nMesh > Create Passive Collider menu, you have the option to choose a nucleus solver through the Make Collide Options window. If the solver used by the passive collider is different from the solver used for the nCloth-affected surface, the collision fails to occur. In this case, the Floor surface is using nucleus1 while the nCloth node is using nucleus3. To solve this problem, select the Floor surface and duplicate it. Move the duplicated Floor1 surface upwards slightly to avoid interpenetration. With Floor1 selected, choose nMesh > Create Passive Collider > ☐. In the Make Collide Options window, change the Solver menu to nucleus3 and click the Make Collide button.
3. Play back the timeline. The polySphere falls, collides with Floor1, and deforms due to the nCloth conversion. The deformation is quite intense, causing the surface to collapse in on itself (**Figure 5.5**). (If the polySphere appears to float over the surface, open the new nRigid4 node's Attribute Editor tab and change Thickness to 0.)
4. You can alter the rigidness of the nCloth through the nCloth shape node's Attribute Editor tab. In fact, a number of presets are provided to emulate different materials. For example, to make the polySphere appear like thick leather, click the Presets button at the top of the Attribute Editor tab and choose thickLeather > Replace from the menu (**Figure 5.6**). This alters the attribute values within the Dynamic Properties section. Play back the timeline. The polySphere collides, but deforms for a few frames and maintains more of its original shape when it comes to rest (**Figure 5.7**). (If the polySphere penetrates the Floor1 surface to an inappropriate degree when it comes to rest, increase its virtual thickness by increasing the Thickness value in the Collisions section of the nCloth shape node tab.)

FIG 5.5 A polySphere, converted to nCloth, deforms as it collides with the Floor1 surface.

FIG 5.6 The nCloth shape node's Presets menu.

FIG 5.7 The thickLeather preset stiffens the nCloth but still allows for deformation.

5. You're free to manually adjust the values within the Dynamic Properties section. For example, to increase the rigidity of the polySphere surface so there is only minor deformation at the point of collision, raise the Stretch Resistance, Compression Resistance, and Deform Resistance values to 100 (**Figure 5.8**). You can also blend preset settings with current settings by choosing a Blend option from the Presets menu. For example, choosing Presets > Silk > Replace 50% will average the Silk preset attribute values with the current attribute values.

FIG 5.8 The polySphere is given even greater rigidity by raising the Stretch Resistance, Compression Resistance, and Deform Resistance values.

6. Apply Steps 1 to 6 to the remaining polySpheres. To save time, you can apply Create nCloth while the remaining polySpheres are selected. However, each polySphere receives a matching nCloth node. Feel free to apply different presets to each nCloth node.

7. If a polySphere fails to fully collide with the Floor1 surface, check the Notes section of the nCloth shape node in the Attribute Editor. Each preset carries important information about the nCloth settings. Occasionally, it's necessary to increase the nucleus node's Substeps value. Substeps determines the number of times this solver calculates per frame; the higher the value, the more accurate the solve and the more processor-intensive the calculation. Note that geometry resolution also affects collision calculations; the higher the geometry resolution, the more accurate the collisions.

8. At this stage, all the polySpheres are overlapping at their start position. Due to the interpenetration of the surfaces, the nCloth objects fall in lockstep. To avoid this, you can give each polySphere a unique start position. To do this, return to frame 1 and move each polySphere trans-form node (**Figure 5.9**). You can also scale and rotate the spheres. We'll further adjust the motion in the section "Varying nCloth Motion with Dynamic Properties" later in this chapter.

FIG 5.9 The polySpheres are given unique start positions by moving the transform nodes on frame 1. An example Maya scene file is included as Project2.17.ma in the /ProjectFiles/Project2/maFiles/ directory.

Reviewing and Deleting nCloth Nodes

When you choose nMesh > Create nCloth, an nCloth transform node, nCloth shape node, and outputCloth node are created (**Figure 5.10**). In addition, the nCloth shape node is connected to a Nucleus node. Once you convert a surface to nCloth, the outputCloth node provides the visible, renderable mesh while the original polygon shape node is hidden. The outputCloth shape node carries all the attributes a standard polygon shape node carries, such as those found in the Render Stats section. The nClothShape node carries the nCloth collision and dynamic properties attributes. Note that nCloth does not support NURBS and subdivision surfaces.

FIG 5.10 An nCloth shape node and outputCloth node, as seen in the Hypergraph: Connections window. Note that the original polygon shape node is hidden.

If you need to remove an nCloth object, select the corresponding mesh in a view panel and choose nMesh > Remove nCloth. The nCloth nodes are deleted and the original polygon surface is made visible once again.

Varying nCloth Motion with Dynamic Properties

If multiple nCloth objects share the same Nucleus node, the motion of each object becomes similar. You can add additional variation, however, by adjusting various attributes of each nCloth shape node. Table 5.1 describes

TABLE 5.1

Attribute	Lower Value	Higher Value
Mass	nCloth falls more slowly. If Mass is extremely low, the object flits like a leaf or plastic bag.	nCloth falls faster.
Lift	If Lift is set to 0, nCloth falls at the same rate, but the nCloth object does not twist or flip.	nCloth is more susceptible to virtual air friction, deforming to a greater degree and falling more slowly.
Drag	nCloth falls more quickly.	nCloth falls more slowly, as if virtual air density is greater or as if object is descending through water.
Tangential Drag	nCloth falls more quickly and deforms to a lesser degree as it falls.	nCloth falls more slowly and deforms to a higher degree as it falls. Whereas Drag tends to deform the object on the leading surface, Tangential Drag tends to deform the object on the trailing surface.
Damp	nCloth falls at same speed but deforms more as it falls.	nCloth falls at same speed but deforms less as it falls.
Stretch Damp	nCloth falls at same speed but deforms more along the trailing portion of the surface (assuming that various Resistance attributes are set to low values).	nCloth falls at same speed but deforms less along the trailing portion of the surface.

attributes found within the Dynamic Properties section and the results of their adjustments when the employed Nucleus node is using default gravity settings.

Assigning Fields to nCloth

To add additional variation to nCloth object motion in Project 2, you can assign various fields. To create the maximum amount of variation with the minimum number of fields, use a single Turbulence field. You can follow these steps:

1. Select all of the nCloth nodes and choose Fields > Turbulence. A new field, turbulenceField3, is connected. (To keep the Hypergraph and Outliner organized, feel free to arrange the polySphere, nCloth, Nucleus, nRigid, nParticle, camera, and light nodes into groups.)
2. Open turbulenceField3's Attribute Editor tab. Change the Magnitude to 100 and Attenuation to 0. Attenuation controls the field's falloff; an Attenuation of 0 causes the field to have equal force over all distances. Play back. The nCloth objects gain additional randomness in their motion. (The outputCloth mesh nodes are visible in the viewers while the original polySphere shape nodes are hidden.)

3. At this stage, the nCloth objects fail to collide with the animal Machine surface. Once again, this is a Nucleus solver mismatch. The nCloth objects are affected by nucleus3 while the Machine surface is affected by nucleus2. Select all of the nCloth nodes and choose nSolver > Assign Solver > nSolver2. Play back. The nCloth objects bounce off the Machine surface. Their initial motion is more rapid as they are pushed along a single direction as they collide with the inner surface of the animal arm. This causes nCloth objects with low rigidity to stretch out (**Figure 5.11**).

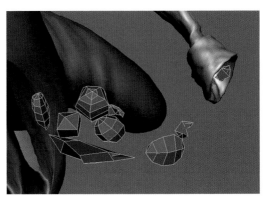

FIG 5.11 Switching the nCloth objects to the nucleus2 solver causes them to have greater speed through collisions with the animal Machine surface. Objects with low rigidity stretch out. An example Maya scene file is included as Project2.18.ma in the /ProjectFiles/Project2/maFiles/ directory.

4. The inverted gravity of the nucleus2 node causes the nCloth objects to float upwards. To counteract this motion without changing the nucleus solver, add an additional Gravity field. To do so, select the nCloth nodes and choose Fields > Gravity. Increase the new Gravity node's Magnitude to 100. Play back. The nCloth objects fall. You can offset the general direction of the objects, however, by updating the new Gravity node's Direction values. For example, to push the objects back slightly in the negative Z direction, enter 0, −1.0, −0.5.
5. The solver change prevents the nCloth objects from colliding with the Floor1 surface. To rectify this, select the Floor1 surface and choose nSolver > Assign Solver > nucleus2. Continue to adjust the attribute settings for the nCloth nodes to create a suitable degree of flexibility or rigidity.

Texturing nCloth

nCloth objects get inherent texture information from the original polygon surfaces from which they are created. Thus, you must assign materials to polygon surfaces. To assign a material to the Project 2 nCloth objects that emulates hot, molten-like debris, follow these steps:

1. Select all the polySphere nodes. Switch to the Polygons menu set. Choose Normals > Soften Edge. This softens the shading on the spheres.

2. In the Hypershade window, create a new Blinn material. Name the material **DebrisMaterial.** Select all the polySphere nodes and assign them to DebrisMaterial.

3. Open the Attribute Editor tab for DebrisMaterial. Set Incandescence to dark orange. In the Special Effects section, set Glow Intensity to 0.1. Click the checkered Map button beside Color and choose the Crater icon from the Create Render Node window. In the Crater's Attribute Editor tab, change Channel 1 to orange, Channel 2 to dark red, Channel 3 to black, Balance to 0.2, and Frequency to 10.

4. Play back the timeline. Stop at a frame where the Cloth objects are relatively close together. Test render (**Figure 5.12**).

FIG 5.12 Close-up of textured and motion blurred nCloth objects.

This concludes Part 8 of Project 2.

Final Rendering of Project 2

We've finished adding and adjusting elements for Project 2. We're ready to render all the simulations at the same time. To prepare for a final render, return the various emitters to their original Rate (Particles/Sec). Using the `Project2.18.ma` file, you can use the numbers included in Table 5.2.

TABLE 5.2

Emitter function	Sample File Emitter Name(s)	Rate (Particles/Sec)
Water emission	emitter1	4000
Bubble emission	emitter4	5000
Sparks emission	MachineEmitter*n* (multiple emitters grouped under the MachineEmitterGrp node)	8
Smoke emission	emitter2 and emitter 3	200

Once the emitters are returned to their previous state, you have the option to render still frames through the Render View or batch render a movie or image sequence. Your render should appear similar to **Figure 5.13**. Feel free to adjust the render quality or resolution through the Render Settings window.

FIG 5.13 The final Project 2 render, as seen on frame 12 and frame 100. An example Maya scene file is included as Project2.19.ma in the /ProjectFiles/Project2/maFiles/ directory.

Although not specifically covered in this book, here are optional steps you can take to improve this project:

1. Animate a simple camera move to show off the 3D quality of the environment and nParticle motion. Batch render an image sequence or movie.
2. Place the camera close to various simulations, such as the instanced mechanical bugs, flowing water, or nCloth debris and render separate stills.
3. Texture the Floor surface to make the scene more complex. Vary the floor geometry so that is has a non-square edge. Build surrounding walls so that the dark red Background Color is not seen.

This concludes Project 2.

Producing Dust Puffs, Fog, Trailing Smoke, and Fireballs with Rigid and Fluid Dynamics

Maya's Dynamics system is unique in that it supports rigid body and fluid simulation. Rigid bodies allow you to dynamically move any geometry through a scene. Rigid bodies react to fields and automatically collide with other active rigid bodies or static passive rigid bodies. The fluid simulation, on the other hand, is provided by Maya's Fluid Effects tools, which reproduce complex fluid systems that are far beyond the reach of traditional modeling, texturing, or animation techniques. In particular, Fluid Effects 2D and 3D containers can simulate a wide range of gases, liquids, and particulate systems. The containers offer an ideal means to recreate smoke, fog, clouds, fire, and explosions.

This chapter includes the following critical information:

- Application of Dynamics active and passive rigid bodies
- Creation and adjustment of 2D and 3D Fluid Effects containers
- Shading, texturing, lighting, and animation of fluid simulations

In addition, this chapter takes you through Parts 1 to 5 of Project 3. Project 3 features a textured and lit environment that showcases an 1800s western mine and a bundle of dynamite (**Figure 6.1**). In this chapter, we'll drop the dynamite into the scene, add a puff of dust as the dynamite hits a rock, add a trail of smoke rising up from the fuse, add receding fog, and create an explosion.

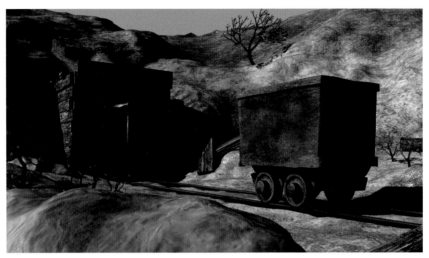

FIG 6.1 The Project 3 Maya scene. In this chapter, we'll add a falling dynamite bundle, dust, smoke, fog, and an explosion.

Dropping an Object as a Rigid Body

The Dynamics system provides a means to convert any surface into an active or passive rigid body and thereby allow dynamic fields and collisions to automatically affect the surface movement.

Converting Surfaces to Active and Passive Bodies

Project 3 features a bundle of dynamite in the foreground, slightly out of frame. To create the illusion that the dynamite has been dropped on the foreground rock, you can animate the dynamite group node transforms. Alternatively, you can convert the dynamite bundle's components into active bodies, apply a Gravity field, and let the dynamic simulation create the motion. To do this as Part 1 of this project, follow these steps:

1. Open the `Project3.1.ma` scene file. This is located in the `/ProjectFiles/Project3/maFiles/` tutorial directory; to avoid missing texture bitmaps, choose File > Set Project and select the `/ProjectFiles/Project3/` folder

before opening the file. The scene includes a mine cart, railroad tracks, mine opening, foreground rock, ground surface, background hill, and a bundle of dynamite in the foreground (slightly out of frame).

2. Open the Hypergraph or Outliner and select all of the surfaces that compose the dynamite bundle. This includes a fuse, seven dynamite sticks, and two bands of tape. Switch to the Dynamics menu set and choose Soft/Rigid Bodies > Create Active Rigid Body. Each selected surface is converted to an active body. This is indicated by a small × symbol at the volumetric center of each surface. In addition, a rigidBodyn shape appears in the SHAPES section of the Channel Box when an active rigid surface is selected. A rigidSolver and universal time1 node are also listed in the Channel Box's INPUTS section.

3. Play back the timeline. Nothing happens. For dynamic motion to occur, you must add at least one field to the scene. To do so, select all of the bundle surfaces and choose Fields > Gravity. Play back. The bundle drops. However, errors occur almost immediately as the various surfaces begin to intersect each other. (To stop a slow playback, press the Escape key.) An error message appears on the feedback section of the Command Line:

```
//Warning: Rigid Body interpenetration occurred
between 'rigidBodyx' and 'rigidBodyy'.
```

If the simulation involved a single rigid body, the error would not appear. Rigid bodies are only able to collide (and interpenetrate) with other rigid bodies. To solve this problem, you can combine all the bundled surfaces into a single polygon surface. To do so, select all of the bundle surfaces, switch to the Polygons menu set, and choose Mesh > Combine. A new, single-node surface named polySurface1 is created. However, history remains between the new surface and the original surfaces. With the new surface selected, choose Edit > Delete By Type > History.

4. At this point, the original bundle surfaces are not needed. To remove them from the scene, choose the Dynamite group node and press the Delete key. Rename the new surface **CombinedDynamite.** Note that Combined-Dynamite is not a rigid body. Also note that the textures for the new surface are unaffected and appear in the correct locations (**Figure 6.2**). You

FIG 6.2 The CombinedDynamite surface, as seen with Hardware Texturing activated in a view panel. An example Maya scene file is included as Project3.2.ma in the /ProjectFiles/Project3/maFiles/ directory.

can examine this by choosing Shading > Smooth Shade All and Shading > Hardware Texturing through a view panel menu.

5. With the CombinedDynamite surface selected, return to the Dynamics menu and choose Soft/Rigid Bodies > Create Active Rigid Body. Shift+select CombinedDynamite and gravityField1 and choose Fields > Affect Selected Object(s). This connects the pre-existing Gravity field with the new surface. Play back the timeline. The bundle falls. However, it passes through the foreground rock. To prevent this, select the Rock surface and choose Soft/Rigid Bodies > Create Passive Rigid Body. Return to frame 1 and play back. The bundle bounces off the rock. As a passive rigid body, the rock surface allows the collision of active rigid bodies but does not move in the scene.

When playing back rigid body simulations, an error similar to the following may appear on the feedback section of the Command Line:

```
// Warning: file: C:/program_directory/scripts/others/timeSlider.mel
line 44: Cycle on 'node_name.worldMatrix[0]' may not evaluate as expected.
(Use 'cycleCheck -e off' to disable this warning.) //
```

The warning indicates a potential evaluation error. The errors generally fall into the following two categories:

* There's a cycle in Maya's DAG (Directed Acyclic Graph) hierarchy. A DAG hierarchy requires that information flow in one direction. If an output of a node eventually flows into its own input, it can cause an evaluation problem (essentially, an infinite loop).
* A time-dependent node does not have sufficient information to properly evaluate a transform matrix.

In the case of Project 3, returning to the first frame of the timeline causes this error to appear. Essentially, there's no transform matrix information for frame 0. This problem is non-destructive and does not adversely affect the playback from frame 1. You can disable future warnings by Cmd/Ctrl entering `cycleCheck -e off` in the MEL panel of the Script Editor.

Note that you must set Play Back Speed to Play Every Frame to see the playback accurately. You can access this attribute by choosing Window > Settings/Preferences > Preferences and going to the Time Slider section.

Reviewing Rigid Body Nodes

When you create an active or passive rigid body, a rigidSolver, rigidBody shape node, and a set of rigidBody transform nodes are added to the scene (**Figure 6.3**). The rigidSolver node is similar to an nDynamics Nucleus node and undertakes the dynamic solver calculations. The rigidBody shape node carries the body's dynamic properties. The rigidBody transform nodes, named rigidBody_*transform*, convert the rigidSolver transforms into transforms usable by the surface transform node. Note that there is only one rigidSolver per scene, while each active or passive rigid surface receives a unique rigidBody.

FIG 6.3 A rigidSolver node, rigidBody node, and a set of rigidBody transform nodes are created for an active rigid body, as seen in the Hypergraph: Connections window.

Fine-Tuning Rigid Collisions

Each active and passive rigid body receives a long list of attributes that affect how the surface moves and interacts with other bodies. You can find this list by selecting the surface and opening the corresponding rigidBody*n* tab in the Attribute Editor. You can alter these attributes to emulate basic physical properties such as weight and roughness. For example, with Project 3, the default rigid body simulation causes the dynamite bundle to bounce and spin unrealistically. To improve the simulation, follow these steps:

1. Select the CombinedDynamite surface. In the Attribute Editor, switch to the rigidBody1 tab. In the Rigid Body Attributes section, change Static Friction to 0.2, Dynamic Friction to 0.4, and Bounciness to 0.1.
2. Select the Rock surface. Switch to the rigidBody2 tab. Change Static Friction to 0.2, Dynamic Friction to 0.4, and Bounciness to 0. Play back. The bundle falls, bounces slightly, then slowly rolls down the rock (**Figure 6.4**).

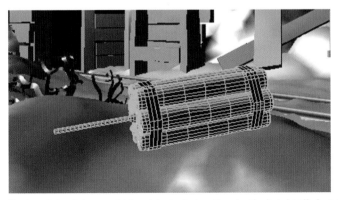

FIG 6.4 The dynamite bundle bounces slightly and slowly rolls down the rock with adjusted rigidBody attributes. An example Maya scene file is included as Project3.3.ma in the /ProjectFiles/Project3/maFiles/ directory.

Static Friction determines how strongly a body resists moving from a resting position; the higher the value, the less movement. Dynamic Friction determines how strongly a moving body resists movement against another body's surface; the lower the value, the more movement. Bounciness sets the resilience of the body; in the case of Maya dynamics, the higher the bounciness, the more rapidly the body moves away from the body it collides with. Note that the attribute values of all bodies involved in a collision determine how the bodies move after the collision. Even if one body is passive, its friction and bounciness settings affect the motion of the active body or bodies.

Nevertheless, active rigid bodies are given several additional attributes. These include the following:

Damping: Sets an opposing force against the rigid body's movement and is similar to drag. A high Damping value causes objects to fall more slowly.

Impulse: Creates a local force on a body which affects its momentum in a particular direction. The direction is defined by an X, Y, Z vector. You can set any axis higher than 1.0 for a greater magnitude along that axis. Impulse offers a means to make a body self-propelled and not solely dependent on fields for motion.

Impulse Position: Determines the location of the impulse force in local object space.

Spin Impulse: Applies a rotational force to the body's center in the direction determined by an X, Y, Z vector.

This concludes Part 1 of Project 3.

Placing Dust Puffs with 2D Fluid Effects

Maya's Fluid Effects system replicates a wide range of fluids in motion. This includes atmospheric phenomena, such as smoke and cloud vapor, and fluid bodies, such as water or molten rock. Fluid Effects are available via the Dynamics menu set and are created through three main methods:

- A 2D or 3D fluid dynamic container holding fluid voxels
- The Ocean system, which creates a large-scale water surface
- The Pond system, which creates a smaller-scale water surface

The Ocean and Pond systems are discussed in Chapter 7. In this chapter, we'll use 2D and 3D fluid dynamic containers. The containers employ Navier-Stokes fluid dynamics equations with each frame to determine the property values of fluid voxels. (*Voxels* are three-dimensional pixels that serve as the basic building blocks of the fluid simulation.)

> **VFX Notes: Using Caches and Fluid nCaches**
>
> Whenever you're working with dynamic simulations, you have the option to employ caches. Caching saves the motion of objects to disk. You can create, replace, and delete caches. You can create standard Dynamics caches for rigid bodies. You can create specialized Fluid nCaches for Fluid Effects systems. For more information, see the "Using Dynamics and nDynamics Caches" in Chapter 10.

Creating a 2D Fluid Container and Emitter

To create a fluid simulation with a container, you can follow these basic steps:

- Create a fluid container
- Add Density and Velocity properties to the container
- Optionally, add Temperature and Fuel properties to the container
- Add color to the resulting fluid
- Play the simulation using the playback controls

There are several ways you can add Density, Velocity, Temperature, and Fuel properties to a container:

- Add a fluid emitter
- Interactively paint fluid properties
- Emit fluid properties from a polygon or NURBS surface
- Emit fluid properties from nParticles or particles
- Apply a predefined gradient of property values

To see a fluid as a shaded mass within the view panels, you must choose Shading > Smooth Shade All through the view panels' menus. Otherwise, the fluid is represented by small dots in the wireframe view.

We'll create a fluid container and add a fluid emitter as Part 2 of Project 3. We'll use this to create a puff of dust as the bundle of dynamite falls on top of the foreground rock. You can follow these steps:

1. Through the Dynamics menu set, choose Fluid Effects > Create 2D Container. A square container, named fluid1, is placed at 0, 0, 0. Using the Channel Box, scale the container down to 0.5, 0.5, 1.0. Rotate the container to 0, 80, 0. Interactively move the container so that it rests on top of the rock where the dynamite bundle makes contact (roughly 7.4, 3.5, 13.3 in x, y, z). With the container selected, choose Fluid Effects > Add/Edit Contents > Emitter. A fluid emitter is parented to the fluid1 node.
2. Play back the timeline. A fluid simulation occurs within the container (**Figure 6.5**). The fluid is shaded white. The fluid represents a material, such as water vapor or smoke particles. The fluid is born at the container's center where the emitter is located. To move the emitter to the bottom of the container, select the fluidEmitter1 node in the Hypergraph or Outliner and use the Move tool in a view panel.

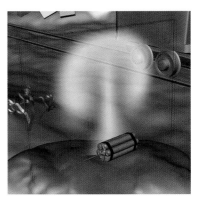

FIG 6.5 A 2D fluid container is placed above the foreground rock. The fluid emitter is moved to the bottom of the container. The initial fluid simulation produces a thin flow that spirals as it rises.

Reviewing Fluid Nodes and Fluid Textures

Before adjusting the fluid simulation, an understanding of fluid nodes is helpful. When a fluid container is created and an emitter is added, a network is created that includes a fluid transform node, a fluid shape node, and a fluid emitter node. The fluid emitter is automatically parented to the fluid transform node. The fluid shape node creates the container seen in the view panels and defines the fluid contents in terms of properties. The fluid shape also serves as the shader for the fluid and is found listed in the Materials tab of the Hypershade window.

In contrast, Fluid Texture 2D and Fluid Texture 3D textures generate fluid-based textures that you can map to the attributes of materials. The texture attributes are identical to a fluid shape node. However, a place2dTexture node is connected to the Fluid Texture 2D texture node, which results in the fluid pattern being mapped directly to the assigned surface. On the other hand, the voxels of the Fluid Texture 3D container supply their color values based on the assigned surface position relative to the texture container.

Working with Fluid Properties

A fluid emitter creates fluid property values that modify the container voxels as the timeline plays. The properties are divided into Density, Velocity, Temperature, and Fuel:

- The Density property adds the fluid to the system (that is, it adds the virtual fluid substance). As the dynamic simulation unfolds, each voxel receives an updated Density value that represents the amount of fluid in that voxel.
- The Velocity property adds motion to the system by moving Density, Temperature, and Fuel values among the voxels. Each voxel is given a vector that includes magnitude and direction. Each voxel's vector changes

over time as the dynamic simulation is calculated. Velocity values are affected by the fluid shape node's internal forces (Gravity, Viscosity, Friction, and Damp, found in the Dynamic Simulation section) and/or added dynamic fields.

- If the Temperature property is added, the voxels store a temperature value (which may cause the fluid to expand, contract, speed up, slow down, or ignite).
- If the Fuel property is added, the fluid's "state of a reaction" is stored. The fluid in any given voxel is unreacted, completely reacted, or is in a transitory state. When Temperature is added, the fluid can ignite, causing Density and Fuel to diminish over time. This allows fluid dynamics to create physically-based explosions.

A fluid emitter must be within the bounds of the fluid container to function. You can add multiple emitters to a single container. To do so, select the container, and choose Fluid Effects > Add/Edit Contents > Emitter.

The specific way in which properties are added to the container over time is dependent on the Contents Method section of the fluid shape node (**Figure 6.6**).

FIG 6.6 The Contents Methods section of a fluid shape node.

The Density, Velocity, Temperature, and Fuel attribute menus offer four options:

Off(Zero) The property is not added.
Static Grid The property values for voxels are provided, but a dynamic simulation for the property is not undertaken.
Dynamic Grid The property values for voxels are provided and updated as the dynamic simulation unfolds.
Gradient The voxel values are tapered in one direction, but do not update over time. This is suitable for making static fluid bodies, such as fog that gets less dense in the Y direction (this is demonstrated in the "Adding Fog with a 3D Fluid Container" section later in this chapter).

By default, Density and Velocity are set to Dynamic Grid while Temperature and Fuel are set to Off(Zero). Each property has additional attributes in the

Contents Details section. You can alter these attributes to create a wide range of simulations. For example, to create a short-lived, puff-like simulation that emulates rising dust for Part 2 of Project 3, follow these steps:

1. Open the fluidShape1 node in the Attribute Editor. You can select the fluid container in a view panel. Expand the Contents Details section and the Density subsection (**Figure 6.7**). Change Buoyancy to 8, Dissipation to 0.8, and Diffusion to 1.0. Buoyancy simulates the difference in mass density between regions with fluid and regions without. Higher Buoyancy values cause the fluid mass to rise more rapidly. Dissipation determines how rapidly the fluid mass breaks up and spreads out. Diffusion averages the Density values so that the fluid mass appears softer and more amorphous. High Dissipation and Diffusion values make the leading edges of the fluid mass smoother and less convoluted. Play back the timeline from frame 1. The fluid creates a less cohesive, more cloud-like form.

FIG 6.7 The adjusted Density, Velocity, and Turbulence subsections.

2. Expand the Velocity subsection. Change Velocity Scale to 5, 5, 5. Velocity Scale serves as a multiplier for voxel Velocity magnitudes. Play back. The fluid rises more rapidly. Expand the Turbulence subsection. Raise Strength to 0.2 and change Frequency to 1.0. This multiplies Velocity values against a fractal noise pattern. Play back. This creates a more chaotic fluid motion.

3. At this stage, fluid Density is added at every frame and the flow of fluid from the emitter does not stop. To control the flow, you can animate Density Scale in the Density subsection. Go to frame 22 (or two frames before the point where the dynamite makes contact with the rock). Set Density Scale to 0 and set a keyframe by RMB-clicking over the value cell and choosing Set Key from the menu. Go to frame 25 (or one frame after the dynamite has touched the rock). Change Density Scale to 0.75 and add a new keyframe. Go to frame 32 (or eight frames after the dynamite has made contact). Change Density Scale to 0 and set a new keyframe. Play back the timeline from frame 1. The fluid "puff" is now short-lived, disappearing fairly quickly. Adjust the position of the fluid container so that the fluid appears directly behind the dynamite bundle in the Persp view.

Adjusting Fluid Shading

The shading method used by the fluid shape node is set by the Color Method menu (in the Contents Method section). By default, the menu is set to Use Shading Color, which forces the node to use colors set by the Shading section. You can set the menu to Static Grid, which assigns unchanging color values to each voxel. You can interactively assign the color values with the Paint Fluids Tool (Fluid Effects > Add/Edit Contents > Paint Fluids Tool). You can set the menu to Dynamic Grid, which derives colors from the simulation itself.

To adjust the shading quality of the Project 3 dust puff, follow these steps:

1. In the Contents Method section, leave Color Method set to Use Shading Color. Expand the Shading section. In the Color subsection, change the color of the default graph ramp point to light tan. You can do this by changing the Selected Color swatch. Play back the timeline from frame 1 and stop on a frame where the fluid remains visible. Test render using the Persp camera. To save time, use the Render Region function of the Render View window.

2. In the Shading section, adjust the Transparency value and create additional test renders over multiple frames (**Figure 6.8**). Note that you can step forward in time; however, if you wish to go backwards, you must play back from frame 1. Nevertheless, to give yourself more control, repeatedly use the Step Forward One Frame button. Note that the dust may be difficult to see with a still render. To accurately judge the fluid quality, it's generally better to batch render a movie. In addition, the background behind the fluid will influence appropriate shading values. For example, a busy background may require a lower Transparency so that the fluid can be seen. Feel free to adjust the render quality through the Render Settings window.

FIG 6.8 Left: The fluid dust puff, seen on frame 27. Right: Same render with the background geometry hidden and the camera's Background Color set to black. An example Maya scene file is included as Project3.4.ma in the /ProjectFiles/Project3/maFiles/ directory.

This completes Part 2 of Project 3.

Adding Fog with 3D Fluid Effects

2D fluid containers differ from 3D fluid containers in that they have a single voxel forming the container depth. When you use 3D containers, you can create more complex fluid shapes. You are also free to move one or more emitters through the 3D container to create a trailing fluid effect.

Setting Up a 3D Container

You can use a 3D container in combination with a gradient Density to create a receding fog in your scene. To create such fog as Part 3 of Project 3, follow these steps:

1. Choose Fluid Effects > Create 3D Container. A new container is placed in the scene. Interactively scale and move the container so that it surrounds the entire model. Place the bottom of the container so that it is slightly below the ground surface (approximately −21, 35, 0 in x, y, z). Note that the lower face of the container is marked with a grid—this indicates the direction of the container's local Y axis.
2. Open the new fluid shape node's Attribute Editor tab. In the Content Methods section, change the Density menu to Gradient. The container fills with fluid. Change the Density Gradient menu to X Gradient. This causes the fluid Density values to run from 1.0 to 0 along the local X axis. This creates the illusion that the fog is thicker further away from the camera. Set the Velocity menu to Off(Zero). The resulting fluid will remain static.
3. Expand the Contents Details section and Density subsection. Note that most of the attributes are grayed-out and inaccessible. Change Density Scale to 0.1. The fluid becomes less dense and more transparent.
4. Expand the Shading subsection. Change the Selected Color swatch for the default graph ramp point to light blue. Test render. A bluish fog appears (**Figure 6.9**). If rendering artifacts are present, such as color banding, checkered squares, or a row of small dots, you can raise the Quality value in the Shading Quality section. A shading value of 4 produces smoother results for Project 3; however, rendering time is significantly increased as the Quality value is raised.

FIG 6.9 A 3D fluid container creates a fog that changes in density along the local x axis. The fluid automatically picks up cast shadows from the scene's light as is evident along the front of the mine entrance.

By default, fluids are lit by lights in the scene. Fluid also supports depth map and raytraced shadows. Hence, in denser areas of the fluid, cast shadows of objects are visible. For example, the irregular wood slats on the side of the mine entrance cast diagonal shadows though the fluid mass.

Working with Fluid Textures

The fluid shape node includes a Textures section. This section allows you to map the fluid's color, incandescence, or opacity with a built-in fractal noise pattern. The noise carries attributes similar to the Noise texture. The noise is mapped to the fluid as a static or dynamic pattern through the Coordinate Method menu. If the menu is set to Fixed, the texture is fixed and does not change during the playback. If the menu is set to Grid, the texture dynamically moves as the voxel values change over time.

As an alternative, you can map various attributes in the Shading section with 3D textures. For example, you can map a Stucco texture to the Selected Color of the Color graph ramp default point and thereby produce fog that has a soft mixture of two colors. As another example, you can map a Volume Noise texture to Transparency and create an irregular density throughout the container. To apply this technique to the Project 3 fog, follow these steps:

1. Open the fluidShape2 node's Attribute Editor tab. In the Shading section, click the checkered Map button beside Transparency. Select the Volume Noise icon in the Create Render Node window.
2. In the volumeNoise1 tab, set Threshold to 0.2 and Amplitude to 0.5. This reduces the contrast within the noise pattern. Set Scale to 0.5, 0.5, 0.5 to reduce the size of the noise grains. Set Noise Type to Perlin Noise, which produces a softer noise pattern. Test render. The fog gains additional variation in its density (**Figure 6.10**). To see the variation more clearly, temporarily hide the Hill surface, return the camera's Background Color to black, and render again. Continue to adjust the Volume Noise attributes until the density variation is acceptable.

FIG 6.10 Left: A Volume Noise texture varies the transparency, and therefore the density, of the fluid fog. Right: Same render with the hill geometry hidden and the camera's Background Color set to black. An example Maya scene file is included as Project3.5.ma in the /ProjectFiles/Project3/maFiles/ directory.

159

This concludes Part 3 of Project 3. Additional uses of the Textures section are discussed in the "Exploding a Fireball with Static 3D Fluid" section later in this chapter.

Trailing Smoke with 3D Fluid Effects

A fluid dynamic emitter need not remain static. You can animate the emitter moving through the container. As the emitter produces fluid, a fluid trail forms. This is ideal for creating a thin wisp of smoke emanating from a flame.

Parenting and Animating a Fluid Emitter

To add a smoke trail to the dynamite fuse as part of Part 4 of Project 3, follow these steps:

1. Choose Fluid Effects > Create 3D Container. Interactively move and scale the new container so that it sits on top of the foreground rock and encompasses the area in which the dynamite bundle moves. Make the Scale roughly 0.6, 0.6, 0.6 and the position roughly 8, 5, 14.
2. With the container selected, choose Fluid Effects > Add/Edit Contents > Emitter. A new emitter, named fluidEmitter2, is placed in the volumetric center of the container. Return to frame 1. Move the emitter to the tip of the fuse. (Optionally, you can use the Snap To Points magnet to snap the emitter to the bundle surface.) With the emitter selected, Shift+select the dynamite bundle and choose Edit > Parent. Play back. The emitter drops with the dynamite, producing a trail of new fluid. Note that overlapping 3D containers do not interfere with each other. Emitters are added to specific containers and will not interact with containers they are not added to.
3. Return to frame 1. Select the fluidEmitter2. In the channel box, keyframe the Translate X, Y, and Z attributes. (Click-drag over the attribute names to highlight, then RMB-click over the highlighted names and choose Key Selected.) Play back and stop at frame 90. Use the Step Forward One Frame button repeatedly so you can stop the playback more accurately. Interactively move the emitter to the base of the fuse and keyframe the Translate X, Y, and Z. Play back. The emitter falls and simultaneously moves down the fuse (**Figure 6.11**). Note that you can temporarily hide other emitters and geometry to see the new fluid simulation more clearly.
4. At this stage, the fluid is thick and amorphous. To create a thinner trail, you can create smaller voxels. In the fluidShape3 tab, change Base Resolution to 48. The container is filled with 48x48x48 voxels. Smaller voxels create smaller changes within the fluid simulation. However, the higher the Base Resolution, the slower the dynamic calculation. Return to frame 1. Note that the grid at the base of the container updates to indicate the higher resolution. To make the voxels even smaller without raising the Base Resolution, scale down the entire container. Through the channel box, set

FIG 6.11 A new 3D container is placed above the foreground rock. Its emitter is parented to the dynamite bundle and animated so that it travels down the fuse. The Ground surface and other emitters are temporarily hidden.

the Scale to 0.4, 0.4, 0.4 and change the Translate to 8, 4, 14. Keep in mind that the fluid cannot extend past the container and may collect along the sides and top of the container if the position is not carefully chosen.

Using a Volume Fluid Emitter and Graph Ramps

At this stage of Part 4 of Project 3, the fluid is widely dispersed as it is generated by the emitter. As an alternative, you can emit fluid from a volume shape. To do so, follow these steps:

1. Open the fluidEmitter2 Attribute Editor tab. In the Basic Emitter Attributes section, change Emitter Type to Volume. Scroll down to the Volume Emitter Attributes section and change Volume Shape to Sphere. The volume emitter works in a similar fashion to one used for nParticles. In this case, Density values are added to the voxels that fall within the emitter sphere. Play back. The fluid is barely visible and does not appear at the fuse itself. The net Density values are so low that the fluid is not visible in some areas. Return to the fluidEmitter2 tab. In the Fluid Attributes section, raise the Density/Voxel/Sec below Density Method to 4.0. This quadruples the Density values assigned to each voxel that falls within the volume sphere. Play back from frame 1. The fluid forms a column. To make the column thin but continuous, reduce the Scale XYZ for fluidEmitter2 to 0.3, 0.3, 0.3 through the Channel Box (**Figure 6.12**).
2. Return to the fluidShape3 Attribute editor tab. Expand the Contents Details section. In the Density subsection, change Density Scale to 4. This further "thickens" the fluid. Change Buoyancy to 8. This gives the fluid a stronger desire to rise. Change Dissipation to 0.2 and Diffusion to 0.1. This begins to soften and spread out the fluid mass. In the Velocity subsection, change Swirl to 10. Swirl imparts swirling motion to the fluid as it travels. In the Turbulence subsection, change Strength to 1.0 and Frequency to 0.1. This imparts additional chaotic motion. Play back from frame 1. The fluid begins to take on an undulating, smoke-like look.

FIG 6.12 A small sphere volume emitter and increased container Base Resolution creates a thin fluid line.

3. Test render from the Persp camera (temporarily hide the background geometry). The fluid is difficult to see. To solve this, scroll down to the Shading section of the fluidShape3 tab. Change Transparency to 0, 0, 0.1 in HSV. (Note that a Transparency value of 0, 0, 0 makes voxels with non-0 Density 100% opaque.) Test render. The fluid becomes visible.

4. To make the fluid smoke appear more sooty, change the default point of the Color graph ramp to dark gray. Note that the Color Input menu for the Color subsection is set to Constant. With this setting, the fluid is colored with the left-most graph ramp value. Change the Color Input menu to Density. This correlates the ramp to Density values. In this case, voxels with high Density values receive color values from the right side of the ramp. Voxels with low Density values receive their color values from the left side of the ramp. Click center of the ramp to insert a new point. With the point selected, change the Selected Color to black (**Figure 6.13**). Test render. The fluid color tapers from black to gray with the gray in less dense edge areas of the fluid.

FIG 6.13 The adjusted Color subsection for the fluid shape node.

5. At this stage, the fluid becomes fairly thin as the dynamite falls. Essentially, the fluid is moving slower than the dynamite bundle. To solve this, you can force the emitter to contribute Velocity values to the container. Switch to

the fluidEmitter2 tab. Expand the Emission Speed Attributes section (Figure 6.14). Change the Speed Method menu from No Emission to Add. The Add option continually adds value with no maximum limit. (In contrast, the Replace option incrementally increases the voxel Velocity values toward a maximum value, which is determined by the fluid shape velocity setting.) Change Inherit Velocity to 6. When the emitter has transform animation, as it does in this case, the emitter velocity is multiplied by the Inherit Velocity and added to the Velocity value passed to the voxels. Play back from frame 1. The fluid becomes thicker as the dynamite falls. Return to the fluidShape3 tab and change Diffusion (in the Density subsection) to 0.2. A higher Diffusion value averages the voxel Density values and creates a softer edge (Figure 6.15). You can also improve the overall fluid render quality for the container by increasing the Quality value in the Shading Quality section.

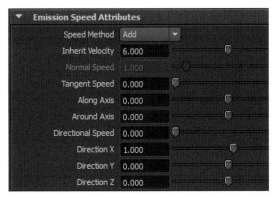

FIG 6.14 The fluid emitter's adjusted Emission Speed Attributes section.

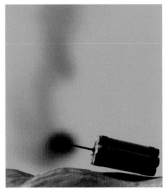

FIG 6.15 The fluid becomes more cohesive when the emitter provides additional Velocity values. The fluid is colored black and gray through the Color graph ramp.

6. Play back the timeline or create a Playblast and examine other parts of the simulation. Note that the older portions of the fluid slowly dissipate and disappear over time. Feel free to adjust settings within the Contents

Details sections of the fluidShape3 node to create aesthetic smoke patterns. Once you're satisfied with the result, unhide any hidden geometry and fluid containers (**Figure 6.16**). Create test renders with the Persp camera. If the new fluid is difficult to see, adjust the Color and Transparency values. For example, lower the Transparency to a darker gray (such as 0, 0, 0.05 in HSV). Optionally, raise the Quality value to improve the render quality of the container.

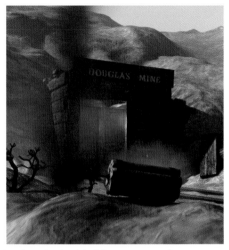

FIG 6.16 The new fluid smoke rendered with the full scene, as seen on frame 24. An example Maya scene file is included as Project3.6.ma in the /ProjectFiles/Project3/maFiles/ directory.

This concludes Part 4 of Project 3.

Exploding a Fireball with Static 3D Fluid

By default, Fluid Effects containers create dynamic fluid simulations where voxels change property values over time. As an alternative, however, you can create a static fluid mass and animate shading and texturing properties to create the illusion of motion.

Creating a Static Fluid Mass

As Part 5 of Project 3, we'll create a fireball (as if the dynamite detonated). You can follow these steps:

1. Choose Fluid Effects > Create 3D Container. Interactively move and scale the container so that it rests on top of the foreground rock. An exact position and scale is not critical at this point. Feel free to temporarily hide geometry and other containers to make the adjustment easier.
2. Open the new fluidShape4 Attribute Editor tab. At the top of the tab, select Disable Evaluation. This makes the fluid static and non-dynamic. In the Container Properties section, deselect Keep Voxels Square. This reveals the Resolution X, Y, Z cells. You can enter different voxel sizes for each local axis. For the moment, enter 40, 40, 40.

3. In the Contents Method section, change the Density menu to Gradient. This reveals the Density Gradient menu. Change the menu to Center Gradient. This fills the container with fluid with the highest density values in the container volumetric center. Change The Velocity menu to Off(Zero). Because the container is no longer dynamic, Velocity values are no longer needed.

4. In the Shading section, alter the Edge Dropoff value. Note how different values erode the edge of the fluid mass. Change the Dropoff Shape menu to Sphere. The mass becomes more spherical (**Figure 6.17**). However, the mass has a very smooth edge. To make the edge more erratic, you can map a 3D texture to the Edge Dropoff. To do so, click the checkered Map button beside Edge Dropoff and select the Volume Noise texture. In the new volumeNoise tab (named volumeNoise2 in the example files), change the Frequency to 5 to scale down the noise pattern. Set Noise Type to Perlin Noise. The addition of the texture will not be visible in the view panels. Test render. The edge of the mass becomes irregular (**Figure 6.18**). If any of the edges of the noise pattern appear compressed or vertically stretched, rotate the container so that one side is flat to the camera and test render again.

FIG 6.17 A new container is placed above the rock. The Density Gradient is set to Center Gradient. The Dropoff Shape is set to Sphere, creating a spherical fluid mass.

FIG 6.18 An irregular edge is created by mapping a Volume Noise texture to the Edge Dropoff.

165

5. By default, the fluid mass is colored white. However, you can base the color on different property values, such as Density or Temperature, or through various gradients. Return to the fluidShape4 tab and expand the Shading section and Color subsection. In the Color subsection, change the Color Input menu to Center Gradient. This relates the graph ramp to the distance from the container volumetric center. That is, fluid close to the center receives color from the right side of the ramp while fluid at the outer edges of the fluid dropoff edge receives colors from the left side of the ramp. Insert four new points into the Color ramp with positions roughly at 0.15, 0.3, 0.5, and 1.0. Change the colors of the points (going left to right) to medium gray, dark gray, orange, yellow, and white (**Figure 6.19**). Change the Interpolation menu for each point to Smooth. Test render. The fluid takes on different colors. You can offset the Color graph ramp and therefore have the fluid mass "slide" through the various colors by changing the ramp's Input Bias value. For example, changing Input Bias to −0.4 causes the fluid to take on more colors from the left side of the ramp (**Figure 6.20**).

FIG 6.19 The adjusted Color subsection.

FIG 6.20 The resulting render with Input Bias set to −0.4.

6. Expand the Incandescence subsection. Change the Incandescence Input menu to Center Gradient. Add a new point to the ramp. Adjust the points so that they fall at 0, 0.15, 0.3, and 0.6. Change the colors for the

points (going left to right) to black, dark gray, orange, and light yellow (**Figure 6.21**). Change the Interpolation menu for each point to Smooth. Set Input Bias to −0.2. Test render. The fluid colors become more intense.

FIG 6.21 The adjusted Incandescence subsection.

7. You can add additional irregularity to the fluid edges by adjusting the Opacity subsection graph ramp. In fact, you can use the ramp to selectively display different regions of the fluid. To do so, change the Opacity Input menu to Center Gradient. Alter the ramp so that it forms three peaks (**Figure 6.22**). This causes the fluid mass to become thin at different depths, forcing the overall mass to have less fluid (**Figure 6.23**). The left side of the ramp corresponds to the outer edge of the fluid while the right side of the ramp corresponds to the center of the fluid. (If Color Input is set to another gradient type, such as Gradient Y, the left side of the ramp corresponds to the top of the gradient.) Remove the extra points from the ramp and return it to its initial state (a left to right slope up). Test render. The fluid regains its solidity.

FIG 6.22 The adjusted Opacity subsection.

Texturing Fluid Color, Incandescence, and Opacity

At this stage of Part 5 of Project 3, the fluid remains fairly consistent in terms of detail and smoothness. You can impose additional variation through the fluidShape4 node's Textures section. Expand the Textures section and select

FIG 6.23 The fluid gains brightness and less fluid density by adjusting the Incandescence and Opacity ramp graphs.

Texture Color, Texture Incandescence, and Texture Opacity. This multiplies each voxel's color, incandescence, and opacity value by the values provided by a built-in 3D noise texture. Use Table 6.1 to alter the noise attributes with the listed values.

TABLE 6.1

Attribute	Value	Notes
Color Tex Gain	0.6	The Tex Gain attributes serve as multipliers for noise values, which in turn are multiplied by the voxel color, incandescence, and opacity values.
Incand Tex Gain	0.7	
Opacity Tex Gain	0.4	
Threshold	0	The greater the difference between Threshold and Amplitude, the greater the contrast within the noise pattern.
Amplitude	3	
Frequency	2.5	The larger the Frequency value, the smaller the noise "grains."

Test render. The fluid becomes more complex (**Figure 6.24**). Experiment with different Color Input Bias and Incandescence Input Bias values, as well as altering the colors in the Color and Incandescence graph ramps. For example, for **Figure 6.24** Color Input Bias is set to −0.4 and Incandescence Input Bias is set to −0.1; in addition, the colors for both graph ramps are darkened and fine-tuned.

FIG 6.24 The built-in noise texture, available through the fluid shape Textures section, adds complexity to the fluid. An example Maya scene file is included as Project3.7.ma in the /ProjectFiles/Project3/maFiles/ directory.

Using Fluid Self-Shadowing and Built-in Lights

Thus far, we've used the default Lighting section settings for fluid shape nodes we've created. As such, the fluid is lit by the scene lights and does not self-shadow. This tends to make the fluid renders appear two-dimensional. To avoid this look, you can activate fluid self-shadows. You can also use the fluid shape's built-in lighting function. To apply these techniques to Part 5 of Project 3, follow these steps:

1. In the fluidShape4 Attribute Editor tab, set the Input Bias for the Incandescence subsection to −0.8. This reduces the incandescence by using the left side of the graph ramp and will allow us to better judge the self-shadowing.
2. Expand the Lighting section (**Figure 6.25**). Deselect Real Lights. This switches the fluid to the built-in fluid light. Note that the Light Type menu is set to Directional (although you also have the option of using a point or generic diagonal light). Set Light Brightness to 3. Change the Directional Light X, Y, Z cells to 1.0, −1.0, −1.0. This sets a directional light vector that roughly matches the current lighting in the scene. Test render. The fluid gains contrast but it's difficult to determine from which direction the built-in light is arriving. Select Self Shadow. Change Shadow Opacity to 1.0 and Shadow Diffusion to 0.5. Test render. The top-left of the fluid mass becomes shadowed. To move the self-shadow to the bottom-left, set Directional Light to 1.0, 1.0, −1.0. Appropriate directional values don't necessarily match the lights in the scene and require experimentation. Test render. The self-shadowing makes the fluid more three-dimensional.
3. To make the fluid edge even more irregular, return to the volumeNoise2 node (mapped to the Edge Dropoff) and change Frequency to 3 to scale up the noise pattern (**Figure 6.26**).

FIG 6.25 The adjusted Lighting section of the fluidShape4 node.

FIG 6.26 Built-in self-shadowing and lighting lend a more three-dimensional look to the fluid. An example Maya scene file is included as Project3.8.ma in the /ProjectFiles/Project3/maFiles/ directory.

Animating Fluid Attributes

VFX Notes: Looking at Explosions

Although there are various types of explosions, there are consistent traits that apply to explosions created with man-made materials on Earth:

- At the point of detonation, the explosive material undergoes a rapid increase in volume and releases a high degree of energy. The event produces high temperatures and the release of gases. The gas expansion sends a shockwave through the air.
- Uncombusted debris is scattered, causing damage to the surrounding area along with the shockwave. Billowing smoke, ash, and soot is produced by semi-combusted materials (**Figure 6.27**).

FIG 6.27 A large-scale gasoline explosion. *Photo © icholakov - Fotolia.com.*

When using static fluid, you can animate the fluid shading attributes to create change over time. You can also animate the container by moving or scaling. With such animation, you can replicate a simple explosion. To do so as Part 5 of Project 3, follow these steps:

1. If currently hidden, unhide the CombinedDynamite, fluidEmitter2, and fluid3 nodes. fluidEmitter2 and fluid3 produce the smoke rising up from the fuse. Go to frame 90. This is the frame where the fluidEmitter2 spherical volume emitter has reached the base of the fuse through animation. Interactively move the fluid4 container so that it's centered on the dynamite (a Translate XYZ of roughly 8.4, 2.3, 13.3). Scale the container down to 0.05 in XYZ. With the container selected, choose Animate > Set Key through the Animation main menu or press the default S hot key. The transforms of the container are keyed. Step the timeline forward to frame 95. Scale the container to 0.7 in XYZ and set a new keyframe. This represents the rapid expansion of gas as the dynamite is detonated. Step forward to frame 120. Scale the container to 1.0 in XYZ, move it slightly upwards in Y, and set a new keyframe. This section of the animation will form the billowing smoke of the explosion.

2. Return to frame 95. At this frame, the explosion should contain bright colors and take on a fairly smooth shape. Open the Attribute Editor tab for fluidShape4. In the Lighting section, reduce Shadow Opacity to 0.5 and raise Shadow Diffusion to 1.0. Reduce Light Brightness to 1.0. In the Shading section, change Transparency to dark gray (0, 0, 0.05 in HSV). Keyframe the Color Input Bias at 0. (To keyframe a numeric cell, RMB-click over the cell and choose Set Key from the menu.) Keyframe the Incandescence Input Bias at 0. In the Opacity subsection, insert a new point into the graph ramp at position 0.25. Set the Selected Value for the new point to 0.7. This delays the transparency and makes the fluid mass more opaque. In the Shading Quality section, set Quality to 2. In the Textures section, keyframe Frequency at 2. Open the Attribute Editor tab for volumeNoise2 (which is mapped to the Edge Dropoff). Keyframe

171

Frequency at 2. Test render. The explosion contains bright colors and is a fairly consistent mass (**Figure 6.28**). If the yellow is too intense, return to the Color and Incandescence subsections of the fluidShape4 tab and reduce the saturation of the yellow ramp points.

FIG 6.28 The fluid explosion on frame 95. The dynamite bundle will be hidden in a later step.

3. Go to frame 120. Key the Color Input Bias at −1.0. Key the Incandescence Input Bias at −1.0. In the Textures section, key the Frequency at 5. Switch to the Attribute Editor tab for volumeNoise2. Key the Frequency at 2. Test render. The fluid appears like grayish-black smoke. If the fluid is too dark to show detail, assign a brighter color to the two left-most points of the Color graph ramp. You can also increase Light Brightness (**Figure 6.29**).

FIG 6.29 The fluid explosion on frame 120.

4. Go to frame 100. Test render. To increase the amount of gray and black seen at the edges of the explosion, change the Color Input Bias and Incandescence Input Bias to −0.2 and keyframe the attributes. Change the orange point in the Color graph ramp and Incandescence graph ramp to red . This helps to emulate the classic red/black fireball seen in movies and TV (**Figure 6.30**). Re-darken the two left-most points of the Color graph ramp if the fluid becomes too gray.

FIG 6.30 The fluid explosion on frame 100.

5. Go to frame 90. Key the Transparency attribute in the Shading section to
 1.0-white. To keyframe a color swatch, RMB-click the attribute name and
 choose Set Key from the menu. Go to frame 95. Key Transparency at 0, 0,
 0.05 in HSV. Go to frame 120. Key Transparency at 0, 0, 0.3. This rapidly
 fades in the fluid then allows it to slowly fade out by the end of the
 timeline. To make the dynamite bundle disappear, select the Combined-
 Dynamite surface and go to frame 91. In the Channel Box, click on the
 Visibility attribute name, RMB-click, and choose Key Selected from the
 menu. Go to frame 92. Change the Visibility value to 0 (off). RMB-click, and
 choose Key Selected from the menu. Be careful not to key the other
 transforms, as this will interfere with the rigid body simulation.
6. The adjustments to the color and transparency may have left the explo-
 sion a bit dark. To offset this, alter the Glow intensity attribute (below
 Transparency in the Shading section). To do so, go to frame 95 and key
 Glow Intensity at 0.25. Go to frame 120 and key Glow Intensity at 0. Go to
 another frame, such as 102, and test render. The post-process glow
 brightens the explosion (**Figure 6.31**).

FIG 6.31 The fluid explosion on frame 102. Glow Intensity is raised above 0. An example Maya scene file is
included as Project3.9.ma in the /ProjectFiles/Project3/maFiles/ directory.

173

7. At this stage, the noise texture applied through the Textures section of the fluidShape4 node and the volumeNoise2 texture mapped to the Edge Dropoff are static. That is, the noise patterns do not change. However, you can animate the time attribute of each to select a different Z-axis "slice" of noise with each frame. To do so, go to frame 90. In the Textures section of the fluidShape4 node, key Texture Time at 0. Go to frame 120. Key Texture Time at 3. Repeat this process with the Time attribute of volumeNoise2. Note that the volumeNoise2 texture swatch updates when you change the Time value.

8. Batch render a movie or image sequence to test the animation. Feel free to adjust any attributes discussed thus far.

This concludes Part 5 of Project 3. Note that static fluid, although relatively easy to set up, cannot produce the realism available to a fully dynamic fluid container. We'll create a more complex and realistic fluid explosion as part of Project 4 in Chapter 9. In particular, we'll use the Fuel and Temperature properties, which have not been utilized thus far. Nevertheless, we'll continue to adjust the Project 3 static explosion in Chapter 7.

Animating Fire, Water, and Damage with Effects, Fluid Effects, Deformers, and Textures

Maya's Fluid Effects tools include the Ocean and Pond systems. While the Ocean system deforms a NURBS or Polygon surface to create animated waves found on an ocean surface, the Pond system creates a 2D fluid container that emulates a smaller body of water. In addition to deformation tools available to manipulate the Fluid Effects, Maya provides a wide array of deformation techniques that you can apply to geometry. You can use these techniques, which include animatable vertices, animatable texture

attributes, and various deformers, to create localized damage to models within your scene. At the same time, Maya provides the Effects menu, which offers a number of presets that construct complex simulations with particles, expressions, and custom shading networks. You can apply and alter the presets to create fire, fireworks, electrical arcs, and similar particle flows.

This chapter includes the following critical information:

- Applying the Ocean and Pond systems
- Working with Effects presets
- Animating textures and deformers

In addition, this chapter will walk you through Part 6 to Part 9 of Project 3. Project 3 features a textured and lit environment that showcases an 1800s western mine and a bundle of dynamite. In Chapter 6, we dropped the dynamite with rigid body simulation and added dust, smoke, fog, and an explosion with Fluid Effects containers. In this chapter, we'll create and animate a new camera, add fire to the dynamite fuse through an Effects menu preset, add a puddle with the Pond system, and add explosive damage with animated textures and animated deformers.

An Introduction to the Ocean System

Before returning to Project 3, we'll briefly investigate Maya's Ocean system.

The Ocean system creates a complex ocean surface simulation, complete with animated waves. The system is set up automatically via the Dynamics menu set > Fluid Effects > Ocean > Create Ocean menu with the resulting ocean surface immediately renderable with Maya Software or mental ray. The system is composed of the following nodes:

oceanPlane and **oceanPlaneShape** These nodes produce a circular NURBS plane that is tessellated and deformed to produce the ocean surface. The tessellation is concentrated in the center so that the edges can serve as distant waves near the virtual horizon.

oceanShader This material is assigned to the surface automatically and includes myriad attributes that determine wave qualities, water shading properties, environmental lighting, and various optional subsystems, such as wave foam generation.

transform and **oceanPreviewPlane** These nodes create a small preview surface that displays the wave deformation and animation in the view panels. If you play back the timeline, you see the waves moving across the surface.

By adjusting various Ocean Shader attributes, you can emulate a wide range of ocean surfaces. These range from a calm sea to a massive storm (**Figure 7.1**).

FIG 7.1 Two ocean systems are placed in a single scene with their NURBS discs overlapping. The two Ocean shaders are adjusted to create calm and stormy seas. An example Maya scene file is included as oceans.ma in the /ProjectFiles/Misc/maFiles/ directory.

An efficient way to learn the functions of various attributes is to retrieve examples by choosing Fluid Effects > Get Ocean/Pond Example and selecting one of the example icons in the Visor.

The Ocean Shader material is also available through the Hypershade. You can assign it to any polygon or NURBS surface. Hence, you can create a rectangular or otherwise irregular ocean surface render (**Figure 7.2**).

FIG 7.2 An Ocean Shader is assigned to a square polygon plane.

Note that the Ocean system is designed to create the ocean surface and not the mass of water that exists below the surface. Nevertheless, you can use the Ocean texture to generate caustic light patterns that may appear below the ocean surface. (*Caustics* are concentrated specular reflections that are often formed by wave peaks, shiny metal pieces, rounded glass, and so on.) The Ocean texture, found in the 2D Textures section, carries many of the same attributes as the Ocean Shader material; however, it has no ability to directly deform a surface and is simply designed to create a 2D wave pattern. You can also pair the Ocean

FIG 7.3 An underwater environment is created by using an Ocean texture and a Fluid Effects 3D container. A green directional light creates raytraced shadows through an upper plane with an Ocean texture mapped to its Transparency. The fluid picks up the raytraced shadows, as is evident by the light and dark streaking. An example Maya scene file is included as underwater.ma in the /ProjectFiles /Misc/maFiles/ directory.

texture with a Fluid Effects container to create a more complete ocean simulation. For example, in **Figure 7.3**, a 3D fluid container and a plane utilizing an Ocean texture as a Transparency map create an underwater environment.

Altering Effects Menu Presets to Create a Burning Fuse

Maya includes the Dynamics menu set > Effects menu with a number of visual effects presets. The presets create complex set-ups that involve various combinations of particles, fields, expressions, shading networks, and geometry. (The exception, in this case, is the Shatter tool, which is designed to fracture polygon surfaces.) Although you can use the presets as is, you can alter the settings and attributes to create custom results.

Applying and Adjusting the Create Fire Preset

The Create Fire preset creates a particle-based fire simulation. The particles are emitted from a selected surface. We can alter the preset to create a burning fuse as Part 6 of Project 3. You can follow these steps:

1. Open the `Project3.9.ma` scene file. This is located in the `/ProjectFiles/Project3/maFiles/` tutorial directory; to avoid missing texture bitmaps, choose File > Set Project and select the `/ProjectFiles/Project3/` folder before opening the file. Go to frame 1. Choose Create > Polygon Primitive > Sphere. A new sphere is placed at 0, 0, 0. We'll use this surface with the Create Fire preset to generate particles. Interactively move the sphere so that it matches the position of the fluidEmitter2's spherical emitter (roughly 7.4, 6.65, 14.8 in XYZ). Scale the sphere down to 0.1, 0.1, 0.1. Select the sphere and Shift+select the spherical emitter and choose Edit > Parent. Move forward on the timeline. The sphere picks up the animation of the emitter and travels down the fuse.

FIG 7.4 A polygon sphere is parented to the fluidEmitter2 spherical emitter.

2. With the sphere selected, switch to the Dynamics menu set, and choose Effects > Create Fire > □. In the Create Fire Effect Options window, set Fire Density to 100, Flame Start Radius to 0.1, Flame End Radius to 0.05, Fire Speed to 1.0, and Fire Turbulence to 0 (**Figure 7.5**). Click the Create button. A new Dynamics particle node is created, as well as turbulence, drag, and gravity fields. The emitter is set to emit from the sphere surface (its Emitter Type menu is set to Surface). The particles are assigned to a new Particle Cloud material. The Life Color, Life Transparency, Life Incandescence, Glow Intensity, and Blob Map are mapped with Ramp and Crater textures. Changing the various attributes in the Options window adjusts the set of expressions written by the Create Fire preset.

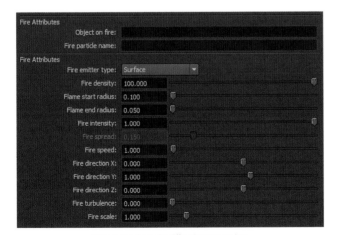

FIG 7.5 The Create Fire Effect Options window.

3. Play back the timeline. Particles are generated, but they are spread out and don't form a solid mass. Open the new emitter1 node's Attribute Editor tab. The emitter1 node is parented to the new pSphere1 node

(which in turn is parented to the fluidEmitter2 node). Note that emitter1's Rate (Particle/Sec) attribute is driven by an expression (as is indicated by the purple value cell). Choose Window > Animation Editors > Expression Editor. Through the Expression Editor menu, choose Select Filter > By Expression Name. The seven expressions written by the Create Fire preset are listed (**Figure 7.6**).

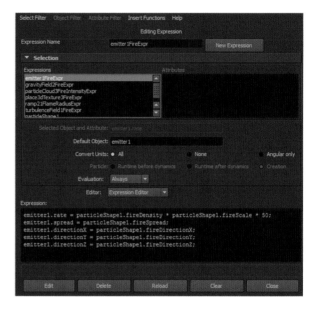

FIG 7.6 The Create Fire expression list. The *emitter1FireExpr* expression is selected and is revealed in the Expression field. The expression is updated with the addition of * 50 at the end of the first line.

4. Click on the *emitter1FireExpr* name. (You can also display the expression directly by RMB-clicking over the Rate (Particles/Sec) cell and choosing Edit Expression from the menu.) In the Expression field add ⋆ 50 to the end of the first line so that it reads:

```
emitter1.rate = particleShape1.fireDensity *
    particleShape1.fireScale * 50;
```

5. Click the Edit button to update the expression. This increases the particle birth rate by a factor of 50. Play back the timeline. The particle mass becomes more dense around the sphere. Select the sphere and open its shape node Attribute Editor tab. Expand the Render Stats section, and deselect Primary Visibility. This hides the sphere from the render. You can also hide the sphere from the view panels by selecting it and choosing Display > Hide > Hide Selection.

6. Test render a frame where the dynamite has contacted the rock, such as 35. (You can hide the background geometry and other fluid containers for efficiency.) The particle mass is fairly transparent. Open the particleCloud2 material in the Attribute Editor. Click on the arrow button beside Life Transparency. A Ramp texture tab is opened. Change the lowest Ramp handle color to HSV 0, 0, 0. Select the middle Ramp handle and change its

color to HSV 0, 0, 0.2. Change the Interpolation menu to Smooth to make the color transitions smoother (**Figure 7.7**). Test render. The particle mass becomes more visible and the particle incandescence becomes more intense. Young particles receive their transparency values from the bottom of the Ramp while old particles receive their transparency values from the top of the Ramp.

FIG 7.7 Updated Life Transparency Ramp for the particleCloud2 material.

7. The particles receive an additional glow through the particleCloud2 Glow Intensity attribute. This attribute is driven by expression. To reduce the glow, click on the *ParticleCloud2FireIntensityExpr* expression name in the Expression Editor and add a / 2 to the end of the line, like so: `particle-Cloud2.glowIntensity = particleShape1.fireIntensity / 2;` Test render. The glow is reduced (although the overall brightness remains intense).

8. Play back the timeline from frame 1. The particles start and stop in a strange fashion as the dynamite falls. This is due to the Lifespan PP expression. To simplify the expression, click on the *particleShape1* expression name in the Expression Editor. Click the Creation radio button. The expression is revealed. As discussed in earlier chapters, a creation expression is applied at the particle birth but does not update the particles after their birth. Replace the old creation expression with the following line and click the Edit button to update:

 `particleShape1.lifespanPP=.05;`

9. Play back. The particles live 1/20th of a second, causing the particle mass to stay close to the fuse. Unhide the fluid3 container (the container that produces the trailing smoke for the fuse). Play back from frame 1. Stop at a frame where the dynamite rests on the rock. Test render. The particles and the fluid smoke overlap. Hence, the black smoke occludes the particles. Return to the particleCloud2 Attribute Editor tab and click on the arrow

beside Life Incandescence. A Ramp texture tab opens. Change the lower Ramp handles to brighter shades of yellow and orange. Change the Interpolation menu to Smooth (**Figure 7.8**). Go to the Ramp connected to particleCloud2's Life Color. Brighten the lower handle colors. Test render. The particles become brighter; however, they remain partially occluded by the black smoke (**Figure 7.9**).

FIG 7.8 Updated Life Incandescence Ramp.

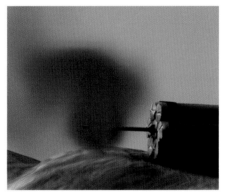

FIG 7.9 Create Fire particles and fluid smoke. Despite the increased incandescence, the particles remain covered by the smoke.

You can light fluid voxels and software-rendered particles with Maya lights. To make the fuse area more intensely lit, create a new volume light and parent it to the spherical fluid emitter. For example, in **Figures 7.10 and 7.11**, a volume light, named FuseLight, is given an orange Color and an Intensity of 10. The scale of the light is 0.5, 0.5, 0.5 with the light icon placed slightly in front of the fuse and particle mass.

This concludes Part 6 of Project 3.

FIG 7.10 A volume light is parented to the spherical fluid emitter.

FIG 7.11 The resulting render. An example Maya scene file is included as Project3.10.ma in the /ProjectFiles/Project3/maFiles/ directory.

Reviewing Other Effects Presets

In addition to Create Fire, there are six other Effects menu presets, which are briefly described below:

Create Smoke Produces a sprite-based smoke simulation. Sprite-style particles map a small bitmap to a small 2D plane at each particle position. You can define the location of the bitmap through the Create Smoke Effects Options window by tying a path into the Sprite Image Name cell. You must use a hardware renderer to render sprite particles.

Create Fireworks Creates a complex fireworks emulation that involves particle emitters, instanced geometry, and expressions.

Create Lightning Extrudes a NURBS tube between two selected objects to form an electrical arc. The tube is given an erratic shape through the use of expressions. Fluctuating glow and incandescence of an assigned Lambert material is also driven by expressions.

Create Shatter Fractures a polygon surface. The Create Shatter tool is detailed in Chapter 9.

Create Curve Flow Creates a particle emitter that emits particles along a selected curve. The preset creates circular handles along the curve that allow you to alter the width of a virtual pipe through which the particles flow.

Create Surface Flow Creates a particle emitter that emits particles along a selected NURBS surface. The preset creates rectangular handles along the surface that allow you to alter the width of a virtual rectangular pipe through which the particles flow.

Rendering Effects with Multiple Cameras

Ideally, when you create a visual effect in Maya, you'll do so for a pre-placed or pre-animated camera. This allows you to adjust attributes and animation to create the best-looking results for that particular view. For example, with Projects 1, 2, and 3, the Persp camera was pre-placed and has served as the rendering camera. A specific camera placement is often necessary for visual effects industry work, where an effect must be integrated with live-action film or video footage. Nevertheless, when a scene requires the use of multiple cameras or an animated camera that moves significantly, it becomes more difficult to fine-tune the effects settings. To explore this potential problem, we'll add a new camera to Project 3 in the next section.

Adding a New Perspective Camera

To add a new camera as Part 7 of Project 3, follow these steps:

1. Unhide any geometry that may be hidden. Choose Create > Cameras > Camera. A new, one-node camera is created and placed at 0, 0, 0. Rename the new camera **RenderCamera2.** Through one of the view panel menus, choose Panels > Perspective > RenderCamera2. Through the same view panel menu, choose View > Camera Settings > Resolution Gate.

2. In the new camera's Attribute Editor tab, change the Focal Length to 25mm. Focal Length emulates the properties of a real-world camera—and a 25mm lens is a wide-angle lens. Note that the resulting view is dependent on the settings of the camera's Film Back section. The Film Gate presets, as well as other attributes such as Camera Aperture, Film Aspect Ratio, and Lens Squeeze Ratio, attempt to replicate the optical properties of specific motion picture cameras. You can also adjust the Film Back section to replicate the properties of modern digital video cameras, which is often necessary for a visual effects project. This issue is further explored in Chapter 8, "Motion Tracking in Maya and Matchmover." For the moment, you can leave the Film Back settings at their default—this is acceptable for Project 3, which doesn't involve live-action footage or digital compositing.

3. Interactively move the new camera to show the opposite view; that is, move the camera near the hill and look backwards (**Figure 7.12**). You can use the following transform settings:

 Translate X: −13.9
 Translate Y: 3.9
 Translate Z: 17.9
 Rotate X: −4
 Rotate Y: 307
 Rotate Z: 0

FIG 7.12 The RenderCamera2 position, as seen from the WorkCamera.

4. In the new camera's Attribute Editor tab, scroll down to the Environment section, and change Background Color to sky blue (each camera carries its own Background Color). Test render with the new camera. Several issues arise. The first concerns the texture on the ground. With the new camera close to the middle of the Ground surface, the texture appears pixelated. The best solution calls for a larger resolution texture with more detail. An alternative solution that will work for RenderCamera2 (but not necessarily other cameras) requires an increase in UV tiling. Open the Hypershade window. RMB-click over the GroundMaterial icon and choose Graph Network. In the work area, double-click place2dTexture7, which controls the UV tiling of file4. In the Attribute Editor, change Repeat UV to 5.5, 5.5 and deselect Stagger. Test render. The pixelation subsides (**Figure 7.13**).

5. The second problem that arises with the new camera placement concerns the boundaries (sides) of the fluidShape3 container, which produce the trailing smoke for the dynamite bundle. By default, fluid interacts with container boundaries as if they are walls, ceilings, or floors. The fluid flattens out or gathers in the corners. One solution

FIG 7.13 The RenderCamera2 view. The quality of the Ground texture improves with increased UV tiling. Note that the trailing fuse smoke gathers at the top of its container.

would be to scale up the container and increase the voxel resolution. An alternative solution requires the deactivation of the boundaries. To do this, open the fluidShape3 Attribute Editor tab. In the Container Properties section, change Boundary X, Boundary Y, and Boundary Z to None. Play back from frame 1. When the fluid reaches the boundaries, it quickly fades out but does not react dynamically to the boundary presence. To further soften the fade, change the Edge Dropoff, in the Shading section, to 0.4. A third solution, which is demonstrated in Chapter 9, is to select the Auto Resize attribute (in the Auto Resize section) so that the container grows as high Density values reach the boundary edges.

6. The explosion is timed to begin at frame 90, yet the fluid smoke continues to flow from the fuse. To turn off and dissipate the fluid smoke, you can animate the Transparency attribute. To do so, go to frame 90. In the Shading section key the Transparency at its current value. Go to frame 96. Key the Transparency at 100% white.

7. The particles creating the fire along the fuse also persist until the end of the timeline. To stop the flow of particles at frame 90, you can add the following lines to the end of the emitter1FireExpr expression:

```
if (frame > 90)
    emitter1.rate = 0;
```

8. The new script lines cause the Rate (Particles/Sec) value to drop to 0 when the timeline passes frame 90. You can edit the expression by opening the Expression Editor, choosing Select Filter > By Expression, and clicking on the *emitter1FireExpr* expression name. Click the Edit button to update the expression once the new lines are added.

Adjusting Pre-Existing Fluid Effects

With the addition of a new camera to Project 3, it's important to test the Fluid Effects. In particular, the container that creates the explosion requires attention. What looks acceptable through the Persp camera may appear inappropriate for the new camera. Here are some steps you can take to improve the explosion for RenderCamera2:

1. Select the fluid4 container. Go to frame 120. Key the Scale at 6, 6, 6. Scaling up the container spreads the fluid over a greater portion of the scene. Key the Translate Y at 10 so that the container slowly rises at the end of the timeline. Key the Rotate Y at 30. This "squares" the container with the camera lens. This produces less distortion in the fluid mass when it's rendered. Go to frames 90, 95, and 100 and key Rotate Y at 30.
2. Return to frame 120. Test render. Lower the render quality, resolution, and fluid Quality value if necessary to save render time. At this point, the explosion smoke appears opaque. Open the fluidShape4 Attribute Editor tab. While in frame 120, key Transparency, in the Shading section, to 0, 0, 0.9 in HSV. Test render. The fluid becomes less opaque. However, the built-in noise texture may produce hard-edged blobs in areas of the fluid. To avoid this, change the Texture Type, in the Textures section, to Billow. Billow produces a softer noise pattern.
3. Go to frame 95. Test render. Although the explosive fireball may be fairly bright, you can create an even greater sense of overexposure by adjusting the Input Bias value for Color and Incandescence subsections. For example, key the Color and Incandescent Input Bias values at 0.2. This favors the right side of the graph ramps, which are more orange and yellow. Note that changing the bias values may require adjustment of the Glow Intensity, which may produce an excessively intense glow. In addition, you may need to desaturate the Color and Incandescence graph ramp point colors if the fluid appears too saturated in the test renders.
4. Go to frame 100. Test render. At this point, there should be the sense that the explosion is flinging out debris. The virtual debris is created by cutting out the dark parts of the fluid with the built-in noise texture and the Volume Noise mapped to the Edge Dropoff. You can alter the size of the debris "chunks" by changing the Frequency of both textures. For example, key the built-in noise Frequency at 1.0 and the Frequency of the volumeNoise2 node at 1.0.

Determining appropriate attribute values for the fluid requires numerous test renders. Any given scene may require significantly different values. As mentioned, camera placement can also impact the look of the fluid. Test render several frames or batch render a movie or image sequence (**Figure 7.14**). Feel free to make additional adjustments to the fluid.

This concludes Part 7 of Project 3.

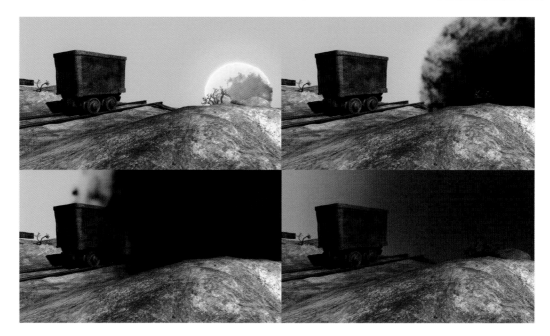

FIG 7.14 Clockwise, from top left: The adjusted fluid explosion at frames 95, 100, 106, and 120. An example Maya scene file is included as Project3.11.ma in the /ProjectFiles/ Project3/maFiles/ directory.

Filling a Puddle with the Pond System

Maya's Pond system is a form of 2D fluid that employs a spring mesh solver and a height field. You can create wakes and ripples on the resulting surface, as well as "float" objects on top of it. While Maya's Ocean system is appropriate for large bodies of water, the Pond system can replicate smaller bodies. In fact, you can use the Pond system to create a large puddle.

Installing a Pond

To add the Pond system to Part 8 of Project 3 and thus emulate a puddle, follow these steps:

1. Through the Dynamics menu set, choose Fluid Effects > Pond > Create Pond > □. In the Create Pond window, set Size to 50 and click the Create Pond button. A shallow 3D fluid container is placed at 0, 0, 0.
2. While the container remains selected, interactively move the container so that it "floods" the depression along the mining cart's rails and creates a large puddle (roughly −16, 0.35, 0 in XYZ). Note that the fluid forms a blue plane in the container center (**Figure 7.15**).
3. Play back the timeline. The pond surface is static. The fluid is assigned to the PondShape1 material, which is a standard Fluid Shape material. Like other Fluid Shape materials, it's connected to the Volume Material attribute of the assigned shading group node. Render a test. At this point, the fluid accepts shadows, but does not raytrace reflections.

FIG 7.15 The 2D fluid container of a Pond system is moved to "flood" the set.

Creating Ripples with Pond Wakes

The Pond system offers an optional Wake emitter, which you can use to create ripples on the fluid surface. In the case of Project 3, you can use the emitter to create a blast wave on the surface as the dynamite explodes. To do so, follow these steps:

1. Select the Pond fluid container and choose Fluid Effects > Pond > Create Wake. A new fluid emitter, named PondWakeEmitter1, is placed at 0, 0, 0. Play back the timeline from frame 1. Ripples appear on the fluid surface. With the emitter selected, interactively move it underneath the rock where the dynamite falls (roughly 8, 0, 15 in XYZ) (**Figure 7.16**). Play back from frame 1. The ripples now emanate from the new emitter location. Note that the emitter must be placed within the fluid container and intersect the pond surface to create ripples.

FIG 7.16 The Wake emitter is placed under the foreground rock so that it intersects the pond surface.

2. To replicate a shock wave, you can scale the emitter over time. Go to frame 90. Key the emitter's Scale at 1.0, 1,0, 1.0. Go to frame 95. Key the Scale at 10, 10, 10. Open the Attribute Editor tab for PondWakeEmitter1. Scroll down

and expand the Volume Emitter Attributes section. Note that the emitter is set to Spherical, although other shapes are available. Scroll up to the Fluid Attributes section. The emitter affects the fluid surface by adding Density to the pond fluid container. Go to frame 90. Key Density/Voxel/Sec at 0. Go to frame 95. Key Density/Voxel/Sec at 1.0. Go to frame 120. Key Density/Voxel/Sec to 0. Play back from frame 1. The pond is static until frame 90. The ripples are the most intense at frame 95, corresponding to the explosion.

3. The ripples travel fairly slowly. To push them ahead of the explosion, return to the Attribute Editor tab for PondShape1. Scroll down and expand the Dynamic Simulation section. Change Simulation Rate Scale to 3. This speeds up the simulation by altering the time steps. Note that the Solver is set to Spring Mesh. Scroll down and expand the Surface section. Note that the Hard Surface attribute is selected. This creates the Pond surface. Other containers in the scene use the Volume Render setting.

4. Play back from frame 1. The ripples move ahead of the explosion (**Figure 7.17**). To accurately gauge the simulation, create a Playblast.

FIG 7.17 Two frames from the Pond simulation. The ripples move ahead of the fluid explosion due to a higher Simulation Rate Scale. The scale of the Wake emitter and the emitted Density push the virtual water a significant amount. An example Maya scene file is included as Project3.12.ma in the /ProjectFiles/Project3/maFiles/ directory.

Floating Geometry on a Pond

The Pond system offers an optional means to "float" geometry on the resulting fluid surface. For example, with Project 3, we can float a cast-off wooden board and have it automatically bob up and down as ripples form. To do so, follow these steps:

1. Select a piece of geometry to float. For example, select the Board17 surface, which is a rectangular piece of wood sitting near the foreground

rock. On frame 1, interactively move the geometry so that it sits on the pond surface (imagine that this is the start position, so you may want to partially "submerge" the geometry into the pond). Once the geometry is positioned, choose Modify > Freeze Transformations.

2. With the board geometry selected, choose Fluid Effects > Pond > Float Selected Objects. The board transform node is parented to a new locator. In turn, the locator Y position is driven by a new expression that reads the fluid height field. Play back from frame 1. The board bobs up and down as the ripples pass by. If there is a significant distance between the locator and the geometry, the geometry may appear out-of-sync with the ripples. To solve this with Project 3, move the locator to the point where the board was positioned. As you move the locator, the board is moved automatically because it is a child of the locator. After you've moved the locator, select the Board17 transform node in the Hypergraph or Outliner and interactively move it back to its proper position. Ultimately, these steps place the locator at the center of the board . Play back. The board is in better sync with the ripples (**Figure 7.18**).

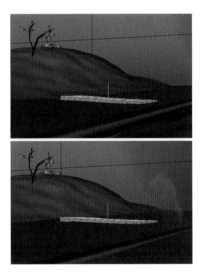

FIG 7.18 The Board17 surface bobs up and down as if floating on the pond surface. The Float Selected Objects tool creates an expression to relate the geometry to the 2D fluid height field. An example Maya scene file is included as Project3.13.ma in the /ProjectFiles/Project3/maFiles/ directory.

The way in which the geometry reacts to the ripples is controlled by attributes added to the Extra Attributes section of the locator shape node tab. For example, higher Buoyancy values make the geometry float on top of the fluid surface, while lower Buoyancy values make the geometry sink. If the pond ripples are large and/ or fast, the geometry may disconnect from the fluid surface and suddenly hover below or above the surface. To counteract this motion, you can raise the Water Damping and/or Air Damping values. With the example files, Water Damping and Air Damping are set to 1.0 so that the board closely follows the fluid surface.

Alternatively, you can apply Fluid Effects > Pond > Make Boats. The Make Boats. tool also parents the geometry to a locator and creates an expression. However,

Make Boats adds rotational relationships to simulate roll and pitch. If you apply Make Boats, change the Buoyancy to 0.5—else thin geometry may float above the pond surface. You can view the expression made by Float Selected Objects or Make Boats by clicking on the expression*n* name in the Expression Editor.

Texturing and Rendering a Pond Surface

By default, the pond fluid surface does not reflect. The Fluid Shape material, in fact, does not support reflectivity. However, you can convert the pond fluid into a polygon surface and assign the result to a Maya or mental ray material. To do so with Project 3, follow these steps:

1. Select the Pond1 fluid container. Choose Modify > Convert > Fluid To Polygons. The fluid container is hidden and a triangulated polygon surface takes its place. Play back. The ripples created by the wake emitter continue to appear as there is a connection between the polygon surface and the fluid container.
2. Open the Hypershade and create a new mia_material. You can find this in the mental ray Materials section. Rename the material **PondMaterial** and assign it to the new polygon surface. In the Diffuse section, set the material's Color to tan. In the Reflection section, set Reflectivity to 0.9, Glossiness to 0.8, and Glossy Samples to 16. (The lower the Glossiness value, the more incoherent and blurry the reflection.) In the Refraction section, set Index Of Refraction to 1.33 and Transparency to 0.7. Test render. The pond surface reflects the environment (**Figure 7.19**).

FIG 7.19 The Pond fluid is converted to a polygon mesh and assigned to a reflective mia_material. An example Maya scene file is included as Project3.14.ma in the /ProjectFiles/Project3/maFiles/ directory.

Note that the type of mesh produced by the Fluid To Polygons tool is determined by the Output Mesh section of the fluid shape node. (This must be set before applying the tool.) For example, you can create a quad mesh by changing the Mesh Method menu to Quad Mesh. You can increase the mesh density by raising the Mesh Resolution value.

This concludes Part 8 of Project 3.

Adding Localized Damage with Animated Deformers and Textures

Maya provides a wide set of deformation tools. Although these are often used for tasks such as modeling or character rigging, you can employ them as a means to add localized damage in a visual effects simulation. You can break the deformation techniques into the following categories:

Vertex Animation You can keyframe the position, rotation, and scale of groups of NURBS or polygon vertices over time. This provides a means to create dents, dings, folds, and similar surface changes.

Cluster Animation Similar to vertex animation, you can convert a set of vertices into a cluster and animate the transforms of the cluster. The cluster serves as a convenient handle. You can create a cluster by selecting vertices, switching to the Animation menu set, and choosing Create Deformers > Cluster.

Soft Modification Tool The Soft Modification Tool allows you to transform vertices. Although similar in use to a transformable cluster, the Soft Modification Tool offers built-in falloff, allowing the surface manipulation to remain smooth and clay-like. You can find the tool in the main Tool Box below the Move, Rotate, and Scale tools. You can also choose Animation menu set > Create Deformers > Soft Modification. You can animate the transforms of the modification handle, which is provided by a softModHandle node.

Blend Shapes Blend shape deformers let you "morph" the shape of one surface so that it matches the shape of one or more target surfaces. Blend shapes are often employed as part of facial animation rigs; however, you can use them to create damage to a surface. Blend shapes operate on a vertex level, moving base vertices to match the vertex positions of the target surfaces. This is demonstrated in the next section.

Lattice Deformer A lattice deformer alters a surface through a three-dimensional cage. You can animate the lattice points transforming over time. This is demonstrated in the section "Animating Damage with a Lattice Deformer" later in this chapter.

Nonlinear Deformers Maya provides a set of deformers through the Animation menu set > Create Deformers > Nonlinear menu. The deformations are based on a handle and a mathematical property, such as Sine, Wave, or Bend. Note that the deformers, in their default state, are off. Raise the Amplitude attribute above 0 for the deformation to occur.

Wire Tool The Wire deformer alters a surface based on the proximity of a NURBS curve. When you apply the tool through the Animation menu set > Create Deformers > Wire Tool menu, the tool gives instructions for its application in the Command Line at the bottom left of the Maya program window. Because the deformation is relatively narrow and follows a curve, you can use the tool to create a thin dent. The Wire Tool is often used in character rigging.

Texture Animation Although not a surface deformation in a strict sense, animating a texture over time can create the illusion that a surface is darkening, blistering, cracking, and so on. This is demonstrated in the section "Animating Damage with a Texture" later in this chapter.

Animating Damage with a Blend Shape

With the Blend Shape tool, you can easily animate a deformation over time. The tool requires a base shape (the geometry that deforms) and one or more deformed targets. The best way to make a target is to duplicate the base shape and modify it with modeling tools. To apply the Blend Shape tool to Part 9 of Project 3, and thereby add damage to the foreground rock, follow these steps:

1. Select the foreground rock surface, named Rock. Choose Edit > Duplicate. Name the duplicate surface **RockTarget.** Move RockTarget out of the view of the rendering cameras. As long as you don't freeze the transformations on the target surface, you can place it anywhere in the scene.
2. Alter RockTarget so it appears damaged. For example, use the Sculpt Geometry tool to press in the top. To apply the tool, select the surface, switch to the Polygons menu set, and choose Mesh > Sculpt Geometry Tool > □. The tool's options open in the Tool Settings panel and the mouse switches to the sculpt brush.

FIG 7.20 The RockTarget surface is moved off to the side of the scene and deformed with the Sculpt Geometry tool.

3. The Blend Shape tool will not function with rigid bodies. Not only is the Rock surface a passive rigid body, but the RockTarget surface becomes a rigid body through the duplication. As a workaround, you can bake the dynamic simulation of the dynamite fall and then remove the rigid body nodes. To do this, return to frame 1 and select the CombinedDynamite surface. Choose Edit > Keys > Bake Simulation > □. In the Bake Simulation Options window, make sure that the tool is set to its default state. You can set a tool to factory settings at any time by choosing Edit > Reset Settings from the window's top-left menu. Click the Bake button. The timeline plays and the dynamic simulation of the dynamite fall is

converted to keyframe animation. When the playback reaches the last frame, a red keyframe line appears at each frame of the timeline. Play back. The dynamite falls as it did before.

4. Select the Rock surface. Open the Hypergraph: Connections window. Connected to the Rock transform node is a rigidBody2 node (**Figure 7.21**). Select rigidBody2 and press the Delete key. The node and its associated transform nodes are removed. The surface is no longer a rigid body. In a view panel, select the RockTarget surface. In the Hypergraph window, choose Graph > Input And Output Connections from the Hypergraph menu. The RockTarget transform node is framed along with an additional rigidBody2 node. Delete the rigidBody2 node. Close the Hypergraph.

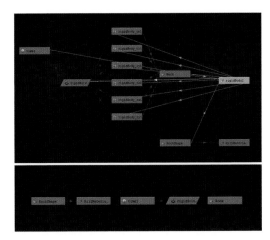

FIG 7.21 Top: The Hypergraph: Connections view of the Rock surface. The rigidBody2 node is selected. Bottom: The network after rigidBody2 is deleted.

5. Select the RockTarget surface. Shift-select the Rock surface. Switch to the Animation menu set. Choose Create Deformers > Blend Shape. Choose Window > Animation Editors > Blend Shape. The Blend Shape window opens with a single blend slider named blendShape1. Move the slider. The Rock surface deforms. To create the illusion that the explosion damages the rock, you can animate the blend slider. To do so, go to frame 90. Click the Key All button next to the slider in the Blend Shape window. Go to frame 93. Move the slider up to 1.0 and click the Key All button. (The Rock surface may be temporarily hidden by the deformed Pond surface—if so, go to the last frame to see the affect of the blend slider setting.)

Animating Damage with a Lattice Deformer

The Lattice tool places a cage around selected surfaces or vertices. You can transform points along the cage divisions to alter the shape of the surface. To place a lattice around the Project 3 mine cart and deform it as if it's damaged by the explosion, follow these steps:

1. Select the entire hierarchy of the mine cart. You can do this by selecting the Cart node in the Hypergraph or Outliner. Through the Animation

menu set, choose Create Deformers > Lattice. The lattice appears around the volume of the cart. The lattice has a default number of horizontal and vertical divisions. You can increase these, and thereby increase the number of lattice points, by increasing the STU Divisions. You can change these values through the Channel Box where S Divisions, T Divisions, and U Divisions appear as attributes in the SHAPES section. S corresponds with the local X axis. T corresponds with the local Y axis. U corresponds with the local Z axis. For example, enter 7, 7, 5 for STU to create evenly-distributed, high-density divisions (**Figure 7.22**).

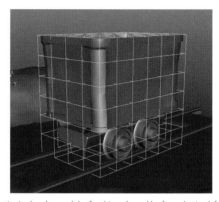

FIG 7.22 A 7x7x5 lattice is placed around the Cart hierarchy and keyframed at its default state at frame 90.

2. Place the mouse over the lattice shape, RMB-click, and choose Lattice Point from the marking menu. The lattice points appear. (If this technique fails to work, you can select the lattice as an object and then click the Select By Component Type and Select Point Components buttons in the Status Line at the top of the Maya program window.) To animate the damage appearing, you can animate the positions of the lattice points. Go to frame 90. Draw a selection marquee around all of the lattice points. Choose Animate > Set Key from the Animation menu set or use the S hot key. Go to frame 95. Move points to create damage. For example, move points along the side inwards to make a large dent. You can also move and rotate all of the points as a single unit and thereby "tip" the cart (**Figure 7.23**). Once the points are adjusted, set a new keyframe on all the lattice points. Go to frame 100, move and rotate the points to bring the cart back to rest on the tracks. Key the points one more time. Play back or create a Playblast. The damage is now animated and roughly corresponds with the fluid explosion.

Should you decide that you no longer want the lattice deformation, you can delete the lattice and the affected surfaces will spring back to their original shape. If you would like to make the lattice deformation permanent for a particular frame, select the affected surfaces and choose Edit > Delete By Type > History. The lattice is removed but the surface is frozen with the current deformation.

FIG 7.23 The cart is given a dent and "tipped" over by transforming and keying lattice points on frame 95.

Animating Damage with a Texture

Although there are many options within Maya to alter geometry over time, you can also animate various texture attributes to create change. One trick is to layer textures through the Color Gain attribute. Of the textures you can layer and animate, noise textures, due to their organic nature, are useful. The Ramp texture can also create a wide variety of animatable patterns. You can use this technique to change the look of the Project 3 ground. You can follow these steps:

1. Open the Hypershade window. Place the mouse over the GroundMaterial icon, RMB-click, and choose Graph Network from the marking menu. The material network is revealed in the work area. Double-click the file4 icon to open the Attribute Editor tab. The file4 node carries the bitmap uses as the ground texture. Scroll down to the Color Balance section. Click the checkered Map button beside Color Gain. In the Create Render Node window, choose the Ramp icon. The new Ramp texture tints the color bitmap.

2. In the new Ramp node's Attribute Editor tab, change the Type menu to Circular Ramp. Change the Interpolation menu to Smooth. Delete the center handle. Change the top handle to white. Change the bottom handle to dark gray (HSV: 0, 0, 0.15). Change Noise to 0.1 and Noise Freq to 10. This series of steps creates a rough gray circle in the middle of a white field (**Figure 7.24**). Because the Ramp is mapped to the Color Gain of the color bitmap, the ground is darkened in the circular area. You can see this area in a view panel by temporarily hiding the polySurface1 pond surface and choosing Shading > Smooth Shade All, Shading > Hardware Texturing, and Renderer > Viewport 2.0 through the view panel menu. At this stage, the circular area appears in the center of the Ground surface. To offset the area and move it towards the foreground rock, double-click the place2dTexture node connected to the new Ramp node in the Hypershade work area (**Figure 7.24**). In the node's Attribute Editor tab, change Offset to −0.5, −0.4. The position of the darkened area updates in the hardware-shaded view panel and within the node thumbnails in the Hypershade.

FIG 7.24 The updated shading network for GroundMaterial. A Ramp is mapped to the Color Gain of the file4 node, which carries the ground's color bitmap. In this figure, the ramp is animated, as is indicated by the animation curve node.

3. To animate the area as if the explosion is throwing soot onto the ground or singeing the dirt, animate the upper Ramp handle. Return to the new Ramp's Attribute Editor tab. Go to frame 90. Select the upper handle. Enter 0.001 into the Selected Position cell and keyframe it. This position makes the Ramp almost completely white. White values have no effect on the color bitmap. Go to frame 100. With the upper Ramp handle selected, change the Selected Position to 0.8 and key it (**Figure 7.25**). This allows the darkened circular area to reappear. Create a test render through Render-Camera2 and compare it to renders of earlier frames. The darkened area appears on the ground near the rock (**Figure 7.26**).

This concludes Part 9 of Project 3.

FIG 7.25 The adjusted and animated Ramp.

FIG 7.26 Top: Frame 1, where the ground is unaffected by the new texture animation. Bottom: Frame 120, where the ground is darkened by the circular area created by the animated Ramp texture. (The pond surface is hidden. Note the deformed rock.) An example Maya scene file is included as Project3.15.ma in the /ProjectFiles/Project3/maFiles/ directory.

Final Rendering of Project 3

We've finished adding and adjusting elements for Project 3. We're ready to render all the simulations at the same time. To prepare for a final render, unhide any geometry or containers that remain hidden. Keep in mind that you must select a camera when batch rendering. To do so, open the Render Settings window, scroll down to the Renderable Camera section in the Common tab, and choose a camera through the Renderable Camera menu.

Your renders should look similar to **Figure 7.27**. Note that the last adjustment of the Ground texture and explosion fluid container was made while looking through RenderCamera2. Hence, those items now appear different when rendering with the Persp camera. Ideally, you would set up and adjust two separate scenes: one for RenderCamera2 and one for Persp.

Although not explicitly discussed in this book, here are some optional steps you can take to improve the Project 3 renders:

- Activate motion blur through the Render Settings window to blur the falling dynamite and other surfaces which are moving or distorting.
- Create and fine-tune a higher resolution texture for the Ground surface that will work for both rendering cameras without requiring tiling.
- Add billowing smoke to the explosion by adding a large 3D fluid container that's dynamically simulated. (This is demonstrated in Chapter 9.)
- Create the illusion of a shock wave by adding a 3D fluid container that simulates dust or dirt being blown across the ground in a circular fashion.
- Add additional damage to the scene by animating geometry or geometry deformers. For example, knock over the small plants.
- Create a particle simulation that represents pieces of rock exploding outwards.

This concludes Project 3.

FIG 7.27 Top: Frame 28, as seen through the Persp camera. Bottom: Frame 97, as seen through the RenderCamera2 camera. Maya scene file is included as Project3.16.ma in the /ProjectFiles/Project3/maFiles/ directory.

Building Reference Models and Motion Tracking with Maya and MatchMover

A large percentage of visual effects work is combined with live-action footage—that is, real-world footage shot with a film or video camera. Such visual effects have the greater challenge of attaining realism. An important part of this challenge involves the matching of moving cameras. If the real-world camera tilts, pans, dollies, or is hand-held, the 3D-generated visual effects must pick up the same camera motion. To determine the camera motion, you can apply *motion tracking*. Although there are many pieces of software that undertake this task, there are manual methods you can apply inside Maya. If you wish to automate the motion tracking, which is significantly more efficient and accurate, you can run an external program. In fact, Autodesk MatchMover is bundled with Maya for just this very purpose.

This chapter includes the following critical information:

- Review of popular visual effects and compositing software
- Manual motion tracking in Maya
- Automated camera tracking in MatchMover

In addition, this chapter will step you through Parts 1 and 2 of Project 4. Project 4 features live-action video footage of an abandoned water station. In Chapter 9, we'll create visual effects that will damage the building. In Chapter 10, we'll composite the Maya renders with the footage. In this chapter, we'll motion track the footage so that we have usable camera information for Chapters 9 and 10. In addition, we'll construct a 3D model of the building to help us with motion tracking and eventual visual effects simulation.

Investigating Visual Effects and Compositing Software

For the first seven chapters, we've worked inside Autodesk Maya. Although Maya provides a wide set of tools for creating visual effects, it is by no means the only software available for such tasks. In fact, it's not unusual for visual effects studios, or professional visual effects artists, to use multiple programs to achieve their goals. In terms of visual effects, Table 8.1 lists commonly-used software and includes information on their strengths as well as their ability to import and export common file formats supported by Maya.

TABLE 8.1

Software	Strengths	Import Formats	Export Formats
Side Effects Houdini	Advanced dynamic simulation tools, including rigid bodies, cloth, particles, and fluid systems; a complete 3D environment, including modeling, animation , lighting, rendering, and compositing tools.	DXF, OBJ, and Alembic	DXF, OBJ, and Alembic
Autodesk SoftImage	A complete 3D package, with modeling, texturing, animation, lighting, rendering, and compositing tools; advanced simulation tools, including crowd generation, fluid systems, rigid and soft bodies, hair, fur, cloth, and ICE (a node-based, visual programming language).	FBX and OBJ	FBX, OBJ, and direct transfer to Maya through Crosswalk system
Autodesk 3DS Max	A complete 3D package, with modeling, texturing, animation, lighting, rendering, and compositing tools; simulation tools, including crowd generation, particles, hair, and fur.	FBX, DXF, OBJ, and STL	FBX, DXF, OBJ, and STL
MAXON Cinema 4D	A complete 3D package, with modeling, texturing, animation, lighting, and rendering tools; simulation tools, including soft and rigid bodies, particles, hair, and smoke/fire systems.	DXF, FBX, OBJ, STL, and Alembic	DXF, FBX, OBJ, STL, and Alembic

Note that Table 8.1 represents a partial list, both in terms of software but also supported file formats. In addition, many animation and visual effects studios write custom software or adapt "off the shelf" software through programming and scripting (including MEL, PyMEL, and Python).

DXF (Drawing eXchange Format) was developed for CAD (Computer-Aided Design) software and is used widely in the architectural and industrial design fields. STL (STereoLithography) was designed for industrial prototyping and continues to be used for 3D printing tasks. OBJ is a geometry file format developed by Wavefront. Alembic is a relatively new format developed by visual effects and animation professionals; it supports a wide array of 3D components and uses the .abc extension. FBX is an interchange file format provided by Autodesk that can carry geometry, expressions, rigs, constraints, cameras, lights, and animation curves. You can import DXF, FBX, OBJ, STL, and Alembic files into Maya through File > Import. Note that the support of various formats is dependent on plug-ins, which you can load through the Plug-In Manager (Window > Settings/Preferences > Plug-In Manager). Here are a few examples:

AbcImport.mll Alembic import
AbcExport.mll Alembic export
fbxmaya.mll FBX import and export
objExport.mll OBJ export

For a complete set of supported file formats and their associated plug-ins, see the "Supported File Formats" page in the Maya Help files. You can also export these formats though the File > Export All or File > Export Selection.

Compositing is another critical aspect of visual effects work. Compositing allows the artist to combine image sequences rendered in Maya or other 3D programs with live-action film or video footage to produce a finished shot. Autodesk Maya is bundled with Autodesk MatchMover and Autodesk Composite. While Autodesk Composite is a node-based compositing tool, MatchMover is designed for motion tracking, which is the main topic of this chapter. Autodesk Composite is one of many compositing programs available. Table 8.2 includes a partial list of commonly-used compositing programs and their particular strengths.

TABLE 8.2

Software	Strengths
Adobe After Effects	Widely-used for motion graphics and commercial production; vast array or 3rd party plug-ins available.
The Foundry Nuke	32-bit floating point architecture designed specifically for the visual effects industry; robust 3D environment that supports imported geometry, lights, cameras, and animation curves.
Eyeon Fusion	Advanced color grading support; built-in volumetric and particle effects; 3D masking tools.

The programs listed in Table 8.2 include motion tracking tools. In addition to these, there are a number of standalone programs specifically designed to produce motion tracking data. These include Imagineer Systems Mocha (which comes bundled with After Effects), Andersson Technologies SynthEyes, Vicon Boujou, and The Pixel Farm PFTrack.

In this chapter, we'll use Maya and MatchMover for motion tracking. We'll use Autodesk Compositor, Adobe After Effects, and The Foundry Nuke for compositing in Chapter 10.

An Overview of Motion Tracking

Motion tracking detects movement within a section of film or video footage so that it can be applied to a 3D scene, a rendered 3D image sequence, or piece of 2D artwork. Motion tracking is necessary for any visual effect shot that involves a moving camera. The motion may take the form of a hand-held camera or something as simple as a short camera pan or tilt. There are several different forms of motion tracking, which are discussed here:

Transform Tracking The left/right, up/down motion of an element within a piece of footage is tracked. This is a 2D form of motion tracking. You can use transform tracking to determine how the original camera was moving or use it to determine how a character, vehicle, or prop is moving through the shot. Transform tracking can also identify scaling created by forward/backward camera motion or scaling created by the focal length change of a telephoto (zoom) lens. One variant of transform tracking is *corner-pin tracking*, which uses four tracked points to determine how a rectangular feature is moving through the footage.

Stabilization Motion tracking tools are used to identify the motion of the camera and remove it so the shot appears to be stabilized (as if the camera never moved at all).

Camera Tracking The motion of numerous points within the footage is tracked. The tracked points are placed in 3D space based on their relative distance from each other as determined by parallax shifting. A 3D camera is "solved" using the points, thus recreating the original camera. Whereas transform tracking and stabilization produce X and Y animation curves that are applied to 2D layers within the compositing program, camera tracking creates a 3D scene with a 3D camera. Depending on the program used, the 3D camera may be employed within the compositing program's 3D environment or exported to a 3D program like Maya. Camera tracking is demonstrated in the section "Motion Tracking with Autodesk Match-Mover" later in this chapter.

Manual Tracking Whereas the previous motion tracking methods are automatic or semi-automatic, manual tracking necessitates the manual placement and animation of a camera in Maya or similar 3D program. The correct camera position and rotation is determined by comparing

a reference model that replicates the location with an image plane of the original film or video footage. This is demonstrated in the next section.

Note that the general process of motion tracking is often referred to as *matchmoving*.

Manually Tracking a Camera in Maya

Although there are a wide variety of motion tracking tools available, it may be useful, on occasion, to manually track a camera inside Maya. This need may arise because the film or video footage has a violently moving camera, poor exposure, a high degree of motion blur, numerous crossing objects, or similar problems. A manual track requires three important steps: creation of reference geometry, adjustment of Focal Length and Film Back settings, and keyframing of the Maya camera position and rotation.

Building Reference Geometry

In order to manually track a camera inside Maya, you need a piece of geometry to line up with a feature in the film or video footage. The easiest feature to model is one that is static and has straight edges and/or 90 degree corners. Hence, buildings are a good candidate. As Part 1 of Project 4, we'll discuss how to recreate the building featured in the Project 4 image sequence.

You can attach an image plane to a Maya camera and thereby use it for modeling reference. For example, choose View > Image Plane > Import Image through the Persp camera view panel menu and browse for a single frame of the image sequence stored in the `/ProjectFiles/Project4/Footage/Building/` directory (**Figure 8.1**). Once the image plane is loaded, you can start constructing the model using standard Maya modeling tools.

FIG 8.1 A single frame from the Project 4 image sequence is attached to the Persp camera as an image plane.

When building a model based on real-word reference, one difficulty that often arises is the correct determination of the model's dimensions. Visual effects professionals make a point of gathering notes, measurements, photos, survey readings, and even LIDAR scans of real objects or locations so that models can be accurately built by their modeling team. If this material is missing or was never gathered, the dimensions must be estimated. If one or more photos of the real-world reference exist, you can use an external image-based modeling tool to establish the model's dimensions. Image-based modeling uses still images to extrapolate where user-defined features are in three dimensions. Such programs as PhotoModeler, Autodesk ImageModeler, and Google SketchUp are designed for this task.

Although there are many ways to construct a model, Google Sketch-Up offers the advantage of image-based modeling tools. With such tools, we can come up with appropriate proportions and rough dimensions for the building featured in the Project 4 footage. To begin a model in SketchUp, you can follow these steps:

1. Launch SketchUp. Choose Camera > Match New Photo. In the Select Background Image file window, browse for the first frame of the Building image sequence in the `/ProjectFiles/Project4/Footage/Building/` folder. A Match Photo option window opens and the image appears in the background. In addition, an origin axis handle, two vanishing point grids, and two pairs of red and green vanishing point bars are laid on top.

2. LMB-drag the origin handle and place it along the closest corner of the building. The origin has the traditional red, blue, and green axes with the blue axis indicating the Z-up direction. Move the origin so that its bottom sits on the virtual ground slightly beyond the bottom of the frame. You can also LMB-drag the blue axis up and down to change the overall scale. A 2D drawing of a man is added to the scene for size reference (**Figure 8.2**). To zoom out of the view, use the mouse scroll button. To move the view left/right or up/down, MMB-drag.

FIG 8.2 The SketchUp origin is moved to the front corner of the building.

3. LMB-drag the ends of the vanishing point bars so that they line up with features in the image. For example, move one of the green bars to correspond with the right side of the tower top. Move one of the red bars to correspond to the left side of the tower top (**Figure 8.3**). The green bars represent the Y axis, which diminishes away from the camera to the right. The red bars represent the X axis, which diminishes from the camera in the opposite direction. Move the remaining two bars. Keep the matching bars on the same side of the building. For example, keep the red bars on the left-facing walls and the green bars on the right-facing walls. The pairs of bars need not be close to each other. However, it's important that the bars follow the perspective present in the image. Hence, it's best to line the bars up with horizontal architectural features, such as rows of bricks, rows of windows, roof lines, and so on. When the four bars are placed, the vanishing point grids are reoriented and 2-point perspective is accurately recreated. When you're satisfied with the orientation of the grids, you can leave the Match Photo function by clicking the Done button in the Match Photo window.

FIG 8.3 Close-up of placed red and green vanishing point bars. The bars follow rows of bricks in order to pick up the correct perspective.

4. Use SketchUp's modeling tools to create a basic polygonal shape to represent the building (**Figure 8.4**). The tools will automatically stick to the grids to ensure the faces are oriented along the X, Y, or Z axes. Unfortunately, it's beyond the scope of this book to discuss modeling in SketchUp in detail. Nevertheless, you can use the Line tool to draw outlines, the Rectangle tool to draw faces, and the Push/Pull tool to extrude faces. For more information on these tools and general functionality of the program, visit the SketchUp Knowledge Base at help.sketchup.com.

5. After you've roughed the model in and have established the important dimensions, you can export it as an OBJ file. To do so, choose File > Export > 3D Model. To bring the OBJ into Maya, choose File > Import. After the file is imported, you're free to apply additional modeling steps to add more detail.

FIG 8.4 Basic model created with the Line, Rectangle, and Push/Pull tools. An example SketchUp project file is included as Building.skp in the /ProjectFiles/Project4/Models/ directory.

Aside from adding accuracy to a motion tracking task, creating a reference model can assist with the creation of visual effect simulations. For example, you can break up the model to form debris and funnel fluid though the modeled window. We'll explore this in Chapter 9.

Working with the Maya Film Back

Whether you construct a reference model in Maya or in an external program like SketchUp, it's important to match the Maya camera to the original camera as closely as possible. This ensures that the placement of 3D objects and simulations will appear in the correct location and will not drift, slide, or otherwise remain mismatched to the original footage.

Ideally, you should match the Focal Length and Film Back settings of the Maya camera to the original camera. For example, the camera used to shoot the video for Project 4 has these properties:

CMOS sensor size:	1/2.5"
Lens at time of shoot:	6.3mm
Approximate height off ground:	2 feet (at the shot start)
Approximate distance from building:	75 feet

You can determine the sensor size and lens size from the camera's technical specifications, which are generally included in the owner's manual. Sensor size is often expressed in non-standardized "inch" types, where the diagonal length of the chip is listed. Therefore, a 1/2.5 inch sensor type has a diagonal length of 1.0 divided by 2.5, or 0.4 inches. To complicate matters, the types are often approximations and the true sensor size is smaller. For example, a 1/2.5 inch sensor generally has a diagonal measurement of 0.283 inches. To determine the true diagonal length, width, and height of the chip, you can

reference table sensor size charts available at various digital video websites. A 1/2.5 inch sensor has a height of 4.29 mm (0.169 inches) and a width of 5.76 mm (0.227 inches), which produces an aspect ratio of roughly 1:34 (that is, the width is 1.34 times the height), 1.34 is close to 1.33, which is the aspect ratio of standard definition television. Note that the camera used for this project was a compact, consumer HD camera. High-end digital video cameras have significantly larger sensors and lenses with larger mm measurements.

After you've determined the lens, sensor width, and sensor height, you can alter a Maya camera to match. To do so for Part 1 of Project 4, you can follow these steps:

1. Create a new Maya scene. Create a new 1-node camera and name it **RenderCamera.** Open the new camera's Attribute Editor tab. In the Camera Attributes section, change Focal Length to 6.3. In the Film Back section, change Camera Aperture Horizontal/Vertical to 0.227, 0.169 (**Figure 8.5**). This is the width/height of the motion picture film aperture or video sensor. Note that this attribute is read as inches. When the aperture values are updated, the Film Aspect Ratio automatically changes to 1.34. While the original camera sensor used the 1.34 aspect ratio, it stored the MP4 video with a 1.78 wide-screen HDTV aspect ratio. We address the conflicting aspect ratios in the next two steps.

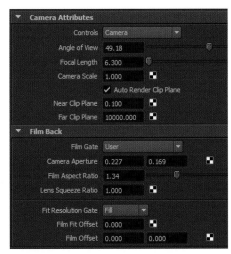

FIG 8.5 The adjusted Camera Attributes and Film Back sections for the RenderCamera.

2. Open the Render Settings window. In the Common tab, change the Image Size Presets menu to HD 1080. Note that the Devise Aspect Ratio changes automatically to 1.777, which is an unrounded variation of 1.78. The render resolution now matches the resolution of the image sequence used by this project.

3. Through a view panel menu, choose Panels > Perspective > Render-Camera. The view panel switches to the RenderCamera view. Through the same view panel menu, choose View > Camera Settings > Resolution Gate. A green or white rectangle appears in the view indicating what is seen by the camera and what area will render. Through the same view panel menu, choose View > Image Plane > Import Image. Browse for the first frame of the image sequence stored in the `/ProjectFiles/Project4/Footage/Building/` directory. The image plane appears and fits within the Resolution Gate. In the image plane Attribute Editor tab, expand the Placement section. The Size Width and Height cells are automatically set to 0.227, 0.169, which matches the values entered into the camera's Camera Aperture Horizontal/Vertical cells. Hence, the 1.78 image is fit to the camera's 1.34 virtual aperture/sensor. This stretching is essentially what the camera did when it captured a 1.78 image on a 1.34 sensor. The Fit menu, in the Placement section, undertakes any necessary image plane stretching. When set to Best, the Fit menu is able to match the 1.78 image to the 1.78 Resolution Gate. Other Fit menu settings undertake different stretching methods, such as matching the vertical or horizontal image dimensions by themselves.

4. With the RenderCamera matched to the original camera, you can proceed to model the reference building in Maya or adapt a model started in an external program such as SketchUp. In either case, adjust the model's scale; for example, the right side of the building should be approximately 10 feet tall. To ensure greater accuracy, move the RenderCamera so that the model lines up with the image plane (**Figure 8.6**).

FIG 8.6 The reference building, constructed in SketchUp and refined in Maya, is lined-up with the image plane by moving and rotating the RenderCamera. By default, the image plane remains fixed to the front of the camera's frustum, even when the camera is moved or rotated. The XRay button for the panel is activated so that the building is transparent. An example Maya scene file is included as Project4.1.ma in the /ProjectFiles/Project4/maFiles/ directory.

5. As previously mentioned, the original camera was approximately 2 feet off the ground and roughly 75 feet from the corner of the right-most building (the building sits on a hill that's higher than the ground where the camera was held). To make the RenderCamera positioning more accurate, you can change Maya's working units to inches, meters, or feet. For example, to change the units to feet, choose Window > Settings/Preferences > Preferences. In the Preferences window, click the word *Settings* in the left column. In the Working Units section, change the Linear menu to Foot. Thus, when positioning the Maya camera, its Translate Y value is indicated in feet. Note that changing the Linear menu may cause the camera clipping planes to cut off objects. To avoid the clipping, raise the Far Clip Plane value through any camera's Attribute Editor tab. (If an orthographic camera is unresponsive and continues to clip objects, you can create a new orthographic camera by choosing Panels > Orthographic > *camera* through a view panel menu.)

6. You can also use measure tools to determine where the camera is in relation to the reference model. For example, choose Create > Measure Tools > Distance Tool, and click twice in a Top view panel. Two locators are placed in the scene and the distance between the two is printed out along a green line (**Figure 8.7**). You can move the locators to update the distance. At this stage, it's also good to check the scale of any imported model; for example, the right side of the building should be approximately 10 feet tall.

FIG 8.7 The Distance tool is placed between the reference building and the RenderCamera icon. The distance is roughly 75 feet . The camera icon has been scaled up so it is easier to see.

The solution for the example scene illustrated by **Figures 8.6 and 8.7** required the following RenderCamera transforms (once again, the linear units are in feet):

Translate X:	69	Rotate X:	13.4	
Translate Y:	2	Rotate Y:	43	
Translate Z:	55.5	Rotate Z:	−0.8	

When fine-tuning the camera's position and rotation, it's often necessary to go through the following steps:

- Leave the reference model at 0, 0, 0 and at "ground level" (with its base sitting at 0 in Y). Interactively transform and rotate the camera icon in the view panels so that it sees the correct side of the model.
- Refine the camera position by using the Alt+mouse buttons shortcuts inside the perspective view panel. Alternatively, highlight a transform attribute in the Channel Box and change its value by MMB-dragging left or right in a view panel.
- Further refine the camera position and rotation by manually raising or lowering values by small increments in the Channel Box.

Note that changing the linear units of a scene may also cause icons to appear excessively small. For example, switching to feet makes it difficult to locate cameras, lights, locators, and so on. You can scale any of these items up without affecting their functionality. For example, change the scale of RenderCamera to 50, 50, 50.

Animating a Matched Maya Camera

After you've positioned the Maya camera to line-up the reference model with the image plane, you can animate the camera so that the reference model appears to take on the camera motion contained in the original footage. This requires that the image plane contains the entire image sequence. To animate the new Project 4 RenderCamera, follow these steps:

1. Set the timeline range to run from 1 to 60. Choose Window > Settings/Preferences > Preferences. In the Preferences window, click on the word *Settings* in the left column. Change the Time menu to NTSC(30 fps). This frame rate matches the frame rate used when the video was shot.
2. Through the RenderCamera view panel, choose View > Image Plane > Image Plane Attributes > RenderCameraShape- > imagePlaneShape1. In the Attribute Editor, note which frame number is loaded through the Image Name cell. In the example Maya files, frame 1 is used. Go to the same frame on the timeline. For example, if you're using 1, go to frame 1. Select the RenderCamera icon in a view panel. Keyframe it at its current position and rotation by choosing Animation menu set > Animate > Set Key or using the S hot key.
3. Return to the image plane Attribute Editor tab. Select the Use Image Sequence attribute. This writes an expression to relate the current frame

to the numbered image sequence. Scrub the timeline. The image sequence plays back correctly, with the frames loaded in the correct order.

4. Go to the opposite end of the timeline. For example, if you keyed the camera at frame 1, go to frame 60. Position the camera so that the building model once again lines up with the image plane. On frame 60, the camera should be slightly lower and to the camera left side. The positional changes should be relatively minor. Change the camera's rotation to further match the model to the image plane. For example, you can use the following transforms:

Translate X:	68.02
Translate Y:	1.21
Translate Z:	55.18
Rotate X:	13.7
Rotate Y:	45.5
Rotate Z:	0

5. The camera motion we are matching is relatively smooth and predictable, so we can use the bisecting method to set additional keyframes on the RenderCamera. For example, go to frame 30, position the camera, set a key, then go to frames 15 and 45 and repeat the process. Continue to set new keyframes in between old ones until the building model follows the image plane smoothly. Some areas of the timeline may require denser groups of keyframes, while other areas may require fewer keyframes. The best way to gauge the animation is to create a Playblast. To create a Playblast, select the RenderCamera view panel and choose Window > Playblast > □. In the Playblast Options window, set the Format, Display Size, and Scale attributes, and click the Playblast button. If you set Format to Image (Maya 2013) or Iff (Maya 2014), Maya's FCheck viewer plays back the result. FCheck is generally more reliable and easier to control than the operating system's default AVI or QuickTime movie player. Note that frames in between frame 1 and frame 60 will require less positional adjustment and more rotational adjustment. Feel free to edit the resulting animation in the Graph Editor. For example, alter the tangent types of the keyframes to create smoother curves.

Rest assured, manual motion tracking is not a fast process and may appear inferior to automated motion tracking methods. However, it's a good technique to be familiar with as automated systems fail on occasion. An example Maya scene file that includes completed manual tracking is included as `Project4.2.ma` in the `/ProjectFiles/Project4/maFiles/` directory.

This concludes Part 1 of Project 4.

Motion Tracking with Autodesk MatchMover

Autodesk MatchMover is a standalone program designed for motion tracking tasks. You can export the resulting data to other programs, including Maya. When you install Maya, you have the option to install MatchMover. By default, you can find the MatchMover program in the /Autodesk/MatchMover20nn/ program directory.

2D Tracking in MatchMover

MatchMover's 2D tracking is an automated form of camera tracking, where a 3D camera is generated from tracked points. The MatchMover interface has two styles of operation: Light and Full. We'll use the Full interface for Part 2 of Project 4. The key interface components are illustrated by **Figure 8.8**.

FIG 8.8 The MatchMover Full interface.

To apply 2D tracking as Part 2 of Project 4, follow these steps:

1. Launch MatchMover. Set the interface menu, at the top-left, to Full. Choose File > Load Sequence. In the Load Sequence window, navigate to the /ProjectFiles/Project4/Footage/Building/ directory. Select the first frame of the Building.##.png image sequence. At the bottom of the Load Sequence window, change the Frame Rate menu to 30 fps (**Figure 8.9**). Leave the Focal Length menu set to Constant and the Motion menu set to Free. These settings match the camera used to shoot the original video–the camera was hand-held and used a fixed (non-tele-photo) lens. (If the footage you import features a changing focal length though a zoom in or zoom out, you can set Local Length to Variable.) Click the OK button. The image sequence is loaded into the workspace.

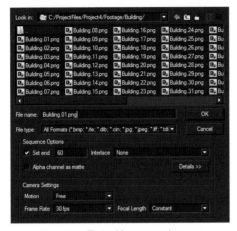

FIG 8.9 The Load Sequence window.

2. Change the timeline Frame Rate cell to **30** (the cell to the left of the word *fps* on the timeline). Using the playback controls, examine the footage.

3. Return to frame 0. By default, MatchMover creates a 3D camera. This is listed in the Project window in the Camera folder and is named Camera 01. Switch to the Camera 01 tab in the Parameters window (**Figure 8.10**). The camera is given a generic Film Back Width and Height, as well as a generic Focal Length value. If you lack specific information about the camera used to shoot the sequence, you can leave the camera properties as is. When the tracking is applied, the Focal and Film Back values are estimated and updated. Alternatively, if you possess the camera information, you can enter it here. To do so, change the Unit menu from mm to Inch. Enter **0.227** into the Film Back Width and **0.128** into Film Back Height (0.227 was determined as the sensor width earlier in this chapter. 0.128 is the sensor width, 0.227, divided by the image sequence aspect ratio, 1.778.) Note that the Ratio cell is set to 1.778 to indicate the image

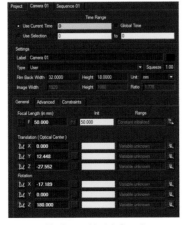

FIG 8.10 The Camera 01 tab before adjustment.

sequence aspect ratio. In the General section, enter **6.3** into the Focal Length cell (beside the small F). Click the Camera Type button at the far right side of the Focal Length line. The Parameter Range Editor window opens. Change the Status section from Free to Fixed. Click the OK button. The Range cell changes from Constant Initialized to Fixed. This indicates that the program will employ the user-entered Focal Length and Film Back values and will not calculate new lens values during the tracking process.

4. In the General section, change the Translation cell values to the following: 0, 2, 0. The units are generic, but we can relate them to feet. In such a case, 2 is 2 feet, which was the approximate height the camera was off the ground at the time of the shoot. You can see the affects of the changes on the 3D camera by switching to the 3D view. To do so, click the small *3D* button at the top-left of the workspace. The image sequence appears as the image plane fixed to the end of the camera's frustum. To change the view within the 3D space, LMB-click and drag the camera buttons at the bottom-right of the workspace. You can return to the 2D view at any time by clicking the small *2D* at the top of the workspace. Return to the Camera 01 tab. In the General section, click the button beside Translate X (it features a small face). The Parameter Range Editor window opens. With Status set to Free, click the OK button. The X Range cell changes to Free. This indicates that the user-defined X value is used as a start value for the tracking (as opposed to an arbitrary value provided by the program). Repeat this process for Y and Z so their Range cells also read *Free*.

5. In the General section, set the Rotation X, Y, and Z cells to 15, 0, −180. This tilts the camera upwards slightly; −180 is necessary for the X rotation to prevent the camera from flipping upside-down. Set the X, Y, Z Range cells to Free using the process outlined at the end of Step 4 (**Figure 8.11**).

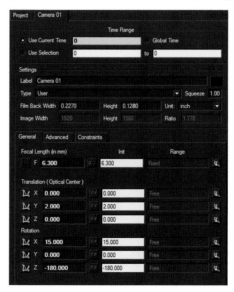

FIG 8.11 The Camera 01 tab after adjustment.

6. Choose 2D Tracking > Automatic Tracking. The Automatic Tracking window opens. Click the Settings button. The window expands to display a preview of the current frame (**Figure 8.12**). A large number of small white cross-hairs are laid over the frame. Each cross-hair represents a trackable feature—that is, a small pattern of high-contrast pixels referred to as a *track*. Change Min Track Length to 30. This forces the tool to only use tracks that survive a minimum of 30 frames (half the length of the footage). (Some tracks will disappear because their pattern is occluded, motion blurred, and so on.) Reduce the Sensitivity slider to the fourth tick mark from the left, reduce the Density slider to the fifth tick mark to the left. When you alter Sensitivity and Density, the number of cross-hairs in the preview changes. Lower values make the tool more particular when choosing potential tracks (for example, the tool concentrates on high-contrast patterns). It also makes the tool less likely to use tracks that may be difficult to create motion paths for. Note that the Track Using menu is set to Grayscale, which tracks by looking at the intensity (brightness) values of pixels. You can also set this menu to Colors to examine RGB pixel values.

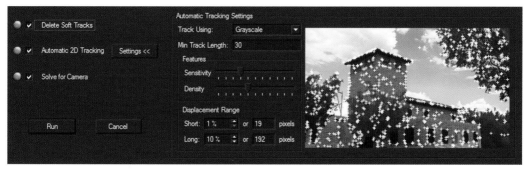

FIG 8.12 The Automatic Tracking window.

7. In the Automatic Tracking window, click the Run button. The tracking proceeds through three phases:
 - Old "soft" tracks, which are tracks automatically generated by the tool, are removed before new ones are created.
 - The motion paths of new tracks are calculated over time.
 - A camera is solved; that is, the 3D camera's position and rotation is updated by interpolating the motion paths of all the viable tracks. If Focal Length and Film Back values were not provided by the user, these values are also calculated and updated.
8. When the tracking is compete, a number of colored track cross-hairs appear in the 2D view of the workspace along with short fragments of motion paths (**Figure 8.13**). Play back the timeline. The track positions update and different segments of their motion paths appear.

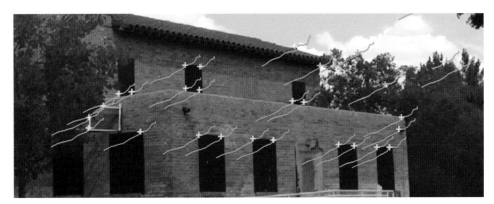

FIG 8.13 Close-up of track motion paths created by the Automatic Tracking tool.

9. Switch back to the 3D view. A number of blue cones appear between the camera and the image plane (**Figure 8.14**). These represent the solved 3D positions of viable tracks. Not all tracks are used. Tracks that disappear or return a low level of confidence (that is, reliable trackability) are ignored. In fact, you can see a full list of tracks and their qualities in the Project window. To see these, expand the Point Tracks and Auto Tracks folders (**Figure 8.15**). Green tracks are good and yellow tracks are fair. In addition, gray tracks are non-viable and are ignored. Should they appear, red tracks are poor.

FIG 8.14 Blue cones represent the 3D-solved positions of tracks. The solved camera appears as a blue camera icon.

10. You can use the camera buttons at the bottom-right side of the workspace to investigate the 3D scene. For example, to orbit about the scene, click the Orbit button and drag without letting go (your mouse does not have to hover in the workspace). The blue cones also indicate the relative positions of tracked detail. For example, the tracks placed over the window frames of the right-most building are closer to the image plane, while tracks placed over various tree leaves are closer to the camera. The positions aren't

FIG 8.15 A small portion of the tracks created by the Automatic Tracking tool. Green tracks are good, yellow tracks are fair, and gray tracks are ignored.

necessarily a perfect reproduction of the real-world scene, but they are generally sufficient for motion tracking proposes. Play back the timeline. The camera is animated and thus emulates the motion of the real-world camera.

Ultimately, the quality of the camera solve is dependent on the quality of the track motion paths. If too few tracks are considered good or fair, the camera solve may be inaccurate. You are free to reapply the Automatic Tracking tool with new settings at any time to update the tracking results. You can also adjust the camera parameters before reapplying the tracking to see slightly different tracking results. Once you're satisfied with the tracking, you can export a camera to Maya. This is discussed in the next section. In the mean time, you can save the MatchMover project file in its native .mmf format by choosing File > Save As. An example MatchMover project file is included as `Tracking.mmf` in the `/ProjectFiles/Project4/mmfFiles/` directory.

Importing a MatchMover Camera into Maya

After you've completed tracking in MatchMover and have produced a solved camera, you can export the camera to Maya. To do this, choose File > Export. In the Export window, choose a File Name, change the File Type to Maya (`*.ma`), and click the Save button.

When opening the exported file in Maya, there are a few adjustments you must make to make the camera usable. You can follow these steps when using the Project 4 MatchMover project created in the previous section:

1. Create a new Maya scene file. Choose Window > Settings/Preferences > Preferences. In the Preferences window, click on the word *Settings* in the left column. Change Time to NTSC(30 fps). The Maya frame rate must match MatchMover's frame rate, else the camera animation will be incorrectly interpreted. Set Linear to Foot to remain consistent with prior steps in this chapter. Click the Save button to close the window. Set the timeline range

to run from 1 to 60. Open the Render Settings window. Set the Image Size Preset menu to HD 1080. To prevent objects from disappearing, increase the Far Clip Plane of each camera to a large number, such as 999,999.

2. To test the accuracy of the camera solve, you'll also need a reference model. For Project 4, you can use the building model. A copy is saved as `Building.obj` in the `/ProjectFiles/Project4/Models/` directory. Import the OBJ by choosing File > Import.

3. Import the Maya scene created by MatchMover by choosing File > Import. An example file is included as `MatchMoverCam.ma` in the `/ProjectFiles/Project4/maFiles/` directory. The new camera, named MatchMoverCam:rzCamera1, and a group of locators appear (**Figure 8.16**). Each locator represents the position of a solved track. You can reduce the size of the locators by selecting the locator nodes in the Hypergraph or Outliner and reducing the Scale values in the Channel Box (you can reduce the Scale of multiple selections in the Channel Box in one step).

FIG 8.16 The initial position of the imported MatchMover camera.

4. Switch a view panel to the new camera by choosing Panels > Perspective > MatchMoverCam:rzCamera1. In addition, choose View > Camera Settings > Resolution Gate. The locators appear in the correct location over the image plane details. However, the building model is not in the correct place. Play back the timeline. The camera is nevertheless animated and the locators follow their associated details in the image plane. (If the image plane is not visible, select the camera icon.)

5. At this stage, the camera and locators are overlapping the edge of the building and are also very small compared to the building. To solve this problem, you can reorient and scale the camera and locators as a group. To do this, Shift-select the camera and the pre-existing locator group nodes, choose Edit > Group. Scale the group to 50, 50, 50 to make it easier to see the camera icon. You can then move and rotate the group so the building lines up with the image plane (**Figure 8.17**). To make it easier to move the camera, move the pivot of the group node so that it lines up with the back of the camera icon lens (**Figure 8.18**). You can go in and out of

pivot mode by selecting the group node and pressing the Insert key. Because the image plane is attached to the camera and a new group node gains the new transforms, the camera animation exported by MatchMover will remain intact. For example, the following group node transforms work well for the example files:

Translate X:	70.2
Translate Y:	1.0
Translate Z:	53.4
Rotate X:	−180.8
Rotate Y:	−47.1
Rotate Z:	184.9

FIG 8.17 The MatchMover camera and locators are grouped together. The group is moved and rotated to line up the building with the camera's image plane.

FIG 8.18 The repositioned pivot of the group node places the transform handle at the back of the camera icon lens.

6. Play back the timeline or create a PlayBlast. The motion tracking works as the building smoothly follows its counterpart in the image sequence (**Figure 8.19**). You can hide the locators at this point to simplify the scene. Open the Attribute Editor tab for the imported camera. Note that the Focal Length is set to 6.3 and the Camera Aperture Width/Height is set to 0.227, 0.128, matching the camera in MatchMover. This produces an Aspect Ratio value of 1.77. Rounding errors between programs have prevented a more accurate 1.778 or 1.78 aspect ratio value from appearing—nevertheless, the value is close enough to make the imported camera work for motion tracking. The Focal length is keyed, but there is no change in value over time.

FIG 8.19 The lined-up building, as seen on frame 1. An example Maya scene file is included as Project4.3.ma in the /ProjectFiles/Project4/maFiles/ directory.

One potential problem when matching a camera is lens distortion. This often occurs near the frame edges and causes detail to distort; for example, an otherwise straight wall may bend as the camera moves. In the example file illustrated by **Figure 8.19**, this manifests as undulation of the far right wall edge. If you know the lens distortion factor, you can enter the value into the Distortion cell of the Advanced tab within the camera's parameter tab in MatchMover. However, determining the distortion factor of the lens requires advanced testing. For example, tests shots with gridded cards must be examined. It's also possible to address distortion issues during the visual effects compositing phase. Compositing is discussed further in Chapter 10.

This concludes Part 2 of Project 4.

Manual 2D Tracking in MatchMover

MatchMover's Automatic Tracking tool automatically determines the locations of tracks. However, you can supervise this process by manually placing additional tracks. Alternatively, you can bypass the Automatic Tracker and

motion track solely using manually-placed tracks. The general approach to manual tracking follows:

- To add a new track, choose 2D Tracking > New Track. Click in the workspace over a feature you'd like to motion track. A new track is placed at the point you click. The Track is listed in the Point Tracks folder in the Project window.
- The track is composed of two boxes: an inner box (pattern zone) and an outer box (search zone) (**Figure 8.20**). The inner box defines the pattern of pixels that the program motion tracks over time. The outer box defines the area to which the program goes to find the pattern if it's lost due to camera motion, motion blur, occlusion, and so on. You can LMB-drag the central cross-hair to move the boxes; as you do, a zoom window shows a close-up of the pattern zone. You can LMB-drag the box corners or handle dots to change their size and shape. A larger pattern box will slow the tracking process. In general, you want to place the track over a high-contrast detail that doesn't leave the frame and has a minimal amount of distortion. To better view the track boxes, you can zoom into the workspace by using the View > Zoom tool. To scroll, use the Pan tool at the bottom right of the workspace.

FIG 8.20 A manually-placed track. The inner box is the pattern zone and the outer box is the search zone.

- After you've adjusted the track position, you can launch motion tracking for the track by pressing the F3 key or choosing 2D Tracking > Track Forward. The timeline is played forward and a motion path is constructed. A close-up view of the pattern zone is displayed in a Tracking Monitor window. Upon completion, the motion path indicates the quality of the tracking (**Figure 8.21**). Green sections are considered high-quality. Yellow sections are considered fair-quality. Red sections indicate bad quality. Yellow and red sections indicate that the pattern box has slipped off the original pattern.
- Select the track, either in the workspace or the Project window. Move the timeline forward. The track moves across the motion path. Stop at a frame where the motion path segment is yellow or red. Examine the quality of the track position. Odds are the track has slipped off the pattern.

FIG 8.21 The initial tracking of a track. The motion path quality is indicated by green, yellow, and red colors.

Interactively move the track to the correct location and therefore force a keyframe onto the track position for the current frame. When a keyframe is added, the remainder of the motion path is removed. You can re-track from the current frame to the end by choosing 2D Tracking > Track Forward. Repeat the process of adding keyframes and re-tracking until the motion path appears accurate. Note that you can track forward, backward, or bi-directionally by choosing the same-name options through the 2D Tracking menu. Also note that the color of a motion path segment is not a guarantee of accuracy—green segments might carry a slightly inaccurate pattern location, Hence, it's a good idea to manually check each frame. When more than one keyframe exists for a track, updating the track position only removes the motion path between the current keyframe and the next keyframe.

- After you've successfully created a track, you are free to add additional tracks. After a sufficient number of tracked tracks are present (generally four or more), MatchMover attempts to solve their positions in 3D space. The solve is indicated by a circle attached to the path in the 2D view of the workspace as a blue cone in the 3D view of the workspace (**Figure 8.22**). The quality of a track is indicated by the green/yellow/red colors of the solved circles and the dots beside the track names in the Project window and the Track window. Keyframes are also indicated in the Track window as black tick marks. You can delete a track at any time if it's considered unusable (with a gray dot) or the track produces a wildly inaccurate 3D solve (its blue cone is in an incorrect location compared to other cones). To delete a track, highlight the track name in the Project window and press the Delete key.

- If four or more 3D-solved tracks are present, you can attempt to solve the 3D camera. As with Automatic Tracking, you are free to adjust the parameters of the 3D camera that are provided when you load the footage. To solve the camera, choose 3D Tracking > Solve For Camera. After the solve is complete, the camera position and rotation updates as it is animated over time. The blue cone positions and the quality color of the

FIG 8.22 A circle appears on the motion path of a track, indicating that the 3D position of the track is solved. When the circle first appears, it may be off the path and connected by a line. A successfully-solved camera places the circle directly on the path.

various tracks may also update (**Figure 8.23**). You can examine the solved camera in the 3D view. You are free to export the camera. If the solve appears inaccurate, you are free to adjust the tracks and re-solve the camera.

FIG 8.23 The Track window after a camera solve with six manually-placed tracks. The black tick marks indicate keyframes. The top colored line indicates the overall quality of the solve. The small *1* and *2* tabs are master reference frames chosen by the camera solving process. An example MatchMover project file is included as ManualTracking.mmf in the /ProjectFiles/Project4/mmfFiles/ directory.

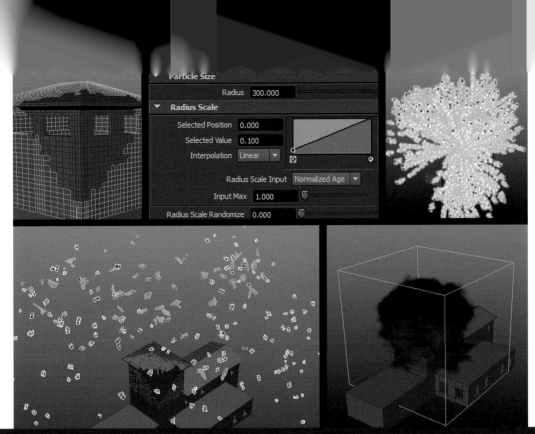

Combining nCloth, nParticles, and Fluid Effects to Create Complex Destruction

Although we've examined each visual effects system in Maya by itself, it's important to remember that you can combine the systems to create more complex results. For example, the destruction of a building or similar structure may involve many different phenomena, including fire, smoke, dust, and debris. As such, you can combine nDynamic and Fluid Effects systems in a scene to create a single visual effects event. In addition, you can use the Create Shatter tool, to "pre-destroy" a reference model.

This chapter includes the following critical information:

- Applying the Create Shatter tool
- Converting shards to nCloth and attaching nParticle emitters

- Setting up fluid containers to interact with passive geometry, nCloth, and nParticles

In addition, this chapter takes you through Part 3 to Part 5 of Project 4. Project 4 features live-action video footage of an abandoned water station. In Chapter 8, we built reference geometry and motion tracked the footage to produce usable Maya cameras. In this chapter, we'll create complex damage to the building by using the Create Shatter effect, nCloth bodies, nParticle emitters, and Fluid Effects containers.

Destroying the Geometry with Shatter and nCloth

The first task when creating structure damage in Maya is to create the large-scale debris. For example, pieces of concrete, bricks, girders, or wood beams may compose the structural elements of a building. You can hand-model these items for the maximum detail. Alternatively, you can break up a reference model into smaller pieces. The Create Shatter tool offers you the means to do this.

Preparing a Model for Shattering

The Create Shatter tool works best when the geometry is properly prepared. As Part 3 of Project 4, we can prepare the building model created as reference. You can follow these steps:

1. Open the `Project4.3.ma scene` file. This is located in the `/ProjectFiles/Project4/maFiles/` tutorial directory. The scene includes a polygon building modeled as reference and a motion tracked camera imported from MatchMover. By default, the camera is named MatchMoverCam:rzCamera1. Through the Channel Box or Attribute Editor, rename the camera **RenderCamera.** Rename the camera group node **CameraOffset** (see **Figure 9.2** after Step 4).
2. Examine the building model. The model was created in Google SketchUp, imported into Maya, and adjusted. There is a minimum amount of detail. The goal of this part of the project is to collapse a section of the building's tower. Hence, it's necessary to separate pieces and construct more detail.
3. Select the faces that compose the wall of the upper tower. You can use the Persp camera to move close to the model. Switch to the Polygons menu set and choose Mesh > Extract. The building is broken into two nodes parented to a group node. Temporarily move the wall section aside (**Figure 9.1**).
4. The windows on the top of the tower are extruded inwards. Although this is useful for particle of Fluid Effects interactions, it will interfere with the Shatter tool's ability to give the surface thickness. Select the extruded faces along the inside of each window and delete them. Select the remaining faces on the top of the tower and choose Mesh > Extract. The

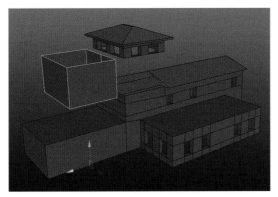

FIG 9.1 Faces composing the tower walls are extracted and temporarily moved aside.

building model becomes three objects tied together with two group nodes. In addition, the Extract tool creates transform nodes designed for an extraction offset. In the Hypergraph, interactively pull the group apart (or, use Edit > Ungroup on each parent node). Delete the transform and group nodes (if they remain). Rename the surface nodes **BuildingBase**, **TowerWalls**, and **TowerTop** to match their namesake location on the building (**Figure 9.2**). At this point, you can also delete the MatchMoverCam:rzTrackerGroup node, along with all the motion tracking locators—they are no longer needed.

FIG 9.2 Updated node names, as seen in the Hypergraph. Note that this scene is using new orthographic cameras to avoid clipping plane errors.

5. Move the TowerWalls surface back to its original position. At this point, the surfaces do not possess UV information. To create a functioning UV layout, select one surface at a time and choose Create UVs > Automatic Mapping.

Preparing a Mesh for the Creation of Shards

The Create Shatter tool breaks the surface in a random fashion, using preexisting edges. Each section is referred to as a *shard*. If the shard count is less than the surface face count, the shards are composed of multiple faces. You can choose the number of shards when applying the tool. You can also force the shards to be in specific locations by applying the tool to a high-resolution surface. For example, to create numerous, brick-like shards, update the model so that it possesses a large number of quadrilateral faces. You can apply various modeling tools to achieve this, including:

- Interactive Split Tool
- Insert Edge Loop Tool

- Cut Faces Tool
- Add Divisions

These tools are all found within the Edit Mesh menu. You can force the Add Divisions tool to add divisions in the U and V directions by selecting the Linearly radio button in the Add Divisions To Face Options window; you can then set the Divisions In U and Divisions In V slider values. As an example, **Figure 9.3** illustrates the result of such modeling.

FIG 9.3 The TowerWalls and TowerTop surfaces are updated to give them higher resolution while maintaining quadrilateral faces. An example Maya scene file is included as Project4.4.ma in the /ProjectFiles/Project4/maFiles/ directory.

The Create Shatter tool requires "clean" surfaces with no errors. In addition, the tool prefers that each surface is assigned to a single material, has a central pivot, and has zeroed-out transforms. To ensure the building surfaces possess these traits, follow these steps:

1. Select the building surfaces and assign them to the default Lambert1 material through the Hypershade window.
2. Center the building surface pivots by choosing Modify > Center Pivot.
3. Choose Modify > Freeze Transformations. The current Translate and Rotate values are set to 0, 0, 0 and the Scale is fixed at 1, 1, 1 for each surface.
4. To remove any unseen errors, such as nonmanifold geometry (edges that are extruded in more than two directions), choose Mesh > Cleanup to launch the Cleanup tool. In the Cleanup Options window, reset the tool by choosing Edit > Reset Settings from the upper-left menu. In the Remove Geometry section, select Lamina Faces, Nonmanifold Geometry, Edges With Zero Length, and Face With Zero Geometry Area. Click the Cleanup button. Any geometry errors that match the selected criteria are removed automatically (these errors are often imperceptible, so there may be no overall change to the surface appearance).
5. As an extra precaution, you can ensure that no unmerged vertices exist on the model by using the Merge tool. To do this, select one surface, such as TowerWalls, RMB-click over the surface in a view panel, and choose Vertex

from the marking menu. Select all the vertices on the surface. Choose Edit Mesh > Merge with its default settings. The tool merges vertices that are within 0.01 world units of each other, including those that already overlap but may not be merged. Select the surface as an object. Chose Edit > Delete By Type > History to remove the construction history. Repeat this process for the remaining surfaces.

Applying the Create Shatter Tool

After the geometry is prepared, you can apply the Create Shatter tool. You can follow these steps to shatter the Project 4 tower:

1. Select the TowerWalls surface. Switch to the Dynamics menu set. Choose Effects > Create Shatter > □. In the Create Shatter Effect Options window, switch to the Surface Shatter tab. Enter **WallShatter** into the Surface Shatter Name cell (**Figure 9.4**). Change Shard Count to 2048. Set Extrude Shards to −1.0. Leave Post Operation set to Shapes. Deselect Triangulate Surface and Smooth Shards. Click the Hide radio button beside Original Surface. Click the Create button. The tool breaks up the surface with boolean operations. At the same time, each resulting shard is extruded along its normal by the number of world units determined by the Extrude Shard attribute (a negative value is an inwards extrusion). Due to the high number of shards, the process may take several minutes.

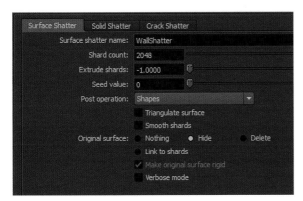

FIG 9.4 The adjusted Create Shatter Effect Options window.

2. Examine the Hypergraph or Outliner. Each new shard is represented by a polygon node under a WallShatter group node. The original surface is hidden. In a view panel, click on the shattered surface in several places. Select one of the new brick-like shards and temporarily move it away from the wall (**Figure 9.5**). Note that the shards meet at their edges.
3. Select the TowerTop surface. Choose Effects > Create Shatter > □. In the Create Shatter Effect Options window, switch to the Surface Shatter tab.

FIG 9.5 A brick-like shard is temporarily moved away from the shattered wall. The wall now attains thickness.

Enter **RoofShatter** into the Surface Shatter Name cell. Change Shard Count to 1024. This will produce larger shards on the roof. Set Extrude Shards to –0.5. A smaller Extrude Shards value prevents the roof from intersecting itself at the edges. Leave Post Operation set to Shapes. Deselect Triangulate Surface and Smooth Shards. Click the Hide radio button beside Original Surface. Click the Create button. The TowerTop surface is shattered and gains thickness.

Aside from the Shatter Surface function, the Create Shatter tool also offers Solid Shatter and Crack Shatter (each in their own tab). Solid Shatter treats the surface as if it's non-hollow and procedes to fill in any interior gaps with extruded faces. Crack Shatter forms cracks in a radiused pattern from a single point and is suitable for recreating broken glass or other 2D surfaces.

VFX Notes: Shatter Plug-Ins

There are a number of plug-ins available for Maya that perform shatter functions. These include Ruins Shatter Matter, ShatterPlus, and Ninja Fracture. Many of these plug-ins are available via `creativecrash.com`. When precise damage is required, it may be necessary to hand-model broken bits and pieces.

Recombining and Scaling Shards

The Create Shatter tool shatters the entire selected surface. In the case of Project 4, this creates a large number of shards. We can limit the shards to a smaller area, however, by recombining shards that will not be seen or are not necessary for the visual effects simulation. You can follow these steps:

1. Using the Select and/or Lasso selection tools, select a jaggy group of shards along the tower corner facing the camera (**Figure 9.6**).

FIG 9.6 Shards at the front corner are selected. These shards will remain intact for dynamic simulation.

2. Invert this selection by using the Select tool and the Shift button to drag a marquee around all of the shards. After the selection is inverted, switch to the Polygons menu set and choose Mesh > Combine. The selected shards are converted into a single polygon surface, named polySurface1. Rename the surface **UnbrokenTower.** With UnbrokenTower selected, choose Edit > Delete By Type > History.

3. The surviving shards touch at the edges. For example, the upper face of one shard is in exactly the same place in space as the bottom face of the shard above it. This generally leads to interpenetration problems when the shards are converted to dynamically-simulated surfaces, such as rigid bodies or nCloth objects. To lessen the potential of interpenetration, you can scale the shards down slightly. To do so, select the shards (but do not select other parts of the building). Through the Channel Box, change the Scale of all the selected shards to 0.95, 0.95, 0.95. Each shard is scaled by its volumetric center (**Figure 9.7**).

FIG 9.7 Shards along the back of the tower are converted into a single polygon surface. The surviving shards are scaled down to avoid intersections. An example Maya scene file is included as Project4.5.ma in the /ProjectFiles/Project4/maFiles/ directory.

Texturing and Lighting Shards

When shards are created with the Create Shatter effect, the original polygon faces keep their UV layout. However, faces created as part of the shard extrusion have no UV information. This prevents detailed texturing, which is necessary for the shards to look brick-like. To give the shards a workable UV texture space and apply a texture, follow these steps:

1. Select all of the shards without selecting other parts of the building. Switch to the Polygons menu set. Choose Create UVs > Automatic Mapping. Open the UV Texture Editor (Window > UV Texture Editor). Because the shards are separate objects, they overlap heavily. In a later step, we'll project a texture onto the shards and convert the texture into a unique bitmap for each shard. Hence, overlapping is not a problem. In a view panel, select one shard. Note that each shard is neatly laid out in the UV Texture Editor so that it maximizes the space (**Figure 9.8**).

FIG 9.8 The shards are given functional UVs by applying the Automatic Mapping tool. A single shard is shown here in the UV Texture Editor.

2. In the Hypershade window, create a new Lambert material. Name the material **ShardMaterial** and assign it to all the shards. Open the Attribute Editor tab for ShardMaterial. Click the checkered Map button beside Color. In the Create Render Node window, click on the Utilities category name in the Maya section of the left column. Choose the Projection icon. In the new projection1 node's Attribute Editor tab, click the checkered Map button beside Image. In the Create Render Node window, choose the File icon. In the new file1 node's tab, click the browse button and retrieve frame 1 of the image sequence in the `/ProjectFiles/Project4/Footage/Building/` directory.

3. In the Hypershade, place the mouse on the ShardMaterial icon, RMB-click, and choose Graph Network. Examine the shading network in the work area (**Figure 9.9**). The shards receive their color from the file1 node, which is projected with the projection1 utility. Return to the projection1 Attribute Editor tab. Change the Proj Type menu to Perspective. Expand the Camera Projection Attributes section. Change Link To Camera to RenderCameraShape. The projection now occurs from the view of the RenderCamera.

place2dTexture1 file1 projection1 ShardMaterial

FIG 9.9 The shading network created for the shards.

4. In the Render Settings window, switch to the mental ray renderer and set the anti-aliasing attributes to high quality. Hide the BuildingBase and UnbrokenTower surfaces. Go to frame 1 and test render. The building color appears on the shards (**Figure 9.10**). If blue sky appears on the bricks along the roofline, you can offset the projected image by adjusting the Offset V value of the place2dTexture1 node connected to the file1 node. For example, an Offset V value of −0.006 is used for **Figure 9.10**.

FIG 9.10 The projected texture.

5. The shards remain poorly integrated due to incorrect lighting. To change this, add several Maya lights. Try to replicate the lighting that existed at the original location. The building was shot on a bright, yet cloudy, day. The light is arriving from the sky, in the direction of the camera, with a significant amount of bounced fill light. You can replicate this with two lights: one strong key and one weaker fill. For example, create a directional light (the key) and an ambient light (the fill). Rotate the directional so it points down from the direction of the camera. Place the ambient light low and to the camera left. The precise position of the directional light does not matter—only its rotation affects its light quality. For example, in **Figure 9.11**, the directional light is rotated −28, 67, 0 while the ambient light is

placed at −18, −31, 80 (**Figure 9.11**). Adjust the light intensities. For example, in **Figure 9.12**, the directional is left with a default Intensity of 1.0, while the ambient light is given an Intensity of 0.8. Note that you may need to scale up the directional light icon so that it is easier to work with.

FIG 9.11 Directional and ambient lights replicate the real-world lighting scenario. The non-shard building surfaces are temporarily unhidden.

FIG 9.12 The lit render.

6. Although a projected texture is suitable for a still frame, it will not work when the shards are in motion. Therefore, it's necessary to convert the projection into bitmap textures. To do so, select all the shards as objects, Shift+select ShardMaterial, and choose Edit > Convert To File Texture (Maya Software) through the Hypershade menu. In the Convert To File Textures Options window, select the Anti-Alias button, change the X Resolution and Y Resolution to 128, and change the Image Format to TIF (**Figure 9.13**). Click the Create And Close button. A new ShardMaterial is created for each shard object. In addition, a new bitmap texture is written out for each shard (hence, the resolution is kept small). The bitmaps are located in the default project directory and are named `projection1-shardn.tif`. The disadvantage of this

system is the large number of materials and texture bitmaps that are created. However, the shards can be animated without risking a sliding texture. In addition, each shard receives a unique section of the projected image (**Figure 9.14**).

FIG 9.13 The adjusted Convert To File Textures Options window.

FIG 9.14 An example shard bitmap created with the Convert To File Texture (Maya Software) tool. The resolution is kept small at 128x128. An example Maya scene file is included as Project4.6.ma in the /ProjectFiles/Project4/maFiles/ directory. The correspondiong texture bitmaps are included in the /ProjectFiles/ Project4/ directory.

The integration of the shards and the image plane is not perfect at this point. For example, the bottom-side of the lower shards can be seen. The gaps between the shards are obvious. Several shards pick up the color of the nearby tree. The shards appear very smooth. Nevertheless, we'll address all these issues as we render and composite the shards in Chapter 10.

Converting Shards to nCloth Objects

To dynamically simulate the movement of the shards, you can convert them to Dynamics system rigid bodies or nDynamics system nCloth objects. To stay within the nDynamics system, we'll use nCloth objects on Project 4. To convert the Project 4 shards, follow these steps:

1. Select all of the shards as objects. Switch to the nDynamics menu set. Choose nMesh > Create nCloth. A new Nucleus solver node is created, as well as a new nCloth node for each shard. This creates a long list of nCloth nodes. To make navigation within the Outliner of Hypergraph easier, select all of the nCloth nodes and group them together with Edit > Group. Name the new group node **nClothGroup.**
2. Each nCloth node has its own set of attributes. To set all of the nCloth nodes' attributes simultaneously, you can use the Channel Box. To do so, select all of the individual nCloth nodes in the Hypergraph or Outliner and switch to the Channel Box. When multiple nodes are selected, you can alter their attributes globally by manually changing the cell values. Enter 0 into the Collide and Self Collide cells. This disables self-collisions and collisions with other passive bodies. Although gaps were intentionally left between the shards, the danger of interpenetration remains once dynamic forces are applied. Interpenetration can cause the dynamic or nDynamic simulation to stop due to an inability to calculate transform information of each rigid or nCloth body. Because we are replicating an outward explosion, the ability of shards to bounce off each other is not mandatory.
3. As a test, temporarily change the nucleus1 node's Gravity value to 1000. Play back the timeline or create a Playblast. The playback is slow due to the high number of nCloth objects. Stop after a few frames (press the Esc key to interrupt a playback or Playblast). Note that the shards begin to fall, although they do not react to the other parts of the building. Return the nucleus1 Gravity value to 9.8.

Exploding Shards with Fields

The goal for Project 4 is to create a blast at the top of the tower that causes the corner bricks to scatter outwards. As such, you can add a Radial field to push the shards. You can follow these steps:

1. Select all of the nCloth nodes. To save time during future steps, you can turn the nodes into a quick select set. To do so, choose Create > Sets > Quick Select Set with the nodes selected. In the Quick Select Set option window, enter a name, such as **nClothNodes**, into the Name cell and click OK. At that point, you can select all the nCloth nodes by choosing Edit > Quick Select Sets > *set name*. With the nCloth nodes selected, choose Fields > Radial. Interactively move the radialField1 icon and place it at the base of the shards, close to the corner facing the camera

(roughly −6, 16, −2 in XYZ). Increase the new radialField1 node's Magnitude to 12. Reduce Attenuation to 0.3 and increase Max Distance (in the Distance section) to 150 to lengthen the field falloff area. Temporarily shorten the timeline to 20 frames. Create a Playblast from the Persp view so that you can view a wide area of the scene. You can unhide Building-Base and Unbroken Tower as reference. The shards explode outwards in a spherical fashion (**Figure 9.15**). To increase the speed to the shards, increase the radialField1 Magnitude. To slow the shards, reduce the Magnitude. Note that the nucleus1 Gravity still affects the shards. Open the nucleus1 node in the Attribute Editor. Increase the Gravity to 250.

FIG 9.15 The shards are blown outward with the addition of a Radial field. In this case, green shards originate from the roof and white shards originate from the walls. Some of the larger shards stretch and deform.

2. To delay the explosion, you can animate the Magnitude attributes of the fields. Return the timeline to its full length of 60 frames. Go to frame 40. Keyframe the Magnitude for the radialField1 node at its present values. Keyframe the nucleus1 node's Gravity at its present value. Go to frame 39. Keyframe the Magnitude for the radialField1 at 0. Keyframe the nucleus1 node's Gravity value at 0. Create a Playblast. The shards begin moving on frame 40. An example Maya scene file is included as `Project4.7.ma` in the `/ProjectFiles/Project4/maFiles/` directory.

> **VFX Notes: Determining the Speed of Debris**
>
> One challenge when creating an explosion is determining the speed that debris should travel through the air. Large-scale objects fall more slowly when compared to small-scale objects. For example, large stones exploding from a volcano take longer to reach the ground than sand tossed onto a table top. When shooting miniatures with film or video, you can apply a formula to determine an appropriate frame rate to make the miniature object fall at the correct speed (square root of the scale multiplied by the base frame rate, which leads to some form of high frame rate/slow motion). However, when setting up a 3D scene, a frame rate

change does not suffice because the dynamic simulation is a simplified version of the real world and the speed that the 3D objects are traveling may be incorrect. As such, the best solution is to compare the simulation to film or video of similar real-world events and make simulation adjustments to match the qualities.

That said, it may be mathematically possible to determine the values supplied to fields and other components of a dynamic simulation. However, the math would be complex and require such information as explosive velocity (which varies with the explosive material involved). Note that the 9.8 value assigned to various Gravity attributes in Maya is based on *standard gravity*, which is the gravitational acceleration of an object in a vacuum near the Earth's surface (9.80665 meters/second2).

Adjusting nCloth Attributes to Emulate Bricks

By default, nCloth surfaces deform as they are subjected to Nucleus gravity and other assigned fields. In the case of Project 4, this causes large shards, such as those along the roof, to twist as they explode outwards. Although this may be acceptable, you have the option to make the nCloth bodies more rigid. To do so, you can adjust the attributes listed in Table 9.1 for the nCloth nodes through the Channel Box.

TABLE 9.1

Attribute	Notes
Stretch Resistance	The amount of resistance under tension. The higher the values, the stiffer the surface but the more expensive the computation.
Compression Resistance	As a rough rule of thumb, keep the Compression Resistance lower than the Stretch Resistance to avoid folding.
Bend Resistance	The amount that the surface resists bending when under strain.
Rigidity	How inclined the mesh is to be a rigid body. This is 0 by default.
Deform Resistance	How much a mesh is attracted to its current shape. This is 0 by default.

It's not necessary to change all of the attributes listed in Table 9.1. Nevertheless, for the Project 4 example files, the following settings are used:

Stretch Resistance = 75
Compression Resistance = 20

Bend Resistance = 1.0
Shear Resistance = 1.0
Rigidity = 10
Deform Resistance = 1.0

This concludes Part 3 of Project 4.

Creating a Trailing Dust Cloud with nParticles

With the collapse or destruction of a building comes a great deal of particulate matter and dust. You can recreate dust with nParticles. To make it appear as if the dust is trailing off the shard debris, you can connect nParticle emitters to nCloth bodies.

Attaching nParticle Emitters to nCloth Bodies

As Part 4 of Project 4, we can attach nParticle emitters to our nCloth objects. You can follow these steps:

1. Select all the nCloth nodes. Switch to the nDynamics menu set. Choose nParticles > Create nParticles > Thick Cloud so that the Thick Cloud preset is selected. Choose nParticles > Create nParticles > Emit From Object > □. In the Emitter Options (Emit From Object) window, change Rate(Particles/Sec) to 50. Click the Create button. An emitter is created and parented to each nCloth node (**Figure 9.16**). While the emitter nodes remain selected, choose Create > Sets > Quick Select Set. In the Create Quick Select Set window, enter a name, such as **nClothEmitters**, and click OK. (Selecting all the emitters can be time-consuming; creating a quick select set makes the selection possible with one step.)

2. At this point, the emitters produce nParticles starting on frame 1. To sync the nParticles with the fields, you can keyframe the Rate(Particles/Sec)

FIG 9.16 A small portion of the nParticle emitters parented to nCloth nodes.

241

changing from 0 to 50. You can keyframe a single attribute on multiple nodes through the Channel Box. To do so, go to frame 40. While all the emitters remain selected, RMB-click over the Rate cell in the Channel Box and choose Key Selected. A keyframe is applied to every selected node. Go to frame 39. Change the Rate value to 0, RMB-click over the cell name, and choose Key Selected.

3. Open the nParticleShape1 node in the Attribute Editor. In the Particle Size section, change Radius to 50. Create a Playblast. The nParticles form trails as the nCloth objects move outwards (**Figure 9.17**).

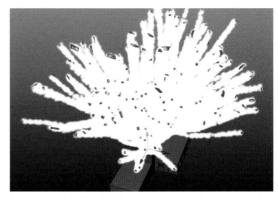

FIG 9.17 nParticles are born at the nCloth object locations over time, producing trailing columns. An example Maya scene file is included as Project4.7.ma in the /ProjectFiles/Project4/maFiles/ directory.

Shading nParticles to Emulate Explosive Smoke

By default, the Cloud nParticle preset assigns the resulting nParticle shape node to an npThickCloudBlinn/npThickCloudFluid shading network. This creates solid white particles. To alter the material and the shape node to create a smoke-like look, follow these steps:

1. Open the nParticleShape1 node in the Attribute Editor. In the Lifespan section, change Lifespan Mode to Random Range. Set Lifespan to 1.0 and Lifespan Random to 1.0. Expand the Particle Size section and Radius Scale subsection. The Radius value is multiplied by the Radius Scale graph ramp. Set Radius to 300. Insert an additional point into the graph ramp to create an upwards slope (**Figure 9.18**). Set the Radius Scale Input menu to Normalized Age. With Normalized Age, the left of the ramp is used for the beginning of the nParticle's lifespan, while the right side of the ramp is used for the end of the nParticle lifespan. These settings cause the nParticles to increase in size over time (as if the smoke cloud is dissipating).

FIG 9.18 The adjusted Particle Size section and Radius Scale subsections of the nParticleShape1 node.

2. Expand the Shading section and the Opacity Scale and Color subsections. In the Shading section, make sure that Surface Shading is set to 0. This guarantees that the npThickCloudFluid Fluid Shape material is used to shade the nParticles, and not the Blinn material. This creates soft-edged nParticles. (Note that the orthographic view panels display the nParticles as flat discs; regardless, they are rendered as spheres.) Set Opacity to 0.25. In the Color subsection, change the Color Input menu to Normalized Age. Insert an additional point into the graph ramp. Change the colors so the ramp goes from black to dark gray. In the Opacity Scale subsection, change the Opacity Scale Input menu to Normalized Age. Add two additional points to the graph ramp to create a tapering reverse slope (Figure 9.19).

FIG 9.19 The adjusted Opacity Scale and Color subsections.

3. Open the npThickCloudFluid shape node in the attribute Editor. In the Textures section, set Frequency to 10. In the Lighting section, deselect Real Lights. Set Directional Light to –1.0, 1.0, 0. Set Light Brightness to 4. Set Shadow Opacity to 1.0.

4. Hide the BuildingBase and UnbrokenTower surfaces. Test render a late frame with mental ray. The nParticles become slightly lighter, larger, and more transparent as they age (**Figure 9.20**). Again, this helps to emulate a dissipating smoke cloud.

FIG 9.20 The nParticles become lighter, more transparent, and larger over time due to the adjustment of the nParticleShape1 and npThickCloudFluid node attributes. An example Maya scene file is included as Project4.8.ma in the /ProjectFiles/Project4/maFiles/ directory.

This concludes Part 4 of Project 4. We'll further adjust the look of the nParticles in Chapter 10 through rendering and compositing.

Combusting an Explosion with Dynamic Fluid Effects

In Chapters 6 and 7, we created a dynamite explosion for Project 3 using a static 3D fluid container. To create the illusion of combustion, we animated the container's built-in texture and shading attributes. Although relatively easy to set up, this technique lacks the realism of a fully-simulated dynamic fluid. In particular, dynamic fluid can take advantage of Fuel and Temperature property changes, which can recreate combustion. In addition, dynamic fluid is able to produce smoke that rolls and undulates upwards (for example, in a classic mushroom cloud).

Installing a 3D Container with High Quality Settings

Fluid Effects containers provide many attributes to improve the quality of the fluid simulation. To create a container with high quality settings as Part 5 of Project 4, follow these steps:

1. Shift+select the nParticle1 node, the shard group nodes, and the nCloth group node and temporarily hide them. Hiding the other dynamic components makes the timeline play back faster. Unhide the BuildingBase and UnbrokenTower surfaces. Switch to the Dynamics menu set and

choose Fluid Effects > Create 3D Container. Rename the new fluid2 transform node **Explosion.** Interactively position and scale Explosion so that it encompasses the top of the tower. For example, a Scale of 200, 200, 200 works well at a position of −2, 55, 1 (**Figure 9.21**). Note that scaling a container using the Scale transform changes the size of the container without scaling the property values inside the container. For example, if you increase the scale of a container with Density values, the fluid appears thinner because the Density value in each voxel is redistributed to fill the larger voxel size. Ultimately, a container that is scaled significantly requires large voxel/second emitter values. We'll address this in a later step.

FIG 9.21 A 3D fluid container is scaled and placed at the top of the tower.

2. Open the new ExplosionShape node in the Attribute Editor. In the Container Properties section, change Base Resolution to 50. Change the Boundary X, Boundary Y, and Boundary Z menus to None. In the Contents Method section, change the Temperature and Fuel menus to Dynamic Grid.

3. Expand the Dynamic Simulation section (**Figure 9.22**). Raise the Damp value to 0.05. Damp progressively diminishes fluid movement over time. Small Damp values help prevent the formation of strong currents within the fluid. Change the High Detail Solve menu to All Grids. High Detail Solve increases the complexity and detail of the fluid without requiring an increase in the number of container voxels. Raise Substeps to 3. Substeps determines the number of times per frame the dynamic calculation is undertaken. Higher Substeps values help prevent erratic fluid motion; the erratic quality often appears as square, rectangular, or otherwise malformed sections of the fluid. Increase the Solver Quality to 30. Solver Quality defines the number of steps used to calculate the incompressibility of the fluid, where higher values create a more accurate fluid mass. Select Emit In Substeps, which allows fluid emission with each substep. Emit In Substeps is useful for fast-moving fluid simulations, such as explosions.

FIG 9.22 The adjusted Dynamic Simulation section.

4. Scroll down and expand the Auto Resize section. By default, Auto Resize is deselected, which means that fluid contacting a container boundary reacts with the boundary. Select Auto Resize. This forces the container to dynamically resize itself when fluid approaches a boundary. The resize creates additional voxels. Note that Resize To Emitter is automatically selected, which causes the container to resize itself if an attached emitter is animated and crosses a boundary. Set Max Resolution to 500. Max Resolution sets the maximum boundary voxel size.

With the container placed, we can add an emitter in the next section.

Adding an Emitter and Working with Fuel and Temperature

Adding Temperature and Fuel properties to a container can create complex simulations where Density and Velocity are affected by heat and reactivity. To work with these properties in Project 4, follows these steps:

1. With the container selected, choose Fluid Effects > Add/Edit Contents > Emitter. An emitter is added to the center of the container. Interactively move the emitter to the bottom of the container. Temporarily extend the timeline to 200 frames. Play back the timeline or create a Playblast. A small amount of fluid appears at the emitter and rises straight up. Due to the scale of the container, the Density values that are provided by the emitter create a low-density fluid. Note that the container resizes itself as the fluid rises.

2. Go to frame 39 (one frame before the explosion starts). Open the fluidEmitter1 node in the Attribute Editor. Set Density/Voxel/Sec, Heat/Voxel/Sec, and Fuel/Voxel/Sec to 0 and keyframe the values. This turns off the fluid, preventing it from appearing before frame 40. Go to frame 40. Keyframe

Density/Voxel/Sec, Heat/Voxel/Sec, and Fuel/Voxel/Sec at 500. (If the container was left at its default scale, much smaller values, such as 1 or 10, could be used.) Go to frame 60. Keyframe Density/Voxel/Sec, Heat/Voxel/Sec, and Fuel/Voxel/Sec at 0. This series of keyframes creates an initial spike in density, temperature, and reactivity (courtesy of increased Fuel) within the fluid. These qualities taper off between frames 40 and 60. The combination of high density, heat, and reactivity will create combustion at the start of the simulation when Temperature properties are increased.

3. Go to frame 40. Open the ExplosionShape node Attribute Editor tab. Expand the Contents Details section and Density subsection. Set Density Scale to 4. This further multiplies the Density values within voxels. Set Buoyancy at 10. A high Buoyancy will be necessary to make smoke rise at the end of the simulation. Set Dissipation to 0.5. This increases the speed with which the Density reduces over time. Leave the remainder of the attributes in the Density subsection set to their default values.

4. Expand the Velocity subsection. Set Swirl to 5. This creates eddies and vortexes within the fluid mass, which often occurs with high-temperature fires and explosions.

5. Expand the Temperature subsection (**Figure 9.23**). Increase Temperature Scale to 4. Set Pressure to 20. Pressure creates an outwards force to counteract fluid compression. A high Pressure value emulates the rapid expansion of gas at the beginning of an explosion. Set Pressure Threshold to 1.0. Pressure Threshold sets the Density threshold at which the pressure is exerted in a voxel. Set Dissipation to 0.5 and Diffusion to 0.1. Dissipation determines how rapidly Temperature values reduce over time. Diffusion controls how rapidly Temperature values are spread to adjacent voxels. Set Turbulence to 3 and Noise to 1.0. Turbulence applies a randomization to the fluid movement while Noise randomizes Temperature values across voxels. If Turbulence is set to 0, the fluid takes on a smooth shape. The affects of Noise are more subtle than Turbulence. Go to frame 40. Keyframe Buoyancy at 0.1. Go to frame 60. Keyframe Buoyancy at 50. This helps the fluid to rise after the initial outwards expansion created by Pressure and combustive forces.

FIG 9.23 The adjusted Temperature subsection, as seen on frame 60.

6. Expand the Fuel subsection. Change Fuel Scale to 4. Leave the remaining attributes set to their default values.

7. To see the result of fluid combustion, we can adjust the colors and transparency of the fluid. Expand the Shading section (**Figure 9.24**). Change Transparency to 0, 0, 0.07 in HSV. Change the Dropoff Shape menu to Off. In the Color subsection, adjust the graph ramp so that it transitions from white to black in a left-to-right fashion. In the Incandescence section, darken the current color values for each point slightly. Change the Interpolation menu for each point to Smooth. In the Opacity subsection, adjust the graph ramp to have a rapid slope. Note that the Color Input menu is set to Constant, while the Incandescence Input menu is set to Temperature and the Opacity Input menu is set to Density. While Incandescence and Opacity are dependent on voxel values, Color is indifferent to the voxel states.

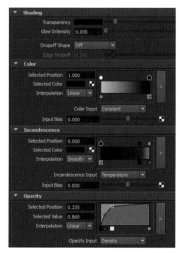

FIG 9.24 The adjusted Shading section.

8. Expand the Display section and set the Boundary Draw menu to None. This hides the container in the view panels. Change the timeline duration back to 60 frames. Return to frame 1 and play back or create a Playblast. The fluid rapidly expands with an orange/yellow color, rolls upwards, becomes black, and reveals a central red/black fireball at the end. If your simulation looks significantly different from **Figure 9.25**, carefully check the attribute values discussed in this section. Small values can have a large impact on the simulation. Keep in mind that the view panel view of the fluid is simplified.

FIG 9.25 The fluid explosion as seen on three frames.

Colliding Fluids with Surfaces

You can collide fluid with any polygon or NURBS surface, so long as the surface is within the container. To apply collisions to Project 4 so that the fluid interacts with the building, follow these steps:

1. Re-display the container by setting the ExplosionShape Boundary Draw menu to Bounding Box. The fluid container need not be perpendicular to the XZ plane. Rotate the container to 10, 0, −10. Move the container to −9, 60, −6. This orients the fluid so that it more closely matches the trajectories of the nCloth objects and nParticles. Move the fluidEmitter1 icon back behind the opening in the wall at roughly 0.045, −0.16, 0.06.
2. Shift+select the UnbrokenTower surface and the container. Choose Fluid Effects > Make Collide. Play back from frame 1. The fluid does not pass through the roof top.
3. Create a primitive cube. Scale and move the cube so that it fills the base of the tower (**Figure 9.26**). Shift+select the cube and the container. Choose Fluid Effects > Collide. Play back from frame 1. The fluid no longer passes through the lower portion of the building, but is forced through the damaged hole.

FIG 9.26 The primitive cube is placed at the bottom of the tower and used as a collision surface for the fluid.

4. The collisions affect the motion of the fluid. Feel free to adjust any of the aforementioned attributes and test the fluid through additional playbacks. To fine-tune the fluid edge quality, try different Turbulence and Noise attributes within the Temperature subsection. You can also raise the Noise value in the Velocity subsection. For example, to give the fluid a more feathery edge, raise the Turbulence subsection Noise to 2.

5. At this stage, the combustion lasts the entire duration of the timeline. This causes a fireball to form in the building opening after the initial blast. You can reduce the potential for combustion by setting an additional keyframe for Heat/Voxel/Sec and Fuel/Voxel/Sec. To do this, go to frame 50. In the fluidEmitter1 Attribute Editor tab, set Heat/Voxel/Sec and Fuel/Voxel/Sec to 0 and key each attribute. This shuts off the addition of Fuel and Heat properties at an earlier point.

6. Create a Playblast. The fluid is generated until the end of the timeline so that the inside of the tower is never seen clearly (**Figure 9.27**).

FIG 9.27 The fluid collides with the building, forcing the fluid to pour out of the damaged hole in the tower. Note the angle of the container. An example Maya scene file is included as Project4.9.ma in the /ProjectFiles/Project4/maFiles/ directory.

Optional Steps for Fluid Set-Up

Although not mandatory for Project 4, there are several additional steps you can take while setting up the fluid simulation:

- Add fields to the container to affect the fluid motion. You can add standard Dynamics fields to a container by selecting a container and choosing Fields > *Field Name*. Use caution, high field Magnitude values may "blow out" the fluid by dissipating the fluid too rapidly. You can activate a volume shape for a field and move the field into the container interior.

- You can collide the fluid with the shards. Shift+select all the shard nodes and the container and choose Fluid Effects > Make Collide. For efficiency, choose Make Collide > □ and reduce the Tessellation Factor before

application. The default Tessellation Factor is 200, which is unnecessarily high for myriad small surfaces.

- Add additional fluid containers to other sections of the building to create smoke pouring out of other windows. Note that multiple fluid containers cannot interact with each other.

This concludes Part 5 of Project 4.

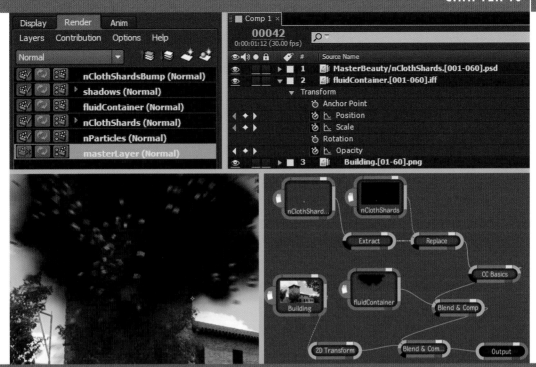

Preparing, Rendering, and Combining Render Passes

Although it's possible to render a Maya animation in a single batch rendering pass, it limits your ability to fine-tune the render outside of Maya. As an alternative approach, you can create render layers and render passes and thereby break the Maya scene into multiple image sequences. This gives you the advantage of using a compositing program to recombine the renders. With multiple image sequences, you can adjust the look of each sequence without affecting the 3D scene as a whole. This is a common procedure in the visual effects industry, where it's necessary to adjust 3D renders to create the maximum amount of realism.

This chapter includes the following critical information:

- Using Dynamics and nDynamics caches

- Setting up and batch rendering render layers and mental ray render passes
- Creating basic composites in Autodesk Composite, Adobe After Effects, and The Foundry Nuke

In addition, this chapter steps through Part 6 to Part 10 of Project 4. Project 4 features live-action video footage of an abandoned water station. In Chapter 8, we built reference geometry and motion tracked the footage to produce usable Maya cameras. In Chapter 9, we created an explosion using the Create Shatter tool, nParticles, and a Fluid Effects container. In this chapter, we'll batch render various visual effects components using render layers and render passes and composite the result in several external compositing programs.

Using Dynamics and nDynamics Caches

Thus far, when examining a dynamic simulation, we've played back the timeline from frame 1 or created a Playblast movie. This forces the program to re-calculate the simulation each time. However, you have the option of using a cache, which will store the motion of objects on disk so that additional playbacks will not require the simulation calculation. (That is, the cache is written as a file on a drive.) Although a cache may not be useful while you are setting up and adjusting a simulation, it may be an efficient tool while you are creating multiple visual effects systems or when you have finished adjusting the simulation and have moved onto other phases, such as texturing or lighting. Note that caches can help maintain consistency during batch renders and speed-up the batch rendering process. (Occasionally, dynamic simulations calculated as part of a batch render will differ slightly from that simulation seen within the program.)

Working with Dynamics Caches

When using Dynamics system tools, you can create and manage a cache in the following ways:

Enabling a Cache Select the object which is affected by motion. With a Dynamics system, this may be a particle node or polygon surface that is converted to a rigid body. Switch to the Dynamics menu set and choose Solvers > Memory Caching > Enable. Play back the timeline from frame 1. Stop the playback at the end of the timeline. Scrub back and forth. The motion is stored in the cache and is accurate.

Adding New Objects to the Cache To add additional objects to the cache, select them and play back. If the cache is enabled, the new object motion is added to the cache.

Deleting a Cache To remove the cache, select it and choose Solvers > Memory Caching > Delete. The object returns to a dynamic simulation when the timeline is played from frame 1.

Disabling a Cache You can save the cache but temporarily disable it for all associated objects by choosing Solvers > Memory Caching > Disable. Alternatively, change the Cache Data attribute to 0 (off). You can locate Cache Data in the Channel Box. For example, Cache Data appears as a channel for the scene's rigidSolver.

Working with Updated Motion If you update the simulation by changing object attribute values or transforming a component, like an emitter, the timeline playback may present a combination of simulation and cache memory. The easiest way to determine what is stored in a cache is to play the timeline backwards. Objects that move smoothly are in cache. Objects that play back inaccurately or skip frames are simulated. When in doubt, you can delete the cache, enable a new cache, and play back the timeline from frame 1. Once again, accurate dynamic simulation requires that the Playback Speed menu, in the Preferences window, is set to Play Every Frame.

Caching Particles In addition to the standard Dynamics cache, Maya also provides particle disk cache that allows you to define the cache file location. To create the cache, choose Solvers > Create Particle Disk Cache > □.

Caching Fluid Effects You can create a cache for one or more Fluid Effects containers by choosing Fluid nCache > Create New Cache through the Dynamics menu set. The timeline is automatically played back and the cache is created. Through the Fluid nCache menu, you have the option to delete, disable, enable, append, and replace the cache for the selected container(s). You can also merge multiple caches. Note that the Create New Cache options are identical to those offered by the nCache > Create New Cache tool provided for nDynamics (described in the next section).

Working with nDynamics Caches

When using nDynamics system tools, you can create and manage a cache in the following ways:

Creating an nCache To create an nCache, select one or more objects whose motion is affected by a Nucleus node, switch to the nDynamics menu set and choose nCache > Create New Cache > □. In the Create nCache Options window, you can choose a cache file location, a cache name, and a frame range. In addition, you can create a single cache file by selecting One File or create a different cache file for each frame by selecting One File Per Frame (Figure 10.1). Click Create. The tool plays back the timeline for the duration you specified. When the playback has stopped, scrub back and forth. The motion is stored in the cache and is accurate.

Deleting a Cache Select an object with an attached cache and choose nCache > Delete Cache.

Replacing an Old Cache with a New Cache If you update the simulation by changing object attribute values or transforming a component, like an emitter, the timeline playback may present a combination of simulation and cache memory. To ensure that the playback is accurate, you can

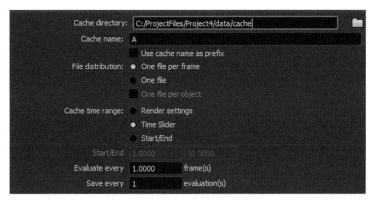

FIG 10.1 The Create nCache Options window.

replace the old cache with a new one by choosing nCache > Replace Cache. Replace Cache carries the same options as Create New Cache.
Attaching a Cache File By default, nCache files are stored in the `/data/cache/` directory within your project directory structure. When using Create New nCache and Replace nCache tools, you also have the option to define your own location. The files include an XML (eXtensible Markup Language) file that defines the cache and carries the object attribute settings, along with one or more binary MC (Maya Cache) files that contain cached transforms. You can attach a pre-existing nCache file to an object by choosing nCache > Attach Existing nCache File and browsing for the cache XML file.
Working with Multiple Caches You can attach multiple caches to an object. Each cache can cover a different frame range. If the cache frame ranges overlap, you can blend the cache transforms together. Each cache receives a matching node. If two or more cache nodes are connected to the object, a cacheBlend node is provided and lets you mix the transforms together (**Figures 10.2 and 10.3**). For the cache blending to function properly, the cache should be generated from objects that produce similar transforms. In this case, the caches were generated from two nCloth objects with identical topology but different nCloth attribute settings.

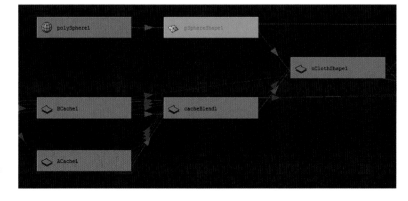

FIG 10.2 Two caches, A and B, are attached to an nCloth object. A cacheBlend node is automatically inserted. This network is displayed in the Hypergraph: Hierarchy window.

256

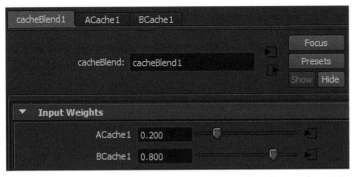

FIG 10.3 A cacheBlend node, as seen in the Attribute Editor. With this example, cache A contributes 20% and cache B contributes 80%.

Fluid Effects nCaches As mentioned, a parallel set of nCache tools are provided through the Dynamics menu set > Fluid nCache menu. These are specifically designed for Fluid Effects objects but function in the same way as those found in the nDynamics menu set > nCache menu.

For additional information on the cache systems, see the "Solvers and Caching," "nCaching," and "Fluid nCache" sections of the Maya Help files.

An Overview of Render Passes

In Chapters 1 and 2 we utilized the Render Layer editor to combine two separate render layers which used different renderers. This represents a crude method of compositing. A more powerful method requires the batch rendering of render passes and recombination and adjustment of those passes in an external compositing program.

Render passes come in two forms: object and shading component. Object render passes simply render out objects separately. For example, you might render the background set, by itself, in the first pass, and then render out the characters, by themselves, in a second pass. Shading component render passes takes this one step further—they render out different shading components of the same object in separate passes. For example, you can render the diffuse, specular, and shadow components of an object separately.

Render passes provide greater flexibility by allowing for adjustments to be made to the renders in the compositing phase. For example, if there is a shadow pass, you can tint, soften, or adjust the opacity of the shadows quickly during the compositing phase. Render passes also make it easier to re-render specific components or objects without requiring that the entire contents of the scene or shot be re-rendered. Every studio approaches render passes in a slightly different fashion; nevertheless, it's a commonly-used technique. This holds true for visual

effects, feature animation, and commercial production. In particular, the visual effects industry benefits from the use of render passes as it's necessary to match CG effects with live-action and the ability to fine-tune renders is critical.

Setting up Render Layers and mental ray Render Passes

There are two ways to create render passes in Maya:

- Set up a render layer and assign objects to it. Optionally, create material overrides or lighting that's unique to the layer. This is a suitable approach when the required result is too complex or unusual for a pre-defined mental ray render pass. This type of pass is demonstrated in the sections "Creating Layer-Specific Lighting" and "Adding a Matte Surface to a Fluid Render Layer" later in this chapter.
- Attach a mental ray render pass to a contribution map, which in turn is assigned to a render layer. The use of mental ray render passes is ideal for splitting a layer up into different shading components. This type of pass is demonstrated in the next four sections.

You can apply both of these techniques to a scene.

Setting Up Render Layers

To create render layers as Part 6 of Project 4, follow these steps:

1. Open the `Project4.9.ma` scene file. This is located in the `/Project-Files/Project4/maFiles/` tutorial directory. Unhide any dynamic components that remain hidden. For example, unhide the nParticle1 node. Open the Channel Box and switch to the Render Layer editor tab. Using the Hypergraph or Outliner, select the nParticle1 node. Through the Render Layer editor menu, choose Layers > Create Layer From Selected. A new layer is created. Double-click the new layer and rename it **nParticles**. Play back the timeline from frame 1. After frame 40, the nParticles appear by themselves. Nevertheless, they maintain the correct trajectories.
2. Return to the masterLayer. In the Hypergraph or Outliner, select all of the shards (you can select the shard group nodes instead of the individual shard polygon nodes). Through the Render Layer editor menu, choose Layers > Create Layer From Selected. A new layer is created. Double-click the new layer and rename it **nClothShards**. Note that the shards appear by themselves on the new layer.
3. Return to the masterLayer. In the Hypergraph or Outliner, select the Explosion fluid container. Through the Render Layer editor menu, choose Layers > Create Layer From Selected. A new layer is created. Double-click the new layer and rename it **fluidContainer**.
4. Return to the masterLayer. In the Hypergraph or Outliner, select the BuildingBase and UnbrokenTower surfaces. Through the Render Layer

editor menu, choose Layers > Create Layer From Selected. A new layer is created. Double-click the new layer and rename it **shadows** (Figure 10.4). We'll use this layer to capture shadows in a later step.

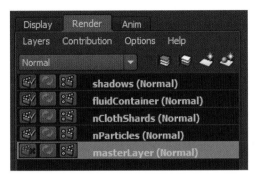

FIG 10.4 Four new render layers are added through the Render Layer editor. By default, the masterLayer is provided and includes all of the objects within the scene.

5. In order to properly render the new layers, you must add the scene's lights to the layers. To do so, return to the masterLayer. Select the directionalLight1 and ambientLight1 nodes. RMB-click over the nClothShards layer and choose Add Selected Objects. Select the nClothShards layer. The lights are now included on the layer. Select the directionalLight1 and ambientLight1 nodes. RMB-click over the fluidContainer layer and choose Add Selected Objects. RMB-click over the shadows layer and choose Add Selected Objects. (The lights are not necessary for the nParticles layer because the built-in light function of the nParticleShape1 node is employed.)

6. Open the Render Settings window. Change the Render Using menu to mental ray. Switch to the Quality tab. In the Raytrace/Scanline Quality section, change the Sampling Mode menu to Custom Sampling. Set Min Sample Level to −2 and Max Sample Level to 0; this creates poor anti-aliasing but speeds up the render. This is suitable for testing render passes. We'll increase the quality at a later step. Note that Maya 2014 adds a Sampling Mode menu to the Sampling section of the Quality tab. To reach the Min Sample Level and Max Sample Level, change the Sampling Mode menu to Legacy Sampling Mode. You can then change the Legacy Sampling Mode menu to Custom Sampling. As an alternative, you can set Sampling Mode to Unified Sampling and set Min Samples and Max Samples values. If you are working strictly with 2014, it's recommended that you use the Unified Sampling for improved anti-aliasing. To reduce the Unified Sampling quality for test renders, lower the Min Samples and Max Samples (for example make them 1 and 2).

7. Switch to the Common tab. Change the Image Size Width and Height to 640, 360. The smaller resolution is suitable for testing render layers. In the Renderable Camera section, switch the Renderable Camera menu to RenderCamera.

Creating mental ray Contribution Maps and Render Passes

You can attach a mental ray render pass to an existing render layer. However, the layer must have a pass contribution map for the pass to function. Contribution maps associate specific render passes with specific render layers. To create a pass contribution map and associate it with a set of render passes for Project 4, follow these steps:

1. In the Render Layer editor, select the nClothShards layer. Go to frame 1. Test render the RenderCamera view. The shards appear in the correct location with the appropriate texture and lighting. However, the image plane remains. Open the Hypershade window, switch to the Cameras tab, and delete the imagePlaneShape1 node. While useful for setting up the scene, image planes are not needed for the final render. In the Render Layer editor, RMB-click over the nClothShards layer and choose Pass Contribution Maps > Create Empty Pass Contribution Map. A small arrow appears to the left of the layer name. Click the arrow to see passContribu-tionMap1 listed.

2. Open the Render Settings window. Note that Render Layer menu (above Render Using) is set to the current layer name. Switch to the Passes tab. Click the Create New Render Pass button (the top-most icon to the right). The Create Render Passes window opens. This lists all of the available, ready-made mental ray render passes. Cmd/Ctrl+select Camera Depth, Diffuse Material Color, and Normalized 2D Motion Vector (**Figure 10.5**). Click the Create And Close button. The selected render passes are listed in the Scene Passes field (**Figure 10.6**). Abbreviated names are used for the passes, so Camera Depth becomes depth, Diffuse Material Color becomes diffuseMaterialColor, and Normalized 2D Motion Vector becomes

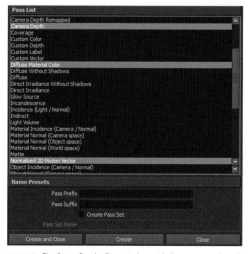

FIG 10.5 The Create Render Pass window with three passes selected.

mv2DNormRemap. You can remove passes from the Scene Passes field by selecting them and pressing the Delete key. You can add additional passes at any time by clicking the Create New Render Pass button.

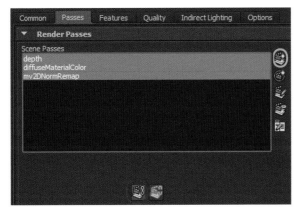

FIG 10.6 Three render passes are added to the Scene Passes field of the Passes tab. The Create New Render Pass button is circled in green. The Associate Selected Passes With Current Render Layer button is circled in red.

3. With the passes selected in the Scenes Passes field (so they turn blue), click the Associate Selected Passes With Current Render Layer button. This button is at the bottom of the Scene Passes field and features a small linked chain. The passes are dropped down into the Associated Passes field. Scroll down. Change the Associated Pass Contribution Map menu to passContributionMap1. Shift+select the pass names in the Associated Passes field and click the Associate Selected Passes With Current Pass Contribution Map button. This button is at the bottom of the Associated Passes field and also features a small linked chain. The passes are copied down into the Passes Used By Contribution Map field (**Figure 10.7**).

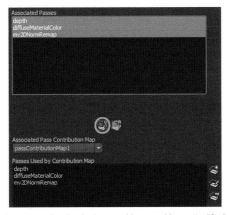

FIG 10.7 The new render passes are listed in the Associated Passes and Passes Used By Contribution Map fields. The Associate Selected Passes With Current Pass Contribution Map button is circled in green.

4. Return to the Common tab in the Render Settings window. In the File Output section, change the File Name Prefix to **Project4.** Change the Image Format to TIFF. TIFF images support alpha channels, which are necessary to transmit transparency information to compositing programs. Note that Alpha Channel (Mask), in the Renderable Cameras section, is selected by default. Change the Frame/Animation Ext menu to name.ext (Single Frame).

We're ready to test render the passes associated with the nClothShards layer in the next section.

VFX Notes: Common Render Passes

Although visual effects, feature animation, and commercial production studios use different combinations of render passes on various projects, there are a few passes that are commonly used. These include:

Diffuse The color component without specularity or reflectivity. This pass may or may not include basic shading (dark and light areas based on the lighting).

Specular The specular component by itself.

Shadow Cast shadows by themselves. This may take the form of the shadow shape in alpha or as the color component cut out in the shadow shape.

Reflectivity Reflections by themselves.

Depth A grayshaded render that encodes distance from the camera. You can use a depth pass to create artificial depth-of-field in the composite. You can also use a depth pass to incorporate atmospheric effects, such as fog. Depth passes are also known as *Z-buffer* or *Z-depth* passes. Depth map shadows are depth renders from the point-of-view of the shadow-casting light.

Matte A pass designed to cut out other layers in the composite. This may take the form of white shape on a black field, either in the RGB or alpha channel. This is sometimes referred to as a *holdout*.

Ambient occlusion A pass that captures darkened areas that form in cracks, crevices, and the points where objects meet. This pass features gray, soft shadows over white surfaces.

Motion vector A specialized pass that encodes XY motion in the RGB channels. This pass allows you to create motion blur in the composite.

Channel Occasionally, specific channels are rendered separately. For example, the alpha channel, which establishes transparency/opaqueness with scalar (grayscale) values, may be rendered as a separate image sequence.

Beauty The net sum of all shading components. This is what you see when you use the Render View. Not all projects require render passes and can use a single beauty pass. This may be due to the simplicity of the project or the taste of the compositing team.

Test Rendering mental ray Render Passes

To render out mental ray render passes, you must launch a batch render. To do so for Project 4, follow these steps:

1. Three render passes were set up for the nClothShards layer in the previous section. In addition, the attributes of the Common tab of the Render Settings window were set to render a single, low-resolution TIFF image using the RenderCamera. To batch render the nClothShards layer by itself, click the Renderable button beside the layer name so that it gains a green check mark. Click the Renderable buttons for the other layers so they are non-renderable (with red Xs). Go to frame 1. Play back the timeline and stop at a late frame. Switch to the Rendering menu set. Choose Render > Batch Render. The render is launched in the background. The render status is shown in the feedback section of the Command Line at the bottom right of the Maya program window.

2. The render passes are deposited in their own directory structure with the projector directory (as determined by Edit > Set Project). The structure follows `images/layer/render_pass`. Thus, in this case, there is a depth, diffuseMaterialColor, MasterBeauty, and mv2DNormRemap directory—each with a single TIFF file. The MasterBeauty directory contains a beauty pass, which is always provided in addition to the custom render passes. Examine the TIFF files in each directory. The depth pass renders grayshaded shards with brighter shades for surfaces closer to the camera (**Figure 10.8**). The diffuseMaterialColor pass renders the shards with their color shading component, but with no shading or self-shadowing. The MasterBeauty pass renders as the render would through the Render View. The mv2DNormRemap pass renders shards in different combinations of green and yellow, indicating XY motion.

FIG 10.8 Left to Right: Detail of depth pass, diffuseMaterialColor pass, MasterBeauty pass, and mv2DNormRemap motion vector pass.

Setting up a Shadow Render Pass

You can add a mental ray render pass to a layer. However, additional adjustments to the surfaces and lights may be necessary to produce a usable result. To add a shadows render pass to Project 4, follow these steps:

1. Select the shadows layer in the Render Layer editor. Click the shadows Renderable button so that it gains a green check mark. Click the

Renderable buttons for the other layers so they are non-renderable (with red Xs). At the moment, the building surfaces are assigned to the layer, but nothing else.

2. Return to the masterLayer. Select directionalLight1 and rename it **KeyLight**. With KeyLight selected, choose Edit > Duplicate. Rename the duplicate **ShadowLight**. Move ShadowLight aside so it's not overlapping KeyLight. Select ShadowLight and ambientLight1, RMB-click over the shadows layer name and choose Add Selected Objects. The lights are assigned to the shadows layer. Go to the other layers, one at a time. If ShadowLight appears on any other layer outside masterLayer and shadows, remove it by RMB-clicking the layer and choosing Remove Selected Objects. (By that token, KeyLight should appear on the master-Layer, nClothShards, and fluidContainer layers, but not the shadows layer.) Open the ShadowLightShape Attribute Editor tab. Select Use Ray Trace Shadows. Return to the shadows layer.

3. In the Hypergraph or Outliner, select the shard group nodes. RMB-click over the shadows layer name and choose Add Selected Objects. The shards appear on the layer. In the Hypergraph or Outliner, select all of the shard nodes. Choose Window > General Editor > Attribute Spread Sheet. In the Attribute Spread Sheet window, switch to the Render tab. The shards are listed along the left. In the Primary Visibility column, click the top cell. Scroll down to the bottom of the list. Shift+click the last Primary Visibility cell. This selects the entire contents of the Primary Visibility column. While the last cell is highlighted, enter **0**. The entire column is turned off (**Figure 10.9**). Note that the outputCloth nodes are listed automatically. So long as the shadows layer was selected, the change in Primary Visibility only occurs for the shadows layer as a layer override. To check this, select a single shard and switch to its shape tab in the Attribute Editor. Primary Visibility is deselected and is orange to indicate an override.

FIG 10.9 The Primary Visibility of all of the shards is turned off through the Attribute Spread Sheet.

4. Select the BuildingBase surface. In the BuildingBaseShape Attribute Editor tab, expand the Render Stats section. Deselect Cast Shadows. *Cast Shadows* turns orange, indicating an automatic layer override. Repeat this process for the UnbrokenTower surface.

5. RMB-click over the shadows layer name and choose Pass Contribution Maps > Create Empty Pass Contribution Map. passContributionMap2 is placed under the layer. Open the Render Settings window. Change the Render Layer menu to shadows. Switch to the Passes tab. Click the Create New Render Pass button. In the Create Render Passes window, select the Shadow render pass and click the Create And Close button. The Shadow pass appears in the Scene Passes field. Click the Associate Selected Passes With Current Render Layer button. The Shadow pass appears in the Associated Passes field. Change the Associated Pass Contribution Map menu to passContribution-Map2. Select the Shadow pass name in the Associated Passes field and click the Associate Selected Passes With Current Pass Contribution Map button. The Shadow pass appears in the Passes Used By Contribution Map field.

6. Batch render a late frame, such as 45. The shards cast shadows on the building, but do not appear (**Figure 10.10**).

FIG 10.10 A detail of the rendered shadows render layer.

Applying Render Layer Material Overrides

In Chapter 9, we textured the shards by projecting a frame from the image sequence and converting the result to small bitmap textures. Although this created the correct colors, it leaves the shards appearing very smooth. Unfortunately, there are a large number of shards in the scene, each with its own material. Thus, updating the materials would prove time-consuming. As an alternative, you can create a material override that assigns a non-permanent material to all of the shards on a new layer. Material overrides were applied in Chapter 2 to ensure that the fire render integrated with the rocks and ground. In this case, we can use a material override to create a custom render pass. To accomplish this on Project 4, follow these steps:

1. In the Hypergraph or Outliner, select the shard group node and the KeyLight node. In the Render Layer editor, choose Layers > Create Layer From Selected. Rename the new layer **nClothShardsBump**. RMB-click the new nClothShardsBump layer and choose Overrides > Create New Material Override > Blinn. A new Blinn material is created and is assigned to all the shards as they exist on the current layer. The old material assignments remain in force on the other layers.

2. Open the Hypershade. Scroll down the list of materials. The new Blinn, named Blinn1, is near the end of the list. Open the Blinn1 Attribute Editor tab. Rename the material **ShardsBump**. Change the Color to white. Click the checkered Map button beside Bump Mapping. In the Create Render Node window, choose the Noise icon. In the new bump2d1 tab, set Bump Depth to 1.5. Test render a later frame, such as 49, in the Render View. If necessary, increase the render resolution to see the resulting detail. The shards are rendered with the ShardsBump material and appear white with gray, bumpy areas (**Figure 10.11**). We'll use this render layer during the compositing phase to randomize the surfaces of the shards.

FIG 10.11 Detail of nClothShardsBump layer, where the shards are given a material override. The override assigns a bumpy gray Blinn to the surfaces. The render will be used during the compositing phase to reduce the apparent smoothness of the shards.

Adding a Matte Surface to a Fluid Render Layer

One potential difficulty of render layers is the ability to fit the different rendered layers back together in the composite. This is particularly difficult if the objects are not distinctly in front of or behind each other. One solution is to add matte surfaces that are able to "cut holes" into other objects. The Use Background material, first explored in Chapter 2, is ideal for this task. To create

matte surfaces that work with the fluid explosion in Project 4, follow these steps:

1. Select the fluidContainer layer in the Render Layer editor. Click the fluidContainer Renderable button so that it gains a green check mark. Click the Renderable buttons for the other layers so they are non-renderable (with red Xs). Play back the timeline from frame 1 or create a Playblast. Create a test render. The fluid explosion flows in the correct direction, colliding with the building surfaces. Because the building surfaces are not included on the layer, however, they are not visible to the layer. In addition, the fluid is not occluded by the building walls. To more accurately render the fluid on its own layer, you can add the building surfaces and render them as mattes, whereby they cut holes into the fluid but do not appear in the render.

2. Return to the masterLayer. Go to frame 1. Select the BaseBuilding and UnbrokenTower surfaces. Choose Edit > Duplicate. While the duplicated surfaces are selected, RMB-click over the fluidContainer layer and choose Add Selected Objects. Return to the fluidContainer layer. In the Hypershade, create a new Use Background material and assign it to the duplicated surfaces.

3. Select the BuildingBase1 duplicate surface. In the BuildingBaseShape1 Attribute Editor tab, expand the Render Stats section. Create an override for Cast Shadows and Receives Shadows (deselect both). Repeat this process for the UnbrokenTower1 duplicated surface.

4. Open the Render Settings window. Change the Render Layer to fluidContainer. RMB-click on the Attribute name *Render Using* and choose Create Layer Override. *Render Using* turns orange to indicate a layer override. Change the Render Using menu to Maya Software (**Figure 10.12**). This does not affect the masterLayer. Any layer that doesn't have an override receives its attribute settings from the masterLayer. (In this case, mental ray may not interpret the Use Background material correctly.) Test render a late frame in the Render View. The fluid explosion is cut by the building. You can switch to the alpha view and see the cut more clearly by pressing the Render View's Display Alpha Channel button.

FIG 10.12 A layer override is created for the fluidContainer layer, allowing it to use Maya Software. The layer is not using contribution maps or render passes.

Preparing the nCloth, nParticles, and Fluid Simulation for Batch Rendering

Before launching a batch render for the simulations, it's worth adjusting the attributes one more time. In particular, it pays to think about how the different render layers will integrate in the composite. In addition, you want to make sure that the render quality for each layer or pass is suitable.

Table 10.1 lists ExplosionShape and fluidEmitter1 attributes you can adjust to improve the Project 4 fluid render.

TABLE 10.1

Attribute	Node and Section	Values Used in Final Example Files	Notes
Base Resolution	ExplosionShape node in Container Properties	80	Higher values produce smaller voxels and more refined fluid. Try to keep values below 100; otherwise, the simulation will slow tremendously. You must re-simulate from frame 1 to see the result. Use caution changing this value as it may significantly alter the look of the simulation.
Substeps	ExplosionShape node in Dynamic Simulation	4	Higher Substeps and Solver Quality values improve the accuracy of the simulation. Use caution changing these values as it may significantly alter the look of the simulation.
Solver Quality	ExplosionShape node in Dynamic Simulation	50	
Color graph ramp	ExplosionShape node in Color	0, 0, 0.3 in HSV	Brighten the color of the right-hand ramp point. This will allow more variation in lighting when Real Lights is deselected (see below).
Incandescence graph ramp	ExplosionShape node in Incandesence	Slide 2nd point (orange) to the left to position 0.6.	Using higher Base Resolution and Solver Quality creates a fluid mass with less orange and more black. Adjusting the ramp adds orange back.

TABLE 10.1 —cont'd

Attribute	Node and Section	Values Used in Final Example Files	Notes
Quality	ExplosionShape node in Shading Quality	3	Raise this attribute incrementally and test render. Slightly larger values will significantly slow the render with large fluid containers (such as those producing fog).
Dissipation	ExplosionShape node in Density	1.0	Using higher Base Resolution and Solver Quality values creates a thinner column of fluid smoke. To regain some of the original volume, the Density section is altered. See Chapter 9 for more detailed descriptions of these attributes.
Diffusion	ExplosionShape node in Density	0.1	
Noise	ExplosionShape node in Velocity	8	Increase the complexity of the fluid shape with a higher Noise value.
Buoyancy	ExplosionShape node in Temperature	Keyframe so that Buoyancy is 10 on frame 40 and 50 on frame 50.	
Pressure	ExplosionShape node in Temperature	Keyframe so that Pressure is 150 on frame 40 and 50 on frame 50.	To create a stronger initial blast, where the fluid is pushed out rapidly, keyframe the Pressure value changing from high to low.
Dissipation	ExplosionShape node in Temperature	0.5	
Diffusion	ExplosionShape node in Temperature	0.2	
Self Shadow	ExplosionShape node in Lighting	On	Select if deselected. Self-shadowing imparts greater variation to the fluid lighting.
Shadow Opacity	ExplosionShape node in Lighting	1.0	Darkens the self-shadow.

Continued

269

TABLE 10.1 —cont'd

Attribute	Node and Section	Values Used in Final Example Files	Notes
Shadow Diffusion	ExplosionShape node in Lighting	0.5	Softens the self-shadow.
Real Lights	ExplosionShape node in Lighting	Off	Switches to the built-in directional light to create a more volumetric look. The lighting is updated on the fluid in the smooth-shaded views of the view panels.
Directional Light	ExplosionShape node in Lighting	1.0, 0.5, 0	Orient the light so that it catches the leading edges of the billowing fluid.
Density/ Voxel/Sec	FluidEmitter1 node in Fluid Attributes	Update keyframes so that value is 2000 at frame 40 and 0 at frame 60.	Using higher Base Resolution and Solver Quality values creates a thinner column of fluid smoke. To regain some of the original volume, the amount of Density, Temperature, and Fuel produced by the emitter is increased. See Chapter 9 for more detailed descriptions of these attributes.
Heat/Voxel/ Sec	FluidEmitter1 node in Fluid Attributes	Update keyframes so that value is 2000 at frame 40, 500 at frame 50, and 0 at frame 60.	
Fuel/Voxel/ Sec	FluidEmitter1 node in Fluid Attributes	Update keyframes so that value is 2000 at frame 40, 500 at frame 50, and 0 at frame 60.	

After you've adjusted the fluid container, reevaluate the nCloth object motion. For example, to increase the shard velocity and avoid crossover (left shards going right and right shards going left), update the frame 40 keyframe for the radialField1 Magnitude so that the value is 30. In addition, lower the Attenuation to 0.2 and raise the Max distance to 200.

The nParticles, by themselves, may render perfectly fine; however, they must be combined with the fluid simulation in the composite. To adjust the shading components of the nParticle mass to better match the fluid follow these steps:

1. Open the nParticleShape1 Attribute Editor tab. In the Color subsection, alter the Color graph ramp to run from dark reddish-orange to dark gray to black in a left-to-right fashion. This causes the nParticles to start orange and turn black as they age and increase in size. This mimics the initial orange/red combustion of the fluid simulation (**Figure 10.13**).

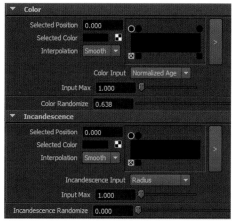

FIG 10.13 Updated nParticle Color and Incandescence graph ramps. The left-hand point on each ramp is dark orange.

2. In the Incandescence subsection, create a similar graph ramp. Change the Incandescence Input menu to Radius. This causes the nParticles to turn black as they expand in size. In the Lifespan section, set Lifespan and Lifespan Random to 0.5. This thins the nParticle mass towards the end of the timeline.
3. Open the npThickCloudFluid material in the Attribute Editor. In the Lighting section, increase Shadow Opacity to 5 to further darken the self-shadows. Change the Directional Light values to 1.0, 0.5, 0 to match the fluid lighting.
4. Open the Render Settings window. Change Render Layer to nParticles. Create a layer override for Width and Height and set the attributes to 640 and 360 respectively. Switch to the Quality tab. Create layer overrides for the anti-aliasing settings of your choice and reduce the render quality. The nParticle render will be heavily blurred and adjusted in the compositing program, so there is no need for a high-quality render.

An example Maya scene file with the changes listed in this section is included as `Project4.10.ma` in the `/ProjectFiles/Project4/maFiles/` directory.

> **VFX Notes: Mixing Resolutions**
>
> You can render layers at different resolutions and with different anti-aliasing qualities to save time. For example, to save render time with the nParticles layer, reduce the render resolution and lower the anti-aliasing quality by applying layer overrides. Again, to apply a layer override, switch the Render Settings window to the correct layer, RMB-click over an attribute name, choose Create Layer Override, and set the attribute value. You can remove an override at any time by RMB-clicking and choosing Remove Layer Override.
>
> In general, you want to avoid scaling up renders in the composite. However, if a render is destined to be blurred or have a reduced opacity applied in the compositing program, such as the Project 4 nParticles render, the scale-up is often difficult to see.

This concludes Part 6 of Project 4.

Batch Rendering Layered PSDs and OpenEXR Files

Render passes created through mental ray support the use of layered PSD and OpenEXR files. This allows all of the render passes for a particular contribution map to be placed inside a single layered Photoshop file or single OpenEXR. Layered PSD files are supported by Adobe After Effects and The Foundry Nuke while multi-channel OpenEXR files are supported by Autodesk Composite and The Foundry Nuke.

Before batch rendering as Part 7 of Project 4, let's review the render layers and mental ray render passes that have been set up thus far (Table 10.2).

TABLE 10.2

Layer Name	Contribution Map Name	Render Pass(es)	Purpose
nClothShards-Bump	None		Render bumpier version of shards with no texture color.
shadows	passContributionMap2	shadow	Capture cast shadows on building walls.
fluidContainer	None		Render fluid explosion, as cut out by building walls.
nClothShards	passContributionMap1	depth	Capture shards' distance from camera.
		diffuseMaterial-Color	Render shard color without shading or self-shadowing.
		mv2DNormRe-map	Capture motion blur vector information.
nParticles	None		Render dust cloud.

When preparing for a batch render, consider creating nCaches or Dynamic caches to speed up the batch rendering process. See the "Using Dynamics and nDynamics Caches" at the start of this chapter.

Rendering Render Passes as Layered PSDs

To set up the Project 4 scene for batching rendering with Layered PSD, follow these steps:

1. In the Render Layer Editor, make all the layers renderable, except the masterLayer (**Figure 10.14**).

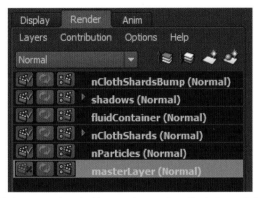

FIG 10.14 All of the layers are made renderable, except the masterLayer. The shadows and nClothShards layers include contribution maps.

2. Open the Render Settings window. Set the Render Layer menu to masterLayer. Check the render resolution and anti-aliasing quality. At this point, a small resolution and low anti-aliasing quality is suitable for a test. Remember that the layers use both Maya Software and mental ray, so you'll need to check the tabs for those two renderers. If a layer doesn't use a layer override, it derives its attribute settings from the masterLayer. Change the Image Format, in the Common tab, to PSD Layered (psd). Note that all of the rendered layers and passes are named with the value entered into the File Name Prefix cell. However, you can create a custom naming set-up by entering tokens (render variables) into the File Name Prefix cell. For example, enter:

    ```
    <RenderLayer>
    ```

This names the rendered images after the render layers or render passes. For a complete list of available tokens, see the "Subfolders and Names of Rendered Images" page in the Maya Help files.

3. Problems arise when rendering depth passes as Layered PSDs. The program is unable to incorporate the Z-depth channel into the RGB channels of the Photoshop file. (Maya IFF files support separate RGB, alpha, and Z-depth

channels.) As a workaround, you can add an additional layer and render the depth information with the Depth Channel (Z Depth) attribute. To do so, select the shard group node and the KeyLight node and choose Layers > Create Layer From Selected through the Render Layer editor. By adding a light to this layer, we can test depth settings in the composite while looking at the corresponding RGB channels. Rename the new layer **depth2.** Open the Render Settings window and change Render Layer to depth2. RMB-click the *Image Format* name and choose Create Layer Override. *Image Format* turns orange. Change the Image Format menu to Wavefront(rla). RMB-click the *Depth Channel (Z Depth)* name in the Renderable Camera section and choose Create Layer Override. Select Depth Channel (Z Depth) so that it's activated. RMB-click the *Render Using* name and choose Create Layer Override. Change the Render Using menu to Maya Software.

4. Play back and stop on a late frame, such as 60. Switch to the Rendering menu set and choose Render > Batch Render. The render layers render, one at a time. If the layer includes contribution map render passes, they are also rendered. The feedback section of the Command Line displays the render progress. You can also launch the Script Editor (Window > General Editors > Script Editor) to watch the progress.

5. When the batch render finishes, investigate the new directory/file structure created for the renders. It appears as follows:

```
images/depth/ (empty folder)
images/diffuseMaterialColor/ (empty folder)
images/MasterBeauty/ (empty folder)
images/mv2DNormRemap/ (empty folder)
images/shadow/ (empty folder)
images/depth2.rla
images/fluidContainer.iff
images/nClothShards.psd (depth layer is empty)
images/nClothShardsBump.psd
images/nParticles.psd
images/shadows.psd
```

The Layered PSD image format option temporarily places each render pass in its own folder as a Maya IFF file. After all the passes for a contribution map are complete, the passes are assembled into a single PSD file and the render pass folders are emptied (**Figure 10.15**). Note that render pass PSD files include a solid color Background that matches the Background Color of the rendering camera. You can remove or ignore the Background during the compositing stage. If a render layer does not possess a contribution map or render passes, it appears as a single-layer PSD with a colored background. In either situation, alpha information is converted to Photoshop transparency (as indicated by the gray-and-white checkers in the layer thumbnails). If a layer is rendered with Maya Software, yet is assigned the Layered PSD image format, it's left as a Maya IFF file (as is the case with the fluidContainer render). Maya IFF files are commonly read by compositing programs, so this does not present a problem. With this batch render, the depth channel is carried by the depth2.rla file.

FIG 10.15 An nClothShards.psd file, as seen in the Photoshop Layer Editor. Each render pass receives its own layer with the addition of a solid-colored Background. An example Maya scene file is included as Project4.11.ma in the /ProjectFiles/Project4/maFiles/ directory.

To batch render image sequences for the layers, change the Frame/Animation Ext to name.#.ext. Change the Start Frame to 1 and End Frame to 60. Set the Frame Padding to 3 (this safely covers any render from 1 to 999 frames). Choose Render > Batch Render. The resulting sequences are numbered *layer_name*.001.psd, *layer_name*.002.psd, and so on. Once the image sequences have rendered, feel free to move them into a custom directory structure. For example, the example files from this point forward use the following directories:

```
images/depth/
images/fluidContainer/
images/nClothShards/
images/nClothShardsBump/
images/nParticles/
images/shadows/
```

Reviewing Renders with FCheck

You can review the quality of rendered still images or image sequence through Maya's FCheck. To do so, choose File > View Image or File > View Sequence. Browse for a single image or the first frame of an image sequence. The FCheck window opens with the image. If View Sequence is chosen, the sequence is loaded, one frame at a time, into memory; once the frames are loaded, FCheck enters into playback mode and you can use the playback controls at the top left of the window.

You can use FCheck to look at RGB, alpha, or depth channels by pressing the matching buttons at the top-center of the window (**Figure 10.16**). If you open a layered PSD or OpenEXR, only the top RGB layer or first RGB channel set is shown. You are also free to examine the renders with other external programs, such as Photoshop; however, some channels may not be accessible, such as depth.

275

FIG 10.16 The depth channel of a rendered image is displayed in FCheck. The RGB, Alpha, and Z-depth buttons activate the channel views.

Rendering Render Passes as OpenEXRs

The OpenEXR format, originally written by Industrial Light & Magic, supports an arbitrary number of channels. Hence, you can store multiple mental ray render passes in a single OpenEXR file. To alter Project 4 to render OpenEXR files instead of Layered PSD files, follow these steps:

1. In the Render Settings window, change the Image Format menu to OpenEXR. As a test, make all the layers renderable except for the masterLayer. Batch render a single frame.
2. Examine the resulting OpenEXR files in Photoshop. Photoshop only sees the RGB channels and the alpha channel, if it exists. You can import the files into Autodesk Composite and examine the various channels through the Options tab of the Tool UI (see the section "Intermediate OpenEXR Compositing in Composite" later in this chapter). You can also import the images into The Foundry Nuke and examine the channels through the viewer or via various channel nodes (see the section "Advanced OpenEXR Compositing in Nuke" later in this chapter).

> ### VFX Notes: 16- and 32-Bit Depths
>
> By default, Maya renders in 8-bit colorspace. That is, each color channel supports 2^8 or 256 colors (or tonal steps). Such a low bit-depth colorspace can lead to rendering errors, such as color banding (posterization). Hence, Maya's mental ray renderer supports 16-bit and 32-bit floating-point colorspace. Not only do the higher bit-depth colorspaces provide a tremendous number of potential colors per channel, but their floating-point architecture supports decimal-place value storage that greatly increases the rendering accuracy.
>
> Many compositing programs support 16- and 32-bit floating-point colorspace. These include Autodesk Composite, Adobe After Effects, and

The Foundry Nuke. By default, Composite and Nuke work in 32-bit space while After Effects offers the option to switch from 8-bit to 16- or 32-bit.

To render in Maya at a higher bit-depth, switch to the mental ray Quality tab in the Render Settings window, expand the Framebuffer section, and choose a higher bit-depth through the Data Type menu. Note that a limited number of image formats support 16- and 32-bit renders. These include OpenEXR and HDR. Maya can also read DDS and floating-point TIFF files if the ddsFloatReader.mll and tiffFloatReader.mll plug-ins are activated.

This concludes Part 7 of Project 4.

Compositing Render Passes

After batch renders are successfully completed, the rendered image sequences must be recombined in the compositing program. Autodesk Composite (previously named Toxik) comes bundled with Maya 2013 and 2014. In contrast, Adobe After Effects and The Foundry Nuke are widely-used compositors that take unique approaches to compositing tasks.

Due to space limitations in this book, only a brief step-by-step introduction to the compositing process is included. For additional information, see the Help files associated with each program or consult more in-depth sources, such as the books "Professional Digital Compositing" or "Digital Compositing with Nuke" (also written by the author).

Basic Layered PSD Compositing in After Effects

After Effects is the most widely used compositing program in the world. It's layer-based and operates in a fashion similar to Adobe Photoshop. 2D Layers are stacked with the upper layers obscuring the lower layers except where there is transparency. A layer may be an image sequence, a movie (QuickTime, AVI, MP4, and so on), or a still image (a piece of artwork, a photo, or After Effects-generated shapes/solids/text). **Figure 10.17** illustrates the main interface components.

FIG 10.17 The Adobe After Effects interface. The Pen tool is circled in red.

To create a basic composite as Part 8 of Project 4, follow these steps:

1. Launch After Effects. Choose File > Import > File. Browse to the `/ProjectFiles/Project4/Footage/Building/` directory. Select the first frame of the Building image sequence—`Building.01.png`. Note that the PNG Sequence check box is selected. As long as the Sequence button is selected, image sequences are imported as a single unit. Click Open. The sequence is imported and is displayed in the Project panel.

2. Choose File > Import > File. Browse to the `/ProjectFiles/Project4/images/fluidContainer/` directory. Select `fluidContainer.001.iff` and click Open. Whenever an image sequence carries an alpha channel, the Interpret Footage window opens (**Figure 10.18**). In this case, select the Premultiplied radio button and click OK. This setting matches Maya's style of alpha premultiplication (which multiplies the alpha values by the RGB values to improve edge quality and to make compositing more mathematically efficient). Repeat the import process with the nClothShards PSD sequence. Whenever the program encounters a multi-layer PSD file, it opens a layer window (**Figure 10.19**). You have the option to merge (flatten) the layers by selecting the Merged Layers radio button or by selecting the Single Layer and choosing a layer name from the menu. In this case, select Single Layer and choose the MasterBeauty layer. PSD transparency is interpreted automatically as alpha transparency.

FIG 10.18 The Interpret Footage window.

3. Repeat the import process until all the PNG/PSD sequences and layers listed in Table 10.3 are imported.

4. Note that After Effects automatically interprets the frame rate of the image sequences. You can see this by clicking on a sequence name in the Project panel. The thumbnail includes the fps number. For this project, we want to interpret all the sequences as 30 fps. If a sequence is interpreted

FIG 10.19 The PSD Layer window with the Choose Layer menu revealing the available layers for the nClothShards image sequence.

TABLE 10.3

Image Sequence	Render Pass Layer
Building.##.png	None
fluidContainer.###.iff	None
nClothShards.###.psd	MasterBeauty
nParticles.###.psd	MasterBeauty

at another frame rate, such as 24, RMB-click the sequence name in the Project panel and choose Interpret Footage > Main. In the Interpret Footage window, change the Assume This Frame Rate cell to 30 and click the OK button. When the sequences are imported, your Project Panel should look like **Figure 10.20**. We'll add Comp 1 in the next step.

FIG 10.20 The Project panel with 4 imported sequences and one new composition (Comp 1). Note the *fps* readout beside the sequence thumbnail.

5. Choose File > Project Settings. In the Project Settings window, select the Frames radio button in the Time Display Style section and click OK. This changes the time markers on the timeline to frames, which is easier to work with when compared to video timecode. Choose Composition > New Composition. In the Composition Settings window, set Width to 1280, Height to 720, Frame Rate to 30, Start Frame to 1, and Duration to 60. Click the OK button. A new composition, Comp 1, is listed in the Project panel.

6. LMB-drag the Building sequence from the Project panel to the layer area of the Comp1 tab of the timeline. The sequence appears in the Viewer panel. The resolution of the sequence is larger than the composition resolution, so the image overhangs and is cropped. To fix this, press Cmd/ Ctrl+Opt/Alt+F to automatically fit the layer to the composition. (You can also change the layer's Scale property to 66.7%; see later steps in this section for information on transforms.) You can zoom in and out of the view by changing the Magnification Ratio Popup menu at the bottom left of the viewer or by using your mouse scroll wheel. You can scroll the viewer by MMB-dragging. You can use the playback controls, in the Preview panel, to examine the footage. You can also LMB-drag the Current Time Indicator back and forth in the timeline. LMB-drag the nClothShards sequence and drop it on top of the Building sequence on the timeline. The shards appear over the building except where there was empty Maya space (which is read as transparent alpha).

7. Go to frame 1. Using the Pen tool, click in the viewer to draw a mask that encircles the core of the nCloth bricks (**Figure 10.21**). Close the mask by clicking on the first point. Expand the nClothShard layer by clicking the small arrow to the left of the layer name (**Figure 10.22**). Expand the Masks section by clicking it's arrow. *Mask 1* is listed. Under *Mask 1*, click the Time icon beside Mask Path (the icon features a stopwatch). This keyframes the mask shape for the first frame. Set Mask Feather to 100. This softens the mask edge. Go to frame 38. Adjust the mask to follow the nCloth structure. As reference, you can line up the mask with the building corner and horizontal outcrop of bricks. To move the mask point, click and LMB-drag. To deselect, click in an empty area outside the mask. To select multiple mask points, LMB-drag a section marquee. To move the mask as a single unity, double-click a mask line and LMB-drag the resulting transform box. To leave the transform box, press the Esc key. Whenever you make a change to the mask, a new keyframe is placed on the timeline, as indicated by a yellow diamond.

8. Proceed to adjust the mask at other frames between frames 1 and 39 so that the mask stays relative to the bricks. Play back the timeline to test. Go to Frame 1. Expand the nClothShard layer's Transform section. Click the Time icon beside Opacity. Set Opacity to 0%. You can enter values into the Opacity number cell. A keyframe is placed on the timeline. Go to frame 26. Set Opacity to 100%. Play back. The Maya render fades in, creating expanding cracks. Go to frame 39. Set Opacity to 100%. Go to frame 42. Set Opacity to 80%. A slightly lower Opacity will blend the

FIG 10.21 A mask, drawn with the Pen tool on frame 1, encircles the core of the nClothShards render. The mask Feather softens the mask edge and disguises the transition from the video footage to the CG bricks.

bricks with the fluid and nParticle smoke. Go to frame 41. This is where the nCloth bricks begin to bulge outwards. Adjust the mask shape so that it encompasses most of the nCloth but leave a soft transition at the bottom (**Figure 10.23**). (To see the mask, the layer must be selected.) Go to frame 46. Adjust the mask so that it's larger than the frame and no longer cuts off any part of the layer (**Figure 10.24**). Play back. The nCloth bricks burst outwards.

FIG 10.22 The expanded Mask and Transform sections of the nClothShards layer. The Mask Path and Opacity are keyframed changing over time. Keyframes are indicated as gray diamonds (or yellow diamonds, if selected).

FIG 10.23 The adjusted mask on frame 41.

FIG 10.24 The adjusted mask on frame 46.

9. LMB-drag the fluidContainer sequence from the Project panel and drop it in the center of the layer stack of the timeline. Start the sequence on frame 1 of the timeline. You can reorder layers by LMB-dragging them up or down. Go to frame 42. Keyframe the fluidContainer's Opacity at 100%. Go to frame 40. Keyframe the fluidContainer's Opacity at 0% (**Figure 10.25**). Play back.

FIG 10.25 The layer stack with fluidContainer added to the center. The Opacity, Scale, and Position properties of the fluidContainer are keyframed.

10. LMB-drag the nParticles sequence and drop it below nClothShards in the layer stack. Start the sequence on frame 1. Go to frame 50. The nParticle render is half the size of the composition. With the layer selected, Cmd/Ctrl+Opt/Alt+F click to fit the nParticles layer to the composition resolution. Play back. The particle simulation occludes the fluid. With the nParticles layer selected, choose Effect > Color Correction > Brightness & Contrast. Choose Effect > Blur & Sharpen > Channel Blur. Two effects are added to the layer. With the nParticles layer selected, switch to the Effect Controls panel (the tab appears immediately to the right of the Project panel tab). The two effects and their options are listed in the new tab. Set Brightness to 35. Set Contrast to 40. Set Alpha Bluriness to 40. This brightens the nParticle render while softening the edges by blurring the alpha channel. Play back. The nParticles continue to create a heavy edge

at the bottom of their mass. To counteract this, reduce the layer's Opacity to 75%. In addition, use the Pen tool to draw a mask on the nParticles layer that cuts through the nParticle base then widens out on the edges. Set the Feather of the new mask to 100.

11. At this point, the nCloth bricks appear clear and sharp-edged. This is due to the lack of rendered motion blur. Although a motion vector pass was rendered, it's in a format that is not read directly by the default version of After Effects. As a workaround, we can apply a radial blur to simulate the blur streaks. To do so, select the nClothShards layer and choose Effect > Blur & Sharpen > Radial Blur. Go to the Radial Blur options in the Effect Controls panel or through the Effects area of the layer. Set and keyframe the properties listed in Table 10.4 to the included values.

TABLE 10.4

Effect	Property	Value	Keyframe?	Frame to key
Radial Blur	Type	Zoom	No	
	Anti-aliasing	High	No	
	Center	482, 284	No	
	Amount	0	Yes	39
	Amount	15	Yes	42

At this juncture, we can adjust the brightness of the bricks. With the nClothShards layer selected, choose Effect > Color Correction > Brightness & Contrast. Go to frame 39. Key Brightness and Contrast at 0. Go to frame 42. Key Brightness at −50 and Contrast at −25. Play back. The nCloth bricks pick up a radial blur that roughly emulates motion blur (**Figure 10.26**). The blur is mildest in the center, as determined by the Center property. In addition, the darker bricks blend in with the mass of smoke.

FIG 10.26 Detail showing radially-blurred nCloth bricks.

12. Play back. The explosion is a bit dim. To flare the explosion, we can add two effects. Select the fluidContainer layer and choose Effect > Color Correction > Brightness & Contrast and Effect > Stylize > Glow. Set Brightness to 30. Set Contrast to 30. Adjust the Glow effect to create a bright burst as the explosion starts. On frame 42, key Glow Threshold at 20%. Key Glow Radius at 60. Key Glow Intensity at 4. On frame 46, key Glow Threshold at 50%. Key Glow Radius at 30. Key Glow Intensity at 1.0. Change the Glow Colors menu to A & B Colors. Change Color A to reddish-orange and Color B to black. By default, the Glow effect creates the glow with the layer's originals color. However, by choosing A & B Colors, you can tint the glow. The Glow effect isolates the bright area of the layer, blurs it, brightens it, and places the result back on top of the layer. This creates an intense red/orange glow within the fluid mass for a few frames (**Figure 10.27**).

FIG 10.27 The Glow effect adds orange intensity to the fluidContainer layer.

13. Play back the timeline. A simple composite of the visual effects is complete (**Figure 10.28**).

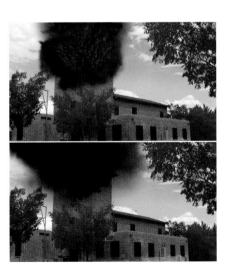

FIG 10.28 Frames 45 and 60. An example After Effects project file is included as Project4.aep in the /ProjectFiles/Project4/aeFiles/ directory.

Keep in mind that this is a very simple demonstration of visual effects compositing and there is a great deal of room for improvement. For example, the following steps will help improve the shot's realism:

- Add cast shadows of the falling bricks.
- Mask the right-hand tree so that the bricks fly behind the leaves.
- Integrate an additional render pass that features the damaged interior of the building (this requires additional modeling and texturing).
- Duplicate and mask the explosion to create a shadow of the smoke cloud to the building.
- Render the nCloth bricks with proper motion blur or utilize the motion vector pass.
- Use the nClothShardsBump render pass to give additional variation to the nCloth bricks. This requires blending the nClothShardsBump render together with the nClothShards layer.
- Add a 2D art element or 2D matte painting that creates additional building damage (for example, scorching).
- Create an artificial depth-of-field by employing the depth2 render pass as a matte.
- Add an artificial camera shake at the point of the explosion. You can achieve this by animating the transforms of a nested composition (one composition placed inside a second composition).

Many of these techniques are demonstrated in the last section of this chapter. This concludes Part 8 of Project 4.

An Introduction to OpenEXRs and Autodesk Composite

Autodesk Composite, formerly known as Toxik, is bundled with Maya 2013 and Maya 2014. Composite is a node-based system, whereby individual tasks are handed to specific nodes. The resulting node networks are similar to Maya's Hypergraph window. Composite supports the use of OpenEXR files. As with many compositing programs, Composite allows you to work with individual channels, whereby you can transfer and combine them to create customized results. **Figure 10.29** illustrates the main interface components.

FIG 10.29 Composite interface components.

To create a simple composition that loads, transforms, and outputs the Project 4 `Building.##.png` image sequence as Part 9 of Project 4, follow these steps:

1. Launch Composite. The program files are located in the Composite2013 or Composite2014 folder within the program installation directory.

2. Choose File > Import from the Menu Bar. The File Browser window opens. Navigate to the `/ProjectFiles/Project4/Footage/Building/` directory. The Building.##.png image sequence is displayed as a single unit—*Building*. Select Building and click the Import button. The footage is imported. The window switches to the Create Composition window and waits for you to choose a location to save the project file. Enter **Project4** or similar name into the Name field, browse to location where you'd like to save the project, and click the Create button. The project is saved with the `.txcomposition` extension. The Create Composition window closes.

3. The Building footage is displayed in the Schematic as a footage Input node (**Figure 10.30**). The node is connected automatically to an Output node. To view the footage in the Viewport, click on the Output node so that it turns yellow. You can scroll in the Viewport (or Schematic) by pressing the Space Bar and LMB-dragging. You can zoom by using a mouse scroll wheel or press the up/down arrow keys on the keyboard. To play back the footage, use the playback controls below the Viewport (at the top-right of the Tool UI section). Click on the Building Import node in the Schematic. The Tool UI section has switches to the Import Image tab, which displays all the properties of the footage. In this tab, set the Rate menu to 30 fps. Set the Offset cell to 1. This ensures that the footage starts on the first frame of the Composite timeline.

FIG 10.30 The Schematic with the Building footage loaded into an Import node. The Output node is connected automatically.

4. Click on the Output node. The Tool UI switches to the Output tab. Change the Width and Height cells to 1280, 720. Change the Rate to 30 fps. Set the End cell to 60 (**Figure 10.31**). This tab determines the project settings.

Composition	Versions	Metadata	Animation	Cue Marks	Pick List	Output	Render

Image Format		P	Pixel Format		P	Time		P
Format	HD 720p		Channels	RGB		Start		1
Width	1280	Height 720	Depth	32 Bits		End		60
Image Aspect Ratio	16:9					Duration		59
Pixel Aspect Ratio	1:1					Poster		1
Rate	30 fps							

FIG 10.31 The adjusted Output tab, as seen in the Tool UI section.

5. The Building footage is cropped due to its larger resolution. Place your mouse over the right-hand gray output bar on the Building Import node. The bar becomes wider. RMB-click to reveal a shortcut menu (**Figure 10.32**). Choose Add From Pick List > Compositing > 2D Transform. A new 2D Transform node is added and is connected in between the Import node and the Output node. (Nodes are referred to as *tools*.) Much like the Maya Hypergraph view, the connection indicates the flow of information. The right side of the nodes is the output side and the left side of the nodes is the input side. Click on the 2D Transform node. Its options open in the 2D Transform tab in the Tools UI. Click the Link button below Scale so it's no longer pushed in. Set Scale X and Scale Y to 0.67. This shrinks the Building footage to fit within our project resolution of 1280x720, as set by the Output node. Note that you can interactively move and rearrange nodes in the Schematic by LMB-dragging them. To see the output of any node, click the node so that it turns yellow. The final result is provided by the Output node.

FIG 10.32 A shortcut menu displaying a short list of nodes. The output bar at the right-side of the Building Import node is RMB-clicked.

To read multi-channel OpenEXR files, you can apply these additional steps:

1. Choose File > Import from the Menu Bar. Through the File Browser window, select the `nClothShards.###.exr` sequence in the `/ProjectFiles/Project4/images/nClothShards/` directory. Note that the file format

type is indicated by a small icon to the left of the sequence name. Click Import. The sequence is placed in a new Input node. To see the contents in the viewer, select the new node. In the Import Image tab, change the Rate to 30 fps and Offset to 1.0.

2. By default, the RGBA channels are output from the OpenEXR files. To choose a different channel, change the Channel Views menu in the Options tab of the Tools UI section. For example, change the menu to DIFRAW:diffuseMateri77326399 to access the diffuse material pass (**Figure 10.33**). (To change back to the default RGBA channel set, set the Channel Groups menu to Color + Alpha.) Note that OpenEXR files do not carry a "MasterBeauty" channel, as does a layered PSD file; instead, the RGBA channels serve the beauty pass.

FIG 10.33 The Channel Views and Channel Groups menu of the imported sequence's Options tab.

Although you can successfully read the diffuse material pass channel, it does not carry its own alpha information. Hence, to use the channel, you must provide it with alpha information. You can do this by transferring the alpha from another input. Transferring channel information between multiple layers or nodes is a common compositing task. To do this, you must make a more complex network. Here are some guidelines for creating, deleting, connecting, and disconnecting nodes:

- To connect one node to another, LMB-drag a connection line from the node's right-hand gray output bar. Drop the connection on the second node's left-hand gray input bar. Some nodes have multiple input bars, each with a specific function. These are described later in this section.
- To disconnect one node from another, Cmd/Ctrl+LMB-drag the connection line. The line is broken at the input side of the node that is receiving the connection. You are free to LMB-drag the broken line and drop it on top of a different node's input bar.
- You can delete a node at any time by selecting it and pressing the Delete key.
- You can create new nodes without any connections by going through the Tools tab. Initially, this is hidden. To access the tab, MMB-click anywhere in the program window. A four-quadrant Gate UI appears at the mouse location. Without releasing the MMB, sweep right over the Tools quadrant. A new panel, with Tools, Views, and Pick List tabs, appears at the program

right-side. The top section of the Tools tab carries tool categories and the bottom section carries the tool list. To create a new tool, LMB-drag the tool icon (a small wrench) from the left of the tool name and drop it in the Schematic. You can connect the new node to other nodes at your leisure. Note that the Tools tab carries a full list of all available tools.

To create a network which transfers alpha from one node to another, you will need to create an Extract node and a Replace node. The required network is illustrated by **Figure 10.34**

FIG 10.34 The portion of the network showing the combination of RGB and alpha channels from two sources so that it forms a single RGBA output.

With this example, the nClothShards sequence is imported into two input nodes. One input node, set to output the standard RGBA channels, is connected to the input of the Extract node. The second input node, set to output the diffuse material pass, is connected to the A input of the Replace node. Note that the Replace node has two inputs. The top input is considered the A input. The bottom input is considered the B input. The output of the Extract node is connected to the Replace node's B input. The Extract node passes the RGB alpha channel to the Replace node. The Replace node combines A and B inputs, where the RGB is taken from the diffuse material channel and the alpha is taken from the Extract node. Hence, two different sources are combined into a single RGBA output.

To layer two or more sequences together in a node-based compositor, you must use a node designed for the layering task. With Composite, you can use the Blend & Comp node. A Blend & Comp node has two inputs. Much like the Replace node, you can consider these A and B inputs. In this case, you can consider the A input as the "top" layer and the B input as the "bottom" layer. By default, A occludes B except where A is transparent. You can alter this behavior by changing the Comp menu in the Blend & Comp tab. Comp determines the mathematical way in which A and B pixels are combined or averaged. The equivalent function in After Effects is the Blending Mode menu,

which is carried by each layer. **Figure 10.35** illustrates a network that uses two Blend & Comp nodes to combine the nClothShards diffuse material pass with the fluidContainer sequence and the Building background.

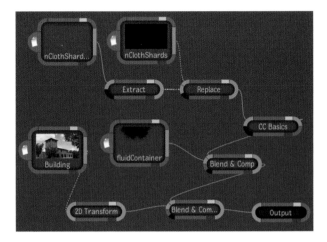

FIG 10.35 Three sequences are "layered" with two Blend & Comp nodes. An example Composite project file is included as Project4.txcomposition in the /ProjectFiles/Project4/txFiles/ directory.

In addition, you can can add tools at any point in the network to adjust the node quality. This is equivalent to applying effects to layers in After Effects. Tools you might apply include various color corrections, blurs, and masking operations. For example, in **Figure 10.36**, a CC Basics node is inserted to adjust the brightness of the Replace node output.

This concludes a brief introduction to Composite and an approach to working with OpenEXRs and channels. This ends Part 9 of Project 4.

Advanced OpenEXR Compositing in Nuke

The Foundry Nuke is a node-based compositing program that was developed for the visual effects industry. As a demonstration of a complex visual effects composite, a completed Nuke file is included here.

Figure 10.36 illustrates four frames from the composition. **Figure 10.37** displays the final node network.

As for the network, here's what the nodes are tasked with in each colored backdrop section (each backdrop is named along the top):

- SHARD_BLUR (red): Uses the motion vector render pass and depth pass to apply motion blur and depth-of-field to the result of the SHARD_BUMP section. The VectorBlur node (orange) applies the motion blur and the Zdefocus node (orange) applies the depth-of-field.
- SHARD_BUMP (yellow): Combines the nClothShardsBump render and nClothShards diffuse material pass to create more complex shards.
- READ_DIFFUSE (green): Reads the diffuse material pass and sends it to the SHARD_BUMP section. With Nuke, you can retrieve specific channels from OpenEXRs or layers from PSD files by using the Shuffle node (dark pink).

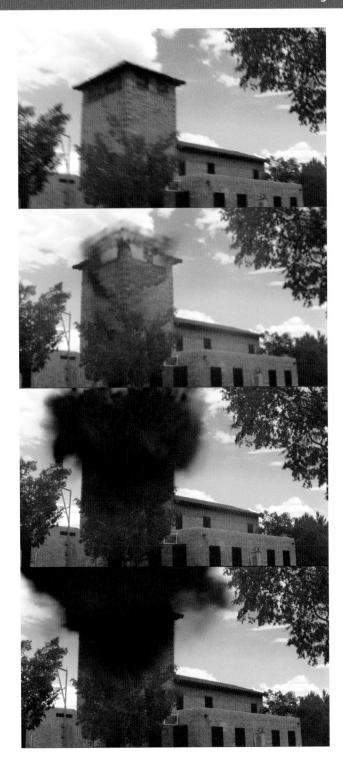

FIG 10.36 Frames 40, 42, 46 and 55 of the Nuke composite. All of the render layers and render passes created in this chapter are used.

FIG 10.37 The final node network as seen in the Nuke Node Graph. The large colored rectangles are backdrops used to organize the network. An example Nuke project file is included as Project4.nk in the /ProjectFiles/Project4/nkFiles/ directory.

- PREP_FLUID (blue-green): Reads and prepares the fluidContainer render. Many Color Correction nodes (light blue) are used throughout the network to adjust saturation, brightness, and contrast of various node outputs.
- PREP_PARTICLES (blue): Two copies of the nParticles render are combined. Extra work is done here to soften the render edges and to match the nParticles to the fluidContainer explosion. Merge nodes (blue) are used throughout the network to combine two or more inputs.
- PREP_SHADOWS (purple): Reads, color corrects, blurs, and masks the shadow render pass. In Nuke, masking is applied through Roto nodes (light green). The output of a Roto is connected to the Mask input of a Merge node.
- KEY_FG_TREE (lime green): The right-hand foreground is cut out with the Keyer node (green). This allows the smoke and debris to appear "behind" the tree leaves. (Essentially, the tree is cut out and placed back on top.)
- CLOUD_SHADOW (pink): A shadow of the smoke cloud is fabricated by altering the fluidContainer render. One advantage of a node-based system is that you can send the output of a single node to the inputs of many other nodes.
- COMBINE_SEQUENCES (orange): All the major sections of the network are combined.
- CAMERA_EFFECTS (purple): An artificial lens flare is created and an artificial camera move is added. You can create a camera move by animating the Scale, Rotate, and Translate of a Transform node (light purple). This section creates the final output, which is currently sent to a Viewer node.

Although this concludes Project 4, there is still room for improvement. Here are a few ideas:

- Add additional fluid simulations that make the explosion and billowing smoke more complex. Create a fluid simulation that replicates a fire that can be seen through the upper windows from the first frame. The motion tracking has already been completed for the entire timeline.
- Create an nParticle simulation that emulates dust falling off the roof line from the force of the explosion.
- Create additional rigid bodies or nCloth bodies that simulate different sized pieces of debris. For example, simulate splintered wood, chunks of concrete, steel beams, and so on.
- In the composite, deform the trees so they appear to be affected by the explosion.
- Create an additional render of the inside of the damaged tower. This requires additional modeling and texturing. As an alternative, create a digital matte painting of the damage and use masking and motion tracking to make it fit (in this case, 2D transform motion tracking is required, which you can accomplish in the compositing program).

Wrap-Up

Maya's visual effects systems are wide-ranging and possess long attribute lists and innumerable means to set them up. In addition, there are almost endless ways to fine-tune the renders in such programs as Composite, After Effects, and Nuke. Therefore, please consider this book a brief introduction to these tools and a glimpse at the visual effects possibilities. If you would like to expand your visual effects knowledge, there are great online resources that include `lynda.com`, `DigitalTutors.com`, and `CreativeCrash.com`. In addition, groups like ACM Siggraph and the Visual Effects Society help to keep animators and artists informed on the latest technological developments and industry resources.

If you would like to see my own animation and visual effects work, please visit `BeezleBugBit.com` or look me up on popular social media networks.

Thanks for reading!

Index

Note: page numbers in italic type refer to Figures; those in bold refer to Tables.